DRAWN TO EXTREMES

DRAWN TO EXTREMES

The Use and Abuse of Editorial Cartoons

CHRIS LAMB

COLUMBIA UNIVERSITY PRESS NEW YORK

COLUMBIA UNIVERSITY PRESS
Publishers Since 1893
NEW YORK
CHICHESTER,
WEST SUSSEX

Library of Congress Cataloging-in-Publication Data

Lamb, Chris, 1958–
Drawn to extremes : the use and abuse of editorial cartoons / Chris Lamb.
p. cm.
Includes bibliographical references (p.) and index.
ISBN 0-231-13066-X (acid-free paper)
ISBN 0-231-13067-8 (pbk. : acid-free paper)
1. Editorial cartoons—United States. 2. Political cartoons—United States.
3. Editorial cartoonists—United States—Biography. 4. Newspaper publishing—Political
aspects—United States. 5. United States—Politics and government—2001—Caricatures
and cartoons. 6. September 11 Terrorist Attacks, 2001—Caricatures and cartoons.
7. United States—Politics and government—Caricatures and cartoons. 8. American
wit and humor, Pictorial. I. Title.

E183.L36 2004
070.4'42—dc22

2004048220

∞

Columbia University Press books are printed on permanent and
durable acid-free paper.
Printed in the United States of America

c 10 9 8 7 6 5 4 3 2 1
p 10 9 8 7 6 5 4 3 2 1

For Lesly and David

CONTENTS

ACKNOWLEDGMENTS

Although I had no idea at the time, *Drawn to Extremes* began in 1983 when I was a graduate student at the University of Tennessee. I decided to write my master's thesis on editorial cartooning. When one of my committee members suggested that I focus on a single cartoonist, I chose Mike Peters of the *Dayton Daily News*, whose cartoons I had read and admired while growing up in Dayton, Ohio. Peters, generous guy that he is, sat patiently with me as I interviewed him for several hours one nice September day in downtown Dayton.

When I finished my master's degree, I approached *Editor & Publisher*, the trade journal of the newspaper industry, about writing an article on Mike Peters. David Astor, one of the magazine's editors, approved the article. Over the next fifteen years, I interviewed about twenty editorial cartoonists for the magazine, including Herbert Block (who is far better known as Herblock), Tom Toles, Ann C. Telnaes, Bob Englehart, Rob Rogers, Jeff Stahler, Wiley Miller, Mike Shelton, Marshall Ramsey, Bruce Tinsley, Bruce Beattie, Brian Bassett, M. G. Lord, Gary Huck, Mike Konopacki, Steve Breen, Mike Ramirez, David Horsey, and Tommy Thompson. I am grateful to these cartoonists and David Astor, who both inspired—and enhanced—my interest in editorial cartooning.

In addition, Richard Samuel West, editor of *Target: The Political Cartoon Quarterly*, published three of my articles, including one on cartoonists and libel. For that article—which later appeared, in part, as a chapter in my dissertation, an article in the scholarly journal *Inks: Cartoons and Comic Art Studies*, and, finally, a chapter in this book—I interviewed a number of cartoonists who had been sued for libel, including Paul Szep, Bob Englehart, Milt Priggee, and Tim Newcomb.

Although it ceased publication in the late 1980s, *Target* remains an invaluable resource for anyone with a scholarly or even a casual interest in

editorial cartooning. There are few people—if, indeed, anyone—who know as much about editorial cartooning as Rich West, author of *Satire on Stone: The Political Cartoons of Joseph Keppler*. In the writing of this book, I also referred with great interest to Stephen Hess and Milton Kaplan's *The Ungentlemanly Art: A History of American Political Cartoons*, Stephen Hess and Sandy Northrop's *Drawn and Quartered: The History of American Political Cartoons*, Roger A. Fischer's *Them Damned Pictures!*, and other books.

As I continued my research on editorial cartooning, I relied heavily on Lucy Shelton Caswell, curator of the Cartoon Research Library at Ohio State University. Lucy also edited *Inks*, which elevated editorial cartooning as a source of scholarly interest. The journal published my article "Drawing the Line: An Absolute Defense for Editorial Cartoons," which I used, in part, in one of the chapters of this book.

When I began work on my doctorate in 1993, I knew that I would write my dissertation on some aspect of editorial cartooning. I chose the limits of cartooning because editorial cartoons represent perhaps the most extreme form of expression found in daily newspapers. For the purposes of my dissertation, I was interested in how cartoonists are restricted by both legal and newsroom pressures. I surveyed cartoonists and their editors to examine their relationship, and my findings formed the basis of "Perceptions of Editors and Cartoonists About Cartoons," published in *Newspaper Research Journal*, and two chapters of this book.

I could not have adequately completed this research without the contribution of dozens of cartoonists and editors. A number of cartoonists—including Nick Anderson, Robert Ariail, Bruce Beattie, Steve Benson, Dennis Draughon, David Hitch, Jimmy Margulies, Gary Markstein, Chris OBrion, Mike Thompson, and Dick Wright—allowed me to use their responses in my dissertation. While writing my dissertation, I was aided immeasurably by the interlibrary loan department at Bowling Green State University. Since then, I have relied on the interlibrary loan departments at Old Dominion University and the College of Charleston.

After finishing my dissertation, I taught at Old Dominion University for two years before moving to the College of Charleston. During the fall of 2000, I suggested bringing a number of cartoonists to campus to discuss the 2000 presidential election, not knowing that it would turn out to be one of the most controversial in U.S. history. In April 2001, I hosted a symposium, "It's a Draw: Political Cartoonists Reflect on the 2000 Presidential Election," that brought to campus Doug Marlette, Joel Pett, Clay Bennett, and Robert Ariail. I was fortunate that the college's Office of Media Technolo-

gy videotaped the speeches and discussions. I relied on the videotapes in the writing of this book.

In addition, in the spring of 2002, I taught a course at the college on editorial cartooning. One of my students, Paige Burns, wrote her term paper on the neglected topic of female cartoonists. She interviewed through e-mail a number of female cartoonists, including Signe Wilkinson, Ann Telnaes, Elena Steier, and Cindy Procious. I also interviewed Genny Guracar for a paper that Paige and I co-wrote on the subject.

As I began working on this book, I wanted to include a sample of cartoons that never had been published, for whatever reason. V. Cullum Rogers, of the Association of American Editorial Cartoonists, kindly sent me a stack of such cartoons, which greatly strengthened chapter 6. Another important resource was the AAEC Web site, edited by Larry Wright of the *Detroit News*.

In the writing of the book, I interviewed a number of additional cartoonists, such as Doug Marlette, Joel Pett, Clay Bennett, Ted Rall, Robert Ariail, Cindy Procious, and Joe Sharpnack. This book could not have been published without the generosity of cartoonists who allowed me to use their work —in some cases for no charge, in others for a nominal charge. I would like to acknowledge the following cartoonists: Doug Marlette, Bob Englehart, Robert Ariail, Paul Conrad, Joel Pett, Clay Bennett, Jeff Stahler, Rob Rogers, Steve Breen, Milt Priggee, Paul Szep, Ann C. Telnaes, Jeff Danziger, Dennis Draughon, Rex Babin, Marshall Ramsey, Steve Benson, Kirk Anderson, Garry Trudeau, Mike Peters, Dick Locher, Aaron McGruder, Pat Oliphant, John Deering, Steve Kelley, Mike Keefe, Michael Ramirez, Don Wright, Kevin Kallaugher, Tom Toles, Wiley Miller, Cindy Procious, Tim Newcomb, and Joe Sharpnack.

In addition, the estates of deceased cartoonists made it possible to use a number of drawings. I would like to acknowledge the estate of Bill Mauldin. Jonathan Gordon of the law firm Weston, Benshoof, Rochefort, Rubalcava, and MacCuish permitted the use of Mauldin's cartoons. Kip Koss of the J. N. "Ding" Darling Foundation allowed me to include the cartoons of "Ding" Darling. The Walter O. Evans Collection permitted me to use the cartoons of Oliver Harrington. And Carolyn Kelly, the daughter of Walt Kelly, allowed me to use a cartoon by Walt Kelly. In addition, I want to acknowledge the assistance of Raegan Carmona of Universal Press Syndicate, Pat Henry of Tribune Media Services, Tony Rubalcava of Copley News Service, Maura Peters of United Media, Marianne Sugawara of Creators Syndicate, James Cavett of North America Syndicate, Guinevere Harwood-Shaw of the *Christian Science Monitor*, and Kay Conrad.

I also want to acknowledge the generosity of the College of Charleston's research and development committee, which provided me with a $3,000 grant so I could concentrate on the book without having to teach during the summer of 2003. I could not have written this book without this grant.

I appreciate Columbia University Press for not only publishing *Drawn to Extremes* but also allowing me to write the book the way I wanted. I also acknowledge the tremendous support I have received from John Michel, senior editor at Columbia, and others at the press, including Jeanie Lu, Lisa Hamm, Margaret Yamashita, and Irene Pavitt. And, finally, special thanks to my wife, Lesly, and son, David, who patiently forgave me for spending so much time at the office.

DRAWN TO EXTREMES

"You Should Have Been in the World Trade Center!"

The September 11, 2001, terrorism attacks on the World Trade Center in New York City and the Pentagon in Washington, D.C., resulted in a day of unprecedented sadness in the United States. Americans wept as they watched on television while one tower—having been hit by a hijacked airplane—burned as another plane approached the second tower. Within an hour, both 1,350-foot towers collapsed into rubble, burying hundreds of firefighters and police officers, many of whom had trudged up dozens of flights of stairs in search of survivors. Newspapers published special editions with pages of photographs and moving accounts of heroism and of tragedy. On the editorial and op-ed pages, columnists wrote tributes to those who had died and demanded retribution against the Saudi terrorist Osama bin Laden, who, it was believed, had masterminded the attacks from Afghanistan.

In their commentaries, however, most columnists and editorial writers could not approach in either sheer force or poignancy what editorial cartoonists could achieve without using words. Mike Luckovich of the *Atlanta Constitution* drew the Statue of Liberty with a tear running down her cheek and the image of burning towers in her eyes (figure 1.1). Bob Englehart of the *Hartford (Conn.) Courant* drew a close-up of Uncle Sam with fire coming out of his eyes (figure 1.2). Other cartoonists, relying on familiar symbols of America, drew the Statue of Liberty weeping, Uncle Sam rolling up his sleeves, and a bald eagle sharpening its talons. Yet others captured New York City firefighters as angels in heaven or Osama bin Laden burning in hell. In one of the more evocative drawings, Jeff Stahler of the *Cincinnati Post* drew a cell phone in the rubble of the Twin Towers with one of the victim's loved ones saying, "I love you" (figure 1.3).

The events of September 11 profoundly changed the rules of engagement for cartoonists, who directed their sense of outrage at a world that was

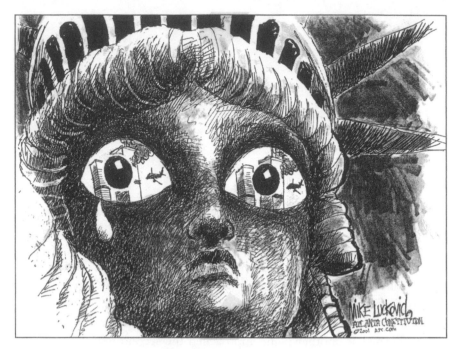

Figure 1.1 Mike Luckovich, *Atlanta Constitution*, 2001.
Reprinted with permission of Creators Syndicate.

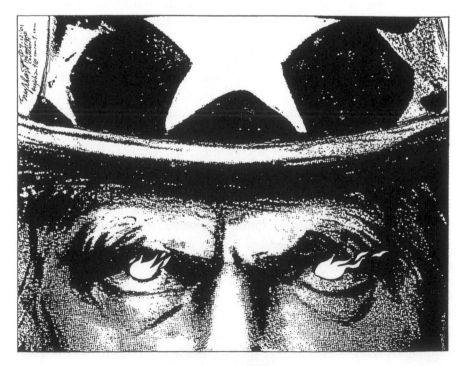

Figure 1.2 Bob Englehart, *Hartford (Conn.) Courant*, 2001.

JEFF STAHLER
Courtesy Cincinnati Post

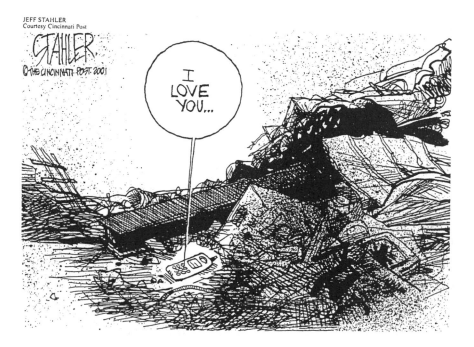

Figure 1.3 Jeff Stahler, *Cincinnati Post*, 2001.

shifting uneasily under their drawing boards. In the months leading up to that September morning, cartoonists had drawn President George W. Bush with big ears and bushy eyebrows, as an undeserved leader who had ascended to the White House even though he had not won the popular vote in the November 2000 presidential election. Cartoonists ridiculed Bush for his garbled syntax and his perceived lack of intelligence and vision. He was seen as a lesser man than his father, who had been president himself. Bush tried to appear presidential by rattling his saber and uttering nationalistic rhetoric, such as calling Iran, Iraq, and North Korea "an axis of evil." But his critics were not impressed. Because of his many foibles, Bush became comfort food for cartoonists, even though their drawings rarely went beyond relatively banal gags to anything approaching hard-hitting social satire.

But after the deaths of thousands of Americans, Bush was no longer just the president; he now was the commander in chief of a country at war, and many Americans, including cartoonists, believed it was inappropriate, even unpatriotic, to criticize him. Now was the time to defend the president and his administration. Cartoonists showed their support by capturing Bush as an indomitable symbol of the country's fight against terrorism: an icon of strength, power, and freedom, like Uncle Sam and the Statue of Liberty. In

a subtle yet significant gesture, a number of cartoonists even toned down their caricatures of Bush. Those who had drawn him with elephant ears, *Akron (Ohio) Beacon-Journal* cartoonist Chip Bok noted, "no longer did so."[1]

Both the suddenness and the enormity of the terrorist attacks stunned cartoonists, leaving them struggling to distill their feelings about what had happened into a single image. "I didn't want to work that day. I just wanted to talk about it with friends and family," said editorial cartoonist Steve Breen, who drew a bald eagle sharpening its talons, which he described as more a cheerleading cartoon than a typical editorial cartoon. "Editorial cartooning is an inherently negative art, whereas [this cartoon is] more of a cheerleading, positive, 'rah, rah,' cartoon," he said. "But it felt so appropriate at the time."[2] *Newark (N.J.) Star-Ledger* cartoonist Drew Sheneman remembered that "the cartoons in the days following the attack expressed the only thing they could: sorrow and disbelief." He added, "As time went on and the country digested what had happened, the commentary changed. The next logical step was anger at the terrorists. Then pride, and gratitude watching the rescue workers. You can read the time line of the tragedy through the cartoons. . . . Each one felt right at the time it was drawn."[3]

Amid the chaos of the first great crisis of the twenty-first century, editorial pages were dominated by images of fiery twin towers, weeping Statues of Liberty, snarling bald eagles, and resolute Uncle Sams rolling up their sleeves and preparing to march into hell for a heavenly cause. But one cartoonist, Ted Rall, scolded his fellow cartoonists for exchanging social criticism for mawkish sentimentality: "The Statue of Liberty crying with a hole in her chest or with a model airplane smashing into her side only conveys one concept: lazy editorial cartoonist." Steve Benson of the *Arizona Republic*, however, argued that the cartoons represented "a gut, emotional reaction in terms of horror and rage to the atrocities of recent days and express the feelings of many of our fellow citizens." He continued, "In that way, they connect to our readers in offering a shared sense of collective identification and natural empathy. . . . I wouldn't call that lazy. I'd call it human."[4]

Social critics work best during periods of widespread reform and unrest, like the civil strife of the late 1960s, not during periods of grief or uncertainty or when the country is at war, when there is a tendency to wrap oneself in the security of the American flag and give unquestioned support to the country's leadership while savaging its enemies. Editorial cartoonists, however, are not supposed to be government propagandists; that is the job of other people. Cartoonists are supposed to keep a jaundiced eye on the democracy and those threatening it, whether the threats come from outside or inside the country.

Sometimes, though, even the most pointed satirists defer to discretion. Editorial cartoonist Pat Oliphant, who has established a well-deserved reputation by dipping his pen into a deep well of scorn and then mercilessly poking whatever irritates him, announced a cease-fire against the Bush administration. He asserted that cartoonists had to support the war effort—at least for the time being.[5] *Doonesbury* cartoonist Garry Trudeau withdrew a week's worth of strips critical of the president.[6] This was not the first time that Trudeau had shown such restraint. During President Jimmy Carter's administration, Trudeau wrote a series on the Reverend Scot Sloane's visit to Iran, where more than fifty Americans were being held hostage. But after several marines were killed in a rescue attempt, Trudeau temporarily withdrew the strip.[7]

Social policy pundit Stephen Hess, co-author of *Drawn and Quartered: The History of American Political Cartoons*, said that the September 11 tragedy left Americans, including editorial cartoonists, shaken, and he described the cartoons in the weeks following the attacks as "very dull." He added that cartoonists were not "necessarily jingoistic like in World War II, but it's almost like they're looking for other things to write about."[8] Mike Luckovich agreed. "After September 11, you just couldn't use humor," Luckovich said. "The tragedy was so enormous, you couldn't be funny. It's almost like you have to come up with cartoons using a different part of your brain."[9]

Soon after the terrorist attacks, however, a few cartoonists returned to social satire, believing—contrary to many in their profession and also their readers—that giving our country's leaders a free pass during times of crisis undermines our democracy. Indeed, Trudeau soon ended his brief armistice with a strip pointing out that President Bush and his administration were using the opportunity of the tragedy to move their conservative programs forward. One drawing shows the White House chief of staff, Karl Rove, telling the president that several of the controversial items on the administration's political agenda were "justified by the war against terrorism!" Bush then replies: "Wow . . . what a coincidence . . . thanks evildoers!" (figure 1.4).[10]

President Bush and other leaders told Americans that they must go about their lives as usual or the terrorists would win. The *Lexington (Ky.) Herald-Leader*'s cartoonist, Joel Pett, took the president at his word. "He wanted us to return to what we do," he said, "and what I do is attack Bush."[11] Pett said that cartoonists had a patriotic duty to return to social criticism: "We start asking questions about lax security. We express our feelings, hopes, even doubts, about our country's capacity for dealing with such an enormous threat. We ask questions about civil liberties, retaliation, racial and ethnic

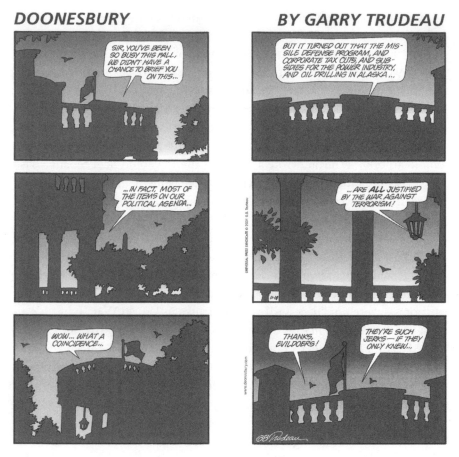

Figure 1.4 Garry Trudeau, © 2001.
Reprinted with permission of Universal Press Syndicate. All rights reserved.

profiling. And inevitably, we return to employing the various tools of our tirades: irony, humor, ridicule, scorn, skepticism, and sarcasm."[12]

A few days after the tragedy, Pett chided Bush for declaring that America would "punish any state that harbored or trained terrorists." Pett wondered whether this included the state of Florida, where the terrorists had lived and taken flying lessons (figure 1.5). In another cartoon, Pett drew a diminutive Bush tugging at the heels of Vice President Dick Cheney while mumbling simplistic slogans against evil: "War against evil, huh Uncle Dick? Evil!" (figure 1.6). Many of the newspaper's readers were not amused by the cartoonist's humor, irony, or sarcasm. They canceled their subscriptions, demanded that Pett be fired, and left profane messages on his voice mail. "One elderly woman spat into the phone that [you] 'should have been

in the World Trade Center,'" Pett said. "Such is the power of the cartoon when it is unleashed."[13]

Given the scarred sensibilities of September 11, one editorial cartoonist's satire became another's sedition; one cartoonist's criticism of the Bush administration became someone else's anti-Americanism. According to Pett, he tried to explain to offended readers that he had both a right and a duty to question the administration: "I wanted to make sure they personally understood that I felt it was our patriotic duty not to go along with the program."[14] Scott Stantis, then president of the Association of American Editorial Cartoonists, said that cartoonists found themselves "under particular scrutiny" after September 11. "A number of cartoonists have heard 'You're a traitor' anytime they question the president."[15]

During times when sensitivities are particularly rarefied, such as the period following September 11, criticism of the American government is often met with charges of anti-Americanism. The mechanics of such labeling can be understood best in the context of theories of nationalism, and it is thus no accident that words like *anti-Americanism* and *unpatriotic* frequently go hand in hand.[16] But confusing patriotism with nationalism is like confusing faith with blind obedience. Patriotism allows for questioning; nationalism

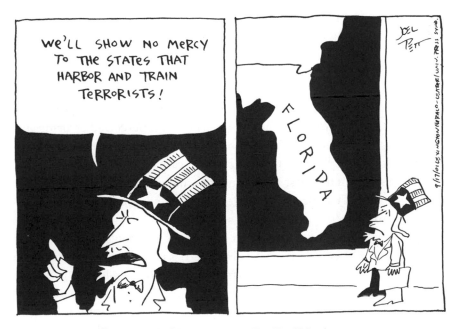

Figure 1.5 Joel Pett, *Lexington (Ky.) Herald-Leader*, 2001.
Reprinted with permission of Universal Press Syndicate.

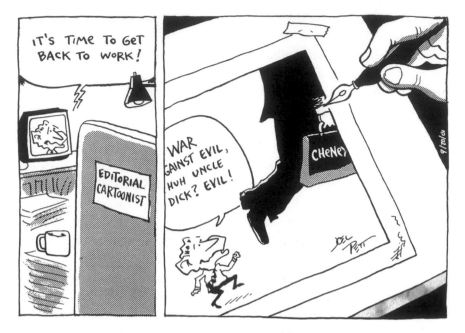

Figure 1.6 Joel Pett, *Lexington (Ky.) Herald-Leader*, 2001.
Reprinted with permission of Universal Press Syndicate.

does not. Nationalism is understood as an ideology that demands absolute loyalty and, in doing so, exacts a high price.[17]

Charges of anti-Americanism are particularly common when the country is being threatened by outside enemies. When this occurs, the government, using the Trojan horse of national security, suspends rights—such as those in the Bill of Rights—that we take for granted during peacetime. During these times, criticism of the government is perceived as being unpatriotic; in 1917, Senator Hiram Johnson of California called "truth" the first casualty of war.[18] Once truth becomes a casualty, social criticism goes on life support, and the First Amendment becomes nothing more than what scholar Zachariah Chaffee Jr. once described as "an empty box with beautiful words on it."[19]

During World War I, President Woodrow Wilson's administration launched the most brutal assault on civil liberties in American history, using the ignominious Espionage Act to arrest hundreds of people who had done nothing more criminal than to have been born in eastern Europe and speak a foreign language. The government's attack on the Constitution left it in tatters. During one of the trials, defense attorney Morris Hillquit argued: "We accept this war as a fact, but we will not surrender our Constitutional

rights of opinion and the freedom to express that opinion. Not for one day, not for one hour, will we surrender these Constitutional rights. No, not even in times of war, for the Government is founded upon the very principles of freedom of speech."[20]

Even before the dust from September 11 had settled, those cartoonists who criticized the Bush administration were therefore cast as unpatriotic and hence anti-American, if definitions of nationalism and patriotism are used interchangeably. But they should not be. "Patriotism is a lively sense of collective responsibility," Richard Aldington, a British writer, said. "Nationalism is a silly cock crowing on its own dunghill and calling for larger spurs and brighter beaks."[21]

A hundred years ago, Senator Carl Schurz of Wisconsin also emphasized the distinction. "I confidently trust that the American people will prove themselves . . . too wise not to detect the false pride or the dangerous ambitions or the selfish schemes which so often hide themselves under that deceptive cry of mock patriotism: 'Our country, right or wrong!'" Schurz said. "They will not fail to recognize that our dignity, our free institutions and the peace and welfare of this and coming generations of Americans will be secure only as we cling to the watchword of *true* patriotism: 'Our country—when right to be kept right; when wrong to be put right.'"[22]

If the definition of nationalism or jingoism is used to define patriotism, editorial cartoons are indeed unpatriotic and un-American. But is jingoism patriotic? Does patriotism extend to racism against Arab Americans? Mike Thompson of the *Detroit Free Press* drew a man raging against Arab Americans. "Let's get even, let's find some Arab-Americans! . . . Let's torment 'em! Let's harass 'em! . . . Let's turn against our fellow citizens! . . . Let's view each other with fear and suspicion, Let's . . . ," the man suggests before he is interrupted by a rat labeled "Terrorists" who continues, " . . . do precisely what I wanted you to do." And then the man, his voice quieting, says, "Right! Do precisely what you wanted us to—" (figure 1.7).

Americans, particularly those on the far right, have frequently abandoned the Constitution when it did not serve their narrow self-interests, by either silencing their political critics or giving law enforcement authorities additional powers to harass their opponents. Such powers have included the federal antisedition laws of World War I and the McCarthyism, black lists, and loyalty oaths of the 1950s. Too often, America has censored speech merely because it was unpopular or disagreeable. In one of her drawings, syndicated cartoonist Ann Telnaes compared the post–September 11 climate with that of the "Red scare," showing a 1950s-era man holding a sign saying "Commies Out," and under him is the label "Red Scare." Next to

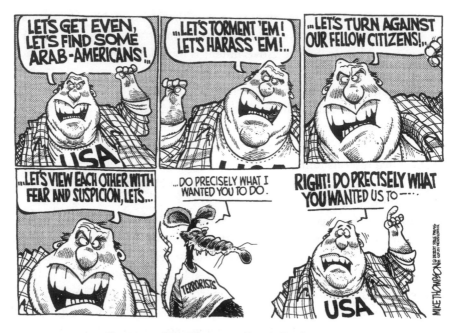

Figure 1.7 Mike Thompson, *Detroit Free Press*, 2001.
Reprinted with permission of Copley News Service.

him is a man with an American flag on his T-shirt and a sign that says "Criticism Out." Under him is the label "Red, White & Blue Scare" (figure 1.8).

After September 11, Americans, caught up in a frenzy of nationalism, waved their flags in support of the Bush administration, giving it unlimited authority to increase its power under the precept of national security. In their haste to make Americans feel safer, the Bush administration increased security at the nation's airports and rooted out those with suspected ties to terrorist organizations. Under the passage of the euphemistically named U.S. Patriot Act, the Justice Department was given wide latitude to wiretap the phones of suspicious people, search their homes without warrants, read their e-mail, and detain them without filing charges against them, a violation of the writ of habeas corpus. With McCarthy-era subtlety, the Patriotic Act even urges Americans to inform on other Americans.

The Patriot Act also disregards the constitutional rights of hundreds of Arab Americans who are being held in jail without due process and are being denied counsel in violation of their constitutional rights. The government announced its intention to put Afghan prisoners of war on trial in secret, which would violate the spirit of international law. Cartoonist Pat Oliphant, his spirit of cooperation broken, compared the tactics of Attor-

ney General John Ashcroft with those of the Afghan Taliban (figure 1.9). "If it's freedom the terrorist hate, then why are we doing away with freedom?" asked Clay Bennett, the editorial cartoonist of the *Christian Science Monitor*.[23] In times of crisis, Steve Benson said, there is a tendency to fall in line and support the administration, no matter what: "The role of the cartoonist is to say, 'Yes . . . but.'"[24]

In addition, the federal government created the Department of Homeland Security, which expanded the powers of federal law enforcement agencies, with little regard for either judicial supervision or constitutional rights. In one cartoon, appearing a little more than a week after the September 11 tragedy, Clay Bennett captured the irony of a country protecting the freedom

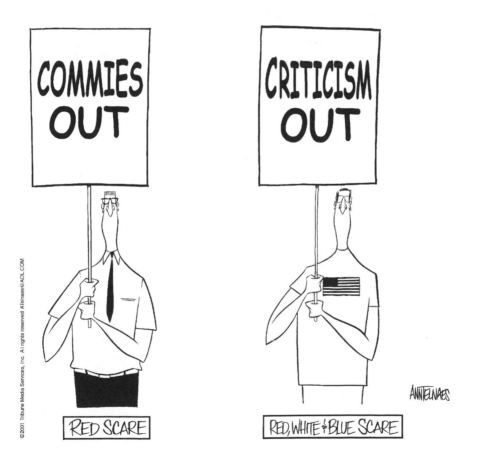

9/29/01

Figure 1.8 Ann Telnaes, 2001. Reprinted with permission of Tribune Media Services.

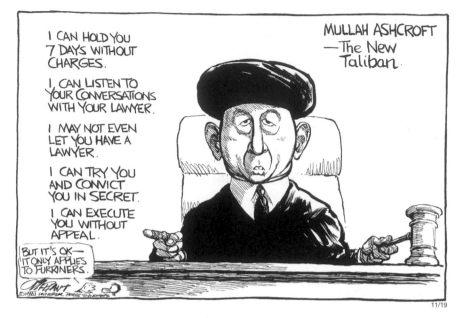

Figure 1.9 Pat Oliphant, 2001. Reprinted with permission of Universal Press Syndicate.

of its people by taking it away. He drew a family looking out through the iron bars in their windows. "I guess it was easier than putting the terrorists behind bars," a man tells his family (figure 1.10). In another cartoon, a horrified couple sits in their house surrounded by Homeland Security agents, one of whom tells the couple: "Now just act normal" (figure 1.11).

Not knowing what to say and afraid of being fired for saying the wrong thing, op-ed columnists and cartoonists lamented that Americans had lost their sense of humor, thereby acknowledging that making jokes in the face of so much tragedy might be inappropriate. But Joe Sharpnack of the *Iowa City Gazette* said that those who wanted to write obituaries for humor were confusing sarcasm with irony. Although it may have been inappropriate to make sarcastic remarks about President Bush's character, irony, he said, "was flourishing." For instance, Sharpnack noted the irony of the U.S. military's dropping both bombs and food on the people in Afghanistan. In one cartoon, Sharpnack drew a CIA operative peeking in on ordinary Americans' lives while an airplane, commandeered by terrorists, is flying toward the World Trade Center (figure 1.12). "If the CIA had been paying attention, it wouldn't have happened," he concluded. "Then they [the government] passed the Patriot Act to shut us up." Sharpnack believes that it is his obligation as both a satirist and an American to raise such issues. "In a

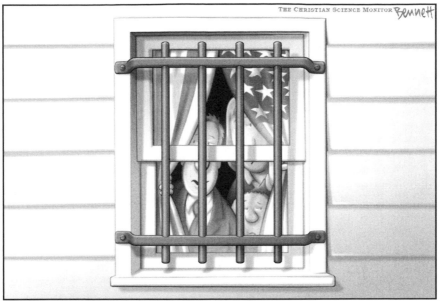

'I guess it was easier than putting the terrorists behind bars.'

Figure 1.10 Clay Bennett, *The Christian Science Monitor*, 2001.

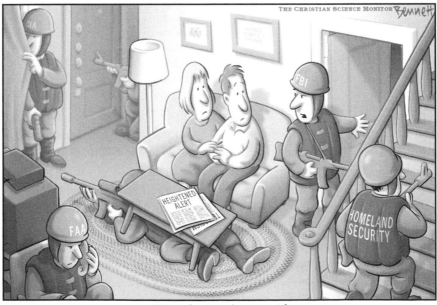

'Now just act normal.'

Figure 1.11 Clay Bennett, *The Christian Science Monitor*, 2001.

Figure 1.12 Joe Sharpnack, *Iowa City Gazette*, 2001.

democracy," he said, "you're obligated to pay attention to the government. If we're just doing what the president says, how are we different from Iraq?"[25]

Two months after the terrorist attacks, Steve Benson drew a cartoon entitled "Dumb Bombs" that shows Bush in a fighter jet dropping bombs labeled with various messages such as "Killing innocent civilians" and "Starving millions of Afghans" (figure 1.13). The fact that the cartoon appeared on Veteran's Day furthered incensed readers in cities like Spectrum, Utah, where more than fifty people appeared at the newspaper's office, including one woman who stood on a desk and kept yelling "treason." The newspaper, *The Spectrum*, issued an apology for running the cartoon. But *The Herald*, a newspaper in Logan, Utah, defended Benson: "We salute Benson for having the courage to boldly express his views. Opinions are not dangerous. It's when people's opinions are stifled that things get scary."[26] Benson observed that the First Amendment—the social critic's best defense—had become a casualty in the war in Afghanistan. "A significant wet towel has been thrown over a lively profession," he said. He reported that one caller told

him that he would be interviewed by the Justice Department and then jailed. When asked about the First Amendment, the caller said that it protected only "correct" opinions.[27]

While not censoring unpopular opinions as blatantly as the Wilson administration had done during World War I, the Bush administration took pains to use its bully pulpit to condemn those who criticized the government, thereby giving the White House stamp of approval to censorship. In a shameful act of endorsing censorship, White House press secretary Ari Fleischer criticized one late-night comic, Bill Maher, for suggesting on his television program that it was the American pilots rather than the hijackers who were cowards because they had dropped bombs from the safety of 15,000 feet. "There are reminders to all Americans that they need to watch what they say," Fleischer added. Maher's program was soon canceled.[28]

On February 8, nearly five months after the attack, the *Concord (N.H.) Monitor* cartoonist, Mike Marland, wanted to criticize President Bush's proposal to tap into the Social Security surplus to fund an increase in military spending. He drew a cartoon of Bush flying a plane called "Bush Budget" into

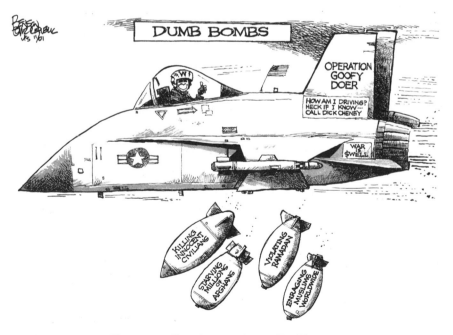

Figure 1.13 Steve Benson, *Arizona Republic*, 2001.
Reprinted with permission of United Feature Syndicate, Inc.

New York City's Twin Towers, which were labeled "Social" and "Security." The *Monitor* apologized for publishing the cartoon and including it on its Web site. Marland also apologized. "I drew on the image of the towers to portray the president as potentially causing a political and financial September 11," he said. But the image of the World Trade Center represented something else to many of those reading the cartoon. Marland admitted that given the sensitivity of the times, he should have used a different image. "It was not my intention to desecrate the memory of those who died that day, nor to add to the anguish and sorrow of their loved ones," he said.[29]

Using shameless nationalistic blather, Fleischer, speaking for the White House, directed the administration's considerable fury at Marland, whose drawing had appeared in a small New Hampshire newspaper. "Equating the president's budget with terrorist attacks that took 3,000 lives is as wrong as wrong can be," said Fleischer, speaking for an administration so insecure about its own policies that it fears free speech. "This is tastelessness and an affront to the people of New York."[30] The incident left Marland shaken. The cartoonist apologized and then destroyed the original. "I am still bewildered by the reaction. As I said, call me stupid, call me naive, but I don't see it as the abomination that so many others do," Marland said. "I also experienced a lot of anger over the reaction to it, mostly along the lines of 'Who the hell are you to tell me what I can draw and can't draw?'"[31]

In early March, Ted Rall drew a cartoon called "Terror Widows," which satirizes the spouses of at least three of the terrorist victims as greedy publicity hounds who turned personal tragedies into lucrative book deals and some measure of celebrity (figure 1.14). In one panel, a widow casually mentions that her husband was on fire when he called her from the 104th floor, and then compliments the interviewer on his tie. In another, a woman relates to a newscaster how she misses her husband but that "fortunately, the $3.2 million I collected from the Red Cross keeps me warm at night." The *New York Times* quickly pulled the strip from its Web site, and the New York *Daily News* called the cartoon "the latest salvo in an increasingly ugly national debate over compensation to victims' families." The victims' families were incensed. One widow declared that she was "overwhelmingly upset and saddened" by the cartoon, saying that it "really crossed the line of decency." Another remarked, "Nobody wants this money. All we want is five minutes with our husbands to say goodbye."[32]

Political commentator Alan Keyes wrote a blistering column for MCNBC.com on what he called Rall's "brutal and inhuman comic strip." He said that the strip was "an assault on the decent national sensibilities crucial to the war effort. Such assaults are a kind of pornography in civic

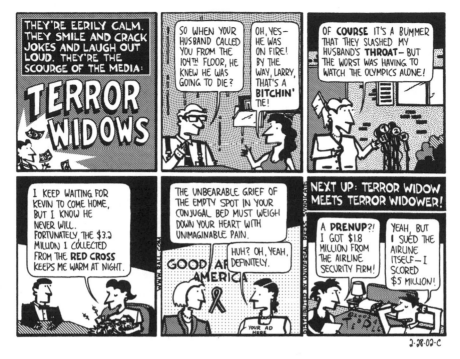

Figure 1.14 Ted Rall, 2002.

discourse." Keyes then called for the suppression of such opinions. "Assaults on the decent judgment of American citizens regarding the just and noble character of a national struggle are, literally, attempts to poison the sovereign," he said. "And we should not tolerate those who seek to debase our judgment and destroy our unity and resolve."[33]

The Association of American Editorial Cartoonists called Keyes's comments "nonsense." In a letter to him, it noted: "As a commentator, surely you must appreciate that the First Amendment is our first and best protection in an open and democratic America." Rall's distributor, Universal Syndicate, issued the following defense: "Rall represents a point of view that will not be everyone's opinion. He is looking at recent news events with the cynical eye of a satirist."[34] For his part, Rall maintained that Keyes represented the attitudes of reactionary conservatives who supported the administration's policies that short-circuited the Bill of Rights. "I was grateful for Mr. Keyes," Rall said, "because his views reflected a huge undercurrent of right-wing Republicans."[35]

Rall refused to apologize for the so-called Terror Widows cartoon. Although he sympathized with most of the families that had lost loved ones, he

said that he directed his cartoon "at a tiny minority of opportunists" who had benefited from the tragedy with book deals and speaking tours. "They're cynically exploiting the dead to their own ends," he said. "Regular viewers of TV news know who I'm talking about."[36] The problem was that a lot of readers missed his intended message and thought instead that the strip was an unprovoked attack on all heartbroken widows and orphans. During an exchange with Fox commentator Bill O'Reilly, Rall explained that his job as an editorial cartoonist was to make readers think. "This cartoon did make me think," O'Reilly replied. "It made me think you were a jerk."[37]

What made Rall's "Terror Widows" strip so objectionable was that his subjects were grieving spouses who perhaps could be forgiven for seeking their fifteen minutes of fame. Although Scott Stantis found the cartoon "reprehensible," as a fellow cartoonist, he defended Rall's right to express himself. Joel Pett said that he "thought the widows cartoon had a point, but went way overboard." Pett then added: "As a friend of mine, Steve Benson, says, 'If you don't cross the line occasionally, you forget where it is.' Too many of us censor ourselves, and I think it's a far worse sin to self-censor than to cross the line occasionally."[38]

According to Rall, in the weeks and even months after September 11, too many cartoonists went to their drawing boards with capped pens and were perfectly happy just to illustrate the government's line. "The truth is," he said, "the editorial cartoons were shameful and disgraceful—weeping Statue of Liberties and American eagles dropping bombs, they were the kind of stuff of empty nationalism. I would say patriotism. But it isn't patriotism."[39] Rall satirized how some Americans were exploiting the spirit of patriotism in a drawing in which a woman tells her boss, "I can't work late today. I have to pick up my kids." Her boss then replies, "So—you're with the terrorists!" (figure 1.15).

Aaron McGruder, who draws the comic strip *The Boondocks*, satirized hyperpatriotism by saying: "When you have too much blind patriotism, bad things can happen."[40] In one strip, he compared Osama bin Laden with George W. Bush: each is "from a wealthy oil family," each "bombs innocents," and so on (figure 1.16).[41] In another strip, he referred to the fact that the Reagan administration had provided financial and military support to Afghanistan in its war with the Soviet Union and to Iraq in its war with Iran. McGruder drew one of his characters calling the FBI's terrorism tip line to identify Americans who had trained and financed bin Laden: "The first one is Reagan. That's R-E-A-G . . . ," he says before the feds hang up on him (figure 1.17).[42]

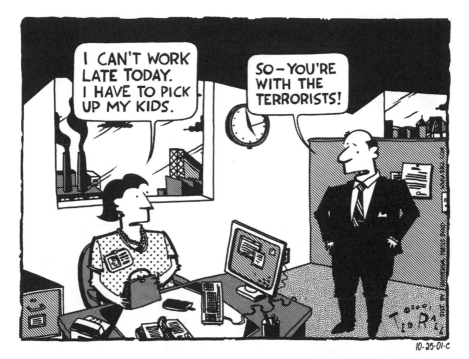

Figure 1.15 Ted Rall, 2002.

A number of newspapers—including the New York *Daily News*, the *Dallas Morning News*, and *Newsday*—refused to publish a *Boondocks* strip that criticized Bush. Mike Needs, the public editor of the *Akron (Ohio) Beacon-Journal*, wrote that the newspaper had received dozens of complaints about the strip but would continue to run *The Boondocks*. If readers do not like the strip, the newspaper's managing editor, Thom Fladung, advised, "Just skip it."[43] Pett said that he was impressed with the editors and publishers who supported their cartoonists. "The editors and publishers who had the courage to go with it and take their lumps are to be admired," he said.[44]

A few weeks after the terrorism attacks, Americans learned that censorship was not the province of merely the far right. The University of California's Berkeley campus newspaper, the *Daily Californian*, published a Darrin Bell cartoon referring to the news report that those Arabs who had died in the suicide attacks of September 11 believed they would be rewarded in the afterlife with dozens of virgins. The cartoon shows two turban-wearing followers of Osama bin Laden standing in the devil's palm,

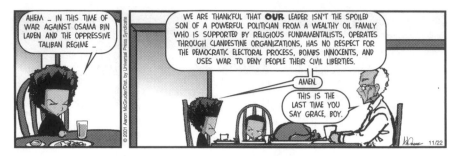

Figure 1.16 Aaron McGruder, 2001.
Reprinted with permission of Universal Press Syndicate. All rights reserved.

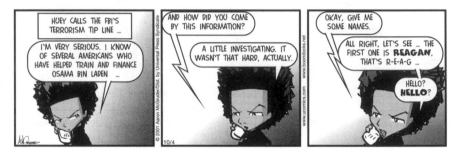

Figure 1.17 Aaron McGruder, 2001.
Reprinted with permission of Universal Press Syndicate. All rights reserved.

surrounded by the flames of hell, a flight manual at their feet, celebrating the deaths of three thousand people. "We made it to paradise," says one. "Now we will meet Allah, and be fed grapes, and be serviced by 70 virgin women." Dozens of enraged students crammed into the newspaper's office, demanding an apology for the drawing, which they believed indicted all Muslims. Given the context of the news report of the reward awaiting the suicide terrorists, the drawing was both appropriate and accurate. To its credit, the newspaper did not apologize, despite pressure from the demonstrators and the university's administration.[45]

Many cartoonists—either wholeheartedly supporting the president or afraid of criticizing him for fear of incurring the wrath of their readers or their editors—castigated America's enemies but refrained from saying negative about the Bush administration. In too many cases, for whatever reason, their drawings had all the bite of recruiting posters. Syndicated cartoonist Ann Telnaes reproached cartoonists for sacrificing their role as social critics to become government cheerleaders. "We shouldn't be flag

wavers," she said. "You can do that in your personal time . . . but not in your cartoons. We're supposed to be a voice of other possibilities."[46]

In one of his drawings, Rob Rogers of the *Pittsburgh Post-Gazette* reminded readers that if we cannot criticize the government during times of crisis, our guarantee of free speech becomes meaningless during times of relative security. Rogers drew a man, wearing a T-shirt with an American flag on the front, who says: "I've got news for the terrorists. I won't be afraid to criticize my country's policies at home and abroad. I won't be afraid to scrutinize the president and other elected officials. Even if it means being branded unpatriotic! Because the minute we give up our right to free speech . . . they win" (figure 1.18).

As unpleasant as editorial cartoons and other social criticism may sometimes be, however, our tolerance of them in times of crisis indicates the strength, not the weakness, of our democracy. If we cannot question the government during times of crisis, our constitutional guarantee of free speech is not worth the parchment it is written on. The First Amendment does not exist so that we can praise our way of life; it exists so that we can question it.[47] If we argue that editorial cartoons are as irreverent as the Boston Tea Party or as patriotic as the Constitution, it

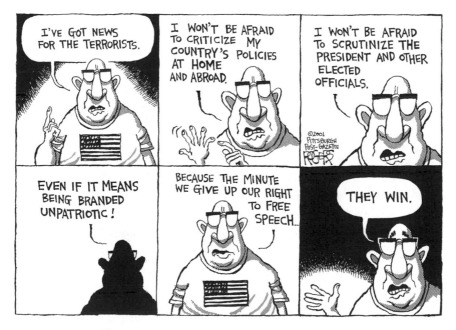

Figure 1.18 Rob Rogers, *Pittsburgh Post-Gazette*, 2001.

seems disingenuous to criticize them as unpatriotic simply for revealing unpopular opinions. "I can't be sure that if the First Amendment were subject to a referendum [after September 11], it would have passed," Rall said.[48]

Israeli cartoonist Ranan Lurie once called the editorial cartoon the most extreme form of expression that a society will accept or tolerate.[49] In a country that prides itself on its tradition of free speech, it is important to explore the limits of free expression. And this can be done in part by looking at the history of editorial cartooning in the United States. Cartoonists in other countries have been killed, beaten, tortured, jailed, and censored. No cartoonist in this country, however, has been killed or tortured—unless you count having to sit through endless editorial board meetings or lectures on appropriateness by overly cautious editors. But cartoonists have been beaten, jailed, and censored.

What, then, are the limits for editorial cartoonists? On the most basic level, cartoonists are limited by their own intelligence, imagination, artwork, sense of ethics, work ethic, deadline, and even sense of politics, morality, or righteous indignation—but only if they draw just for themselves. If they want an audience, they must consider the tastes and sensibilities of their editors and their readers. If a cartoonist goes too far, he or she will find that social critics have critics of their own. For instance, after the publication of his "Terror Widows" cartoon, Rall said, a number of newspapers dropped him, which is fairly common after controversial cartoons. But in addition, Rall noted, New York City firefighters came to his apartment blowing their horns and banging on his door, yelling obscenities and threatening his life. Rall also said that he had received a number of death threats, and one in particular, according to his caller identification, came from a New York Police Department precinct. "Who was I supposed to call?" Rall asked.[50]

As New Yorkers cleared the debris from what was once the World Trade Center and Americans waited nervously for another attack, that sense of anxiety was increased when it was reported that anthrax was being spread through the mail to newsrooms, television stations, and the offices of elected officials. Once again, cartoonists found themselves at their drawing boards and computers trying to figure out what to say about the toxic substance that had killed a few people. At certain times, humor is less appropriate than it is at other times, and this appeared to be one of those times. The limits of acceptability always depend on the prevailing social milieu.

A day after the *New York Post* revealed that one of its staffers had ingested anthrax from a letter, the paper's cartoonist, Sean Delonas, drew one of the newspaper's editors saying: "What sort of twisted sicko would send us anthrax?" The cartoon's second panel shows Mort Zuckerman, the publisher of the newspaper's rival, the *Daily News*, addressing an envelope containing anthrax to the *Post*. In protest, at least two advertisers pulled their ads from the *Post*. The cartoon was "way out of line," the owner of one car dealership said. "You're telling the public that he's [Zuckerman] is a terrorist. It's a time to stand together and fight a common enemy."[51]

At its best, satire forces us to take a look at ourselves for what we are and not what we want to be. We may not always like what we see. In reference to the enormity of the September 11 attack, stunned Americans asked themselves and their fellow Americans: "Why do they hate us?" In response, Rall drew an American general explaining: "They don't hate us. They just don't understand us." In the next three panels, a bomb labeled "USA" explodes, leaving a civilian, with only his head remaining, who says, "I hate America." The general retorts, "No you don't. You've been suckered by anti-American propaganda! We're not arrogant, self-indulgent, ignorant hypocrites. We're the good guys!" The civilian replies, "Maybe you're right. Maybe you Americans just have an image problem." The general then asks, "So: friends?" "Can I have the rest of my body back?" the torso-less man returns. "Don't be sassy, soccer ball," the general tells him (figure 1.19).

In one of his cartoons, Clay Bennett drew Uncle Sam reading a newspaper with the headline "U.S. Image Abroad" and commenting, "I don't know why we're seen as arrogant, hypocritical, and self-absorbed." Then in the next panel, Uncle Sam adds, "We're not self-absorbed" (figure 1.20). Steve Benson drew a bloated Uncle Sam who is wearing a T-shirt reading "Operation Enduring Ignorance" and whose feet are stuck in oil spills, one labeled "Mideast Oil Addiction" and the other "Israeli–Palestinian Blood Feud." Appearing both frustrated and perplexed, Uncle Sam asks, "I can't seem to put my finger on why they hate us so much." Nearby, an Arab replies, "Your foot will do."

Critics of the administration have contended that if we conserved our oil, we would not be so dependent on the Middle East. If Americans used their oil more wisely, the argument goes, they would be less reliant on the Middle East, but Bush, whose family made its fortune in oil, has ignored calls for conservation. Some cartoonists have forced readers to look at

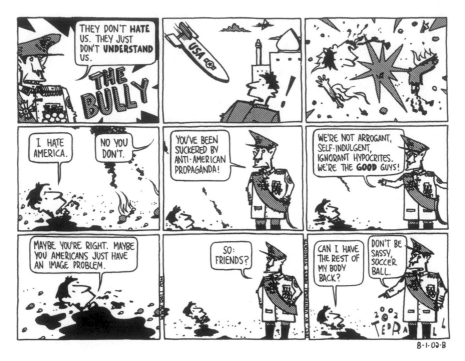

Figure 1.19 Ted Rall, 2002.

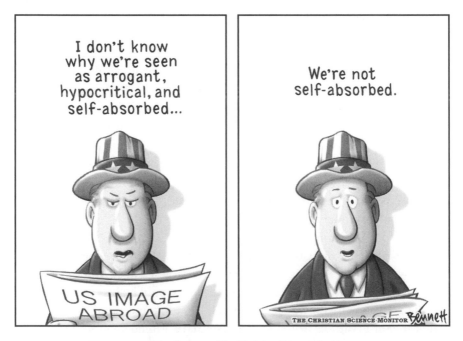

Figure 1.20 Clay Bennett, *The Christian Science Monitor*, 2002.

themselves, and even into their garages, by capturing the hypocrisy of Americans driving gas-guzzling SUVs while proclaiming their patriotism. The *Cincinnati Enquirer* cartoonist Jim Borgman showed two drivers, one in a fuel-efficient car and the other in a gas-guzzling SUV, sporting American flags and bumper stickers. The cartoon says, "Choose the patriot."[52]

For an editorial cartoon to have an effect, it must resonate with readers in a way that is intimate, personal, and often uncomfortable. "The function of anyone in communications, anyone who has an impact in his work," the late cartoonist Bill Mauldin once observed, "is to jar, shake, needle people out of their fat-headedness."[53] When Herbert Block, who signed his cartoons "Herblock," was once asked to define editorial cartoons, he told the story of the teacher who asked her students to come up with an example of their kindness to animals. One boy offered this: "One time I kicked a boy for kicking a dog." Herblock said that as a cartoonist, he tried to show his love for his fellow men by kicking the big boys who kick the underdogs. "In opposing corruption, suppression and abuse of government office," he said, "the political cartoon has always served as a special prod—a reminder to public servants that they are public servants."[54]

Editorial cartoonists must point out what is wrong, often by making it look ridiculous. They must challenge the government or whatever needs changing, whether the reader agrees or even cares. This sometimes requires producing an image so startling that it reaches up from the newspaper and grabs the readers by the collar and shakes them out of their slumber. "In a democratic society—where apathy and ignorance lurk as sources of constant danger—there are few instruments as powerful as editorial cartoons in shaping public opinion," John Kuenster wrote more than forty years ago. "Sometimes, free people have to be punched, figuratively speaking, between the eyes to awaken them to their heritage . . . to remind them freedom thrives best in an informed, alert society."[55]

Rarely does a cartoonist know what, if any, difference he or she has made. When Doug Marlette was asked whether his drawings ever made a difference, he deadpanned: "Yes, I ended the Vietnam War."[56] More seriously, though, editorial cartoons on local issues have sometimes altered public policy. Sometimes the reaction to a cartoon is more visceral, such as an obscenity-filled phone call or an e-mail or letter with lots of capital letters and exclamation points. Paul Conrad, the longtime editorial cartoonist of the *Los Angeles Times*, often drew cartoons that jangled readers' nerves. One reader mailed him a tin box filled with dog excrement; another wrote, "Dear Conrad, you Commie bastard, I can't wait to read your obituary."[57]

But Defense Secretary Donald Rumsfeld credited cartoonists for ending one of his ill-advised strategies. In the aftermath of the terrorist attacks, Rumsfeld announced the creation of the Pentagon's Office of Strategic Influence to spread false news items to foreign journalists to manipulate international public sentiment. For some Americans—including cartoonists, op-ed columnists, and commentators—Rumsfeld's arrogance lacked both ethics and honesty. In response, the *Toledo (Ohio) Blade*'s cartoonist, Kirk Walters, drew a reporter interviewing an army general in a cartoon entitled "The Pentagon." "When you announced you'd lie to the public, you were telling the truth?" The general replies, "That's right." "Then you backtracked and said you'd always tell the truth. Which is a lie?" "That's right," the general says. "So are you telling me the truth about lying or lying about telling me the truth?" "That's classified," the general answers. Citing the strong reaction from columnists and editorial cartoonists, Rumsfeld disbanded the office. "The office is done," Rumsfeld snapped. "What do you want, blood?"[58] A skeptical Tom Toles then drew Rumsfeld telling reporters that the boarded-up office was out of business and, in the next panel, saying to the person behind the door: "They're gone."

After September 11, *Washington Post* editors Leonard Downie Jr. and Robert Kaiser chronicled American journalism from superficial banter to great consequence, as both print and broadcast reporters took their responsibilities more seriously.[59] In a rare act of putting the news before profits, networks stayed on the air without commercial interruptions for more than a day after the planes hit the towers. But after a brief period of responsibility, the television networks returned to their pre–September 11 emphasis on reporting mainly soft news and White House press releases. Newspapers, too, pressured by corporate demands for double-digit profits, also cut expenses, sacrificing their journalistic responsibilities for the sake of happy stockholders.

The tragedy certainly had an effect, for better or worse, on editorial cartooning, which had been in steady decline as fewer and fewer cartoonists had less and less to say about less and less substantial issues. Then the terrorist attacks demonstrated the distinctions between the two schools of editorial cartooning: those who want to hit their reader between the eyes and those who want to tickle their funny bone. Cartoonists like Pett, Benson, and Rall use satire to challenge readers and shake them out of their complacency, whereas the so-called gag cartoonists soften their message with humor. Chip Bok of the *Akron Beacon-Journal* described the difference in styles: hard-hitting cartoonists "express the firm and fiercely independent

opinion that the news is serious" and understand that this sometimes means offending readers who may cancel their subscriptions. In contrast, the gag cartoonists see "current events merely as a platform for launching gags that make readers laugh but not think."[60]

Seattle Post-Intelligencer cartoonist David Horsey wrote an essay on how Osama bin Laden had made cartoonists "feel relevant again."[61] This probably was true, but how relevant and in what way? If cartoonists felt the need to wave their American flags, then their cartoons might have been relevant, but they were as provocative as a Mother's Day card, lacking whatever it is that gives social criticism its particular soul. If cartoons were drawn just for the purpose of outrage, they might have been provocative, but they lacked finesse. Somewhere in between, leaning to the side of outrage, were those cartoonists who had the courage to try to capture society's pathos and excesses. But for every one of those cartoonists, there were many others who did not know what to say and therefore said little.

Rall, supported by the *Village Voice* and a Los Angeles radio station, traveled to Afghanistan to learn what he could about the country that America was now bombing in retaliation for the terrorist attacks on its soil. Rall said that this experience gave his drawings a particular insight that was not present in the work of most other cartoonists. He pointed out that the last thing Afghanistan needed was more bombing, because the country was blessed with "two natural resources, dust and rocks."[62] When he returned to the United States, he was disappointed by the editorial cartoons he saw. "Having been to Afghanistan, I was terribly offended when I returned to see my colleagues' work on this war because they knew nothing about it," Rall said. "They were in favor of killing innocent people."[63]

As the search for bin Laden continued and the war in Afghanistan bogged down in the mountains, the Bush administration moved toward unfinished business in Iraq, where Bush's father, as president, had won a war in 1991 but had failed to oust its leader, Saddam Hussein. In 1991, Iraq invaded Kuwait, and American support for the Gulf War was high. Again, editorial cartoonists who questioned the war received death threats. Steve Benson remembered being called "a traitor" who should "shut up and support the troops" or go live in Iraq. He said he had trouble convincing these critics that their intolerance of dissent might make them more comfortable living in a dictatorship than in a country with a constitutional guarantee of free speech.[64] Benson also praised his newspaper for publishing his drawings, especially when the newspaper was actively supporting Bush.[65]

Joel Pett, who also has the support of his newspaper, observed that his readers responded with more restraint to his antiwar drawings as the Bush administration began planning to attack Iraq than they had to his anti-Bush cartoons after September 11. But he thought that would change once the fighting began. Clay Bennett added: "Once the actual combat begins, people expect you to fall in line, whether it's justified or not." Bennett remembered working for the *St. Petersburg (Fla.) Times* during the first Gulf War. Before the war began, he could criticize the government, but "the boot came fast once the bullets started flying." Things, Bennett noted, were different at the *Christian Science Monitor*, which did not reject any of his antiwar drawings: "They didn't say 'boo' to me. I sing their praises for that."[66]

Unlike the 1991 Gulf War, which the public overwhelmingly supported because Iraq had invaded Kuwait, opinion was split over whether the United States should invade Iraq in 2003, because it made it, and not Iraq, the aggressor. The Bush administration insisted that it had to liberate Iraq from Saddam Hussein. Bennett drew a small boy watching television news coverage of the bombs exploding in Iraq" "Gosh, I sure hope nobody ever liberates *us!*" (figure 1.21). "I purposely made it a child watch-

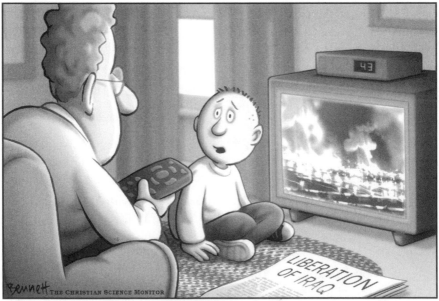

'Gosh, I sure hope nobody ever liberates us!'

Figure 1.21 Clay Bennett, *The Christian Science Monitor*, 2002.

Figure 1.22 Clay Bennett, *The Christian Science Monitor*, 2002.

ing it all happen. I wanted the child's understanding of the words in the context that they were spoken," Bennett said. "I had some people saying it was 'tremendous' and other people said it was 'horrific.' And that was just from the staff of the *Monitor*."[67] In another cartoon, Bennett drew a checklist for the invasion in which the only thing left unmarked is "a reason" (figure 1.22).

"President Bush Has Been Reading Doonesbury
and Taking It Much Too Seriously"

On November 3, 1967, Garry Trudeau, who later created *Doonesbury*, published his first editorial cartoon in his college newspaper, the *Yale Daily News*, which criticized hazing practices at several fraternities. The crude drawing shows two naked pledges being branded on their rear end with an iron with the symbols DKE. Delta Kappa Epsilon had earned a dubious recognition by initiating its pledges by pressing the tip of a smoldering wire coat hangar to the small of their backs. When the *New York Times* interviewed the fraternity's president, a compassionate-conservative-in-training named George W. Bush, he defended the practice by saying that the wound was "only a cigarette burn." In September 1999, a year before Bush became president of something far bigger, Trudeau published the cartoon again, reigniting what Mark Singer of the *New Yorker* described as "a one-sided feud with the Bush clan," whereupon Trudeau poked fun at the Bushes and the Bush family responded with a highly exaggerated sense of indignation.[1]

The *Doonesbury*–Bush feud, such as it is, began about twenty years ago after the elder George Bush changed his position on a number of sensitive issues after becoming the running mate of the Republican presidential nominee, Ronald Reagan. In his *Doonesbury* strip, Trudeau pictured Bush announcing that he had placed "his political manhood in a blind trust." In the cartoon, Bush is asked by reporters if his manhood would be earning interest while in the trust, and Bush replies, "Very little. There's not that much capital" (figure 2.1). Bush, the person, reacted angrily. "Garry Trudeau," he said, "is coming out of deep left field. The American people are going to be speaking out, and we'll see whether they side with Trudeau or the Reagan–Bush message."[2]

When Trudeau again ridiculed what he perceived as the vice president's lack of character, Bush again protested: too much, it appeared. "I had the personal feeling that I wanted to go up there and kick the hell out of him,

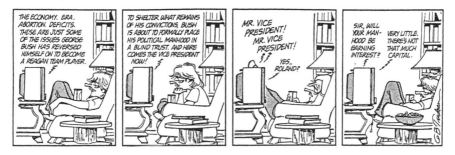

Figure 2.1 Garry Trudeau, © 1984.
Reprinted with permission of Universal Press Syndicate. All rights reserved.

frankly," the vice president said. At another point, Bush snapped: "This *Doonesbury*—good God! He speaks for a bunch of Brie-tasting, Chardonnay-sipping elitists." As president, Bush complained so often about how he was portrayed in *Doonesbury* that the *Oakland (Calif.) Tribune* once admonished him to reserve his ire for weightier issues: "President Bush has been reading *Doonesbury*," the newspaper said, and "taking it much too seriously."[3]

We expect—and probably should demand—our country's leaders to be made of sturdier stuff. If public officials are so thin-skinned that they react personally to criticism, whether it comes from a political opponent or a cartoonist, one wonders how they could have progressed so far in the Darwinian, rough-and-tumble world of politics. Cartoonists—like moths—are drawn to flames, and the more easily they can create heat, the more satisfying the gibe is. We could argue that Trudeau was much harder on President Ronald Reagan than on Bush, at one point taking readers on a tour of the president's head and finding only marbles. Reagan's response, unlike that of his vice president and successor, was more presidential. "Cartoonists occupy a special place in my heart," he said. "I hope Garry Trudeau will remember that. It's heart, not brain, heart."[4]

Trudeau believes that Bush and his family took his criticism especially personally because they considered him a traitor to both his Yale brethren and his privileged class. "When Garry Trudeau questioned [my dad's] manhood, I didn't like it at all," George W. Bush once said. "And I made it absolutely clear to Trudeau, who was two years behind me at Yale University. And if he didn't like me telling him that, I didn't care."[5] Another Bush son, Jeb, who became governor of Florida, confronted Trudeau at the 1988 Republican National Convention and began yelling at him. Because of the noise level around them, Trudeau could not understand what Jeb was saying, so the cartoonist simply smiled benignly. Jeb later told an interviewer

that he had warned Trudeau to "walk softly," which Trudeau suggested was not a particularly "useful suggestion" for a satirist. "Telling a cartoonist to walk softly is like asking a professional wrestler to show a little class," Trudeau said. "It's just not a productive suggestion."[6]

As a satirist, Trudeau goes where the best satire lies—and if he unnerves his subject in the process, so much the better; such insecurity is unbecoming in public officials. George W. Bush won the presidency in 2000, but without winning the popular or, at first, electoral vote. Indeed, he won Florida, his brother's state, only after a controversy over disputed ballots and only after the Supreme Court finally declared him the winner. The Bush family found itself in the White House once again. For Trudeau, having another Bush in the White House was good for business. "It took his brother, his father, his father's friends, the Florida secretary of state, and the Supreme Court to pull it off," Trudeau said. "His entire life gives fresh meaning to the phrase 'assisted living.'"[7]

Trudeau drew President George W. Bush as an empty cowboy hat, which meant merely adding a hat to the cartoonist's image of the first President Bush, who had been drawn without any substance, not a nowhere man but a nothing man. Bush the elder's vice president, Dan Quayle, considered an intellectual lightweight, was captured as a feather. Trudeau drew Newt Gingrich, the unpredictable and explosive Republican Speaker of the House, as a time bomb. Bill Clinton became a waffle, reflecting both his sense of gastronomy and his sense of politics. If Clinton objected to the characterization, he did not give Trudeau the satisfaction of a Bush-like slap. "On some days, I think it's wonderful; some days I'm not so sure," Clinton said, "which means I probably feel the same way about Mr. Trudeau that he feels about me."[8]

If *Doonesbury* had no influence, there would be no need for people like George Bush to become so unglued or for others like the former Speaker of the House Thomas "Tip" O'Neill, a Democrat, to try to stop the distribution of a series about his questionable business practices.[9] Former Richard Nixon aide John Erlichman, however, did succeed in killing a *Doonesbury* series, although the circumstances gave him no reason to gloat. After Erlichman resigned abruptly during the Watergate scandal, Trudeau and his syndicate canceled a week's worth of strips on the embattled Erlichman. In a sporting gesture, Erlichman later wrote a note to Trudeau, apologizing for the inconvenience.[10]

In 1985, *Doonesbury* satirized a Palm Beach, Florida, statute requiring servants to have identification cards (figure 2.2). A state legislator then introduced the so-called Doonesbury bill challenging the statute. "What I

Figure 2.2 Garry Trudeau, © 1985.

know about the ordinance is what I read in *Doonesbury,*" the president of the Florida Senate admitted. The strip was successful in forcing the statute into ignominy.[11] Given *Doonesbury*'s readership and influence, there is no doubt that other politicians have shied away from introducing legislation for fear of how it would appear in a *Doonesbury* strip. Trudeau said he takes what is going on in the news and twists it to make his own conclusions. He noted that he is "interested in what the outsider sees—the public face the politician chooses to project, chooses to be judged on, nothing could be fairer. He's setting the agenda, I'm merely reacting to it."[12]

It is not uncommon for subjects of *Doonesbury* strips to question their fairness, although not always their accuracy. The Republican caucus of the Virginia General Assembly once censured *Doonesbury* after a series satirized then Senator-elect John Warner and his wife, actress Elizabeth Taylor, and the circumstances under which he became senator. Warner lost in the Republican primary. But when the winner died in an airplane accident, Warner offered to pay the dead man's campaign debt and then set up a trust fund for his family. Warner then became the GOP's nominee for the Senate.[13] "I don't think we should sit placidly by and let the gnomes of the world run over us without expressing indignation," the sponsor of the censure said. For his part, Warner said, "The facts in the strip are totally false and inaccurate. Oh, I'm not going to pick them out. The people of Virginia know the facts."

When *Doonesbury* revealed that law-enforcement authorities had harassed a prison convict named Brett Kimberlin, who had accused Dan Quayle of once using drugs, Quayle complained that it was "well known that Garry Trudeau has a personal vendetta against me." In response, the late-night comic Johnny Carson pointed out, "Vice President Quayle is mad at Garry Trudeau for satirizing Quayle in his comic strip," and then delivered the

punch line: "That's the way to get through to Quayle. Make fun of him on the comic page—he's bound to see it." The *New York Times* later reported that the *Doonesbury* series on Kimberlin and Quayle was accurate.[14]

Time magazine noted that in *Doonesbury*, "the real and the fictive combine and actually blend into commentary—and the results are often closer to the truth than mere news reports."[15] Edward Rosenheim Jr. wrote that all satire involves a departure from literal truth, a reliance on what might be called "satiric fiction."[16] Satire, according to another writer, gives us not literal truth but rhetoric, "not transcriptions of reality but revealing distortions based on an appearance of reality."[17] Satirists do not paint an objective picture of the evils they describe; instead, they usually offer a travesty of the situation, which at the same time directs attention to reality and offers an escape from it.[18]

The result is often unflattering, although satire, like beauty, is in the eye of the beholder, causing hysteria for some and leaving others in hysterics. Senator Alphonse D'Amato of New York reacted intemperately on the Senate floor to a *Doonesbury* series that accused the Republican Party leadership of orchestrating the impeachment of President Bill Clinton. Senator George Mitchell of Maine, the Democratic Majority Leader, responded: "I am distressed that a comment about the senator in a cartoon would cause him to launch such a sharp attack on President Clinton."[19]

In 1987, Arizona's governor, Evan Mecham, a Republican, faced a recall movement after he rescinded the state's Martin Luther King Jr. holiday, supported the author of a textbook that referred to black children as "pickaninnies," and referred to his critics as "a bunch of homosexuals and dissident Democrats."[20] In one of his strips, Trudeau drew Mecham defending himself against charges spread by "queers and pickaninnies." Mecham said through a spokesman that he was considering suing Trudeau because he had been "totally misrepresented" by the strip, since he had never actually used the words *queers* and *pickaninnies*. Universal Syndicate's editorial director, Lee Salem, said that Trudeau was simply using "exaggeration" and "hyperbole."[21] Mecham did not file a lawsuit.

When Trudeau is criticized for his unfairness, he responds by saying that "criticizing a political satirist for being unfair is like criticizing a 260-pound nose guard for being too physical."[22] Satire is supposed to do a lot of things, but being fair is not necessarily one of them, as Trudeau himself explained: "All the tools of [the cartoonist's] trade—distortion, caricature and ridicule—mitigate against fairness."[23] Like any satirist, Trudeau uses distortion and hyperbole to make his point. But his information, he says, is based on a central truth; that is, his characters react to real events and real stories.

Unlike other comic strips, *Doonesbury* deals with real people and makes specific charges, which unnerves both newspaper editors and their readers. In one President Reagan–era series, "Sleaze on Parade," radio commentator Mark Slackmeyer lists name after name of former administration officials who resigned or were fired after charges of legal or ethical misconduct (figure 2.3).[24] Even though Trudeau based his strip on a report prepared by a House of Representatives subcommittee, it contained an error, and the strip's syndicate, Universal, sent a note of clarification to subscribers.[25] A number of newspapers, including the *Los Angeles Times*, decided against publishing the strip, and other newspapers deleted those names that could not be independently verified.

During President Richard Nixon's years in office, Mark Slackmeyer concluded a brief "Watergate profile" of Attorney General John Mitchell with the remark that "everything known to date could lead one to conclude he's guilty! That's guilty! Guilty, guilty, guilty!!" (figure 2.4). Trudeau later explained that he was only trying to parody the hysteria of Nixon foes, but

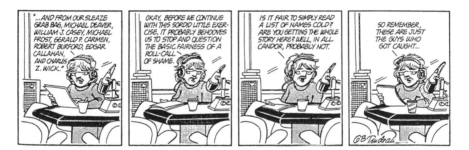

Figure 2.3 Garry Trudeau, © 1986.

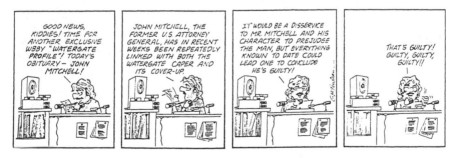

Figure 2.4 Garry Trudeau, © 1973.

dozens of papers nevertheless decided not to run the strip. In an editorial, the *Washington Post* pointed out, "If anyone is going to find any defendant guilty, it's going to be the due process of justice, not a comic-strip artist. We cannot have one standard for the news pages and another for the comics."[26]

Trudeau once devoted a series to singer Frank Sinatra, who had been given the Medal of Freedom by President Reagan and an honorary degree by the New Jersey Institute of Technology. One strip included a photo of Sinatra and Aniello Dellacroce, who, it said, had been charged with the murder of a Gambino family member, Charley Calise (figure 2.5). Other strips, which also were based on news accounts, portrayed Sinatra as a foul-mouthed and vulgar bully. Once the series began running, Sinatra's lawyers demanded a list of newspapers that published *Doonesbury* so they could pressure them into either not running the series or running retractions. But the syndicate refused to accommodate their request.[27] Sinatra released a public statement saying that Trudeau's work was created "without regard to fairness or decency."[28] In an aside comment, "Old Blue Eyes" called the strip "as funny as a tumor."[29] A number of newspapers, however, decided against publishing the series because it did not mention that Dellacroce was later acquitted.

During the 1984 presidential election, Trudeau drew his dim-witted newsman Roland Burton Hedley taking readers on a trip through President Reagan's brain. In one panel, Hedley said: "Welcome to the mysterious world of Ronald Reagan's brain. Home of nearly 80 billion neurons, or 'marbles,' as they are known to the layman." Two dozen newspaper editors either dropped the series or postponed it until after the election, explaining that it was too partisan. Because of *Doonesbury*'s content, editors have strug-

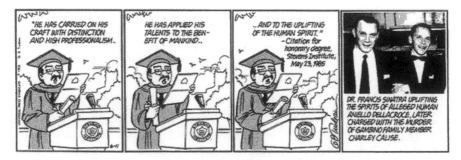

Figure 2.5 Garry Trudeau, © 1985.
Reprinted with permission of Universal Press Syndicate. All rights reserved.

gled with whether it belongs on the op-ed page or in the comics and some-
times even whether it should be included in the newspaper at all.

Like the best satire, *Doonesbury* mirrors the society it serves by person-
alizing it—and mocking it. "Caricatures," Ralph Waldo Emerson wrote
in his journal, "are often the truest history of the times."[30] W. Clark
Hendley compared the satire of Trudeau with the satire of Horace, who
wanted to "tell the truth, laughing." Hendley wrote that "just as Horace
minutely examined the society of his own day, Trudeau forces us to look
at ourselves not as we would like to be but as we are." Hendley continued:
"In their use of vital comic traditions, believable and yet running charac-
ter types, in their gentle mockery and avoidance of the righteous indig-
nation characteristic of satire, in their keen ear for the idiom of daily
speech . . . the two show even the seemingly disparate can be profitably
joined together."[31]

Throughout *Doonesbury*'s long run, newspapers have rejected strips that
bring into the open issues and lifestyles that editors feel are not appropri-
ate for their impressionable readers. When *Doonesbury* introduced a gay
character, Andy Lippincott, a number of newspapers showed their disap-
proval by canceling the strip. Then, when Lippincott developed AIDS,
other newspapers dropped the strip. But many readers—primarily those
who had AIDS or knew someone with the disease—welcomed the series.
"The epidemic does have a funny side," one AIDS sufferer explained.[32] In
one of the more poignant *Doonesbury* strips, Lippincott succumbs to AIDS
as the Beach Boys' song "Wouldn't It Be Nice" plays in the background.
The *San Francisco Chronicle* even published Lippincott's death on its obitu-
ary page. An AIDS memorial quilt includes his name in one of its squares
with other victims of the disease.[33]

Doonesbury's characters change with the times, but they stay true to char-
acter and do not become caricatures. Trudeau's characters grow up, go to
college, make friends, have conversations about real-life things, watch tele-
vision, find jobs, lose jobs, raise families, struggle with middle and even old
age, suffer from Alzheimer's disease, and even die. Unlike editorial car-
toons, which generally stick to the front pages, *Doonesbury* takes us deeper
into the newspapers and therefore deeper into our lives, and the result is
something truer than you will find anywhere else in the mass media. When
Trudeau chronicled the efforts of Joanie Caucus to gain admission to law
school, the deans of four real-life law schools sent him their application
forms. Trudeau said he received so much mail addressed to Joanie that his
"mailman thought I was living with her."[34]

A number of characters in the strip's ensemble were inspired either by metaphors—such as the women's movement, corporate greed, and the shallowness of television news—or by real-life people. Trudeau's Mike Doonesbury is self-inspired. "Megaphone Mark" Slackmeyer is Trudeau's answer to Yale University radical Mark Zanger. Uncle Duke is a thinly disguised replica of counterculture journalist Hunter Thompson. Thompson, however, did not see the imitation as the highest form of flattery. "If I ever catch that little bastard," he was once reported as saying in reference to Trudeau, "I'll cut his lungs out." The late congresswoman Millicent Fenwick, a Republican from New Jersey and the inspiration for Congresswoman Lacey Davenport, was more positive. "I think it's marvelous," she said. "After all we have to be able to laugh at ourselves in this business."[35]

One could contend that Trudeau is not just America's most successful satirist but also its best, better than Mark Twain, Ambrose Bierce, H. L. Mencken, or anyone before or after them. In part, this is because for more than thirty years, Trudeau has succeeded at something as ephemeral as social satire. His success lies in his ability to create distinct characters; adapt to a changing America; capture its headlines, zeitgeist, and idioms; and avoid taking anything, including himself, too seriously. Trudeau has so far shunned mean-spiritedness, the occupational hazard that has been the downfall of other satirists, including the comic-strip artists Walt Kelly of *Pogo* and Al Capp of *Lil' Abner*, who lost their way after they were swallowed up by their own pretense or indignation.

In an article in the magazine *Reason*, Jesse Walker wrote that in recent years *Doonesbury* had declined in relevance and merit, that it had once spoken to a generation but now was largely self-absorbed. The strip, according to Walker, had ceased to be fashionable.[36] Walker is right to an extent: familiarity breeds contempt or, at least, indifference. We do not quote *Doonesbury* as much as we once did, nor does it shock or tickle us as it once did. When Trudeau introduced the strip, America was a satirist's playground. But we are more jaded now and less socially and politically conscious, having progressed from the imperial presidency of Richard Nixon to the pants-free presidency of Bill Clinton. Indeed, after three decades, it is remarkable that *Doonesbury* still shocks or tickles us at all, and yet it does.

If *Doonesbury* has grown long in the satiric tooth, as Walker suggested, one cannot see it in the numbers. The strip runs in more than 1,300 newspapers, which means it is read—or at least glanced at—by millions of readers every day. In his history of comic strips, M. Thomas Inge wrote that any phenomenon that plays so heavily on the sensibilities of its readers deserves attention, if only for purely sociological reasons.[37] Trudeau's influence,

therefore, is reflected not just in the prickly reactions of those he criticizes but also in the impact he has made on his profession, in part because he forced editors to stop shrinking the size of comic strips so they could publish more of them. Just as Walt Kelly's *Pogo* influenced Trudeau, his *Doonesbury* has influenced other socially aware strips, like Berke Breathed's *Bloom County*, Jeff MacNelly's *Shoe*, Doug Marlette's *Kudzu*, Aaron McGruder's *Boondocks*, and Bruce Tinsley's *Mallard Fillmore*. The *Boondocks* has been marketed as the black *Doonesbury* and the conservative *Mallard Fillmore* as the anti-*Doonesbury*. In addition, Latino cartoonist Lalo Alcarez refers to his strip, *La Cucaracha*, as *Doonesbario*.[38]

After Trudeau spoofed right-wing talk-show hosts for "hate radio," the conservative Tinsley fired back with a series of his own that criticized *Doonesbury*. "Calling all conservatives hatemongers does violence to the language," Tinsley said. "It trivializes genuine hatemongers."[39] Tinsley's exaggerated sense of indignation would seem to be a reaction more appropriate to an oversensitive politician or a right-wing talk-show host. Satirists are least effective when they become political apologists. Indeed, after a promising beginning, Tinsley's *Mallard Fillmore* has become a one-trick pony that nips at the same standard liberal issues over and over, causing some readers to laugh, no doubt, because even though it lacks surprise, it offers the comfort of an old joke between friends.

As a satirist should, Trudeau is truer to his satire than to his politics, which means that he also looks to his left for inspiration. So far, Trudeau has resisted the temptation to respond to his critics with anything more than a bemused smile and a shrug. Although he may be shaped by his liberal views, he is not blinded by them. He was no friend of Presidents Jimmy Carter and Bill Clinton or anyone in their administrations. Janet Reno, who served as the U.S. attorney general during the Clinton administration, once observed: "I'm sure God is at this point very angry with Garry Trudeau."[40]

Satire uses ridicule, sarcasm, irony, and caricature to expose or attack the vices and follies of society. It has its origins in a state of mind that is both critical and aggressive. It is directed at human absurdity, inefficiency, or wickedness. Edward Rosenheim Jr. said that satirists try to make their victims "suffer," through either their own injured awareness or the ridicule that the satire creates in minds of others. "Satire is not only an attack. It is an attack upon discernible, historically authentic particulars," he said. "The reader must be able to point to the world of reality, past or present, and identify the person or thing that the satirist is condemning."[41]

The basic technique of satirists is reduction: degrading or devaluing the targets of their satire by reducing their stature and dignity. Satirists try to

reduce their victims by removing them of their rank, status, and clothes, showing the world that there is nothing underneath all the beautiful robes except an ordinary mortal.[42] Mike Peters once compared the editorial cartoonist with the little boy looking at a naked emperor on a Roman parade ground. "A journalist reporting [a story] cannot say, 'Hey, that guy's a liar.' But the cartoonist can say, 'Wait a minute. That guy's not wearing a stitch on his body.'"[43]

Matthew Hodgart wrote that all good satire contains an element of aggressive attack and a fantastic vision of the world transformed. He said satire is written for entertainment, but it "contains sharp and telling comments on the problems of the world in which we live, offering 'imaginary gardens with real toads in them.'"[44] Satirists find themselves on the outside looking in, seeing a world that is unjust and immoral and in need of reform. They believe that the establishment plays by its own set of rules, which benefit themselves at the risk of everyone else. Indeed, Hodgart wrote, satire can "release powerful enough acids to break down the attitudes of mind that hinder reforms."[45]

The tradition of satire dates back to the Greek Archilochus, who in the seventh century B.C.E. was one of the first, according to one writer, to "dip a bitter Muse in snake-venom."[46] From the beginning, the satirist has skated on the thin edge of censorship and retribution. Among the early writers published for their satire were Daedalus, who was imprisoned; Wieland and Hephaestus, who were crippled; and Prometheus, who was chained to a rock.[47] In 1599, the archbishop of Canterbury and the bishop of London issued an order prohibiting the printing of any additional satire and required that already published to be burned.[48] After publishing "The Shortest Way with Dissenters" in 1703, a biting satire of England, Daniel Defoe was fined and sentenced to three times in the pillory.[49]

History is long on examples of cartoonists who were punished for their attacks. French artist Honoré Daumier was sentenced to jail for his drawings of King Louis Philippe. During World War I, Aristede Delanoy was jailed for a year by the French government for criticizing the politicians Aristide Briand and Georges Clemenceau. In Germany, artist George Grosz was fined 500 marks, and his portfolio of prints was confiscated.[50] In the Netherlands, artist Louis Raemaekers was prosecuted by his government for his anti-German drawings, which endangered the country's neutrality.[51] And during World War II, Adolf Hitler ordered that the name of English cartoonist David Low be put on the Gestapo's list of people to be exterminated.[52]

In recent decades, a Palestinian cartoonist was murdered, and cartoonists were jailed in Uruguay, Iran, the former Soviet Union, Panama, and other countries. Turkish and Indian editors were jailed for approving the publication of disrespectful cartoons.[53] In 1993, a high-ranking Japanese politician even committed suicide over the publication of a cartoon.[54] "It is hard to imagine an American politician taking his life over a few brush strokes, but then it's been a long time since shame has played any significant role in American public life," Trudeau wrote in a *New York Times* op-ed piece. "Its absence may make the job of the editorial cartoonist a little tougher, but at least it's conspicuously safer."[55]

By definition, satire is a destructive art. It is, after all, intended to shake us out of our sense of apathy or indifference and bring about reform. "The best cartoons," the late cartoonist Boardman Robinson observed, "often grow out of a sense of indignation. They express one's reaction from the meanness and futilities of life, one's feeling of resentment at social wrong and oppression." Columbia University professor Gilbert Highet wrote that the satirist "is able to distinguish right from wrong in society and willing to attack the wrong without reservation."[56] Cartoonists feel that positive cartoons are a contradiction in terms. "Cartoons are ridicule and satire by definition," cartoonist Paul Conrad said. "A negative attitude is the nature of the art."[57]

For this reason, cartoonists tend to be more progressive—and therefore more liberal—than the rest of us, because they are interested in reforming society and not maintaining the status quo, which, by definition, tends to be conservative. "By nature, cartoonists are anti-institutional iconoclasts, attacking the status quo," *Arizona Republic* cartoonist Steve Benson said. Paul Conrad said that there are more liberal cartoonists than conservative cartoonists because "conservatives don't have a sense of humor."[58] Pat Oliphant, who calls himself a "reasoning liberal," says that there are no good conservative cartoonists: "The conservative tends to be all for the status quo."[59] In 1984, when Ronald Reagan, a Republican, ran against Walter Mondale, a liberal Democrat with the charisma of chicken broth, Oliphant voted for Reagan. But the vote was strictly business for Oliphant, who asked, "Who wants to draw Mondale for four years?"[60]

Cartoonists embrace the title of social critic yet object to being called cynics, asserting that there is a profound difference between being a critic and being a cynic. "Cynicism leads to hopelessness," Clay Bennett of the *Christian Science Monitor* said. If he were hopeless, he added, "I wouldn't be spending so much time trying to change the world."[61] Doug Marlette, who

majored in philosophy at Florida State University, explained that cynicism is rooted in the Greek word *konokos*, meaning "like a dog." But cynics, if one is to use the literal definition, act in a nihilistic manner with no sense of social consciousness. Skeptics, according to Socrates, question authority in order to seek a higher level of truth, which, Marlette said, is what he tries to accomplish with his drawings.[62]

America's tradition of rebellion and free speech explains, to some extent, the country's involvement with social satire, which is reflected in its tradition of editorial cartooning. Christopher Morley wrote that editorial cartoons reflect an angry side of the American conscience. "There has always been something sui generis in the American comic spirit, though. I don't know that it has ever been recognizably defined. A touch of brutality, perhaps? Anger rather than humor? Various words rise to mind . . . sardonic; extravagant, macabre—we reject each one," he said. "Yet the mere fact that it suggests itself points to some essential hardness or sharpness of spirit."[63]

A lot of cartoonists see themselves in a never-ending battle between us and them, with them being those in power who use that power for their own personal benefit at the expense of the rest of us. For this reason, for many cartoonists the best definition of editorial cartooning is "to afflict the comfortable and comfort the afflicted." Unrestricted by journalistic standards of objectivity and fairness, cartoonists direct their incredulity, anger, or morality at whatever most outrages them. Cartoonists distort the news of the day to express what they regard as the truth about someone or something. "Cartoonists violate every rule of ethical journalism," the late cartoonist Jeff MacNelly said. "They misquote, trifle with the truth, make science fiction out of politics and sometimes should be held for personal libel. But when the smoke clears, the [editorial] cartoonist has been getting closer to the truth than the guys who write political opinion."[64]

When editorial cartoonists are at their best, they are like switchblades: simple and to the point, they cut deeply and leave an impression. For instance, few articles or photographs are as memorable as David Levine's drawing of President Lyndon Johnson lifting his shirt to reveal a gallbladder scar shaped like Vietnam, whereas four decades later, few remember the photo of LBJ showing reporters and photographers his gallbladder scar. Johnson was driven from office by his failure to properly manage the Vietnam War. With brilliant juxtaposition, Levine captured LBJ's legacy with no words in a way that transcended any written work.

Years after the *Washington Post's* Herbert Block—or Herblock, as he signed as his name—portrayed a stubbly-faced Richard Nixon climbing out of a sewer, Nixon said: "I have to erase the Herblock image."[65] Trudeau's

depiction of the first President Bush as a wimp infuriated Bush to such a degree that, it has been suggested, it prodded him into declaring war against Iraq in 1991. If true, it is reminiscent of the words alleged to have been spoken by the publisher William Randolph Hearst, who, itching for the United States to go to war with Spain, told Frederic Remington, his illustrator in Cuba: "You furnish the pictures and I'll furnish the war."[66]

By starkly uncovering the naked truths of our emperors, cartoonists have contributed to the political and social fabric of America since the founding of the republic, when Benjamin Franklin's crude drawing "Join, or Die" called for a united front against England in 1754 (figure 2.6). In 1812, an editorial cartoon depicted a salamander as a newly created political district devised by Massachusetts governor Elbridge Gerry, thereby introducing the word *gerrymander* into the lexicon (figure 2.7). At the turn of the twentieth century, Hearst lured the popular Richard Outcault and readers of his comic-strip character the Yellow Kid away from Joseph Pulitzer's *New York World*. Indeed, the strip came to represent the lengths that newspapers would go for circulation, thus introducing the term *yellow journalism*.

Thomas Nast of *Harper's Weekly* became the first cartoonist to fully demonstrate the impact that the cartoon could have on American society, first during the Civil War and then during his assault on New York City's ignominious Tammany Hall political boss William Marcy Tweed. Nast introduced or created the symbols of the Democratic donkey, Republican elephant, and Tammany Hall tiger. If the imagery is powerful enough, there is no need for more than a few—if any—words. In Nast's cartoon "The Brain," he captures "Boss" Tweed as a sack of money (figure 2.8), and

JOIN or DIE

Figure 2.6 Benjamin Franklin, *Pennsylvania Gazette*, 1754.

Figure 2.7 Elkanah Tisdale, *Boston Gazette*, 1812.

THE BRAIN

Figure 2.8 Thomas Nast, *Harper's Weekly*, 1871.

in his cartoon "Under the Thumb," Tweed's control over New York City is immediately evident (figure 2.9).

As it was in Nast's day, whether their intent is to tickle the funny bone or jostle people's sensibilities, cartoons still are often at their most effective when they are stripped to their most basic form and meaning. In 1980, Mike Peters of the *Dayton (Ohio) Daily News* captured Jimmy Carter's White House as Carter's teeth in a cartoon that he included in the package he entered in the competition for the Pulitzer Prize (figure 2.10). After Peters won the prize, he described the lasting value of the editorial cartoons. "Great editorial cartoons contain basic truths—and are relatively timeless. . . . The individuals portrayed in the cartoon may change, but the themes do not," he said. "People may not remember Boss Tweed . . . but they know we're always going to have the all-around scoundrels who turn up in politics. So when the cartoonist Thomas Nast portrayed Tweed as a sack of money, he captured that type in a way that will always be remembered."[67]

Of the cartoonists working today, none is better than Clay Bennett, a finalist for the Pulitzer Prize for five consecutive years, ending in 2004. Bennett's strength lies in the economy of his satire; he can say more with fewer words than any other cartoonist. His drawings are clean, and his message is unambiguous. Unlike some of his colleagues who giggle at the news

UNDER THE THUMB.

THE BOSS. "Well, what are you going to do about it?"

Figure 2.9 Thomas Nast, *Harper's Weekly*, 1871.

Figure 2.10 Mike Peters, 1976.
Reprinted with special permission of North America Syndicate.

or others who strike at their prey with the self-restraint of an evening of professional wrestling, Bennett uses satire with the precision of an infantry sniper. He gets into position, takes aim, and fires carefully, rarely missing and often leaving images that speak for themselves (figure 2.11).

After being fired by the *St. Petersburg (Fla.) Times* in 1994, Bennett trained in computer graphics in order to produce fully animated color cartoons for the Internet. His cartoons do not look like other cartoonists' work. But a computer—like a pen—can go only so far to make a strong statement. At some point, it requires a message. "Using a computer, my cartoons get so much closer to what I see in my mind's eye," he says. "Of course, computers don't think up any ideas for you." Robert Laird, the op-ed editor of the New York *Daily News*, which runs Bennett's cartoons, said that they are "very visual, very sculptural. They just jump off the page at you. You don't see that from anyone else. It's sort of startling to see how several cartoonists will come up with the same idea. That never happens with Bennett."[68]

Beginning with Nast, the profession has always had its leaders and its followers. In post–World War II America, several cartoonists drew as Bill Mauldin or Herblock did; in the 1960s, it was Pat Oliphant; and then in the 1980s, it was Jeff MacNelly. The so-called MacNelly clone—craftsmanship

fused with intelligent and often piercing humor—still can be found on editorial pages. One reason, Tony Auth of the *Philadelphia Inquirer* explained, is that newspapers and syndicates encourage cartoonists to draw like "Oliphant and MacNelly."[69] Joel Pett said that editors "don't like stuff that takes much thinking or analysis."[70] Cloning, he added, is the cartoonist's answer to "pack journalism."[71]

Imitations, however, are rarely, if ever, as good as the original, whether they are movies, television programs, or cartoons, and their prevalence can indicate staleness in a profession, which in turn reflects a lack of creativity or a general sense of laziness. But imitations are just as likely to be the result of the cartoonist's drawing a predictable gag or settling on his or her first draft rather than staying a little longer at the drawing board. "I rarely settle for my first idea. Usually that will be an idea shared by other people," said Bennett, who can take twelve hours or more to complete a cartoon. "I spend hours trying to come up with a spontaneous thought."[72]

During the 1950s, Bill Mauldin's popularity was reflected in the number of other editorial cartoons that looked like his. He said that he was inspired by other cartoonists, but they had no discernible impact on his work. "I'm too conceited to pattern myself after . . . anyone. I don't want to be in the

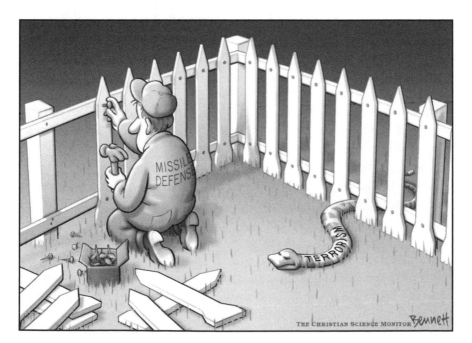

Figure 2.11 Clay Bennett, *The Christian Science Monitor*, 2001.

position of stealing anybody else's stuff," Maudlin said, adding that he was aware that other cartoonists were too derivative of his work. "I never resented anyone stealing my stuff," he said. "Imitation is the highest form of flattery. But I sure don't want to be taking anybody else's."[73] As Bennett pointed out, however, there is a difference between two cartoons looking alike and two cartoons saying the same thing: "You don't have to steal the drawing to steal the idea."[74]

When one cartoon strongly resembles another, it can be the result of great minds thinking alike, or it can be a coincidence. But there certainly have been instances of outright plagiarism. Unlike articles or columns, in which plagiarism can be documented by comparing the language in one story with that in another, editorial cartoons, which are less literal, thus are less amenable to comparison—unless one of the artists is particularly careless or shameless. When Pett was president of the Association of American Editorial Cartoonists, he, at the urging of other cartoonists, wrote a letter to one cartoonist telling him that some cartoonists were concerned that his drawings looked suspiciously like those of others. The cartoonist denied the charge but said he would work harder at avoiding cliché work.[75]

In editorial cartooning, cloning or, in particularly egregious examples, plagiarism is compounded by the intrinsic nature of the work. Editorial cartoonists satirize what is in the news on a given day, work under deadline, and rely on the same symbols. Ted Rall argued that cartoonists have to rid themselves of traditional symbols and create a brave new world for the profession. Rall, who does not work for a daily newspaper, draws a comic strip, abhors traditional symbols, includes dozens of words in a single strip, and uses kidney punches and not punch lines. "Democratic donkeys and Republican elephants still prowl a hundred drafting tables and every city in America awakens to tortured analogies on the op-ed page," he says, "ships piloted by president-as-captain going down in a sea labeled 'deficit.'"[76]

To be effective, editorial cartoons need the involvement of the reader or audience. In addition, cartoons often require a background or context to make sense, whether it is an editorial appearing next to it or the reader's knowledge of the subject matter being satirized. In politics, there are distinct advantages to being an incumbent, from setting the agenda in the media to simply having name recognition with the electorate. But if incumbents have advantages in some areas, they are not transferred to the drawings boards of editorial cartoonists. As one study of the 1992 presidential election confirmed, because editorial cartoonists react to well-known politicians and generally have a negative tone, they tend to be anti-incumbent. This study also found that cartoonists were much harder on

President George Bush and his vice president, Dan Quayle, than on either of their opponents, Democrat Bill Clinton or independent Ross Perot.[77] Pat Oliphant expressed his profound disappointment at Clinton's election: "I hate changes of administrations because you have all your villains in place and they take them away."[78]

Besides having to be aware of the issue or person being satirized, readers also must be aware of the meaning of the symbols in a particular cartoon. This partly explains why cartoonists often ignore complicated issues or grossly simplify them. In addition, whenever a complex issue is reduced to its simplest component, as a cartoon often must do, something can— and often does—get lost in the translation. If the cartoonist and the reader are not connected, conceptually or contextually, the reader may not understand the cartoon's meaning or receive a message different from the one intended.[79]

Cartoonists can increase the odds of making sure that they are on the same page as their readers by including familiar political symbols and popular cultural references or by labeling what may be unfamiliar. But this may also be a distraction, just as laugh tracks speak to a less sophisticated ear and ketchup to a less sophisticated palate. In the comic weeklies of a century ago, cartoonists made their point by using references from the classics and antiquity. As the mass media have become more pervasive, cartoonists increasingly use popular references from movies and television. Just as some television programs pride themselves on smart writing, some cartoonists look down on their drawing boards from a higher brow. For instance, Conrad uses Shakespearean references, and Marlette often draws from the Bible (figures 2.12 and 2.13).

Visual satire differs from written satire in its use of caricature, or the deliberate distortion of a particular individual's features for purposes of laughter or mockery. Werner Hofmann wrote that caricature "protests against ideal beauty and claims for itself freedom to reform the world in terms of ugliness; it protests against the dogma of the lofty and sublime, which are alone supposed to be artistic, by looking critically at simple men as well as at notable dignitaries." Caricature requires two artistic impulses: to observe reality objectively and to transform it subjectively. Hofmann wrote that it "glances behind the scenes of the world's stage and finds in the wings the confusing trappings of a 'topsy-turvy world.' It clothes itself in the jester's motley, and in its jokes folly becomes a profound wisdom."[80]

Cartoonists, then, prefer their subjects to have trappings that are both widely known and easy to caricature. For instance, as Roger Fischer pointed out, "Boss" Tweed probably was no more corrupt than a number of other

"ALAS, POOR AGNEW, MITCHELL, STANS, EHRLICHMAN, HALDEMAN, DEAN, KALMBACH, LARUE, MARDIAN, STRACHAN, MCCORD, LIDDY, CHAPIN, HUNT, COLSON, KROGH, MAGRUDER, YOUNG—I KNEW THEM ..."

Figure 2.12 Paul Conrad, *Los Angeles Times*, 1972.

" AND WHEN THOU PRAYEST, THOU SHALT NOT BE AS THE HYPOCRITES ARE : FOR THEY LOVE TO PRAY PUBLICLY THAT THEY MAY BE SEEN OF MEN. " — JESUS

Figure 2.13 Doug Marlette, *Charlotte (N.C.) Observer*, 1984.

New York City politicians, but he lent himself far more to caricature. Tweed was a tactless, greedy, and overbearing loudmouth, to be sure, but he also was bearded and corpulent and therefore easy to caricature. Nast chose Tweed not because the political boss was the devil incarnate, as the cartoonist pictured him, but because, as author Thomas Leonard explained, the politician was "the easiest man in government to portray as a menace."[81]

The nineteenth-century cartoonist Joseph Keppler said that "the secret to caricature is exaggeration, of course. But first we have to determine what feature is to be exaggerated. If a man has an extraordinarily prominent nose we must make it more prominent, but we must preserve the character of the face." As in parody, the copy must reflect the style, verse, and meter of the original. "But caricature does not deal merely with faces and forms," Keppler added. "It has to deal with character as well. If a man is notoriously stingy, that stinginess must be pictured in his caricature, and pictured extravagantly, so that it will stand out as the most prominent feature of the portrait."[82]

As caricaturists, editorial cartoonists sometimes walk a fine line between exaggeration and ethnic stereotyping, which reflects the seamy side of the profession's history and the biases of those who work in the profession. For instance, Nast's anti-Catholicism drifted toward the pathological. In "The American River Ganges," the artist portrayed Roman clerics as crocodiles

[108] THE AMERICAN RIVER GANGES. September 30, 1871
The Priests and the Children.

Figure 2.14 Thomas Nast, *Harper's Weekly*, 1871.

infesting our shores to eat our young children (figure 2.14). When editorial cartoons first became a fixture of American newspapers, Jews were drawn as large-nosed shysters, the Irish as drunken leprechauns, and blacks as lazy daydreamers who reserved their industriousness for chasing hens or watermelons.[83]

American Indians were depicted as bloodthirsty savages who had to be removed for both their own good and the good of society. During World War II, cartoonists, basing their drawings on little more than the atrocities of Pearl Harbor and Bataan, drew Japanese as barbaric savages lacking any humanity. In more modern times, Mexicans appear as lazy and mustached and feminists as shrieking and masculine. Since the Gulf War in 1991, cartoonists have drawn Arabs as rock-dwelling or carpet-flying terrorists, making little attempt to go beyond the popular, if highly distorted and often false, images, which means that these drawings can perpetuate racial, religious, and gender stereotypes.

In an effort to correct stereotypes of sexual, ethnic, and religious groups, the radical left established beachheads on liberal college campuses like the University of Wisconsin, the University of California, and Antioch College in the late 1970s and early 1980s. With good intentions, if one is to give the left the benefit of the doubt, the result was "political correctness," which

has had a profound impact on commentary and criticism, making it hard to criticize any minority without being called a racist, a sexist, or worse. This has not, however, cured prejudice, as intended, but forced it deeper inside, depriving us from discussing the issues that divide us. In these politically correct days, it is fashionable for those who are offended to express their indignation in the name of offended people everywhere, skin alive those who utter contrary opinions, force them to apologize, and then have them banished to the Tower of Babel.[84]

Several recent examples paint a bleak picture not just for editorial cartooning but for any criticism of minorities on college campuses or even the open discussion of issues of race or gender. In February 2002, Syracuse University's daily newspaper suspended its cartoonists and apologized for publishing a cartoon of a burglar, armed with a crowbar, with a round, black face and white lips crawling through a living-room window. The cartoonists said that the burglar in the drawing was not intended to be black but was wearing a ski mask. "There was never any thought in our minds that it could be anything other than a ski mask," one of the cartoonists insisted. "If anything, it's a stereotype of criminals." In an example of glaring overreaction, the university's president scolded the newspaper in public.[85] Also in 2002, Colorado College's student newspaper in Colorado Springs published an April Fool's Day issue with articles and cartoons that a number of students claimed were racist. The editor and managing editor were forced to resign, but not until after they were ordered to apologize.[86]

The Texas A&M student newspaper published a cartoon that was intended to satirize the fact that airports were hiring security guards who lacked a high-school diploma. The cartoon caricatured a poor black mother admonishing her son, who had a "F" on his report card: "If you ain't careful, you gonna end up doing airport security." When readers objected because the characters had been drawn with stereotypical features, the college's president, using his bully pulpit, publicly rebuked the newspaper and pressured its editor into apologizing.[87] Black students at Purdue University demanded that the student newspaper quit running syndicated cartoonist Pat Oliphant because he criticized the issue of cash reparations for slavery. Sue Rousch, the managing editor of Universal Press Syndicate, acknowledged that Oliphant had been called a racist before but defended his work. "He's an equal opportunity offender," she said, "but he's not a racist."[88]

In perhaps the most ridiculous instance of campus censorship, Harvard University officials reportedly forced the editor of the business school newspaper to resign in November 2002 after she ran an editorial cartoon that criticized those running a computer program in the career services

department as "incompetent morons." A week earlier, Harvard had can-
celed a reading by a poet who criticized the Israeli army. As has become
common on college campuses, it is left to the students to offer calm wisdom
to administrators when it comes to free speech. "Harvard Business School
administrators should have confronted the disrespectful cartoon with criti-
cism on the paper's opinion pages, rather than with heavy-handed and in-
timidating threats to the paper's editors," Boston University's newspaper
editorialized. "They should have defended the performance of the career
services department instead of working to simply erase criticisms of the de-
partment. Students should get active in defense of their free speech rights
and defend the open environment they deserve."[89]

Editorial cartoonists who work for daily newspapers also struggle with
making harsh comments without appearing racist or sexist, which some-
times results in their avoiding certain subjects for fear of being called racist
or sexist. Political caricature that restricts itself to appearance falls short of
what it should do. Such caricature is bound to be ineffectual, and depend-
ing on what else is distorted, it may be irresponsible as well. Ted Rall,
whose work often elicits a strong response from readers, once said: "We all
know that caricature is at the heart of [editorial] cartooning in this country.
But when does caricature become offensive?"[90] Rall said that he thought
that a lot of caricature tended to be offensive. For instance, it can be offen-
sive whenever certain attributes of a group are exaggerated, such as lips for
blacks or noses for Jews. To avoid such portrayals, he said, he tends to use
little personal caricature.[91]

Los Angeles Times cartoonist Mike Ramirez said that he received com-
plaints whenever he portrayed Jews with large noses, acknowledging that he
drew just about everyone with a big nose. The problem, he added, is that "I
don't want the message distracted by big noses" because then the "cartoon
becomes ineffectual."[92] Steve Kelley said that few cartoonists use blatant
stereotypes such as "pickaninnies" for blacks or choose "hook noses" to
identify Jews. Kelley acknowledged that he had been criticized for using a
Frito Bandito character for Hispanics. He also said that he was criticized
whenever he drew welfare mothers as blacks. He noted, however, that al-
though more welfare payments go to whites than blacks, proportionately
they go to a higher percentage of blacks.[93]

Atlanta Journal-Constitution editorial cartoonist Mike Luckovich once
drew a cartoon showing a politician holding a black baby and saying, "Ei-
ther your unskilled, uneducated mother gets a job, or you're dead meat."
Luckovich's intent was to chide Congress's attempt to reform welfare, but
the message was misinterpreted, drawing charges of racism because it rein-

forced the stereotype that welfare recipients were black. The *Journal-Constitution* did not apologize for the cartoon but ran a full page of letters from readers and also brief columns by Luckovich and its editorial page editor, Cynthia Tucker. Luckovich said that it is natural that his cartoons would cause some response and expressed his frustration when "the message you're trying to get across is obscured."[94]

In 1994, the *Sacramento (Calif.) Bee* published a drawing by Dennis Renault that shows two Klansmen looking at a quotation by Nation of Islam leader Louis Farrakhan that says: "You can't be a racist by talking—only by acting." One of the Klansmen responds: "That nigger makes a lot of sense." The drawing was based on a speech made by a Farrakhan aide who had attacked Jews, the pope, homosexuals, and some black leaders. Even though the cartoon was meant to deplore racism, the use of the explosive epithet brought a torrent of criticism on the newspaper, which apologized for the cartoon.[95]

Jeff MacNelly drew four priests discussing singer Sinead O'Connor's appearance on a live television program, during which she tore up a photo of the pope. After one of the priests says, "Probably abused as a small child by some authority figure," another thinks to himself: "Wonder what she's doing Friday night?" Joseph Cardinal Bernardin called the MacNelly cartoon, which referred to charges of child abuse by priests, an unwarranted attack on the Catholic Church. The *Chicago Tribune*, despite pressure from Catholic groups, did not apologize, explaining in an editorial that "the issue of [child abuse] remains, here and elsewhere, a subject of enormous public concern and legitimate journalistic comment, whether it be through personal reflections of columnists and political satire by cartoonists or comment by the newspaper in its editorials."[96]

But the *Tribune* has since reconsidered its defense of hard-hitting satire, bowing apologetically to the virus of political correctness. On May 30, 2003, it published a cartoon by Dick Locher, who had retired from the newspaper but continued to distribute his work through the Tribune Media Services, that satirizes the American involvement in the Israeli–Arab peace process. In the drawing, President Bush is shown on a bridge labeled "Mideast Gulch," laying down dollar bills in front of a heavyset man, presumably Prime Minister Ariel Sharon, who has a large nose and a Star of David on his jacket and who is thinking : "On second thought, the pathway to peace is looking a bit brighter" (figure 2.15).

The drawing was intended to satirize how the United States was attempting to influence the Israeli government with millions and millions of dollars in aid. But critics saw only an anti-Semitic stereotype of a hook-nosed Jew as greedy. Offended readers sent in letters and e-mails complaining about the

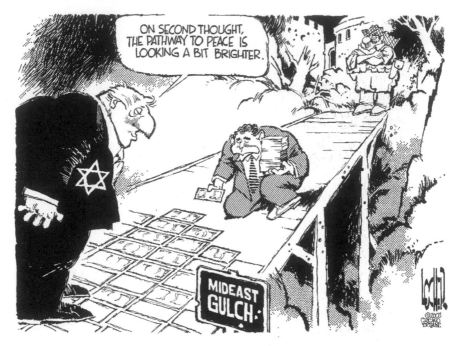

Figure 2.15 Dick Locher, 2003. Reprinted with permission of Tribune Media Services.

cartoon. One reader charged that the drawing "propagates odious anti-Semitic themes while distorting essential realities."[97] Another complained that it was "blatantly anti-Semitic, reinforcing the long-held racist image of Jews as avaricious and greedy." The newspaper's public editor, Don Wycliff, agreed, calling the drawing racist.[98]

In his column, Wycliff quoted the newspaper's editorial page editor, Bruce Dold, as saying that Locher was trying to comment on the "influence the U.S. can exert through the foreign aid it provides to Israel." Dold, however, added that "the cartoon carried several other messages that could be seen as drawing on anti-Semitic symbols and stereotypes."[99] When the complaints continued, the *Tribune* apologized, refusing to defend either Locher or his right to comment, as it had done a decade earlier with Mac-Nelly's criticism of the Catholic Church. Taken in context, the Locher drawing was appropriate, and no apology was needed because, as the *Tribune* itself had once written, it was "a subject of enormous public concern and legitimate journalistic comment, whether it be through personal reflections of columnists and political satire by cartoonists or comment by the newspaper in its editorials."[100]

3

"No Honest Man Need Fear Cartoons"

During the 2000 presidential campaign, Democratic candidate Al Gore, the standing vice president, was widely perceived as wooden, remote, boring, and calculating. His opponent, the Republican nominee, Texas governor George W. Bush, was seen as dim but highly bankrolled. The presidential election inspired little passion on the part of either the electorate or the editorial cartoonists. "The worst thing was how packaged it was. Everything was scripted," *Christian Science Monitor* editorial cartoonist Clay Bennett said. "Both camps were as calculated as I've ever seen." According to Pulitzer Prize winner Doug Marlette, "When everyone is controlling all their ideas and everyone is trying to be careful and acceptable, it makes for boring cartoons," adding, "It was incredibly boring until the end. Then it got interesting."[1]

On election night, everything, including the winner, was called into question, and the line between news and satire became so blurred that it became nearly indistinguishable. Even though Gore won the popular vote, he had not secured enough electoral votes to claim the presidency. The election hinged on Florida, where Bush's brother Jeb was governor and where charges of voting irregularities turned the Sunshine State into a banana republic. On election night, the television networks not once but twice projected the winner in Florida, only to correct themselves. When America woke up the morning after the election, it still did not know who its next president would be and would not know for more than a month, as Democrats and Republicans exchanged insults and legal challenges over ballots bounced from court to court. As the outcome in the decisive state of Florida dragged on, the election itself became a cartoon, and Florida became the banana peel we all slipped on.

Generations from now, it may well be the editorial cartoonists who created the most realistic picture of the election. If ever an election was of the

cartoonists, by the cartoonists, and for cartoonists, this was it. Cartoonists caught the absurdity of the election, with their drawings cutting through the charges of voter fraud, the squabbles over recounted and uncounted ballots, and court challenges that led to the Supreme Court, where the conservative majority decided the election in Bush's favor. In separate cartoons, Robert Ariail of *The State* in Columbia, South Carolina, captured Gore's fate in Florida, the resolution of the ballot fiasco, and the vice president's reluctance to disappear even when the outcome seemed to have been decided (figures 3.1–3.3).

The results of the election left America—and particularly the Democrats—bruised and shaken. Liberals dipped their pens into their sense of outrage and went to work. In an essay published in the *New Yorker*, cartoonist Art Spiegelman called an emergency meeting of the United Cartoon Workers of America to discuss not only how they should refer to Bush, the "asterisk president," but also how he should be drawn, whether as the children's book character Curious George or as *Mad* magazine's poster boy, Alfred E. Neuman. Spiegelman suggested appropriating Neuman's line "What me worry?" to simply "Worry." The president-elect, Spiegelman added, "has accepted his role as laughingstock, mangling our language into entertaining one-liners as he willingly sticks his head through the hole in the canvas to receive our cream pies."[2] In a cartoon by John

Figure 3.1 Robert Ariail, *The State* (Columbia, S.C), 2000.

Figure 3.2 Robert Ariail, *The State* (Columbia, S.C.), 2000.

Figure 3.3 Robert Ariail, *The State* (Columbia, S.C.), 2000.

Deering of the *Arkansas Democrat Gazette*, a bearded speaker, microphone in hand, tells a crowd: "And if George W. Bush is elected, it will mean the creation of 50,000 new jobs!" When one passerby declares, "I had no idea Bush was backed by Big Labor," another man replies: "Those are political cartoonists" (figure 3.4).

Cartoonists immediately seized on the possibilities of a Bush presidency by pouncing on his deficiencies, real or imagined. They exaggerated the size of Bush's ears and eyebrows. They shrank him in size, reflecting that he was a lesser man than his father, who himself was largely perceived as a lesser man than his predecessor, Ronald Reagan. Bush was regarded as an intellectual lightweight, an unworthy inheritor of the throne. Marlette wondered whether the new president had inherited the presidency rather than worked for it. He drew Bush's secretary of education, Rod Paige, giving a speech: "—and if America's children don't work hard and apply themselves in school, where will they end up?" Standing next to him, President Bush, tie hanging loosely from his collar, is playing with a yo-yo (figure 3.5).

Then came the terrorism of September 11, and with it, a new and more presidential Bush emerged on the editorial pages. In the fog of war that followed, cartoonists gave Bush a battlefield promotion from Curious

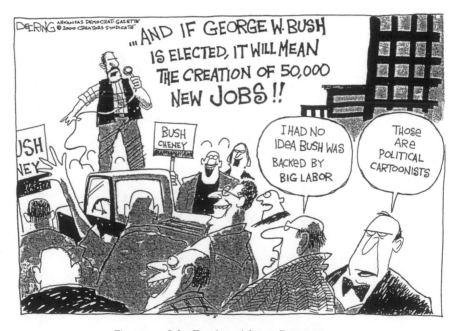

Figure 3.4 John Deering, *Arkansas Democrat*, 2000.
Reprinted with permission of Creators Syndicate.

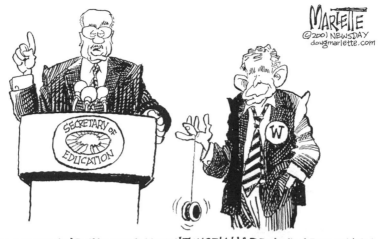

"—AND IF AMERICA'S CHILDREN DON'T WORK HARD AND APPLY THEM-
SELVES IN SCHOOL, WHERE WILL THEY END UP?"

Figure 3.5 Doug Marlette, *Newsday*, 2001.

George to George Washington and replaced social criticism with propa-
ganda. This reflected a sense of ambivalence among the nation's editorial
cartoonists, who, day after day, produced little of consequence. Satirists
should use whatever means at their disposal to lord over the public trust
and hold accountable those with power and influence who are abusing
their privileges. According to Charles Press, editorial cartoonists must re-
veal our leaders as "moral degenerates who are undeserving of what they
receive from the system."[3]

Politics is a natural arena for satirists; in fact, the terms *editorial cartoon-
ist* and *political cartoonist* are often used interchangeably. Most great
satirists—including Horace, Juvenal, Jonathan Swift, and Honoré Daumi-
er—were keenly interested in political reform. Matthew Hodgart wrote
that political satire requires several conditions. First, there must be a degree
of free speech. Second, there must be an interest on the part of an educat-
ed public to become involved in political affairs. Third, there must be some
confidence on the part of the satirist that he or she can have an influence.
And fourth, there must be a large audience that enjoys wit and imagination
and understands the satire.[4] Hodgart's criteria for satire can also be applied
to editorial cartoonists in American society. Editorial cartoonists have made
their greatest impact when the following conditions exist: social unrest,
charismatic politicians, an appropriate technology, a healthy newspaper in-
dustry, and a supportive editor. Cartoonists are least likely to succeed when

there is state-sanctioned repression, a contented or fearful status quo, an abundance of banal politicians on the front pages, poor or unavailable technology, and/or a struggling newspaper industry.[5]

America's first popular editorial cartoon, "Join, or Die," which called for a united front against England in 1754, shows a snake divided up into the American colonies. Unfortunately, the cartoon was badly reproduced because the colonial printers used equipment that had been discarded by British printers. Accordingly, during America's early years, editorial cartoons were uncommon because technology made it expensive to both produce and reproduce them. Because it was handicapped by inadequate printing equipment and perhaps even a sense of purpose, cartooning remained in its primal stage until the early decades of the nineteenth century, when technological advancements merged with political upheaval.[6]

For cartoonists to have more than just a passing impact on society, the wherewithal had to exist to cut the costs of production and distribution. In addition, satirists needed a foil who could arouse their readers. During the 1820s, editorial cartooning was given both Andrew Jackson and lithography, a method of printing that could produce a more detailed picture more quickly.[7] In addition, the charismatic Jackson was a natural for satirists, with his frontier manner, sense of egalitarianism, and populist distaste for both monopolies and special privileges.[8] His administration included such controversies as his fight with the Bank of America and the Peggy Eaton affair, in which Jackson defended the wife of his secretary of war, causing a rift in the cabinet and resulting in the resignation of several of its members. E. W. Clay drew the cabinet members as rodents in "Rats Leaving a Falling House."

After a series of forgettable presidents, Abraham Lincoln was elected in 1860, which ignited regional differences over slavery and states' rights and split the country into North and South. When we think of Lincoln today, he is a bronze and marble icon representing all that is good and decent about the presidency. As president, though, he was particularly suited to a graphic artist's interpretation, with his tall, ungainly frame, homely features, and beard (figure 3.6). Even his habit of spicing his speech with amusing stories became fodder for cartoonists.[9] "The living Lincoln," as Roger Fischer pointed out, "served as a very human foil in many cartoons"—from the lithographs of Currier and Ives to the satire of Englishman John Tenniel to the venomous work of Confederate Adalbert Volck.[10] In a real sense, Lincoln came to represent the differences between South and North, with Southern sympathizers like Volck demonizing him while Northern artists like Thomas Nast deified him.

Long Abraham Lincoln a Little Longer.

Figure 3.6 Frank Bellew, *Harper's Weekly*, 1864.

Nast, America's first great cartoonist, began working as an editorial cartoonist for *Frank Leslie's Weekly* when he was fifteen. Nast's graphic style was inspired by Tenniel; his artistic political inspiration came from Daumier and other French artists; and his philosophy derived from the liberalism of mid-nineteenth-century Germany.[11] In 1862, Nast began working for *Harper's Weekly*, and it was here he did his best work and had his biggest influence, largely because of the freedom he was given by publisher Fletcher Harper. It was because of Harper—more than any other person—that Nast's cartoons and *Harper's Weekly* became identified with the nation's history.[12] It was no accident that Nast created the profession in his own image because he came along during a period of tremendous social upheaval. Subject matter such as the Civil War, Reconstruction, and the Tweed ring elevated his work to have its maximum impact.

Lincoln reportedly called Nast "our best recruiting sergeant" for drawings that put the North on the side of the angels. Nast's notoriety, however, spread throughout the South, and he received several letters threatening his life. One of his friends told him he would have been burned at the stake if he had fallen into the hands of Confederate soldiers.[13] Conversely, Volck represented the views of the South, and his work reflected his hatred of the North and, in particular, of Lincoln. In one of Volck's cartoons, Lincoln is at his desk writing the Emancipation Proclamation. His foot rests on the Constitution and the devil is holding his inkwell. Had the war turned out differently, so might have the fortunes of Nast and Volck: after the war, Nast went on to his greatest success while Volck faded into relative obscurity.

As the war was ending, Nast galvanized Lincoln Republicans with the drawing "Compromise with the South," which attacked moderates or sympathizers who wanted peace at any price, even if it meant yielding to the South any point that was necessary to bring the seceding states back into fold. "The cartoon of Nast represented the defiant Southerner clasping hands with the crippled Northern soldier over the grave of Union heroes fallen in a useless war," Nast's biographer Albert Bigelow Paine wrote. "In the original design there had been a number of accompanying pictures, but Fletcher Harper considered the central idea sufficient."[14] After Lincoln was assassinated, Vice President Andrew Johnson became the president, and radical Republicans, like Nast, figured that Johnson would reflect their philosophies. But instead of supporting radical Republicanism, Johnson, a Southerner, was more sympathetic to the South, and so Nast criticized him for betraying Lincoln's principles.[15]

As a radical Republican, Nast attacked the Democrats' racism, including the Ku Klux Klan's violence against blacks. Nast also supported black peo-

ple's right to vote and civil rights legislation. His "Patience on a Monument" was a tribute to their forbearance.[16] But although this liberalism is prevalent in his works, there is also—as Morton Keller pointed out—a "persistent, disturbing strain of hostility to Catholics in general and to Irish-Americans in particular. It might seem paradoxical that an artist quick to respond to the cause of the underprivileged (whether blacks, Chinese or Indians) should be unrelentingly hostile to this substantial American minority. But Nast's anti-Catholic cartoons, like every facet of his work, had an intimate relationship to his radical Republicanism point of view. The good society of the radical Republican was liberal, progressive, nationalistic and Protestant."[17]

As the 1872 presidential election approached, the Republican Party was regarded as representing union, progress, and liberalism, whereas the Democrats remained the voice of secession.[18] Nast praised one as lavishly as he attacked the other. In fact, Nast was credited with helping elect General Ulysses Grant president. Nast became a golden boy of sorts to the Republican Party faithful. At the height of his influence, he visited Washington and wrote to his wife about a party given "for the Grant men of Washington to meet me, and I can tell you they came, with a vengens [*sic*]. . . . The power I have is terrible."[19]

In the years after the Civil War, Nast permanently established his reputation with his campaign against New York City's Tammany Hall boss William Marcy Tweed. It was, of course, "Boss" Tweed who summarized the simple potency of the editorial cartoon by saying: "Let's stop them damned pictures. I don't care what the papers write about me—my constituents can't read; but damn it, they can see pictures!"[20] Shortly after Nast began attacking Tweed in *Harper's Weekly*, the Democratic political boss canceled *Harper's* contract to publish textbooks for the city's schools.[21] According to Paine's fawning biography of Nast, when Nast and *Harper's Weekly* continued to publish cartoons, the Tweed political machine offered the cartoonist a $500,000 bribe to cease and desist. "I made up my mind not long ago to put some of those fellows behind bars," Nast told friends, "and I'm going to put them there."[22]

Nast's reputation rests primarily on his assault on Tweed, who ended up in jail for his crimes against the city. Keller called Nast's campaign against Tweed "a sustained attack in its passion and effectiveness that stands alone in the history of American graphic art" (for example, figure 3.7).[23] Nast disliked the political machine because it was made up largely of Catholics, and Tweed was no exception. Tweed also was blunt-spoken and arrogant, and his phrases like "To the victor belongs the spoils" were on the public record,

WHO STOLE THE PEOPLE'S MONEY ? — DO TELL . N.Y.TIMES. 'TWAS HIM.

Figure 3.7 Thomas Nast, *Harper's Weekly*, 1871.

ready to picked apart by Nast and other critics. In "The Tammany Tiger
Loose," the tiger snarls, "What are you going to do about it?" as it mauls
Lady Columbia while the Tweed gang looks on approvingly (figure 3.8).

With his crusade against Tweed, Nast established editorial cartooning as
"an enduring presence in American political culture," according to Fischer,
by fusing "creative caricature, clever situational themes, and honest indig-
nation to arouse the populace and alter for the better the course of human
events: the ethical imperative which lifts transitory journalism into tran-
scending art."[24] In his use of animal imagery and unbridled malevolence,
Nast set the standard against which future cartoonists would be measured.[25]
C. G. Bush, who worked with Nast at *Harper's Weekly* and then became one
of the first cartoonists to work regularly for a daily newspaper, said: "Nast,
more than any other man, demonstrated that a cartoon is not necessarily a
humorous caricature, but a powerful weapon of good or evil."[26]

Nast's insights, however, were not always the sharpest. His worship of
Grant as a war hero kept him loyal to the general through eight years of
presidential misrule, which tarnished the artist's credibility and demon-
strated to satirists that close friendships with politicians were bad for busi-
ness. In addition, Nast's fame, ego, and physiognomy made him a target

for other cartoonists. When Nast sided with the Democrat Grover Cleveland over the Republican James G. Blaine in 1884, his fellow cartoonists attacked him with the same viciousness that he had once attacked Democrats.[27] Nast now found himself attacked by his own monster. His rivals found that his personal features—his diminutive torso, pointed chin, and goatee—lent themselves to caricature as a monkey, rat, or malevolent dwarf.[28]

After a quarter century of influence, Nast's reputation began to fade. When he and his editor split over editorial differences, the artist tried to publish his own magazine, which failed, and he faded from the political landscape he had influenced for the past quarter century. He died in December 1902. By the hundredth anniversary of Nast's death, however, his legacy was secure. "He gave cartoonists a template to follow—you can be strong and courageous, and make a difference," said Jeffrey Eger, editor of the *Journal of the Thomas Nast Society*. According to editorial cartoonist V. Cullum Rogers, Nast was "the ultimate symbol of the cartoonist as crusader." The *Philadelphia Daily News* editorial cartoonist Signe Wilkinson said that she "didn't get into the profession because of Thomas Nast, but the profession is here because of Thomas Nast." Unlike those artists who take on politicians hundreds or thousands of miles away, Nast understood that

THE TAMMANY TIGER LOOSE.—"What are you going to do about it?"

Figure 3.8 Thomas Nast, *Harper's Weekly*, 1871.

local cartooning had the biggest impact. "People should remember that Nast's most powerful and influential cartoons," Wilkinson pointed out, "were his local cartoons about Tammany Hall."[29]

During the last quarter of the nineteenth century, some of the best cartoons were found in partisan comic weeklies such as *Puck*, *Life*, and *Judge*. Austrian immigrant Joseph Keppler of *Puck* became Nast's rival and successor. Keppler—who also copublished *Puck*, thereby securing himself a sense of freedom that few other cartoonists have enjoyed—believed that there was nothing wrong with entertaining his readers but that cartoons drawn solely to entertain were rarely memorable. Keppler directed his precise satiric judgments at both the political and the social scene. "Keppler felt that a democratic society must be ever vigilant, not so much to external threats but to internal threats, those that stand in the way of the society achieving its promise," Richard Samuel West wrote in *Satire on Stone: The Political Cartoons of Joseph Keppler*. "He saw [that] the duplicitous and greedy tendencies of those who exercise political and religious leadership must be monitored; [that] the callousness and lack of humanity of those with money and those who seek it must be moderated; and [that] the suffering of the poor and discriminated against must be alleviated."[30]

Newspapers were slow to accept editorial cartoons, first because of technological limitations and then because of their editors' shortsightedness. But that changed when editorial cartoons helped shape the outcome of the 1884 presidential election. In June 1884, *Puck* published Bernard Gillam's cartoon "The Tattooed Man," which was an imitation of a French painting based on the story of the Greek orator Hyperides, who won a verdict by having his client expose her beauty in court. In Gillam's drawing, which was distributed throughout New York City, all the charges ever made against James Blaine are pictured across his body (figure 3.9). Ironically representing a case of work before pleasure, Gillam was a Blaine supporter who voted for the candidate he helped defeat.[31]

A few days before the election, *New York World* publisher Joseph Pulitzer printed Walt McDougall's "The Royal Feast of Belshazzar Blaine and the Money Kings" across the front page of his newspaper (figure 3.10). The drawing, using biblical imagery to attack robber barons feasting on such dishes as lobby pudding and monopoly soup, satirized an opulent dinner party in honor of James Blaine. It was reproduced throughout the state. If Blaine had won New York State, which he only barely lost, he would have won the election, so it was common to hear—though impossible to prove— that the cartoon helped decide the election.[32]

Figure 3.9 Bernard Gillam, *Puck*, 1884.

Figure 3.10 Walt McDougall, *New York World*, 1884.

Editorial cartooning continued to be transformed by technology: first from woodcuts to stone lithography and then from drawings to photo-engraved line art mass-produced by letterpress. "In 1900, some newspaper artists still scratched their drawings on chalkplates, and the printed cartoons were a confusion of awkward, angular lines," Richard E. Marschall wrote. "Thereafter, pen-and-ink drawing dominated, as photoengraving became standard in the industry." During the 1910s, he continued, "artists shifted to the lithographer's crayon on textured paper, a look that was near-universal until mechanical shading [tones applied chemically to the original cartoon] came along in the late 1960s."[33]

As a result of advanced technology and the apparent influence of editorial cartoons, politically partisan editors began to hire their own cartoonists to improve their newspapers' circulation and reputation. But just as many actors failed to make the transition from silent films to "talkies," a lot of cartoonists struggled with the transition from the leisurely routine of the comic weeklies to the frantic pace of the dailies, which required them to produce a drawing every day.[34] Instead of thoughtful satire, most cartoonists made drawings that, according to one writer, "were intended to divert rather than to challenge the viewer."[35] Publishers, still not quite sure what to do with cartoonists, preferred gags and humorous vignettes because they did not offend their readers' Victorian sensibilities.

As was often the case, Joseph Pulitzer and William Randolph Hearst were ahead of their fellow publishers in realizing that cartoons represented a type of visceral commentary unmatched elsewhere in the newspaper, one that could appeal to a vast number of readers while furthering their own political ambitions. Hearst, in particular, argued that society was coming apart as resentment grew among the different classes. To Hearst, cartoonists could capture the sense of reform and social conflict by directing their frustration at those robber baron monopolists who absconded with public money, appropriated the public trust, and profited off the backs of the poor.

During his days as an unapologetic liberal Democrat, Hearst brought Homer Davenport to the *New York Tribune* from the *San Francisco Examiner* and unleashed him against the Republican power brokers and corporate trusts. An admirer of Nast, Davenport's "Boss" Tweed was Senator Mark Hanna of Ohio, credited with orchestrating the election of William McKinley as president. Davenport skewered the corpulent, dollar-marked Hanna and his puppet McKinley. In one cartoon, a dollar-marked Hanna is brutishly stepping on a skull labeled "Labor" (figure 3.11).[36] He wanted Hanna to feel his attacks, and he apparently got what he wanted. Hanna once broke into tears when showing a fellow senator one of Davenport's 1896 drawings.

Mr. Hanna's Stand on the Labor Question.

Figure 3.11 Homer Davenport, *New York Journal*, 1900.

"That hurts," he blubbered, "to be held up to the gaze of the world as a murderer of women and children. I tell you it hurts."[37]

Davenport's colleague on the *Tribune* was the former *Puck* cartoonist Frederick Burr Opper, who provided droll commentary without Davenport's trenchancy. Opper used humor to present a ridiculous picture to "arouse the risibilities," whereas, according to journalist B. O. Flower in 1905, Davenport produced images that were "so brutally savage, indeed, that they arouse in the moral nature of even the easy-going Americans' feelings not unlike those which would be awakened if we suddenly beheld as from a mountain height some fearful crime of the great and powerful against the weak and helpless—a crime like the massacre of helpless Armenians by the Turkish hordes. No cartoonists has ever exhibited such power in arousing the conscience-side of our life or the deeper moral sentiments."[38]

In addition, Hearst lured away from Pulitzer's *New York World* the popular Richard Outcault and readers of the artist's comic-strip character the Yellow Kid. The street urchin of the slums—with his bald head, gap-toothed grin, and characteristic nightshirt—made wry commentary in slang that made him famous. His catchphrase "keep de change" entered the vocabulary, and readers turned to him with their morning coffee or afternoon beer. Religious leaders, however, expressed their concern about the Yellow Kid's influence.[39] Another Hearst cartoonist, Winsor McCay, who drew the *Little Nemo in Slumberland* strip, was credited with inventing the modern-day animated comic strip.[40]

Other newspaper publishers used cartoonists to advance their own political agendas. They recruited cartoonists from other newspapers, paid them high salaries, and put their work on the front page. This period has been called the "golden age" of editorial cartooning. According to Henry Ladd Smith, the issues were simple enough to be easily interpreted, and there was enough elemental violence to satisfy the satirist.[41] When politicians, unaccustomed to being so brutally caricatured, found themselves on the sharp end of the cartoonist's pen, they took measures to rid themselves of their tormentors. Between 1897 and 1915, the legislatures of New York, California, Pennsylvania, Alabama, and Indiana considered bills outlawing cartoons (figure 3.12).

In New York City, political boss Thomas Platt had an anticartoon bill presented to the New York legislature in 1897, whereupon Davenport drew a cartoon entitled "No Honest Man Need Fear Cartoons," in which he compared "Boss" Platt with "Boss" Tweed (figure 3.13). Then after the bill died, Davenport drew another cartoon, "There Are Some Who Laugh and Others Who Weep," in which he pictured himself laughing

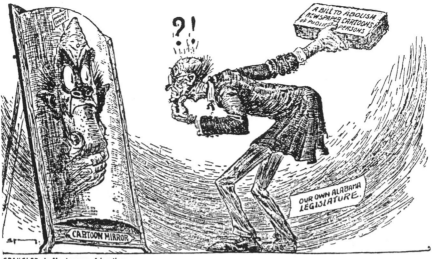

SPANGLER, in Montgomery Advertiser

Figure 3.12 Frank Spangler, *Montgomery (Ala.) Advertiser*, 1915.

while Platt and Tweed cried.[42] In Pennsylvania and California, anticartoon bills were subsequently made into law. Having been brutally ridiculed in the San Francisco newspapers, the California legislature passed a law that forbade the publication of caricatures without the consent of the subjects.[43] But rather than having its desired effect, the law was ridiculed into obscurity.[44]

In 1903, the state of Pennsylvania passed a bill that outlawed disrespectful or malicious cartoons and punished violators with imprisonment of up to two years and fines of up to $1,000.[45] "No law more infamous," the *New York Sun* said, "has ever been enacted by any American Legislature."[46] The legislation was the result of an unrelenting series of cartoons in the *Philadelphia North American* the previous year by cartoonists Charles Nelan and Walt McDougall against the gubernatorial candidate Samuel Pennypacker and Senator Matthew Quay, who was also the boss of the state Republican Party's corrupt political machine.

The *North American* publisher, Thomas Wanamaker, a political rival of Quay's, bought the newspaper in 1899, hired Nelan from the *New York Herald* and McDougall from the *New York World*, and turned them loose on Quay and his cousin Pennypacker, a longtime Philadelphia jurist who had been used to speaking his mind from the bench with little or no criticism.[47] Nelan's ridicule of Pennypacker came almost daily, and as the gubernatorial campaign progressed, the cartoons received more and more regularly the

NO HONEST MAN NEED FEAR CARTOONS.

Figure 3.13 Homer Davenport, *New York Journal,* 1897.

top five columns of the eight-column front page. Nelan reminded readers that Pennypacker and Quay were cousins, and he often charged that Pennypacker was a parrot of the corrupt Quay machine, making his point by drawing Pennypacker as a parrot. Nelan also found that an effective way of criticizing Pennypacker was merely to caricature the judge's own words, especially when the jurist defended Quay as a greater statesman than either Daniel Webster or Henry Clay.[48] In addition, the cartoons often contained references to a number of issues, which strengthened their message without being confusing.[49]

If Nelan hoped for a reaction from Pennypacker, he was not disappointed. At one point on the campaign trial, Pennypacker charged Nelan "with the kind of slander which is closely akin to treason and leads directly on the road to anarchy and the overthrow of cherished institutions."[50] Shortly thereafter, he called the *North American* "a worthless advertising sheet, miscalled a newspaper, which hires needy young artists to pervert their art."[51] The newspaper responded with a cartoon by Nelan entitled "A Calm Judicial Opinion," in which the Pennypacker parrot is inspecting a copy of the newspaper while screaming, "Worse than worthless! Worse than worthless!!" (figure 3.14).

Pennypacker easily won the election in November. In his inaugural address in January 1903, he called for the suppression of disreputable newspapers like the *North American*. A week later, State Representative Frederick Pusey introduced a bill making it a crime to publish any cartoon "portraying, describing, or representing any person, either by distortion, innuendo or otherwise, in the form or likeness of beast, bird, fish, insect, or other unhuman animal, thereby tending to expose such person to public hatred, contempt, or ridicule."[52] In a cartoon running across the top of the front page, McDougall drew Quay as a dying oak, Pennypacker as a frothy stein of beer, and Pusey as a small potato (figure 3.15). McDougall also wrote an editorial to demonstrate how easily the Pusey bill could be circumvented. "He [Pusey] should have included more than the animal kingdom alone, for we have an ample field in the vegetable if not even the mineral field," McDougall said. "Every cartoonist has a Noah's Ark full of worn, broken and decrepit animals, bugs and such, but the fresh vegetable field is untouched. What chances of caricature lie in the tomato, the string bean, the cucumber, the onion and the leek cannot be guessed."[53]

With the Quay machine behind it, a revised version of the bill passed through the Pennsylvania Senate and awaited the approval of the House of Representatives. One of the bill's opponents, a newspaper publisher, appealed to his colleagues to act above approach: "Let our behavior be such

A CALM JUDICIAL OPINION

THE PARROT—*"Worse than worthless ! Worse than worthless ! !"*

Figure 3.14 Charles Nelan, *Philadelphia North American*, 1902.

that the cartoonist must treat us kindly. If it be otherwise, the fault is not all with the newspapers or the cartoonists."[54] On May 1, the *North American* reported that Pennypacker would sign the bill into law. A day later, Nelan drew Pennypacker as a dwarf sabotaging a printing press, which was supported by wooden planks labeled "Constitutional Guarantee of Freedom of the Press" (figure 3.16). Pennypacker signed the bill on May 12, insisting that the "bill would be cordially and cheerfully accepted by the press."[55] Hundreds of newspapers, however, criticized the governor.[56] The *New York Times* editorialized that "the most reactionary measure that has

Figure 3.15 Walt McDougall, *Philadelphia North American*, 1903.

passed any American legislature in recent years is defended by the most re-actionary argument that any governor has had the insolence to employ."[57] The *New York Evening Post* wrote, "It is late in the day for public men in this country to imagine that they may or should enjoy immunity from criticism. . . . If they are so thin-skinned, their remedy is private life."[58]

The Pennsylvania libel law served little function other than to expose the governor to widespread ridicule. In his biennial address in 1905, Penny-packer called for further repressive measures against the press. But this time, with Quay now dead, Pennypacker's appeal was ignored. In 1907, shortly after the inauguration of a new governor, the law was repealed. In 1909, Pennypacker defended his attempts to purify the press: "The rude, vulgar and often malicious pictures put forth in the guise of wit and carica-ture are destroying the artistic sense, if not the kindly instincts, of a whole generation of young people, who are growing to maturity looking upon them as one of the ordinary instincts of life. The sensational journal has succeeded in almost destroying the old-time confidence of the people in, and the respect for, those vested with authority."[59]

According to Pennypacker and other critics of editorial cartoons, the savage drawings of public figures had created a climate responsible for the assassination of President McKinley. McKinley's death put the larger-than-life Theodore Roosevelt into the White House, and Roosevelt, ac-cording to cartoonist John T. McCutcheon, was "an inexhaustible Gol-conda of inspiration for the cartoonist." Roosevelt was a whirling dervish,

PENNYPACKER: I will stop this "most conspicuous of ills."

Figure 3.16 Charles Nelan, *Philadelphia North American*, 1903.

a chest-pounding, progressive reformer with a bushy mustache, a monocle, and a talent for self-dramatization. He used colorful phrases like "rough riders," "Speak softly and carry a big stick," "I feel like a bull moose," and "muckrakers," which he used to characterize the investigative reporters of the day.[60] When Roosevelt ran for election in 1904, Homer Davenport drew Uncle Sam standing behind Roosevelt, saying, "He's good enough for me." Republicans spent $200,000 to print and distribute the drawing.[61]

The Progressive Era has been identified as a period of rebellion against the unfettered power of corporations and corrupt political machines but also as a time of concern for the victims of the new order: the workers and immigrants confined to slums and exploited by corporations and politicians.[62] Muckraking journalists exposed corruption in American business, society, and politics. To support their accusations with satire, reporters and cartoonists created a unique journalistic moment that channeled public indignation into citizen activism.[63] This impulse for reform—which appealed to workers, farmers, intellectuals, progressives, ethnic minorities, and radicals—provided the impetus for the growth of the American Socialist Party.[64]

Starting with 10,000 members in 1901, the Socialist Party grew to 118,000, recruiting heavily from the millions of immigrants from Germany and eastern Europe. By 1912, more than 1,000 socialists held office in the United States, including a congressman, Victor Berger, of Wisconsin, and 79 mayors.[65] The party's strength could be gauged in the more than three hundred socialist periodicals published in the United States, including Berger's *Milwaukee Leader*, Eugene Debs's *Appeal to Reason*, and *The Masses*.[66] *The Masses* was a cultural product that originated in the spirit of muckraking, socialism, and revolt before World War I.[67] One author wrote that the magazine reminded its readers that irreverence was part of American culture and that distrust of the system was as American as the Founding Fathers.[68] Its artists included Robert Minor, Boardman Robinson, and Art Young, who worked for metropolitan newspapers and donated their work to *The Masses* because the magazine gave them something they did not get in the commercial press: control over their work.[69]

These artists created stark images that included indictments of capitalism, religion, sexism, racism, and militarism. In Young's poignant street scene of ghetto life, two children are looking up at the sky and one says: "Gee, Annie, look at the stars, thick as bedbugs!" In Robinson's cartoon "The Deserter," a firing squad takes aim at a pacifistic Jesus Christ. *The Masses*'s natural enemy was Anthony Comstock, head of the New York Society for the Suppression of Vice. In one *Masses* cartoon, Comstock was drawn as a sadistic pygmy, and in another he was shown dragging a bewildered woman into court because she had given birth to a "naked child" (figure 3.17).[70] During its short history, the magazine was targeted by the New York Society for the Suppression of Vice, suppressed by the New York City subway newsstands, and banned from college libraries and reading rooms. *The Masses* and other radical publications ultimately were censored by the U.S. government.

World War I began in Europe in 1914, but the United States generally remained untouched by the war until May 1915, when a German submarine sank the *Lusitania*, a British passenger ship, and 128 Americans were lost. The outrage over the incident was echoed in cartoons such as one by Rollin Kirby of the *New York World* that shows the ghosts of drowned children imploring a German soldier, "But why did you kill us?"[71] Although the *Lusitania* tragedy by itself was not enough to bring Americans into World War I, many people believed that the incident demonstrated the need for preparedness. "Ding" Darling, then of the *New York Tribune*, depicted America as a shepherd fast asleep, oblivious to the threats to its security.[72] Other cartoonists warned against jingoists who wanted to drag the country into the

Figure 3.17 Robert Minor, *The Masses*, September 1915.

war. In early 1916, Oscar Cesare drew President Woodrow Wilson answering his door to the dogs of war.[73]

During the summer of 1916, the United States still remained neutral, albeit not disinterested. America's reluctance to join Europe in war was apparent in the editorial cartoons of the nation's newspapers. In its July issue, *Cartoons*, a trade journal that each month reprinted dozens of drawings from the country's mainstream newspapers, published a drawing of Uncle Sam being lured toward a waterfall labeled "War" by mythological sirens named "German Lawlessness" and "British Lawlessness." He insists, "No, you won't get me."[74] In its July issue, *The Masses* published Robert Minor's searing antiwar drawing of an army medical examiner looking up at a hulking, headless recruit and gushing: "At last a perfect soldier!" (figure 3.18).[75] Minor and other *Masses* artists hardened the look of editorial cartooning by

ARMY MEDICAL EXAMINER: "At last a perfect soldier!"

Figure 3.18 Robert Minor, *The Masses*, July 1916.

using grease crayon on paper, which influenced the next generation of socially conscious cartoonists like D. R. Fitzpatrick of the *St. Louis Post-Dispatch*, Rollin Kirby of the *New York World*, Edmund Duffy of the *Baltimore Sun*, Oliver Harrington of the *Pittsburgh Courier*, and Jacob Burck of the *Chicago Sun-Times*.[76]

Cartoons published cartoons that associated preparedness with patriotism, such as one in which Columbia pleads, "The Storm Is Coming! Help!"[77] But it also included drawings that criticized the war as a trough for military pork.[78] In the magazine's June issue, cartoonist Robert Carter of the *New York Evening Post* wrote that the nation's five hundred cartoonists were presented with an unprecedented opportunity in their first big war. Thousands of cartoons had been published on the war, he said, but cartoonists had not reached their potential. "I think the war cartoon," he said, "is still to be made."[79] As it turned out, the American cartoonist of World War I toed a thin line between nationalism and propaganda.

President Wilson and the Democratic Party made "Americanism" a central issue during the 1916 presidential campaign, calling Charles Evans Hughes, the Republican presidential candidate, "pro-German" and questioning the patriotism of "hyphenated Americans." Of the 32 million first- or second-generation Americans, one-third had roots in central Europe, where the families and friends they had left behind were now engaged in the Great War with England and its allies.[80] After Germany unleashed its unrestrictive submarine warfare, sinking U.S. ships, a growing number of Americans, including cartoonists, felt that the United States had no choice but to fight back. This was the message in "Ding" Darling's cartoon "How We Forced Germany into the War" (figure 3.19).[81]

In November, Wilson was reelected with the slogan "He kept us out of the war." But once elected, Wilson and his administration solidified the country's support for war by suppressing dissent with impunity. Robinson, Minor, Young, and other radical artists worked for mainstream newspapers and magazines until public opinion changed from neutrality to preparedness to unequivocal support for the allies. At this time, both Robinson and Minor were fired from their newspapers for refusing to draw prowar cartoons.[82] Young worked for the *Metropolitan Magazine* until it, too, came out in support of the war, and he lost his job soon afterward.[83] By the end of 1916, among the cartoonists working for large dailies, only Luther Bradley of the *Chicago Daily News* opposed military involvement.[84] When Bradley died in early 1917, *Cartoons* wrote: "His cartoons were strikingly antimilitaristic. He observed a scrupulous neutrality, condemning only war and barbarism."[85] In his final cartoon, a man labeled "War,"

Figure 3.19 J. N. "Ding" Darling, 1916.
Reprinted with permission of the J. N. "Ding" Darling Foundation.

The Final Answer?

Figure 3.20 Luther D. Bradley, *Chicago Daily News*, 1918.

his boot on "Peace Proposals," is sharpening a sword labeled "Renewed Efforts" (figure 3.20).

Apart from the German American and socialist papers, with their relatively small circulation, the Hearst papers were the ones most often accused of disloyalty. Having bitterly opposed the United States's entry into the war, the Hearst papers, fearful of being censored by the government, eventually offered tepid support for the American war effort. Their equivocal attitude, however, caused them to be widely attacked as unpatriotic. One cartoon showed a snake coiled in the American flag, with the snake's body spelling "Hears-ss-ss-st."[86] In September 1917, under threat from the government, Hearst hired Louis Raemaekers of Holland, known for his graphic depictions of German brutality. *Cartoons* reported Raemaekers's contributions to the war effort while contrasting them with those of the Hearst newspapers.[87] As dissident cartoonists were silenced, the rest of the country's cartoonists fell into line, either afraid of the consequences or truly convinced that they were involved in a noble cause.

Cartoons reflected the changing mood of the nation's cartoonists. It published recruiting posters and stories about how artists were contributing to the war effort. Darling showed a mother waiting on the porch for a letter from her soldier son: "Buying Liberty Bonds seems a simple matter when we consider the burdens others are carrying." The magazine published drawings of Uncle Sam with a hoe in one hand and a rifle in the other, say-

ing, "Work or fight." Its April issue was dominated by prowar drawings, such as one showing American pacifists embracing the German kaiser.[88]

In early April 1917, Wilson asked Congress to commit the country to a foreign war that had butchered millions and shaken Europe's foundations. The government organized a tremendous campaign to convince previously neutral Americans that they must support the military effort.[89] The administration established the Committee on Public Information (CPI) to—in the words of its director, George Creel—"plead the justice of America's cause before the jury of Public Opinion."[90] The CPI's mobilization of public opinion required the cooperation, willing or not, of the nation's filmmakers, editors, writers, artists, and cartoonists. It oversaw dozens of different departments, including the Division of Films, the Bureau of War Photographs, the Division of Pictorial Publicity, and the Bureau of Cartoons. The Bureau of Cartoons sent a weekly bulletin to hundreds of cartoonists that suggested appropriate topics, such as selling Liberty Bonds, popularizing the draft, warning against German propaganda, and depicting the kaiser with a bomb.[91]

On June 15, 1917, Congress passed the Espionage Act, which provided for $10,000 fines and imprisonment of up to twenty years for anyone obstructing military operations.[92] Unfortunately, the definition of "obstructing military operations" was so broad as to restrict nearly any criticism of war. Attorney General Thomas Gregory turned his unrestrained fury on the radical left. More than 1,500 people were arrested for violating the Espionage Act, and 900 were jailed or deported. Nearly all the Socialist Party's leaders were jailed or deported, including Debs, Berger, Emma Goldman, and Bill Haywood, president of the Industrial Workers of the World (IWW). Joseph R. Conlin wrote that the Department of Justice raided the IWW headquarters in more than thirty cities, displaying "a cheerful disregard" for such obligatory legal procedures as search warrants.[93] Press historian John Stephens called World War I "a black mass celebrated by the nation's leaders."[94]

A provision of the Espionage Act empowered the postmaster general, Albert Burleson, to declare unmailable any periodicals that interfered with the war effort.[95] Burleson directed the Espionage Act primarily at the socialist press.[96] As the foreign, socialist, and pacifist presses were summarily put out of business and their editors sent off to jail, the mainstream press turned a blind eye, which compounded the pity, unaware that First Amendment rights cannot be selectively defended, that when one paper is suppressed, all others are threatened.[97] George Juergens wrote that in the

early decades of the twentieth century, the First Amendment did not mean what it does today.

The spirit of free speech, however, remained in the pages of *The Masses*. While cartoonists working for mainstream newspapers depicted Germany as the war's aggressor and villain, *Masses* artists made no such distinctions; to them, war was evil, and any country involved was an accessory to that evil. The *Masses* cartoonists considered their criticism of the government to be their constitutional right but also their duty as Americans. In broadsides against capitalism, militarism, and complacency, Young, Robinson, and Minor used their grease pencils to provide such brutal images as Robinson's "Europe, 1916" (figure 3.21). In Young's "Congress and Big Business," a man representing Congress enters a room and asks: "Excuse me, gentlemen, where do I come in?" Big Business then replies: "Run along now—We got through with you when you declared war for us" (figure 3.22).

Figure 3.21 Boardman Robinson, *The Masses*, October 1916.

Congress: "Excuse me, gentlemen, where do I come in?"
Big Business: "Run along now — We got through with you when you declared war for us."

Figure 3.22 Art Young, *The Masses*, August 1917.

The Masses ultimately paid a price for its insubordination. The Post Office declared the July 1917 issue of the magazine unmailable. It included the drawings "Congress and Big Business"; "Conscription," which shows naked men and women being used as cannon fodder (figure 3.23); and "Making the World Safe for Capitalism" (figure 3.24). Although *The Masses* challenged the constitutionality of the Espionage Act in court, it lost, thereby sealing its fate. Several of the magazine's editors, writers, and cartoonists were then indicted individually for violating the Espionage Act but were ultimately freed after two hung juries. The government then dropped its case. Young and the other *Masses* staffers were spared largely because, unlike the others prosecuted under the Espionage Act, they looked American, spoke English, and had capable counsel.[98]

In 1918, *Masses* artist Maurice Becker, who had been born in Russia, was sentenced to twenty-five years of hard labor at the military prison at Fort Leavenworth, Kansas, for being a conscientious objector. During his trial, the cartoonist said he did not believe it was right to kill a human being under any circumstances: "Much of my artistic work and many of my

Figure 3.23 Henry Glintenkamp, *The Masses*, August 1917.

Figure 3.24 Boardman Robinson, *The Masses*, August 1917.

sketches and cartoons done since the war began . . . bear me out in this statement."[99] Two German American cartoonists, Hans von Stengel and Karl Frederick Widemann, who criticized the United States's participation in the war, were arrested and charged as spies. Von Stengel's drawing "Seven Million Slackers" ridiculed the United States' military plans. *Cartoons* quoted the *Brooklyn Eagle*, which condemned the drawing as treasonous: "Printed as it was four months after we had entered the war, [it] is either alien propaganda work or treason."[100]

During World War I, cartoonists became cheerleaders for Uncle Sam and crusaders for U.S. Army recruiters and the Red Cross. They attacked Germany and its European allies. They also beat the war drums in time with the Wilson administration, questioning anyone who did not support the American war effort. In one of his drawings, W. A. Rogers of the *New York Herald* portrayed dissenters as treasonous weeds that had to be uprooted.[101] George Hecht, who headed the Bureau of Cartoons, edited a book called *The War in 100 Cartoons*, depicting images of American virtue and German barbarism. "There has probably been no group of persons which has proven itself more eager to serve under the Great War than have the cartoonists of America," Hecht wrote.[102] World War I had turned the "golden age of cartooning" into the "dark age of cartooning" as cartoonists replaced social activism with nationalism and jingoism.

4

"McCarthyism"

More than a hundred years ago, as editorial cartoonists made their presence on the front pages and editorial pages of daily newspapers, the art of graphic satire was considered masculine because of the power and esteem associated with demanding social reforms, exposing corporate corruption, and ridiculing political leaders.[1] In the first two decades of the twentieth century, however, women made their introduction into editorial cartooning. Drawn by the suffrage movement, these women made a difference in society with their cartoons in newspapers and magazines demanding a constitutional amendment to give women the right to vote.[2]

In the introduction to Alice Sheppard's book *Cartooning for Suffrage*, Elizabeth Israels Perry wrote that women artists like Lou Rogers, Blanche Ames, and Edwina Dumm shaped "a visual rhetoric that helped create a climate more favorable to change in America's gender relations."[3] These women saw editorial cartooning as a way to create social change and improve the place of women in America.[4] Sheppard believes that suffrage cartoons were significant because they were drawn by women and promoted women's issues. "By the close of the suffrage campaign," she wrote, "women's art reflected the new values of feminism, broadened its targets, and attempted to restate the significance of the movement."[5]

In Ames's drawing "Meanwhile They Drown," a well-dressed man and woman are standing on a pier while women labeled "Sweat Shops," "White Slavery," "Disease," and "Filth" struggle to stay afloat in the stormy waters below. The man, holding a life preserver labeled "Votes for Women," tells his companion: "When all women want it, I will throw it to them." His woman companion, sitting on a box labeled "Anti-suffrage," responds, "We don't need it."[6] Rogers drew Lady Liberty extricating herself from a rope called "Politics Is No Place for Women" (figure 4.1). In another cartoon, she pointed out that the arguments against suffrage belonged to the past, by

Figure 4.1 Lou Rogers, *Judge*, 1912.

showing a series of extinct volcanoes marked "Suffrage Is Not a Natural Right," "Women Don't Know Business," "Women Would Lose Their Influence," and "Bad Women Would Out-Vote Good Women."[7]

The issue of women's suffrage also appealed to such progressive-minded male cartoonists as Art Young, Boardman Robinson, D. R. Fitzpatrick, and Rollin Kirby. Kirby drew a woman standing on top of a ballot box surveying the promised land.[8] "Ding" Darling's most political cartoon before World War I, according to Richard Samuel West, was called "Why Mr. Wilson Doesn't Open the Door to Women's Suffrage." It showed President Wilson cowering behind a curtain while a suffragette, with two black people standing behind her, knocks on the door. If Wilson opens the door for women, the cartoon implies, he also must open it for blacks.[9] For the most part, however, the issue of women's suffrage seemed only to amuse or even offend most editorial cartoonists, who either joked about women's rights or ridiculed their pretensions.[10]

Women cartoonists contributed their work to newspapers and magazines like *Life*, *Judge*, *Woman's Journal*, and *Suffragist*. Edwina Dumm worked as an illustrator for the *Columbus (Ohio) Monitor*, which also published her editorial cartoons. But the *Monitor* ceased publishing in 1917, and soon after, Dumm, unable to hook up with another newspaper in

Columbus, moved to New York City, where she worked as a comic-strip artist for the next several decades.[11] She later said that she had felt no discrimination as an editorial cartoonist, although she added that during her relatively short time in Columbus, she was never invited to meet with the city's other newspaper cartoonists, all of whom were known to have enjoyed socializing together.[12]

With the passage of the Nineteenth Amendment, women secured the right to vote, and most suffrage organizations, having achieved their objective, faded into the background, some believing that victory had been won and others fearful of the image that social causes "unsexed" a woman.[13] As it turned out, the influence of women cartoonists was short-lived, as they fell victim to their own success and the seemingly impenetrable barrier of sexism that kept women in their place. Gender stereotypes were kept alive in part by men, who served in virtually all positions of authority at newspapers, and by male cartoonists who captured the "ideal" woman as non-threatening and genteel: a compliant and subservient wife, child bearer, and homemaker.[14]

Early women's rights activists were deemed "unsexed" and "unwomanly" for daring to make political or social commentary.[15] In a cartoon drawn by Katherine Milhous, she maintains that "it doesn't 'unsex' her [a woman]" to scrub floors, care for the ailing, work in factories, or wait tables but that voting "is another story."[16] Signe Wilkenson, the only woman now working full time as an editorial cartoonist for a daily newspaper, said: "After the [suffrage] campaign succeeded, these cartoons vanished from the printed page, leaving rare, brittle clippings and the 19th Amendment as the only traces of their public lives."[17]

Never before or since have so many women worked as editorial cartoonists as they did during the 1910s. It was decades before another woman worked as a full-time cartoonist for a newspaper, in part because of sexism but also because of social mores that demanded more feminine pursuits for women. Female cartoonists were almost unheard of—or at least not recognized—as serious cartoonists again until the 1970s. In 1975 Lillian Weckner Meisner, then working for the *Trumball (Conn.) Times*, became the first woman to join the Association of American Editorial Cartoonists.[18] The same year, Etta Hulme of the *Fort Worth Star-Telegram* also joined the AAEC and became its first female president in 1986. Hulme also was the first woman to become syndicated in 1978.[19]

Even now, there still are few women editorial cartoonists. Lucy Shelton Caswell, curator of the Cartoon Research Library at Ohio State University, said that the reason women have not achieved a comparable degree of

success in editorial cartooning goes beyond the newsroom, to society. She referred to feminist Linda Nochlin's essay "Why There Are No Great Women Artists," in which Nochlin suggests that the causes are societal: "The fault lies not in our stars, our hormones, our menstrual cycles, or our internal spaces, but in our institutions and education—education understood to include everything that happens to us from the moment we enter this world of meaningful symbols, signs and signals."[20]

By 1920, the Progressive Era had ended; social criticism had been silenced; and only remnants of the radical left remained, its leaders in jail, in exile in a foreign country, or otherwise marginalized. Social liberalism had been replaced by conservatism and social activism by laissez-faire abstention. Cartoonists had toned down their satire as a result of the purge on free speech during World War I, the Red scare that followed the war, and a general disinclination among Americans toward anything serious. Indeed, cartoonists had departed so much from the tradition of Thomas Nast and Homer Davenport that they had become little more than illustrators of their newspapers' editorials or chroniclers of the trivial.[21]

The newspaper profession went into decline and, with it, editorial cartooning. As newspapers became less partisan and more objective, editorial cartoons were moved off the front pages and reduced in size and prestige. Newspaper mergers led to fewer newspapers, and the development of syndication meant that newspapers could run a number of cartoons without having to hire even one cartoonist, and therefore there now were fewer cartoonists working for fewer newspapers.[22] But for the fortunate few—like Jay Norwood ("Ding") Darling, whose work appeared on the front page of the *Des Moines Register* for half a century—syndication translated into wealth, fame, and influence.[23] Darling's work became popular because it was so well crafted and detailed. In small part this was because he had another artist provide the finishing touches but also because readers could digest his cartoons during breakfast or dinner without upsetting their sensibilities.

Unlike the Progressive Era reformers who brandished a sword to slay the corrupt trusts, Darling took a more conservative approach. Instead of angering presidents and other politicians, he became friends with them, idolizing Theodore Roosevelt and then Woodrow Wilson. Unlike *The Masses* cartoonists, for instance, Darling supported preparedness and then became a voice of nationalism as America entered World War I. When the war ended, Darling's work became more progressive, supporting Wilson's call to reject isolationism, and he criticized dissident Republicans as petty, absurd, and naive for opposing Wilson's League of Nations. In one Darling drawing, Wilson presents Senator Henry Cabot Lodge, a Republican, with a painting

of the goddess of peace. Lodge accepts it, saying that it "needs touching up in a few places," and then proceeds to ruin the painting (figure 4.2).[24]

The League of Nations issue politicized Darling, who found in Wilson an ideal for peace. Thus, in the either–or world of satire, those who opposed the league in turn opposed peace. When Wilson left the White House in 1921, he was replaced by Warren Harding and then Calvin Coolidge, who ultimately kept the United States out of the international peace body. When Wilson died, Darling drew a shepherd's mountaintop cabin in the middle of a blizzard. A black wreath hangs on the cabin door, and a staff, identified as "International Leadership," lies in the snow. Elsewhere in the drawing are sheep, doomed to die in the snowstorm. The caption says: "And no shepherd has since come forth to take his place."

Darling became one of the best cartoonists between the world wars, mixing, according to Richard Samuel West, "political opinion, graphic whimsy, and sagacious perspective." But he never again became either as socially critical or as politicized as he had after World War I. "Politically, Ding had little to say," West said. "His statements during this early period were vaguely progressive in character: John Q. Public unable to ring a call through to Congress because the Big Interests being taxed down to the buff by an irresponsible government. . . . This was knee-jerk politics—the type of superficial opinion children picked up at the local country store and repeated to their friends."[25]

Darling's work, which emphasized gentleness over social criticism, represented the profession for the next few decades. His influence was not measured solely in the millions of readers who enjoyed his soft touch; in addition, his drawing style inspired countless other cartoonists, notably Herbert Block, or Herblock, who grew up in the Midwest. Darling had an influence on both cartooning and wildlife. A lifelong naturalist, his drawings led to legislation protecting habitat for birds and animals.[26] In fact, his interest in preserving natural habitat outlasted his influence as a cartoonist, as evidenced by the J. N. "Ding" Darling National Wildlife Refuge on Sanibel Island, Florida.

After World War I, editorial cartoonists replaced harsh social commentary with cheerful pictures that did little more than produce wry one-liners and banal chuckles. Whereas the cartoonists of the Progressive Era had worked in reform-minded urban areas like New York City, the cartoonists during the years between World War I and World War II—like Darling, John McCutcheon, Carey Orr, and Vaughn Shoemaker—typically lived in the Midwest and reflected the Republican, pro-business policies and attitudes of their publishers and editors. Gustavus Widney, writing during

Figure 4.2 J. N. "Ding" Darling, 1919.
© Reprinted with permission of the J. N. "Ding" Darling Foundation.

John McCutcheon's formative years with the *Chicago Tribune*, said that the cartoonist was "not a reactionary, but content with the world as he finds it, and he has found it a pretty good sort of place."[27] McCutcheon himself once said, "Preaching and scolding day after day made one a bore and not apt to be paid attention to." Carey Orr, his colleague at the newspaper, added, "There is nothing finer than a good cartoon that makes people smile."[28] In addition to McCutcheon and Orr, Joseph Parrish was on the *Tribune*'s staff. The newspaper was appropriately referred to as "a kind of Yellowstone Park for the disappearing herd of cartoonists."[29]

As the country slumped into the Depression in the 1930s, one might have expected that cartooning would have become more biting, but the mood of the country was filled with more fear and uncertainty than anger and social protest. For the most part, cartoonists captured the Depression with sweet or at least bittersweet poignancy. McCutcheon won the 1932 Pulitzer Prize for his drawing of a man, identified as a "victim of bank failure," sitting on a park bench. A nearby squirrel asks, "But why didn't you save some money for the future, when times were good?" and the man replies, "I did" (figure 4.3).

Cartoonists working for mainstream newspapers reflected the views of their conservative editors and publishers, who opposed President Franklin D. Roosevelt and considered his New Deal policies socialistic. In one cartoon by Carey Orr, the New Deal is pictured as a Trojan horse threatening the Constitution. And in one of his drawings, "Ding" Darling satirized FDR's administration for trying to balance the wealth of American people more fairly (figure 4.4). As the labor movement came into its own and the political left came back to life, liberals argued that the president and his reforms did not go far enough. But the middle-of-the-roaders held firm for the four times–elected FDR. Roosevelt—with his cigarette lighter, glasses, heavy chin, and perpetual smile—lent himself more easily to gentle caricature than satire.

At the turn of the century, Frederick Opper of the *New York Journal* introduced a befuddled little man called "The Common People," who also became known as "John Public" or, eventually, as Vaughn Shoemaker of the *Chicago Daily News* christened him, "John Q. Public."[30] The symbol reflected the common person. He was confused and whimsical, dealing with life with a droll smile and a cigar and not with indignation or anger. In his later years, Art Young, who had once risked going to jail over his right to express himself, said that cartoonists had since abandoned their right to comment merely to satisfy their publishers. "Most of them today are too much like lawyers working for a rich clientele to interest me very much," Young said.[31]

"A Wise Economist Asks a Question."

Figure 4.3 John McCutcheon, *Chicago Tribune*, 1931.

Unlike most of those working in the profession, cartoonists such as D. R. Fitzpatrick of the *St. Louis Post-Dispatch*, Edmund Duffy of the *Baltimore Sun*, and Rollin Kirby of the *New York World* worked not in pen and ink but in grease pencil or crayon and believed that their duty was to puncture the status quo and not merely tickle it. These and a few other men broke with their more whimsical colleagues and drew with a sense of purpose. The more radical ones, like William Gropper, questioned the wisdom of a political and economic system that had so spectacularly collapsed, closing businesses and farms and turning so many lives inside out. Mainstream liberals expressed their frustration with a society in which so

EVENING UP THE BRAINS

Figure 4.4 J. N. "Ding" Darling, undated.
© Reprinted with permission of the J. N. "Ding" Darling Foundation.

few had so much and millions of others were homeless, many forced to ride the rails and beg for food. In one of Fitzpatrick's most famous drawings, an indigent man stands in a soup line with the caption "One Person Out of Every Ten" (figure 4.5).

Unlike most of his midwestern colleagues, Fitzpatrick supported the New Deal reforms. Working for the progressive, Pulitzer-owned *Post-Dispatch*, Fitzpatrick struck at the Depression with another cartoon that was meant to represent the meager assistance that people in his state were receiving. He drew a starving family inside their starkly bare home as a skeleton stood in the doorway with "45 cents a day" written across his face. Fitzpatrick's inspiration was Boardman Robinson, as well as Robert Minor, whose job he inherited when Minor left for New York, where he did his most memorable work for *The Masses*. Minor was an unapologetic leftist who gave up editorial cartooning to become an activist in the Communist Party.[32] When Fitzpatrick retired after forty-five years with the *Post-Dispatch*, the cartoonist conceded that he had "made a lot of people goddam mad."[33]

The same could be said for Edmund Duffy, who impressed his editor, the venerable H. L. Mencken, so much that Mencken said, "Give me a good cartoonist and I can throw out half the editorial staff." Like Mencken, with whom he worked for years, Duffy believed that strong commentary should begin at home. Duffy was fearless in condemning the growing Ku Klux Klan movement in Baltimore. In one cartoon, he showed a Klansman removing his hood to reveal himself as nothing more than a dim weakling. After a mob lynched a black man, Duffy drew a black man dangling from a rope. The drawing includes only the title of the state song, "Maryland, My Maryland!" (figure 4.6). Incensed readers attacked the *Sun* delivery trucks and beat up the drivers.[34]

Rollin Kirby's unforgettable character, Mr. Dry, was credited, in part, with ending Prohibition by depicting it, according to Charles Press, as "a seedy-looking, ignorant hick rather than a high-minded idealist," as Prohibition sponsors proudly touted themselves. In one drawing, the creepy Mr. Dry is leading a chorus of "My Country 'Tis of Thee" (figure 4.7). Kirby was not particularly impressed with the state of the art, which, he said, had grown stale because cartoonists were relying on the same trite symbols— such as the Democratic donkey and the Republican elephant—that had been around since the days of Thomas Nast.[35] In addition, cartoonists were saying little of consequence. The editorial cartoon, Kirby said, had become a "qualified picture which is guaranteed to offend no one and therefore has lost most of its pungency."[36]

ONE PERSON OUT OF EVERY TEN
JANUARY 16, 1938

Figure 4.5 D. R. Fitzpatrick, *St. Louis Post-Dispatch*, 1938.

Figure 4.6 Edmund Duffy, *Baltimore Sun*, 1931.

"NOW THEN, ALL TOGETHER, 'MY COUNTRY 'TIS OF THEE'"

Figure 4.7 Rollin Kirby, *New York World*, 1920.

Although the so-called sunnier-side-of-life school of cartooning may have appealed to editors and readers, it had its limitations, primarily because it failed to reveal ugly truths, to shake readers out of their complacency, and to warn them of the danger lurking behind a politician's sanctimonious smile. Behind their self-satisfactory chuckles, these cartoonists denied the fact that history repeats itself unless we stop it and that the invisible hand does not fix what ails society. Therefore, it is up to editorial cartoonists to awaken society and demand its involvement in protecting democracy, regardless of how unpleasant the intrusion might be.

With the memory of World War I only a generation away, cartoonists, reflecting American opinion, urged the government to avoid being drawn into another European conflict. C. D. Batchelor of the New York *Daily News* drew a striking image of war as a prostitute, telling a soldier representing young Europeans: "Come on in. I'll treat you right. I used to know your daddy." Reflecting the isolationism of the newspapers they worked for, editorial cartoonists underestimated the threat of Germany and Japan. Even Adolf Hitler was usually not drawn as a savage figure but as a little man with a funny mustache.[37]

As America moved closer to war, cartoonists, as they had during the Great War, became predictably nationalistic and so offered little memorable criticism of their own government or military. Also predictably, Hitler was transformed from a foolish-looking ninny into the brutal murderer he was. In 1939, D. R. Fitzpatrick transformed the Nazi swastika into a bloody death machine. Vaughn Shoemaker showed Hitler ordering a figure of a skeleton driving a cab, "Take me to Czechoslovakia, driver," which Field Marshal Hermann Göring called a "horrible" example of "anti-Nazi propaganda" (figure 4.8).[38]

After the Japanese bombed Pearl Harbor, the United States had no real choice but to enter the war. Unlike World War I, when the U.S. government had to force ambivalent Americans to support the war, Pearl Harbor unified the country without any need for another espionage act. But as they had during World War I, cartoonists became government propagandists, ignoring the government's suspension of civil liberties, most notably the imprisonment of thousands of Japanese Americans in internment camps. Cartoonists made no attempt to distinguish between the ruthless Japanese government and the rest of the Japanese people, including those who were American citizens and were being detained in violation of their constitutional rights. Japanese people were often reduced to savage, buck-toothed primates.

When President Roosevelt proclaimed the four freedoms of all American citizens—freedom of speech, of worship, from want, and from fear—a

Figure 4.8 Vaughn Shoemaker, *Chicago Daily News*, 1938.

few liberals like Jacob Burck and D. R. Fitzpatrick broke out of the other editorial cartoonists' conformity to question whether the government could protect these freedoms by sacrificing them. When Fitzpatrick learned that federal investigative agencies were illegally bugging American homes, he drew a man on a roof, labeled "Wire-tapping," listening in on a conversation.[39]

As is often the case, however, some of the best social criticism was found outside the mainstream. William Gropper drew Big Business pushing Uncle Sam into World War II. Black cartoonists like Oliver Harrington, E. Simms Campbell, and Francis Yancey, barred from working for mainstream newspapers, made strong statements condemning racism in black weeklies like the *Pittsburgh Courier*, *Chicago Defender*, and *Amsterdam News* and in the Afro-American chain. In one of his drawings, Yancey drew a tiny figure looking up at a sphinx of FDR. "What are you going to do about the anti-lynching bill?" the figure yells at the sphinx. In response, the caption says: "He never said a mumbling word."

Langston Hughes called Oliver Harrington a first-rate social satirist and America's most popular black cartoonist. His character Bootsie expressed the frustrations of many blacks. In one of Harrington's most famous drawings, a brother and a sister are looking out a window of a house

in the slums. The boy says: "Ooh, look, Sis, a robin red breast, and it must be spring. Do you reckon Uncle Bootsie was lying when he said spring comes three weeks earlier over 'cross town where the white folks live'?" During World War II, Harrington drew cartoons illustrating how combat conditions alleviated racial tensions and hoped that America would move toward its promise of equality after the war. When that did not happen, his comic strip criticized the treatment of black soldiers, segregation, and lynching. His growing popularity also earned him a file in J. Edgar Hoover's Federal Bureau of Investigation.[40]

The most evocative battlefield work during World War II was Sergeant Bill Mauldin's *Willie and Joe* strip, which featured two unshaven soldiers making wry comments, giving readers a refreshing sense of life in a foxhole. "I drew pictures for and about the dogfaces because I knew what their life was like and I understood their gripes," Mauldin said. "I wanted to make something out of the humorous situations which come up even when you don't think life could be any more miserable" (figure 4.9). But Mauldin had his critics. General George S. Patton ordered Mauldin to his headquarters and berated him for undermining the soldiers' morale. Pat-

"JOE, YESTIDDY YA SAVED MY LIFE AN' I SWORE I'D PAY YA BACK. HERE'S MY LAST PAIR OF DRY SOCKS."

Figure 4.9 Bill Mauldin, 1944.
Reproduced with permission of the estate of William H. Mauldin.

ton's opinion notwithstanding, Mauldin became the youngest cartoonist to win a Pulitzer Prize.[41]

Mauldin returned home after the war as the country's best-known cartoonist. But instead of imitating his colleagues and turning out drawings with neither bite nor bile, he criticized segregation and the House Un-American Activities Committee. In one drawing, he used juxtaposition to combine his hatred of the Ku Klux Klan with his suspicion of the committee. In it, a corpulent law-enforcement official tells another man, "Investigate them? Heck, that's my posse," and motions toward a Klansman and another man, who is carrying a copy of *Mein Kampf* and is labeled "Professional Bigot."[42] In another, Mauldin reduces segregation to an illiterate redneck. In it, he criticizes two segregationists who want to discourage blacks who want equal rights. One of the rednecks tells the other: "Let that one go. He says he don't wanna be mah equal" (figure 4.10).

Mauldin's work made editors so uncomfortable that they stopped buying it. Mauldin later said that his syndicate told him that it was bad for business to include social satire in his cartoons. In 1949, frustrated by this, Mauldin left the profession for a decade, turning to acting, writing, and

"Let that one go. He says he don't wanna be mah equal."

Figure 4.10 Bill Mauldin, 1947.
Reproduced with permission of the estate of William H. Mauldin.

even running unsuccessfully for Congress.[43] When Fitzpatrick retired from the *St. Louis Post-Dispatch*, he was replaced by Mauldin, who left a few years later for more freedom at the more liberal *Chicago Sun-Times*, where he shared an office with Jacob Burck. While working in Chicago, Maudlin also worked with John Fischetti, another Pulitzer Prize winner.

Mauldin's influence on cartooning transcended his art, as he served as a mentor and inspiration for a number of other cartoonists, like Mike Peters, M. G. Lord, and Garry Trudeau. Of his work after *Willie and Joe*, nothing matched the poignancy of his drawing of a weeping Abraham Lincoln after the assassination of President John F. Kennedy, which inspired a million imitations after tragedies such as the explosion of the space shuttle *Challenger* and the terrorist attacks on September 11, 2001 (figure 4.11).

When the Soviet Union began to expand its empire after World War II, many Americans began to fear the rise of Communism on the home front. Opportunistic right-wing politicians like Republican senators Joseph McCarthy of Wisconsin and Richard Nixon of California seized on the national anxiety to attack their political opponents by questioning their patriotism, thereby returning the country to the cynical, dark days of World War I. As

Figure 4.11 Bill Mauldin, 1963.
Reproduced with permission of the estate of William H. Mauldin.

they did then, cartoonists supported the government during the Red scare, either directly with their drawings or indirectly with their silence, when it sent critics to jail for doing nothing more illegal or extreme than exercising their constitutional rights of free speech and free association.

If you had ever questioned the government—or even knew someone who had—you could become guilty by suspicion, have your name put on a "blacklist," and have your life turned inside out by the FBI, the Justice Department, or local police authorities. Jacob Burck was arrested because of his association with Communists, although because, in part, he was working for a mainstream newspaper, he was ultimately cleared. When Oliver Harrington learned that he was being investigated by the House Un-American Activities Committee, he left for Europe. While in exile, he drew cartoons about racial discrimination in the United States, which were published in influential black newspapers such as the *Chicago Defender* and *Pittsburgh Courier* (figures 4.12 and 4.13).[44] He never returned to live in America, dying in what was formerly East Berlin, Germany, in 1995.

Few people dared question either the injustice or the irony of the right wing's effort to silence civil liberties in the name of Americanism. But in 1949, the *Washington Post*'s Herbert Block—or Herblock, as he signed his cartoons—drew a man labeled "Hysteria" climbing a ladder to douse the Statue of Liberty's flame (figure 4.14). As was often the case during his seven decades as a cartoonist, Herblock—whether taking on demagogues like McCarthy and Nixon or the military's infatuation with the atomic bomb with the drawing "Mr. Atom"—was ahead of his fellow cartoonists in embracing the traditional ethic of the profession.

Herblock's greatest contribution to editorial cartooning was his attacks on the right wing's anti-Communist hysteria, for which he coined the term *McCarthyism* (figure 4.15). By reducing the vast right-wing conspiracy to a single word, Herblock turned McCarthy into a metaphor for the abuses of the Red scare, which helped turn public opinion against McCarthy. "I was thinking, 'I'm going to find a word for this,'" Herblock later remembered. "It's not McCarthy himself and I can't use something with a lot of words in it. I used McCarthyism. I didn't know if it was going to be picked up or used again."[45]

One of McCarthy's confederates was Richard Nixon, who arrived in Washington from California in 1947 as a Communist-hunting congressman, and then was elected senator by falsely smearing the Democratic candidate, Congresswoman Helen Gahagen Douglas, as a Communist. The Republicans' presidential candidate, General Dwight D. Eisenhower, bowed to the party's right wing and selected Nixon as his running mate in the 1952

"Officer, what Alabama bar was you holed up in back in '44
when I was in Normandy protectin' your civil rights?"

Figure 4.12 Oliver Harrington, undated.
Reprinted with permission of Walter O. Evans Collection of African-American Art.

"Here Brother Bootsie, take this extra hammer I got here in case
the gentlemens of the law decides that this demonstration
is *too* peaceful!"

Figure 4.13 Oliver Harrington, undated.
Reprinted with permission of Walter O. Evans Collection of African-American Art.

Figure 4.14 Herbert Block, *Washington Post*, 1949.
Reprinted with permission of The Herb Block Foundation.

presidential election. During the 1954 midterm elections, Herblock tried to capture the essence of Nixon and his gutter politics. In his drawing, Herblock sketched a stubbly-faced Nixon climbing out of a sewer while campaigning for other Republicans (figure 4.16).

Herblock kept the stubble on Nixon's face until he was elected president in 1968. Then, in a cartoon, Herblock offered Nixon a free shave. "He was a new president and I thought I'd give him a chance," Herblock explained, "but it turned out to be the same old Nixon." Herblock and the liberal *Washington Post* found a common and long-standing enemy in the sensitive Nixon, who once announced that he had canceled his subscription to the *Post* because his daughter had come home from school crying after being teased about a cartoon in the morning paper. When asked about the story, Herblock laughed and said: "I guess they didn't put that one up on their refrigerator."[46]

Walt Kelly, the creator of *Pogo*, joined Herblock in denouncing McCarthy and other Communist hunters who wrapped themselves in the American flag and then persecuted their critics with character assassination. Kelly introduced a character to his Okefenokee Swamp called Simple J. Malarky, who looked and acted so much like Senator McCarthy that many

Figure 4.15 Herbert Block, *Washington Post*, 1950.
Reprinted with permission of The Herb Block Foundation.

"HERE HE COMES NOW"

Figure 4.16 Herbert Block, *Washington Post, 1954.*
Reprinted with permission of The Herb Block Foundation.

newspapers took offense and dropped the strip (figure 4.17).[47] Kelly's running caricature of J. Edgar Hoover angered the paranoid FBI director so much that he ordered cryptanalysts to search the cartoons for hidden Communist messages in code.[48]

During the Cold War of the early 1960s, Kelly drew the Soviet premier, Nikita Khrushchev, as a medal-wearing hog and the Cuban premier, Fidel Castro, as a cigar-smoking goat. Editors again rejected the strips because they thought they would jeopardize the peace process.[49] According to Jules Feiffer, who contributed brilliant commentaries on America's social scene for forty years, Kelly helped resuscitate editorial cartooning. "Walt Kelly put rage back into the political cartoon—something that had been missing since the early days of the trust-buster cartoons in the early 20th century," Feiffer said, adding: "He put a kind of moral indignation to the form, pure with a degree of zealotry."[50]

Herblock and Kelly notwithstanding, editorial cartoonists, their symbols grown stale, did little to either advance social debate or unnerve politicians during the 1950s. Cartoons mostly illustrated headlines, and their political perspective was wrapped in Red scare tentativeness.[51] In an article on syndicated cartoonist John Milt Morris, *Time* wrote: "He draws his syndicated

Figure 4.17 Walt Kelly, © 1953.
Reprinted with permission of Okefenokee, Glee, and Perloo, Corp.

editorial-page cartoons as he parts his hair: right down the middle. . . . [They] either delicately straddle current controversies or join all mankind in approving mother love and condemning sin." Editorial cartooning became banal and predictable. It was as if, as one writer put it, "editorial cartoonists had just run out of ideas."[52]

Henry Ladd Smith wrote in the *Saturday Review* in 1954 that editorial cartoonists had lost much of their influence in American journalism, that not long ago every self-respecting newspaper had an editorial cartoonist whose work was often put on the front page. But that day had passed, partly because editors had become less partisan and because the cartoons themselves relied too much on trite imagery. "This is very sad, for the cartoon has an honorable place in the history of American journalism," Smith said, noting that the slow death of editorial cartooning was not necessarily something to be mourned, because so few cartoonists were producing quality work. "If our press is concerned with producing light, instead of heat, then the political cartoon doesn't deserve better—excepting, of course, that handful of virtuosos who can supply our desperate need for helpful interpretation."[53]

Smith's article inspired the creation of the Association of American Editorial Cartoonists in 1957, as well as a series of reflective pieces on the profession. Cartoonists insisted that their work had suffered because of syndication, which preferred drawings that would appeal to the greatest number of readers. Herblock said there were too few "fighting cartoonists" in the 1950s because of editors' unwillingness to run provocative work.[54] Everette E. Dennis supposed that the decline in cartooning was a result of the natural process of aging, because more than half the cartoonists continued working into their seventies and eighties, and the longer they stayed at their drawing boards, the duller their pencils became.[55]

By the early 1960s, some of those cartoonists had been at their drawing boards since the early twentieth century was in short pants. They had seen

a world of changes, but their job had hardly changed. According to Edmund Valtman of the *Hartford (Conn.) Times,* "the editorial cartoon was once more dominant as an influence on political thought than now. This was during a period when newspapers held a virtual monopoly on the public's attention and quest for news and opinions." Fitzpatrick said that earlier cartoonists had been more likely to express their own opinions and not the opinions of their newspaper. He added that a lot of talented cartoonists had left newspapers for other jobs where they had more freedom. When asked whether editorial cartooning had a future, Fitzpatrick suggested that it might exist not in newspapers but on television.[56]

Scott Long of the *Minneapolis Tribune* said that "if a good cartoon seems less effective today than it was yesterday, this is only because there is a lot more competition for the reader's attention than ever before."[57] In a separate essay, Long said that editorial cartoons were essential to a democracy. "Outspoken, courageous and independent editorial pages are essential to the survival of democracy," he wrote in 1961. "Editorial cartoonists are in the vanguard of that fight to make them so. If the fight is lost, then all of us—editorial cartoonists, editorial writers, editors, publishers, newspapers—will go down the drain anyway."[58]

Then over the next several years, the profession began to transform itself, energized by the work of Herblock, Bill Mauldin, Paul Conrad, and Pat Oliphant, all of whom were incensed at social wrongs and had a keen sense of satire and the support of their newspapers. One of those who reminded cartoonists that it was not only their right but also their obligation as Americans to question the government was Oliphant, an Australian. Oliphant, who had been frustrated by repressive press laws and conservative editors in his native country, began including a small penguin in the bottom of his drawings, which, he said, would often offer a sharper perspective that the publisher would not allow in the cartoon itself.[59]

When Oliphant arrived in the United States in 1964 to work for the *Denver Post,* President Lyndon Johnson was escalating the war in Vietnam while campaigning against ultraconservative Republican presidential candidate Barry Goldwater. According to Oliphant, it was like "having died and gone to heaven."[60] American editorial cartooning was, he believed, "a laughing stock among other countries of the world," with its use of stagnant symbols and muted sense of commentary. The American people were ready for a different kind of cartoon,[61] and Oliphant's cartoons included, according to Mike Peters, "a certain satire . . . that we did not have in this country."[62]

Before submitting his work for the 1967 Pulitzer Prize, Oliphant looked at a book of past winners' cartoons and noted that they tended to

be "jingoistic sorts of cartoons." He found a cartoon he had drawn the previous year portraying North Vietnamese leader Ho Chi Minh carrying the corpse of a Viet Cong soldier. "They won't get *us* to the conference table . . . will they?" the caption reads (figure 4.18). Oliphant won the Pulitzer Prize that year. "It's a fraudulent award," he said. "You only need one Pulitzer to be able to criticize a Pulitzer."[63] Since then, because Oliphant has never submitted his work again, he has not won another Pulitzer, and, given his constant criticizing of other editorial cartoonists, he also has never won any awards for congeniality.

Although Oliphant's criticism of the Pulitzer continues to have merit, enough cartoonists have won for the right reason that Oliphant's tirade has been reduced to a shrill mantra. Two years after Oliphant won his Pulitzer, John Fischetti won the prize for his work on civil rights, including a drawing of a shirtless black man, his wrists bound in chains. The manacle on his right wrist says "White," and the one on his left wrist says "Racism." Underneath, the tag line reads: "Why don't they lift themselves up by their own bootstraps like we did?" Such drawings, like those depicting racism drawn by Edmund Duffy decades earlier, represent editorial cartooning at its best. This happens when the cartoonist takes a moral, but often unpopular, stand that challenges a prevailing, and often immoral, point of view, angering the stooges who are hell-bent to prevent their world from progressing from the tar pits. Such cartoons force us to look

"THEY WON'T GET US TO THE CONFERENCE TABLE . . . WILL THEY?"

Figure 4.18 Pat Oliphant, *Denver Post*, 1966.
Reprinted with permission of Universal Press Syndicate. All rights reserved.

into the mirror of social reality and make a lot of other people, including editors, uncomfortable.

As it was in Duffy's day, expressing such opinions was dangerous in the 1960s. During the summer of 1963, Bill Sanders began working for the relatively conservative *Kansas City Star*. Shortly thereafter, one of the editors told Sanders that his work had prompted "more letters to the editor in a month than we've had in the last five years over cartoons." When Sanders called for integration, readers threatened his life, calling him a Communist, a pinko, and a "nigger" lover. When Sanders did not let up, readers began trying to intimidate the newspaper's publisher into firing him, but it did not work.[64]

Like Oliphant and others who made a name for themselves, Paul Conrad combined meticulous art with biting satire, leaving little doubt who was being caricatured and what the artist really thought of his subject. Conrad's work often has the subtlety of a punch in the mouth, and sometimes his cartoons draw blood. Conrad, a devout antiabortion Catholic, once drew a cartoon of a fetus nailed to a cross with the words "Abortion on demand."[65]

Conrad, a liberal on most things except abortion, worked for the *Los Angeles Times*, a conservative newspaper. There, he often criticized Richard Nixon and Ronald Reagan—the state's leading Republican figures in the second half of the twentieth century—both of whom the newspaper endorsed. While grateful for and perhaps even indebted to the newspaper's support, Nixon and Reagan could not ignore Conrad. As the Watergate scandal unraveled, those on the far left learned that they had been right about Nixon all along. Among other things, he had kept lists of his enemies and directed the FBI, the Internal Revenue Service, and other government agencies to harass them.

When the Associated Press notified Conrad that he was on one of Nixon's "enemies lists," Conrad said that he was "absolutely delighted." Because one of the newspaper's editors had made one of the Nixon's earlier lists, "I offered to trade him two Pulitzers for that," Conrad said. "Then I said, 'screw that,' there will be more lists. I was on the second list." Conrad determined that was why he had been audited for four years. "I had no idea at the time," he said.[66] Herblock, much to his surprise, did not make any of Nixon's "enemies lists." By working for the *Washington Post*, which had launched the Watergate investigation, Herblock believed he was an enemy by association. That is, *Post* staffers did not have to be on the list, he said; it was assumed.[67]

Herblock's drawing of Nixon climbing out of a sewer certainly left an impression on the politician, who told his aides that if he ever ran for president, he would have "to erase the Herblock image."[68] One of Nixon's

friends told the author Theodore White that Nixon would "never forget that Herblock cartoon, with him climbing out of the sewer."[69] Herblock said he was happy to hear that Nixon had taken such an interest in his work. "As a cartoonist, it kind of made your day when you heard something like that," Herblock said. "He was very conscious of criticism."[70]

Thomas Nast had "Boss" Tweed in the 1870s; a century later, editorial cartoonists had Richard Nixon. As it has often been suggested, if Nixon had not already existed, cartoonists would have had to invent him. Nixon was not just easy to draw—with his sagging jowls, ski-jump nose, five o'clock shadow, hunched shoulders, and fingers waggling in the air in a double V— but he inspired such distrust and contempt that satire jumped off the editorial page and danced irreverently on cartoonists' drawing boards. According to Mike Peters, Nixon "was our Camelot." The Watergate scandal therefore was the Holy Grail (figures 4.19 and 4.20).

During the 1960s and early 1970s, the nation found itself torn apart by the civil rights movement, the unpopular Vietnam War, and the Watergate-doomed presidency of Richard Nixon. College students burned their draft cards, demonstrated against the war, and openly questioned ideas previously accepted. "We've had a tendency to idolize politicians, to put presidents on pedestals. All that was undermined by the war, and then by Watergate," Doug Marlette said.[71] And there to capture the tenor of both protest and reform were the nation's editorial cartoonists. "We went off the picket line and right onto the drawing board," said Peters, who was hired by the *Dayton (Ohio) Daily News* amid the tear gas of the Democratic National Convention in 1968.[72]

For the first time in decades, newspaper editors were hiring cartoonists, often to replace those who had retired or died, taking with them their sense of benign conservatism. In return, in a reflection of the times, powerful images reemerged on editorial and op-ed pages, drawn by long-haired liberals who believed that questioning the government was not a privilege that came with experience but a birthright as an American. After the Watergate investigation led to President Nixon's resignation, journalism become more confrontational. Editors allowed things in the newspaper that they had not previously permitted. "Cartoonists are much more free today," *Boston Globe* cartoonist Paul Szep observed. "We can draw and write things we never could before Nixon and Vietnam. But how many cartoonists will test that or want that?"

For those willing, the result was a spirit of reform that had not existed since the Progressive Era. Cartoonists who got their start during the social unrest of the late 1960s and early 1970s included Peters, Marlette, Szep, Jeff

May 24, 1974

Figure 4.19 Herbert Block, *Washington Post*, 1974.
Reprinted with permission of The Herb Block Foundation.

Figure 4.20 Paul Conrad, *Los Angeles Times*, 1974.

MacNelly, Tony Auth, Don Wright, Jules Feiffer, and Garry Trudeau. *Newsweek* wrote that it had been a long time since there were "so many good cartoonists or more wretched excesses" to satirize. "On their sketch pads the bedrock of American democracy is turning into a pit of quicksand," the article added. "As our leaders flounder across it, the cartoonists press closer to the edge, vying to capture the polls' expression as they go under."[73]

But this did not last after Americans walked away from the picket lines, found jobs and relative prosperity, and began raising families. Nixon's resignation was followed by the end of the Vietnam War, and the country slipped into another period of complacency, during which its presidents, including Gerald Ford and Jimmy Carter, appeared more like substitute teachers, temporary and forgettable. Carter's toothy grin belied the common view that he was a living example of the Peter principle. Ford, who pardoned Nixon, damaged his credibility by denying that there was any quid pro quo, as Peters captured in one of his drawings (figure 4.21).

It is not good for business when cartoonists share with the president the same politics—or much of anything else. During the Carter administration,

Figure 4.21 Mike Peters, *Dayton (Ohio) Daily News*, 1974.
Reprinted with special permission of North America Syndicate.

Jeff MacNelly, a conservative, won the second of his three Pulitzers with a style that continues to influence the profession, lacking the forcefulness of Conrad or Oliphant but full of detail and humor and capable of pricking the skin. When Ronald Reagan became president, MacNelly found that he could not muster the right kind of anger to produce satire, so he went on leave. "I think that basically Reagan hasn't outraged me as much as Carter," MacNelly said.[74]

For many cartoonists, the amiable Reagan, like Franklin Roosevelt, was so popular that readers resented any sort of personal attack. But Conrad did not hesitate to portray his longtime nemesis as, among other things, the warhead of a nuclear missile, a vulture, a scarecrow, a clown, and an elephant's hind end. In one cartoon, Conrad drew Reagan holding up a beaker of urine for drug testing, which had the caption, "Uncle Sam wants yours!" The *Los Angeles Times* received more letters about that cartoon than it did about any other cartoon or article during the Reagan administration. While Reagan was president, the White House hosted a luncheon for the nation's editorial cartoonists, but Conrad's name was not on the guest list. White House spokesman Pat Buchanan explained that "the invitation must have gotten lost in the mail."[75]

As partisan politics became particularly divisive during the tenure of Newt Gingrich, a Georgia Republican, as Speaker of the House, cartoonists closed ranks. In *Mallard Fillmore*, Bruce Tinsley criticized congressional Democrats for rejecting, on ideological grounds, President George H. W. Bush's choice of Robert Bork to be a justice on the Supreme Court. In one series, inspired by the Bork rejection, Tinsley attacked a number of liberal causes. Revolted by the confirmation hearings, the strip's title character, a duck, flees into the Washington, D.C., streets only to find himself caught in the cross fire of an afternoon crack deal. The duck then dives into a dumpster for protection. When he emerges, covered with garbage, he is given a grant by the National Endowment for the Arts for his "brilliant display of dumpster performance art." The duck later finds a job with a political journal but is fired for sexual harassment after complimenting a women colleague on her "nice shoes." Desperate, he applies for a job with a television station and is hired because he represents a minority: amphibious Americans. "I'm making money again," the duck says. "I should be happy, but I'm not. I didn't get hired because I'm a good journalist. I got hired because I'm a duck."[76]

Other conservatives who became established during the 1980s and 1990s included Mike Ramirez, who won the Pulitzer Prize in 1994 while he was at the *Memphis Commercial Appeal* before moving to the *Los Angeles Times*,

where he succeeded Paul Conrad when the latter retired. Also working out of southern California, conservative Mike Shelton of the *Orange County Register* became one of the first cartoonists to use color in his cartoons. Initially Shelton thought that color might detract from the traditional contrast of black and white. When George H. W. Bush reneged on his "no new taxes" pledge, Shelton drew the president with his trousers down, mooning through an Oval Office window and saying: "Hey, taxpayer, read this!" Readers flooded the newspaper with letters to the editor, in part, Shelton thought, because the cartoon was in color. He even suggested that color cartoons might help invigorate the newspaper industry, which was losing readers to television and other diversions.[77]

When Bush selected Clarence Thomas to be an associate justice on the Supreme Court, the nomination brought the issue of sexual discrimination to the front pages, striking an emotional chord with American women, just as the Bork nomination had prodded conservatives into political action. For Ann Telnaes, the defining moment in her career came when Thomas was accused of sexual harassment during his confirmation hearings, by a former employee, Anita Hill. The investigation of Hill's accusations by an all-male Senate subcommittee incensed Telnaes. "As a woman who worked in the private sector," she said, "I was well aware of the realities of sexual harassment and gender discrimination and was outraged at the behavior of the senators at those hearings."[78]

Telnaes said that it frustrated her to see Hill's claims disregarded by the all-male subcommittee. Inspired, she turned her pique into cartooning in hopes of bringing a voice to those not heard, in particular women. She began self-syndicating editorial cartoons during the hearings. Then, after Thomas's confirmation, Telnaes quit her job and moved to Washington, D.C., to become a full-time editorial cartoonist. Within months, the North America Syndicate added her to its package of thirteen cartoonists, which is distributed to a few hundred newspapers. Telnaes was the syndicate's only female cartoonist. Her work is now distributed by Tribune Media.

Since the Thomas hearings, American companies and organizations have strengthened their sexual harassment policies, and corporations have hired more and more women as executives. In addition, women have advanced in politics, entering the U.S. Senate, courtrooms, boardrooms, and other professions once dominated by men. But this has not been the case in editorial cartooning, in which only a handful of women work on a regular basis for daily newspapers and only three are nationally syndicated: Etta Hulme of the *Fort Worth Star-Telegram*, Signe Wilkinson, and Telnaes, the latter two having won Pulitzer Prizes.

Telnaes says that her gender matters—and it shapes her work. She said she frequently illustrates issues that resonate more with women than with men. She tends to gravitate toward subjects that do not attract male cartoonists, such as issues of sexism on both a national and an international level. For instance, Telnaes said she was drawing cartoons illustrating the mistreatment of women in Afghanistan long before it became front-page news in America. "I've been doing editorial cartoons about the Taliban since 1996 because I wanted to highlight the human rights abuses women were experiencing," she said. "Most male cartoonists only started doing cartoons addressing the Taliban after September 11" (figure 4.22).[79]

When Democrat Bill Clinton defeated George H. W. Bush in the 1992 presidential election, he made sex—and not necessarily gender—a central issue of his administration. With Clinton in the White House, however, cartoonists had not had it so easy since the Nixon years. Like Nixon, Clinton—with his curly hair, bulbous nose, chubby cheeks, and ample girth—was easy to draw. Like Nixon, Clinton's character failings were well known and attracted many critics. For those in the business of satire, Clinton was a godsend; he seemed to write his own material, and cartoonists were all too willing to transmogrify his words—such as "I feel your pain," into just "I feel you"—although too often cartoonists resorted to regional stereotyping by depicting the Rhodes scholar as a white-trash cousin of Lil' Abner.

Figure 4.22 Ann Telnaes, undated.

For the most part, Clinton's shamelessness made him his own enemy, and cartoonists learned that the best way of attacking the president was simply to quote him. When having to admit that he had indeed smoked marijuana, Clinton nonetheless maintained that he "had not inhaled." When he was accused of having a sexual relationship with a White House intern named Monica Lewinsky, Clinton denied that the relationship had been sexual because the two had not actually had intercourse. At another point while he was under oath, Clinton told his interrogator that his answer depended on "what the meaning of the word *is*, is."

The investigation into Clinton's wrongdoings by the independent counsel Kenneth Starr led to the impeachment of the president and the release of the salacious Starr Report, chronicling the president's sex life, which demeaned both the presidency and the independent counsel's office. Despite the far right's calls for the president's removal from office, the rest of the country did not believe that Clinton's scandals, although tawdry and even illegal, rose to the level of the high crimes and misdemeanors necessary for impeachment. In short, Americans went about their lives amid unprecedented economic prosperity, keeping a keen eye on their dividend checks but caring little about the state of political and social affairs—and the era's cartoons reflected that (figures 4.23 and 4.24).

To some cartoonists, Clinton was an embarrassment of riches. To others, like Doug Marlette, a southern progressive like Clinton, the president was simply an embarrassment. Marlette admitted that he initially was attracted to Clinton's charisma and that he liked the president but later changed his mind, proving again that cartoonists should not mix business and pleasure with those they might satirize. Marlette said he should have listened to his better instincts, what he called his "killer angels." Marlette said that Clinton's legacy was that he "emboldened the right wing."[80]

Despite his administration's scandals and investigations, Clinton was consumed with his legacy. Accordingly, Oliphant drew the president, an avid golfer, asking for a mulligan from a bearded man named "Posterity," who answered "No." When Clinton prepared to leave office after his second term, cartoonists knew that their job was about to become more difficult. "As a decent American, I'm glad Clinton can't run in 2000," Steve Breen said. "As a decent editorial cartoonist, I'm sad he can't." Chip Bok of the *Akron (Ohio) Beacon-Journal* remarked that having Clinton in the White House was exhausting for a satirist: "Anyone will be better than Clinton because it [was] just so tough staying ahead of him in terms of satire." According to Oliphant, "We've gotten to the point now where parody and

Figure 4.23 Joel Pett, *Lexington (Ky.) Herald-Leader*, 2001.
Reprinted with permission of Universal Press Syndicate.

Figure 4.24 Robert Ariail, *The State* (Columbia, S.C), 1998.

satire have been overtaken by reality. This is a very uncomfortable time as far as I'm concerned. What do we do?" he asked. "It's funny enough itself, I suppose. But it's sort of tragic, too, at the same time. . . . I'm being leapfrogged by events all the time."[81]

But instead of satire, the editorial cartoons regarding the Clinton presidency were more like burlesque. In turn, parody became self-parody, as legitimate questions of high crimes and misdemeanors were reduced to jokes about the president's wearing boxer shorts embroidered with hearts; cracks about his wife, Hillary, ordering him to the doghouse with the presidential pooch, Buddy; or gags about cigars versus sexual innuendo. Whereas cartoonists once captured the essence of social outrage, they now—reflecting the Clinton administration—seemed derivative of Jay Leno and Comedy Central, whose gags were pleasant on the palate but had the satiric stuff of cotton candy. Oliphant dismissed his colleagues working during Clinton's time in office as "just a bunch of jokesters now."[82] Paul Conrad blamed cartoonists themselves for the poor state of the art. He said they did not read up on the issues and instead merely illustrated headlines or fell back on easy gags over strong commentary.[83]

Of the five cartoonists with the greatest influence on editorial cartooning since World War II, three have died since the summer of 2000: MacNelly, Mauldin, and Herblock. Conrad, who has retired from the *Los Angeles Times*, continues to have his work syndicated, and Oliphant is seventy years old, but his work still might be the best in the profession. Not all the cartoonists have traded their punches for punch lines, and while cartoonists are tired of hearing Oliphant and Conrad complain about their shortcomings, they do not necessarily disagree. The *Lexington (Ky.) Herald-Leader*'s editorial cartoonist, Joel Pett, said that "too much editorial cartooning today is opinion-free gag writing . . . uninformed, unenlightened, largely unconscious. The lite's on but nobody's home."[84] Signe Wilkinson of the *Philadelphia Daily News* said that the country's cartoonists "are under a lot of pressure" as newspapers fold, make staff cuts, or encourage "bland, gag-oriented cartoons rather than hard-hitting ones."[85]

Newspaper readership has continued to decline. Many newspapers have merged, leaving fewer and fewer cities with more than one newspaper. Clay Bennett said that less competition should have made the newspapers more courageous. "You would think that would embolden newspapers. But it has done the opposite. It has made them more cautious, tepid, and bland," he said. "As soon as you're the only game in town, you see them pull back. It doesn't make any sense to me."[86] Inextricably linked to this is what Marlette

calls the "corporatization" of the industry, in which newspapers are cautioned against doing anything to "stir something up."[87] In addition, as corporations bought up newspapers, they trimmed the staffs in order to increase their profit margin, which has meant fewer and fewer openings for cartoonists.

Taking their marching orders from the front office or underestimating the value and power of editorial cartoons or both, editors have either fired their cartoonists or rejected their more provocative drawings. Most daily newspapers have opted for publishing relatively generic syndicated cartoons because they are cheaper and generate fewer phone calls than do cartoons about local sacred cows.[88]

Consequently, the number of editorial cartoonists today is shrinking, the result of a stagnant newspaper industry and overly cautious editors who have little sense of political satire or who do not want to upset their corporate board of directors, publisher, or readers. If this continues, editors may succeed where "Boss" Tweed failed.[89] Joel Pett, expressing the frustration of his colleagues, told editors: "The medium has a proud history of treating readers to a unique mix of devastating humor, savage ridicule, bitter irony and chilling tragedy. And you people are killing it."[90]

"Second-Class Citizens of the Editorial Page"

Doug Marlette's 2001 novel *The Bridge* begins with the narrator, an editorial cartoonist named Pick Cantrell, describing a drawing of a close-up of the pope wearing a button with the words "No Women Priests," which was intended to criticize the pope and the Catholic Church for their continued prohibition of female priests. An arrow points from the inscription "Upon this rock I will build my church" (Matthew 16:18) to the pope's forehead. After Cantrell's Long Island, New York, newspaper, *The Sun*, published the cartoon, offended readers complained to the publisher, editor, and cartoonist. In response, the editorial page editor, Richard Kerfield, who had approved the drawing, called Cantrell and told him that the newspaper was going to apologize for running the drawing.

"Apologize?" Cantrell replied. "Why?"

"It was a mistake to run the drawing," Kerfield said.

"How can expressing an opinion be a mistake?" Cantrell asked

"You crossed the line. It was offensive to Catholics."

Despite Cantrell's protest, the newspaper ran an apology in the next day's edition. Cantrell then publicly questioned the integrity of the apology, telling one reporter: "I don't mind kissing the publisher's ring, but I just wish he would take it out of his back pocket." Cantrell was then ordered to the publisher's office, where he was told he had been put on probation and could no longer work at home; he would have to do his work at the newspaper, where he would be better supervised. When Cantrell angrily protested, the publisher told him that he could be replaced. The argument escalated, and the publisher called the southern-born and -bred Cantrell a "cracker." Cantrell then hit his publisher in the jaw and then, after being told he was fired, continued his assault by repeatedly striking the publisher with the man's own yachting trophy.[1]

For Marlette, a Southerner, his protagonist Pick Cantrell was self-inspired. The pope cartoon and the dispute about the apology were based on real events that took place while Marlette worked for the New York City edition of the real Long Island newspaper *Newsday*. The cartoon in question, which appeared as described in the novel, was published on June 3, 1994 (figure 5.1). After more than a hundred readers complained, the newspaper apologized for running the cartoon, saying that the newspaper had not meant to criticize the pope or the Catholic Church. "We regret that many readers were given an unintended message," James Klurfeld, the newspaper's real editorial page editor, said.[2]

Marlette responded with an op-ed piece in the newspaper saying that the message in the cartoon had been the one he had intended. He called the apology wrong and unnecessary. "It is always bad news when a newspaper apologizes for expressing an opinion—bad news for the First Amendment, bad news for journalism and bad news for readers," he said, adding: "The point of opinion pages is to focus attention, to stimulate debate and to provoke argument. If we can't discuss the great issues of the day on those pages of our newspapers, fearlessly and without apology, where can we discuss them?" Klurfeld responded by saying that the newspaper "would have been better off if we had not run the cartoon. . . . We shouldn't run something that's so open to misinterpretation. It's not that the topic is off limits; it's how you do it."[3]

Figure 5.1 Doug Marlette, *Newsday*, 1994.

But art, whether it is a painting, a sculpture, or an editorial cartoon, is often subject to interpretation. In addition, apologizing for a unpopular opinion on a social issue undermines the value of free speech, as Marlette pointed out, and apologizing to quell a controversy is particularly distressing. Instead of encouraging dialogue, as an editorial page should do, the apology suppressed it, sending the message that the newspaper lacked the courage of its own convictions. If the newspaper really believed that the cartoon had been misinterpreted, it could have included a note from the editor explaining the meaning of the cartoon or, maybe, could have discussed why it was running the cartoon. If *Newsday* apologized because it thought that the cartoon had been read literally, then the apology was based on the newspaper's wrongly imposing the same standards it applied to news articles. Editorial cartoons are satiric representations of news events; they are not literal, nor are they intended to be taken literally.

Although the First Amendment gives editorial cartoonists what amounts to absolute freedom, editors and publishers are not so generous. In the newsroom, where freedom is ultimately measured, a cartoonist's freedom depends on the beliefs, tastes, politics, and even sense of humor of his or her publisher or editors, who have veto power over whether or not a drawing will be published. Conflicts are inevitable between cartoonists and their superiors, particularly if they disagree over what a cartoon is intended to do. If these differences of opinion occur often enough, they will lead to dissatisfaction, confrontation, or even dismissal.[4]

Marlette said that the apology created a temporary rift in his relationship with his editor. As happened in the book, Marlette was put on probation for his insubordination, he said. When the Times-Mirror chain, which owns *Newsday*, decided to suspend the newspaper's New York City edition, it led to massive layoffs for that newsroom. Marlette kept his job, but he was asked to move to Long Island to work in the newsroom there. Marlette, who kept an apartment in Manhattan and a home in North Carolina, did not want to give up his Manhattan apartment for one on Long Island. *Newsday*, however, insisted that its cartoonist live in Nassau County, creating what became irreconcilable differences.[5] In October 2000, *Newsday* commissioned East Coast native Walt Handelsman, the Pulitzer Prize–winning cartoonist of the *New Orleans Times-Picayune*, to illustrate the New York Yankees–Mets World Series. In the following months, Marlette and *Newsday* grew farther apart. Finally, in February 2001, the newspaper announced that Marlette would be replaced by Handelsman.[6]

In May 2001, a few months after Marlette left *Newsday*, the *San Diego Union-Tribune* fired Steve Kelley, its award-winning cartoonist who had

worked there for twenty years, over a dispute with an editor over a drawing. In the offending cartoon, Kelley drew two adults walking past two teenagers wearing then-fashionable low-slung jeans. "Say what you what about today's teen-agers," one of the adults says, "they'll have no shortage of plumbers" (figure 5.2). An editor rejected the drawing as offensive, so Kelley submitted a revised copy to another editor. When Robert A. Kittle, the newspaper's editorial page editor, saw the drawing on the page, he removed it, but it was inadvertently distributed through the Copley News Service and appeared in a number of newspapers. When the *Union-Tribune*'s senior editor accused Kelley of trying to sneak the cartoon into the newspaper, the cartoonist responded by swearing at him and was fired, thus losing his job over not a principle but a low-grade cartoon.[7]

The newspaper, however, did not report the firing, leaving readers to wonder what had happened to the popular cartoonist. Kelley said that the newspaper offered him six months' severance pay if he would not talk about the firing, but he refused the money. After he went public with the news, the *Union-Tribune* finally published a story. Kelley said that he had suspected the

Figure 5.2 Steve Kelley, 2001. Reprinted with permission of Creators Syndicate.

newspaper had been looking for a reason to terminate him. He said that the newspaper's corporate legal counsel had told him a year earlier that if it were up to him, the cartoonist would be fired. "I was too conservative for him," he said. "I think when you pull the executioner's hood off, you're going to find him." Then the Copley News Service, which is owned by the same company that owns the *Union-Tribune*, notified the cartoonist that it would no longer distribute his work.[8]

Editorial cartoonists have always had difficulty finding a newspaper job. It used to be said that for a cartoonist to find a job on a daily newspaper, another cartoonist had to die, quit, or be fired. In recent years, however, more and more vacancies have gone unfilled. In the case of *Newsday* and the *Union-Tribune*, however, both, to their credit, replaced their cartoonists with Pulitzer Prize winners. The *Union-Tribune* hired Steve Breen from the *Asbury Park (N.J.) Press*, and *Newsday* hired Handelsman from the *New Orleans Times-Picayune*, which then hired Kelley. The *Asbury Park Press* did not replace Breen.

After working for three decades as an editorial cartoonist, Marlette found himself without a newspaper, although his work continued to be distributed by the Tribune Media Services. He still lives in North Carolina and now works for the *Tallahassee (Fla.) Democrat*, which broke with current newspaper practices and hired its first cartoonist. "At a time when newspapers are getting rid of cartoonists, cutting back and not hiring," Marlette said when he was hired in June 2002, "it is absolutely heroic that the *Tallahassee Democrat* is taking on a political cartoonist."[9]

Within a few months, though, Marlette drew a cartoon that once again put him in the middle of a tempest. In reaction to a series of suicide bombings in Israel committed by Muslim extremists, Marlette, borrowing from the popular Christian phrase criticizing gas-guzzling SUVs, "What would Jesus drive?" drew a Ryder truck, driven by a Muslim, hauling a nuclear bomb. Below the cartoon the caption reads: "What Would Mohammed Drive?" (figure 5.3). Muslims, who consider drawings of the Prophet to be blasphemous, voiced their disapproval by sending thousands of e-mails to Marlette and to the *Democrat*, which had not run the cartoon in its print edition, although it had inadvertently, and briefly, appeared on its Web site. The Council on American Islamic Relations and the Muslin World League demanded an apology from Marlette, his syndicate, and the *Democrat*.[10]

Marlette explained that he would not apologize because in the context of post–September 11 America, the cartoon was accurate in using a Ryder truck, like the one used by convicted Oklahoma City bomber Timothy McVeigh. "I'm sorry to report that the image in post 9/11 America that

What Would Mohammed Drive?

Figure 5.3 Doug Marlette, *Tallahassee (Fla.) Democrat*, 2002.

leaps to mind is the Ryder truck, given to us by the terrorist Timothy McVeigh, carrying a nuclear warhead and driven, alas, not by an Irish-Catholic or a Jewish Hasidim or a Southern Baptist, but by an Islamic militant." Marlette added that his cartoon was not intended to be taken literally, adding dryly that "there were no Ryder trucks in Mohammed's time." He said that Muslim groups were misdirecting their anger. "Muslim fundamentalists have committed devastating acts of terrorism against our country in the name of the Prophet," he said.[11]

The *Democrat*'s executive editor, John Winn Miller, said the newspaper would not apologize because it had not published the cartoon, even though, because of a technological glitch, the drawing had appeared briefly on the paper's Web site. He said the newspaper had not run the cartoon because it thought it was bad taste to make fun of religious icons. Miller, however, defended Marlette's right of expression. "This is an honored American tradition," he said, noting that humor and satire depend on exaggeration. When Marlette joined the newspaper, Miller said that the cartoonist would have the freedom to be "provocative, but he'll have an editor."[12]

One of history's lessons for editorial cartoonists is that they may be in the business of expressing their opinions, but those opinions are published at the discretion of their editor or publisher. To wit, Thomas Nast did not lose his job from *Harper's Weekly* because of "Boss" Tweed but because he lost a power struggle with his editor. During Nast's glory years with the

magazine, publisher Fletcher Harper gave him a free hand—but only as long as the cartoonist supported the radical Republicans. When Harper died, the caustic Nast and his more genteel editor, George Curtis, found themselves more and more at odds. "When he attacks a man with his pen it seems as if he were apologizing for the act," Nast said. "I try to hit the enemy between the eyes and knock him down."[13] After leaving *Harper's*, Nast tried to start his own magazine, but it failed and he never again regained the prominence he once had.

The relationship between cartoonists and editors is often tenuous, the result of both personal and professional differences. Editorial cartoons are confrontational in nature, and often so are the people who draw them. The qualities that lend themselves to social criticism—sarcasm, bluntness, irreverence, and a contempt for authority—do not lend themselves to accommodating personalities. Cartoonists can be temperamental and argumentative, particularly if they believe strongly that they have nailed an issue or a politician—even to a cross.

Editors, in contrast, usually are former reporters trained to keep their opinions out of their copy. They are verbal rather than visual. "Editors are some of the most visually blind people I know," Doug Marlette said.[14] In addition, people do not become editors by continually challenging authority. If they do not learn to compromise, they will remain buried in middle management, having to share their desk with another editor in middle management and having to feign interest at one meeting after another. While compromise is valuable in international diplomacy and organizational politics, it often is the death of an editorial cartoon. *Washington Post* cartoonist Tom Toles once remarked that committee work always looked like committee work.[15]

When Marlette, then with the *Charlotte (N.C.) Observer*, was interviewed for a job at the *Atlanta Constitution*, his editor, Bill Kovach, told him he thought it would be good for the newspaper's reputation to have its own cartoonist. Marlette then told Kovach that if he hired him, he would have to be prepared for the headaches: "Bill, you like the idea of having a cartoonist. Do you understand that if you hire me, you will be awakened at home because of my cartoons. That's the reality." According to Marlette, Kovach then replied: "Yeah. I can deal with that."[16]

In return, Marlette won the 1988 Pulitzer Prize for editorial cartooning during his first year with the *Constitution*. His winning cartoons, which were based on his work at both the *Constitution* and the *Observer*, focused on the sex and fraud scandals involving evangelist Jim Bakker and his North Carolina–based Praise the Lord (PTL) television network. Jim Bakker and his

wife, Tammy Faye, showed Marlette's drawings on their PTL program, denouncing them as blasphemous. While Marlette was working in Charlotte, angry readers telephoned him, calling him a "tool of Satan." "That's impossible," Marlette told them. "Our personnel department gives tests screening for tools of Satan. Knight-Ridder newspapers have a policy against hiring tools of Satan." Marlette added that "religious zealots are not known for their sense of humor."[17]

In his Pulitzer packet, Marlette included a drawing about Jerry Falwell as a snake in the PTL garden: "That's right—Jim and Tammy were expelled from Paradise and left me in charge!" (figure 5.4). Falwell, Marlette said, demanded an apology. When Falwell's supporters called Marlette, citing Scripture, Marlette quoted Scripture back at them, telling them that the New Testament refers to religious professionals as snakes.[18] After the Falwell cartoon, Marlette said he received a chilly reception from the newspaper's reporters because Falwell had been their primary source for Bakker's financial and sexual proclivities. After seeing himself ridiculed in Marlette's drawings, Falwell was less forthcoming to reporters, which made their job more difficult.[19]

When Marlette left for *Newsday*, the *Atlanta Constitution* hired Mike Luckovich. Luckovich emerged as one of the more visible cartoonists in the profession, in 1995 winning the Pulitzer Prize, based in part on his attacks

" THAT'S RIGHT — JIM AND TAMMY WERE EXPELLED FROM PARADISE AND LEFT ME IN CHARGE! "

Figure 5.4 Doug Marlette, *Charlotte (N.C.) Observer*, 1987.

on Newt Gingrich, his fellow Georgian and the Republican Speaker of the House. Gingrich, accompanied by his two daughters, had served his wife divorce papers while she was recovering in the hospital after cancer surgery. Gingrich became apoplectic over a Luckovich cartoon in which Gingrich, surrounded by two brazen-looking women labeled "D.C. highrollers," is saying "I want a divorce" to a woman in a hospital bed, labeled "Georgia Constituents" (figure 5.5). The famously mean-spirited Gingrich told the newspaper that its reporters would be banned from all of the congressman's appearances until it apologized.[20]

Behind every successful cartoonist lies a supportive, if long-suffering, editor who got into journalism for the right reasons. And behind every long-suffering cartoonist is a flaccid editor who should have searched a little longer during career day in high school. Most editors fall somewhere in the middle. "The cartoonist is fortunate who has an editor who either agrees with him all the way or who respects the cartoonist's position enough to give him free rein," one cartoonist said.[21] That, according to Clay Bennett, is just about the best you can hope for: "The worst thing is

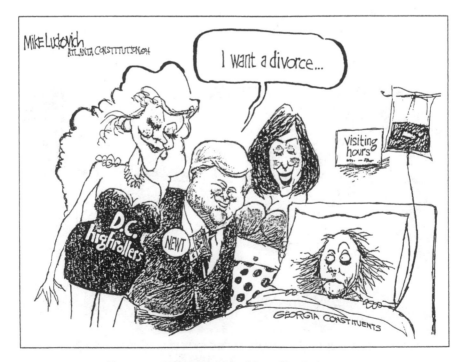

Figure 5.5 Mike Luckovich, *Atlanta Constitution*, 1994.
Reprinted with permission of Creators Syndicate.

an editor who is a frustrated cartoonist who thinks he or she can help you on your quest."[22]

In one survey of editorial cartoonists and editors, they both agreed that there was a direct connection between freedom from restraints and the effectiveness of the cartoon.[23] When cartoonists were asked what their newspaper could do to improve their work, their most common response was "more freedom." But editors were understandably reluctant to surrender too much freedom to the cartoonist. After all, it is their job to see that the newspaper's policy is followed. Editors know that if they give cartoonists too much rope, they will give readers enough rope to hang the editor—or the publisher.

Paul Conrad's drawings of then California governor, Ronald Reagan, prompted Reagan to call *Los Angeles Times* publisher Otis Chandler to complain. In fact, Reagan called Chandler so often that he stopped taking the governor's calls. So Reagan then had his wife, Nancy, call, until Chandler began refusing her calls, too.[24] Thomas Johnson, who succeeded Chandler, said that he received both praise and criticism for Conrad's work. Johnson once said that he would have objected to two cartoons if he had been consulted before their publication. In one, Conrad drew the beleaguered Chrysler Corporation chairman Lee Iacocca, who was chairman of the Statue of Liberty Foundation, as Lady Liberty herself, raising not a torch but his middle finger. In the other, Conrad expressed his contempt for northern California's refusal to share its water surplus with parched southern California. In the drawing, a man labeled "Northern California" is urinating on southern California (figure 5.6).[25]

As long as editorial cartoonists have been working for editors, cartoonists have learned to not challenge editorial policy directly but merely to avoid the publisher's sacred cows. During his career at the *St. Louis Post-Dispatch*, D. R. Fitzpatrick had independence over what he drew and how he drew it—to a point. Fitzpatrick, a Democrat, refused to support his newspaper when it endorsed Republican Alf Landon over Franklin D. Roosevelt in 1936 and Thomas Dewey against Harry Truman in 1948.[26] In 1952, Herblock took a vacation from the *Washington Post* when it backed the Republican presidential candidate, Dwight D. Eisenhower. Earlier in his tenure with the newspaper, the *Los Angeles Times* gave Conrad a leave of absence during the 1964 presidential campaign when his cartoons criticized Barry Goldwater, whom the newspaper endorsed for president. None of these men had the freedom to contradict editorial policy; they merely had the right to remain silent.

Newspapers generally make allowances for cartoonists who win Pulitzer Prizes or otherwise distinguish themselves. Unlike Conrad, whose politics

Figure 5.6 Paul Conrad, *Los Angeles Times*, undated.

differed from those of his newspaper, Herblock, a liberal, and Jeff Mac-Nelly, a conservative, generally reflected the editorial lines of their respective newspapers—the *Washington Post* and the *Chicago Tribune*. For the most part, however, Conrad, Herblock, and MacNelly all had good relationships with their editors, who respected their talents and gave them the freedom to produce memorable and often searing images. It is no coincidence that, given their talent and autonomy, Conrad, Herblock, and MacNelly are three of America's best and most decorated cartoonists, each winning three Pulitzer Prizes.

Twenty years ago, when James Squires was editor of the *Chicago Tribune*, he wrote an op-ed piece after the newspaper published a MacNelly cartoon showing the Irish Republican Army as a rat leprechaun detonating dynamite. Squires said that this drawing caused him more grief than all the words written by all his reporters in a year. Nonetheless, he insisted that he was committed to letting MacNelly do his job in as unrestrained and unfettered a way as possible. Why? "Because the political satires of Jeff Mac-Nelly and those of a handful of similarly talented newspaper cartoonists represent the most incisive and effective form of commentary known to man and one as vital to the exercise as free speech and open debate as any

words that ever appeared on such pages," he said. "To censor them would be a definite disservice to art, and a probable danger to democracy."[27]

Squires, who later left the newspaper and is now a Democratic Party strategist, had both a keen appreciation of editorial cartooning and a sense of the *Tribune's* storied reputation for editorial commentary. For decades, John McCutcheon and Carey Orr (and, to a lesser extent, James Parrish) helped shape both editorial cartooning and the newspaper. During the 1970s, the newspaper again had three cartoonists—Pulitzer winners Mac-Nelly and Dick Locher, and Wayne Stayskal, who moved to the *Tampa Tribune*, where he still works.

But the *Chicago Tribune's* strong support for editorial cartooning belongs to another time. The newspaper did not fill the vacancy left by Locher's retirement, who continues to have his drawings distributed by Tribune Media, nor has it found a successor for MacNelly, who died in June 2000. Sadly, MacNelly is both gone and forgotten by the newspaper. The *Tribune's* editorial page editor, Bruce Dold, has said for some time that the newspaper planned to hire a cartoonist but was less specific when asked when that might happen.[28] The *Christian Science Monitor's* editorial cartoonist, Clay Bennett, remembered a conversation he had with Dold at an awards banquet. "When a paper like the *Chicago Tribune*, with its tradition, chooses not to have a cartoonist, it sends a terrible signal that we're not an important or valuable part of the staff," Bennett said he told Dold. And how did Dold react? "He agreed," Bennett said.[29]

Lexington (Ky.) Herald-Leader editorial cartoonist Joel Pett said that newspapers have reacted to their declining readership by going into full retreat, which is reflected in layoffs, less in-depth reporting, and weaker editorial pages. Cartoonists blame the staff cuts on the stagnant newspaper industry and overly cautious editors who do not want to run the risk of offending politicians, advertisers, or readers. Newspaper editors, Pett said, "are panicking, thinking, 'Oh, My God, we're losing readers.' One of their responses is, 'We shouldn't offend anyone.' When you start doing that, you're not going to want to publish anything that might offend. They should publish a lot more cartoons that are provocative."[30]

And that, according to Pett, should begin at home, where editorial cartoons hit hardest and leave the biggest impression. Pett said that his publisher and editor want to make a critical difference in Lexington and not just serve as a mouthpiece for business interests. The newspaper knows that an editorial cartoon "is a great tool for throwing its weight around," he said.[31] When the governor tried to lure profitable chicken-processing plants to the state, which would offer low-wage jobs, the newspaper argued

Figure 5.7 Joel Pett, *Lexington (Ky.) Herald-Leader*, 1999.
Reprinted with permission of Universal Press Syndicate. All rights reserved.

against the industry because of how it would affect the environment. In one of his cartoons, Pett drew the governor at the ribbon cutting for a new freeway, proudly announcing: "The freeway that wrecks the forest and pollutes the lake cuts ten minutes off the drive from the chicken plant to the emergency room!" (figure 5.7).

Pett, who has worked for the newspaper for twenty years and serves as one of the senior members of its editorial board, acknowledged that his longevity gives him a sense of autonomy not common in the profession. As editorial page editors come and go, Pett remains. "They come into a place that already has a cartoonist, who has a reputation," he said, "and they assume that you know what you're doing." It also does not hurt that Pett won a Pulitzer Prize in 2000, winning by including a number of local cartoons in his packet (figure 5.8). When asked about his freedom, Pett said, "I have as much or more than anybody working. Which is why I love this job."[32]

Bob Englehart, who has worked for the *Hartford (Conn.) Courant* for more than two decades, acknowledged that he has a good working relationship with his newspaper, although, by his own admission, it did not begin like that. Soon after he was hired, he commented on the announcement that Northeast Utilities wanted to raise its profits, which would result

in higher rates. Englehart suggested that a new company logo might be a screw and a *U*. The cartoon provoked an immediate and explosive reaction: some readers were offended, while others were delighted that the venerable paper had shown some spirit. "It scared the pants off my bosses," he remembered, "they didn't realize that an editorial cartoon could stand for something and can rouse outcry." After that, however, Englehart was told that he would have to send sketches of his cartoons not only to his editorial page editor but also to the editor and publisher.[33]

Two-time Pulitzer finalist Robert Ariail of *The State* in Columbia, South Carolina, said that when he was hired, he was told to draw local cartoons. "I did local cartoons and then the phone calls came, and they said, 'Don't do local cartoons anymore,'" he said. Ariail said that there had been a change of editors since then and that his newspaper now supports him. He said that his editorial page editor, Brad Warthen, "thinks like a cartoonist. He doesn't pull me back."[34] As a result, Ariail has been able to jump into the most divisive issue facing South Carolina: the presence of the Confederate flag on the capitol dome in Columbia and its subsequent removal to the nearby Confederate memorial.

Other American cartoonists also ridiculed the flying of the flag on state grounds as a narrow-minded anachronism. It is one thing to criticize the

Figure 5.8 Joel Pett, *Lexington (Ky.) Herald-Leader*, 1999.
Reprinted with permission of Universal Press Syndicate. All rights reserved.

Figure 5.9 Robert Ariail, *The State* (Columbia, S.C), 1999.

Old South from hundreds or thousands of miles away, but quite another to do so when your newspaper is basically in the same neighborhood where the flag flies, especially when no matter what you say, it will upset thousands of readers. In one cartoon, a legislator and a Confederate flag supporter stand atop the capitol dome, with the Confederate flag flying overhead. The flag supporter is saying, "You just can't let these fringe groups sway you," as thousands of people are protesting below (figure 5.9). In another, a white-bearded Civil War re-enactor in a Confederate uniform, representing those who cherish the past, defiantly growls: "Forget, *hell!*" The ghosts of a slave family then silence him by saying: "No, sir . . . we won't" (figure 5.10).

When Lee Judge worked for the *San Diego Union*, he found himself at odds with his editorial board, which at the time had a number of former Richard Nixon staff people working in executive positions at the newspaper. "We butted heads almost every day," Judge said, "and they fired me almost a year to the day after I came aboard." Judge then went to work for the *Kansas City Star*, where he established himself as a local cartoonist, rejecting syndication that would have obligated him to draw mostly national and international subject matter. By focusing on local issues, he has had far more impact, which occasionally has forced city officials to address issues

they might have otherwise ignored.[35] "It sets me apart in everyone's mind," Judge noted. "They think, 'Oh, he's from here. He's drawing about schools here, or sports teams—or the local government.'"[36]

The *Los Angeles Times* once published a story about disabled children whose operations were being delayed or who simply could not get their wheelchairs repaired because of cuts in the state budget in Sacramento. After reading the article, Paul Conrad drew a cartoon quoting the state's governor, George Deukmejian, from a speech he had made the day before in which he had spoken of "a world that seems to have learned little about common human decency." Conrad's cartoon showed Deukmejian speaking of human decency while a child with clubfeet tugs at his pant legs. The budget cuts were restored immediately.[37]

The *Seattle Post-Intelligencer*'s David Horsey, who won the Pulitzer Prize in 1999 and 2003, also credits his newspaper for bringing out his best work. In fact, his editor sometimes devotes a full page to his work. Horsey says his situation at his newspaper is in stark contrast to that of cartoonists at the newspaper's competitor, the *Seattle Times*. "While the *Times* chews up cartoonists and spits them out on a regular basis, I've had nothing but support from my various editors and publishers," Horsey said.[38] Horsey's reference to the *Seattle Times* is to the newspaper's reputation as a graveyard for editorial cartoonists. In 1994, the newspaper fired Brian Bassett after he had

Figure 5.10 Robert Ariail, *The State* (Columbia, S.C), 1999.

worked there for sixteen years. His cartoons were not syndicated but were mostly on local topics.[39] In 1996, the newspaper hired Chris Britt but let him go after five months. During the summer of 2002, it hired Eric Devericks.[40]

A month before the *Times* fired Bassett, the *St. Petersburg (Fla.) Times* fired Clay Bennett, in part, he thought, because his politics were more liberal than his editorial page editor's. Nine cartoonists—including eight Pulitzer Prize winners—sent the newspaper a letter protesting the firing. "Clay Bennett is one of America's best cartoonists. His cartoons are thoughtful, irreverent and seriously funny. Disagreement and arguing on editorial pages are the reasons those pages exist," the letter said. "To get rid of a cartoonist whose provocative work is an example of the highest standard of our profession merely points out the obvious: Bennett is being dismissed because an editor disagrees with his point of view. The truth is the reader's to figure out after reading a variety of points of view. That will be harder and harder to do if voices like Clay Bennett's are silenced."[41] The ax falls from both right to left and left to right. Bruce Tinsley thinks that he was fired from the Charlottesville, Virginia, *Daily Progress* because his conservative opinions contrasted with those of his liberal editor. Afterward, Tinsley then created the conservative comic strip *Mallard Fillmore*.[42]

After losing his job, Bennett struggled without a newspaper for several years before being hired by the *Christian Science Monitor*. He remains grateful to the newspaper. Bennett said that even though the newspaper often does not run his work, he agrees with its fundamental approach, and therefore they agree more often than not. A lot of editorial cartooning is based on "the dark side of life," Bennett said. "At the *Monitor*, they don't like excessive gloom and doom. They don't like character assassination." But neither does he, said Bennett, who prefers issue-oriented cartoons. "When you villainize someone, you scapegoat them. You let everyone else off the hook," Bennett said. "You're fooled into believing that if you get rid of that one person, everything will be fine. The truth of the matter is that most of our problems are more systemic in nature."[43]

Newspapers must believe that editorial cartoons have some value, or else why would they run them every day on their editorial and op-ed pages? Their readership studies tell them that editorial cartoons are popular and, in fact, bring some readers to the editorial pages who normally would not read them. Finally, it is obvious that cartoons contribute commentary. Why, then, do so few newspapers have cartoonists on their staffs? When editors are pressed to answer, they shrug and plead poverty. But even when the newspaper industry was prospering, most newspapers did not have editorial cartoonists on their staffs. And of those that did have cartoonists,

most gave them the Rodney Dangerfield treatment, which suggests that newspapers, unlike their readers, underestimate—and certainly underappreciate—the value of humor, satire, and visual commentary. "The world likes humor, but treats it patronizingly," E. B. White wrote several decades ago. "It decorates its serious artists with laurels and its wags with Brussels sprouts. It feels that if a thing is funny it can be presumed to something less than great, because if it were truly great it would be wholly serious."[44]

Newspapers like the *New York Times* pride themselves on the depth of their reporting, analysis, and writing. But the *Times* also has a blind spot when it comes to editorial cartoons, the most extreme form of expression in a newspaper. Instead of publishing staff-drawn cartoons with strong messages, the *Times*, which has not had a staff editorial cartoonist since the 1950s, once a week runs syndicated drawings that often are little more than jokes of the day, as if they want to prove the point that editorial cartoons are the Brussels sprouts of the editorial page. In fact, the *Times*'s selection of editorial cartoons has become its own little joke among editorial cartoonists. "Who picks them?" Doug Marlette asks. "Helen Keller? Stevie Wonder?"[45] When Marlette sees one of his own cartoons in the *Times*, he wonders, "What am I doing wrong?"[46]

Gail Collins, the *Times*'s editorial page editor, once remarked that because of the sheer forcefulness of editorial cartoons' presence, they tend to overshadow everything else on the page. "It does seem to be that, often, the editorial cartoon is such a large and powerful voice, it tends to suck the air out of the page," Collins said. "It takes an enormous amount of the power of the page and funnels it one direction."[47] This seems an odd justification, as if the New York City Opera fired Beverly Sills or the Chicago Bulls benched Michael Jordan for having such a powerful presence.

The *Times*'s courageous attitude toward free speech is not often extended to staffers with opposite viewpoints. After the newspaper published an editorial criticizing golfer Tiger Woods for not being more critical of the Augusta National Golf Club's ban on women members, two sports columnists responded with pieces that disagreed with the newspaper's editorial, and both columns were summarily killed. Doug Marlette, however, suspects that the *Times* does not have a cartoonist on staff because its editors thrive on control. Marlette remembered a conversation he had with former *Times* editor Max Frankel, who told him, "The problem with editorial cartoons is that you can't edit them," to which Marlette responded: "Why would you want to?"[48]

All employees of a news organization are subject to controls of some kind, whether influenced by outside forces like advertisers, enforced by newsroom

policy, or dictated by professional routines. Todd Gitlin noted that these routines are structured in the ways that journalists are socialized, trained, edited, rewarded, and promoted; that they shape the ways in which news is defined, events are considered newsworthy, and "objectivity" is defined.[49] Newsroom policies are established by either the publisher or the editor and then are passed down to other midlevel editors and, finally, to reporters.[50] Disagreements on issues between reporters and editors are essentially moot, because the conventions and organizational structure of journalism demand that opinions be restrained by the writer or excised by the editor. Whenever media workers deduce what their supervisors want and give it to them, de facto control has been exercised. Socialization represents a powerful influence in how newsroom employees act. Journalists who want to be promoted are expected to conform to the policies of the newsroom.

The literature on the sociology of news focuses primarily on editors and reporters. Reporters who have mastered the routines of the profession—such as knowing what questions to ask, where to find information, and how to write a story under deadline—are valued for their professionalism. For journalists, professionalism consists of structuring stories in an inverted pyramid, covering beats, meeting deadlines, maintaining contacts with sources, rewriting press releases, presenting different sides of an issue, and otherwise being "objective." The claim to objectivity enables story selection, treatment, and context to become an implicit foundation for interpreting news events. A reporter can claim objectivity by citing procedures such as verifying the "facts," presenting supporting evidence, using quotation marks judiciously, and structuring the information in an appropriate sequence.[51]

For editorial cartoonists, however, there is no inverted pyramid, no need for contacts with sources, no need to present both sides of an issue, and no need to be objective; in fact, these all are counterproductive to satire. Cartoonists are not expected to break the news; rather, their job is to satirize it. A cartoonist's work is a reflection of the artist's tastes, interests, attitudes, and biases. An artist who supports a woman's right to choose an abortion can express that in his or her cartoon; by comparison, a reporter covering a story cannot, or at least should not, include his or her opinion. Unlike reporters, editorial cartoonists' professional status depends on their freedom and ability to express their opinions.[52] In their study of the relationship between editorial cartoonists and their editors, Daniel Riffe, Donald Sneed, and Roger Van Ommeren concluded that cartoonists may require more autonomy than anyone else in the newsroom.[53]

Although some cartoonists consider that one of the rewards of their profession is the freedom to express their opinions, most believe that they are

restrained by their editors, who often do not understand the basic function of an editorial cartoon. According to one survey of editorial cartoonists and their editors, almost 45 percent of cartoonists said that they did not think editors understood the purpose of editorial cartoons.[54] For instance, Bruce Beattie of the *Daytona Beach (Fla.) News-Journal* said that he was fired from a Honolulu newspaper over his differences of opinion with his editor. "I wanted to become a nationally syndicated cartoonist," Beattie said. "His philosophy was that he wanted me to do local cartoons. But it was worse than that. He wanted me to do cartoons of tourists doing funny things in grass skirts. We had to part ways."[55]

Editorial page editors usually are former reporters, not cartoonists. Whereas editors are taught to rely strictly on the facts, cartoonists satirize the facts. Editors tend to be literal; cartoonists are figurative. And although editors, reporters, and photographers are usually restricted by professional notions of objectivity, the cartoonist's job is to provide commentary.[56] These differences between editors and cartoons help explain why editors do not understand the function of editorial cartoons, why cartoonists are often given less freedom than editorial writers or columnists have, and why so few newspapers have their own cartoonist on staff.

"Writers grow up to be editors," Mike Peters of the *Dayton (Ohio) Daily News* said. "Cartoonists just grow up to be old cartoonists." When Peters was hired by the *Dayton Daily News* in 1972, he was working in the art department of the *Chicago Daily News*. He knew it was the last promotion he would get as a cartoonist. On his last day in Chicago, he went to lunch with two of the greats in the profession: Bill Mauldin and John Fischetti. "It was almost like them initiating me into a club," he said. "So we got on the elevator and the three of us editorial cartoonists went downstairs and we went over to Ricardo's and sat at the editorial cartoonists' table, and we had editorial cartoonists' drinks, and we sat around talking about editorial cartoons."[57]

Peters has been working at the *Dayton Daily News* ever since. Other newspapers have tried to hire him, but Peters has remained with the *Daily News*, largely because he has a good relationship with the newspaper. "I wouldn't have stayed at this paper if I had a bad situation. I've been to other papers, and I know I've got a real good situation. I do whatever I want to do. It doesn't mean they're going to print it, and that's their prerogative," he said.[58] When Peters, a Pulitzer Prize winner, wanted to move to Florida and send his cartoons from there, the newspaper obliged. Membership in the Pulitzer club, of course, has its privileges. But as Marlette and other cartoonists have learned, it does not guarantee lifetime security.

The conflict between cartoonists and editors over issues of freedom and function obviously is nothing new. In 1902, Charles G. Bush of the *New York World* said that he had to ridicule his own political party at the insistence of his editor, who belonged to the other party.[59] In 1911, "Ding" Darling left Iowa for the *New York Globe*, where he had recurring conflicts with his editors over their insistence that his work reflect the newspaper's editorial policy. His frustrations boiled over in a letter he wrote in 1913. "The newspaper organizations down here," he said, "are all for the world like a factory organization in which the foreman is responsible to the stockholders and below his level everyone is subject to the axe for the sake of dividends." Shortly thereafter, he returned to Iowa, where he worked for the next half-century for the *Des Moines Register* and was allowed to express views contrary to those of the newspaper's editors, although this did not happen very often.[60]

During the Progressive Era, when cartoonists perhaps had more influence than at any other time, they still were largely hired guns who publishers and editors gleefully set loose on their critics. Homer Davenport's trenchant drawings of a fat, dollar-stained Mark Hanna was an extension of publisher William Randolph Hearst's feelings. If Davenport had caricatured Hearst's friends with the same contempt, the publisher would not have laughed quite so hard, and the cartoon may not ever have been published. Cartoonists who insist on drawing their own conclusions have always had difficulty finding outlets that will publish their work. Thomas Nast, it should be remembered, tried to publish his own magazine, in which he would have had complete autonomy, but the venture failed.

Sometimes cartoonists donate their work to an alternative or a radical magazine just to see it in print, but it is unlikely that they will be compensated as well as if they worked for a mainstream newspaper or magazine. In the 1920s, when Al Hirschfeld was working for *The Liberator*, a watered-down successor of *The Masses*, a cartoon critical of Father Coughlin upset his editors, who felt it would alienate those loyal trade unionists who were Catholic. "Insisting that sanity, reason, honesty, political truth were all incontestably on my side," Hirschfeld later said, "I finally convinced them I was not only stupid, willful, and irresponsible, but—this from the proletarian poet—that I also was acting like a lousy dictator. At any rate, the drawing was never used, and I have ever since been closer to Groucho Marx [than Karl]."[61]

Illustrator Edward Sorel once called editorial cartoonists "the second-class citizens of the editorial page" and noted that newspapers have a double standard: one for their columnists and the other for their editorial car-

toonists. Cartoonists, unlike columnists, Sorel pointed out, must submit their drawings to their editor before they are published and are expected to support the newspaper's editorial policy. "I cannot call it censorship since it was never any other way," he said. "The notion of giving the same freedom of expression to the artist that is given to the columnist is simply undreamed of."[62] John Somerville, who left editorial cartooning in the late 1950s, observed that columnists were given more freedom and scope than editorial cartoonists were. "Editorial policy is not so much the limiting factor in many cases," he said, "but rather the absence of understanding on the part of the editor as to the role the editorial cartoonist should play."[63]

In 1962, a number of cartoonists went public with their demand for more freedom, in a series of articles published in *Editor & Publisher*, the newspaper industry's trade magazine. Bill Sanders wrote that "a careful and honest examination of America's editorial cartoons reveals a vast wasteland of multicaptioned, hackneyed cartoons."[64] Hugh Haynie added that he had walked out of an interview with an editor when informed that if he were hired, he would be told what he could or could not draw. "Editorial cartoons, as such, are the dullest, most monotonous thing that appears in the daily newspaper," he said. Like Sanders, Haynie classified himself as a liberal and insisted that for a cartoon to be effective, it had to be critical, and harshly so.[65]

The *Editor & Publisher* series concluded with an appeal from cartoonist Bill Crawford, who called for a "new cartoon" that "can't be an illustrated headline. It must have a personal slant—must convey a feeling about the news that the reader can identify with."[66] Vaughn Shoemaker spoke for the older generation of cartoonists who, having spent decades deferring to their editors, criticized the younger cartoonists for their presumptuousness. "They appear to have brought little new to our field unless it is a brazen demand for freedom which they as of yet have not earned," Shoemaker said. "Instead of making unjust demands for carte blanche control over copy which is interpreted as representing the views of the newspaper, a good cartoonist will learn all he can from his experienced editor in the hope that he may develop sound, mature judgment."[67]

Watergate forever changed the relationship between the public and politicians because it changed the relationship between politicians and reporters, from one of complicity to one more adversarial in nature. The rules changed so profoundly that things could never be the same. In post-Watergate journalism, reporters, columnists, and cartoonists have been able to say things in print that they had only thought before. But this did not necessarily mean that editors would give cartoonists the freedom to contradict the newspaper's editorial position.

Editorial page editors debated how much freedom cartoonists should have in a 1979 series of articles in *The Masthead*, the newsletter of editorial page editors. Ladd Hamilton, senior editor of the *Lewiston (Idaho) Morning Tribune*, argued that giving free rein to cartoonists would be "irresponsible" because "the opinions expressed on an editorial page should have the support of the paper except when they appear in columns and letters plainly identified."[68] His opinion was criticized by Don Robinson, editorial page editor of the *Eugene (Ore.) Register-Guard*, who said: "Where did [anyone] get the idea that a published editorial cartoon has to jibe with the view of the paper? Why should that limit be imposed on cartoonists any more than on columnists, letter writers, or other essayists who make their way into the editorial forum."[69]

Too many newspapers still insist that editorial cartoonists—and editorial writers and staff columnists—adhere to a narrow standard maintaining that all opinions must agree with those of the newspaper, except those written by readers or, perhaps, syndicated columnists. Such a parochial notion contradicts not only the best interests of an editorial page but also the best interests of a democracy, in which the best ideas often come as the result of the clashing of differing opinions. It also defeats the point of an op-ed page, which is intended to offer viewpoints contrary to those of the editorial board. It is shortsighted to restrict the very people—columnists and editorial cartoonists—who are best qualified to render an opinion. Finally, it makes for a pretty dull newspaper. *The Masthead* solicited cartoonists to illustrate their arrangement with their editors in pictures (figures 5.11 and 5.12). In recent years Wiley Miller and Jeff Danziger also have done this with their illustrations (figures 5.13 and 5.14). And in a drawing by Doug Marlette, Benjamin Franklin's editor decides against publishing Franklin's "Join, or Die" cartoon for fear of offending King George III (figure 5.15).

Cincinnati Enquirer cartoonist Jim Borgman raised the issue that editorial cartoons are signed commentary like a column and that, like columnists, cartoonists should be allowed to express a perspective that might conflict with that of the editorial board. Borgman said that his newspaper received very few letters suggesting that readers were confused by a contrary cartoon about the paper's position on issues. "The signed cartoon is recognized as its own voice. What my editor may lose in control over that space, he gains in freshness, vigor, and spontaneity, the stuff of debate," Borgman wrote, adding that he believed that he brought readers to the editorial pages, asking: "Isn't that as valuable to your editorial page as it is to me?"[70]

Cartoonists have asked for no more—and no less—freedom than an editor would give a columnist. Signe Wilkinson of the *Philadelphia Daily News*

Figure 5.11 Lee Judge, *Kansas City Star*, undated.

Figure 5.12 Dana Summers, *Orlando (Fla.) Sentinel*, undated.

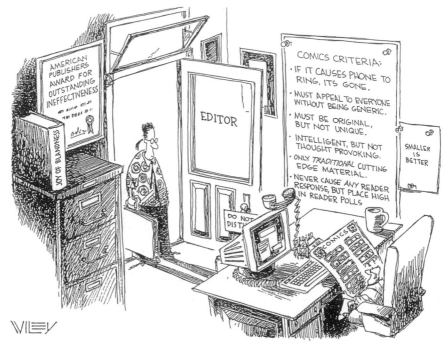

Figure 5.13 Wiley Miller, undated.

said that her newspaper gives her the freedom to draw cartoons that do not agree with its editorial policy. "I feel like we're more like columnists," she said.[71] When Tom Toles was with the *Buffalo (N.Y.) News*, he said that "you take a greater pride and interest in something when it's your own."[72] Another cartoonist put it this way: "The problem of having to please someone else is that you don't think up the best cartoon; you sit and try to dream up something that will get by the brass."[73]

Cartoonists who try to circumvent editorial policy, no matter how creative, can find themselves without a job. When Rob Lawlor of the *Philadelphia Daily News* wrote his estranged wife's unlisted telephone number across the chest of a jailed apartheid prisoner, he was fired. In 1983, Paul Szep of the *Boston Globe* drew President Ronald Reagan saying to Soviet Premier Yuri Andropov: "Hey, Yuri, guess who's getting a new MX missile system to help arms reduction and world peace?" Andropov replies with a two-word obscenity in Russian. Szep was suspended for two weeks.[74] "I love [Szep]. But he can be a pain in the ass. . . . He reduces the paper's credibility with people by [being] tasteless," *Globe* editorial page editor Martin Nolan said.

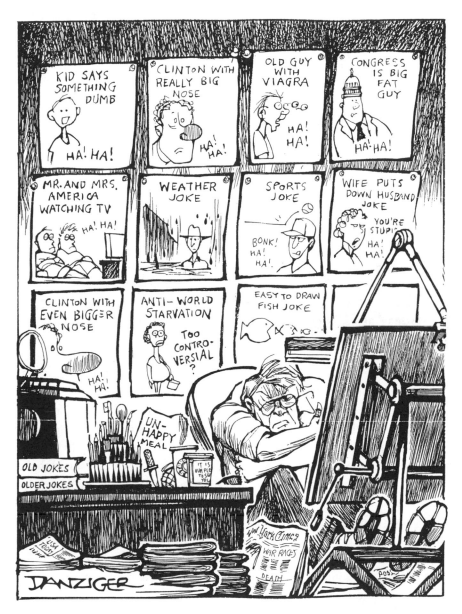

Figure 5.14 Jeff Danziger, undated.

"SORRY, BEN . . . NICE CARTOON, BUT KING GEORGE MAY BE OFFENDED."

Figure 5.15 Doug Marlette, undated.

The late Ralph McGill, a venerable Atlanta newspaper editor, said that a good relationship between editor and cartoonist is mutually productive. "Both strengthen one another. Cartoonists do not like to have their creative instincts controlled by editors," McGill said. "Cartoonists should develop their own ideas because that is where the talent lies."[75] McGill was right, as Rollin Kirby acknowledged years earlier: "A good idea has carried many an indifferent drawing to glory but never has a good drawing rescued a bad idea from oblivion."[76] The late John Fischetti claimed that Kirby did not mention how to get a good idea published if the idea is at odds with a newspaper's editorial policy. That, he said, was "the rub."[77] Fischetti's editor, Ken McArdle, wrote that it was not necessary for the relationship between a cartoonist and his or her editor to always be harmonious but that he tried to make it possible for Fischetti to create his best ideas.[78]

When M. G. Lord was working at *Newsday*, her editor, Sylvan Fox, complained that Lord's editorial cartoons caused him problems because she distorted the facts and that he tried to tone down the cartoons for the purposes of fairness. Lord responded by saying that she entered editorial cartooning with the independent-minded Honoré Daumier as her hero. But because she wanted to remain a cartoonist, she had decided to adopt as her new hero Marshal Philippe Pétain, the Frenchman who had run the

German-occupied Vichy government of France during World War II and was later tried for treason.[79] When Marlette went to work at *Newsday*, he, too, found that the newspaper had what he referred to as "a didactic approach" to editorial cartoons. "They would call me and ask me to change the caption," he said. "I'd say, 'I can change the caption but then I'd have to start over.' An editorial cartoon is organic. Everything is connected to everything else." Marlette added that he had conflicts with his editors at *Newsday* if his cartoon did not "fit into their liberal, knee-jerk doctrinaire view."[80] In one of his drawings, Marlette nicely captured the difference between editorial cartoonists and their editors (figure 5.16).

Marlette said that his editors at the *Charlotte Observer, Atlanta Constitution,* and now *Tallahassee Democrat* had a better understanding of the editorial cartoon. He praised his current editor, Mary Ann Lindley, for "getting it." "She wrote a column for fifteen years," he said. "She understands that part of the deal is being interesting . . . being provocative. She will say, 'It might not be how I would say it, but it's your right.'"[81] Clay Bennett explained that just as there are editors who are called "writer's editors," there are editors who are "cartoonist's editors." What that means, Bennett said, is having an editor who understands what he is trying to accomplish and supports him.[82]

Jerry Fearing, the longtime editorial cartoonist of the *St. Paul Dispatch and Pioneer Press,* once observed that too many editors are suspicious of cartoonists because they seem to believe that cartooning is something that a few people picked up in the third grade and is not a particularly respectable way for a grown-up to earn a living. "Unfortunately, the editor you end up with depends entirely on the luck of the draw. If you get a good one, take care of him. See that he eats right, supply him with vitamins, discourage him from drinking or smoking—anything that might shorten his life," Fearing said, adding: "More than likely, you'll end up with the one of the other kind, which will teach you to be humble and patient. It'll also increase your religious fervor because you'll spend a lot of time praying . . . that some other paper will hire him away."[83]

Ed Williams, the veteran editorial page editor of the *Charlotte Observer,* recognizes the importance of a good relationship with his editorial cartoonist. Williams, who worked with Doug Marlette and now Kevin Siers, said it was an unnatural act for editors to work with cartoonists, "a mispairing of the magnitude of a marriage between Hillary Clinton and Howard Stern (or maybe, for that matter, Hillary Clinton and Bill Clinton)."[84] Williams said that the "cartoonist's job is to be provocative" and the "editor's job is to decide what a family newspaper will publish." He said

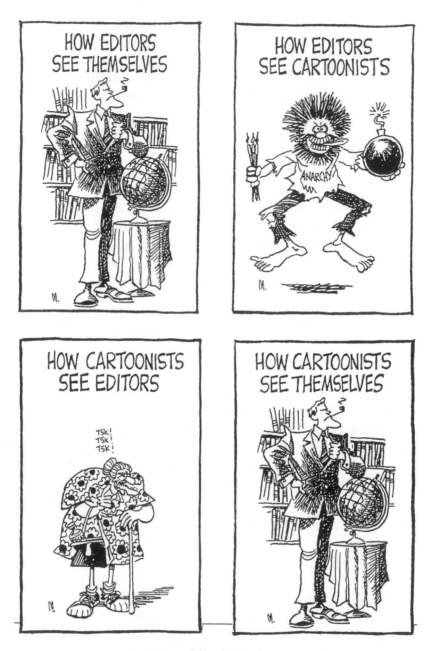

Figure 5.16 Doug Marlette, undated.

he treats the cartoonist in the same way as he does a columnist: "So the standard I apply is not whether the cartoon reflects our editorial position ... but whether it makes a point that the general reader of our pages is likely to understand and whether it is within the general bounds of taste and hyperbole that we apply to cartoons."

Williams said that before the newspaper publishes a cartoon, the editor and cartoonist should be able to defend it. If he can do that, there is no need to apologize. In a quarter century, Williams said he has had to apologize for only one cartoon, which criticized a local judge for releasing a prisoner. When the cartoonist submitted a sketch of the cartoon, he and Williams discussed it. Later in the day, after Williams had left the office, the cartoonist revised the cartoon, making it better visually but factually inaccurate by shifting the emphasis from the judicial system to a specific judge. In a column, Williams concluded that the cartoon had wrongly blamed the judge and apologized. "The judge then asked for the original so he could frame it with the apology," Williams said.[85]

Apologies can breach the trust between cartoonist and editor. Several years ago, Steve Benson of the *Arizona Republic* used an image of the Oklahoma City, Oklahoma, bombing to criticize the death penalty, which angered hundreds of readers, including relatives of those who had died in the tragedy. Benson's editorial page editor, Paul Schatt, defended the cartoonist by saying that "you have to give a cartoonist freedom to be creative." However, the newspaper's executive editor then apologized for the "unintentional distress" caused by the cartoon.[86]

Shortly afterward, Benson submitted a cartoon spoofing the Southern Baptists' boycott of the Walt Disney Company. Schatt told him to draw something less controversial, whereupon Benson submitted his resignation because he believed the reaction to the death penalty cartoon had had a chilling effect. After discussing the matter with Schatt and other newspaper executives, Benson reconsidered, saying that Schatt had supported him during the death penalty cartoon flap. "Paul donned his asbestos suit, walked into the heat of the battle, and defended me," Benson said, adding that while the newspaper had apologized for his cartoon's "unintentional distress," it had not apologized for the cartoon.[87]

"We Certainly Don't Want to Make People Uncomfortable Now, Do We?"

Doug Marlette remembers the first time one of his editorial cartoons was not published. While working in the art department of the *St. Petersburg (Fla.) Times* during the late 1960s, the newspaper ran a story about a local high school that had the nickname Rebels, flew the Confederate flag, and played "Dixie" at football games. Black students, who had recently been bused to the school, protested the school's customs, which angered the white students and resulted in racial confrontations. As he drove home from work, Marlette thought of a cartoon with a couple of white school-children, including a girl holding a flag with a German swastika who says: "I just don't understand why those Jewish kids are so uptight about our school flag!" (figure 6.1). His editor, however, decided against publishing the cartoon because it would exacerbate an already tense situation.[1]

This was not the last time Marlette's work was left on the drawing-room floor. While he was working deep in the Bible Belt for the *Charlotte Observer* in North Carolina, the state led the nation in the number of death-row convicts. Marlette drew Christ marching up Golgotha with an electric chair on his back (figure 6.2). The newspaper's editorial page editor decided against publishing the cartoon, which created a debate among newsroom staffers about whether the decision was censorship or editorial imperative. The editor wrote a column explaining why he had not run the Christ cartoon and accompanied his explanation with the suppressed drawing, which Marlette found puzzling, if not ironic.[2]

Later, when Marlette was working for *Newsday*, Catholic prelates decided that politicians who supported abortion rights should not be allowed to take Communion. Marlette drew Christ and the apostles from Leonardo da Vinci's *Last Supper* under a sign that said "No shirt, no socks, no pro-life, no service." Marlette said his editor rejected the drawing because it made fun of religion. In another cartoon, Marlette criticized John Cardinal O'Connor

Figure 6.1 Doug Marlette, not published, undated.

Figure 6.2 Doug Marlette, not published, undated.

for having hired a public-relations firm to publicize the church's views on abortion. Marlette's cartoon shows a Roman soldier and a bishop at the Crucifixion, with the latter saying: "He should've hired a good p.r. firm!" (figure 6.3). His editor, he said, considered the drawing in bad taste and would not publish it.[3]

Marlette said that his conflicts over whether a cartoon should be published rarely involve drawings that are political in nature. And even when they are about politics, he said, the reason they are rejected has more to do with taste. For instance, Marlette said that *Newsday* once rejected one of his drawings that satirized the outspoken and often salacious radio-talk-show host Howard Stern after he announced that he would run against New York's incumbent governor, Mario Cuomo. In the cartoon, Marlette depicted Stern in a trench coat and garters, flashing the Statue of Liberty, who responds: "It looks like a challenge to Cuomo's leadership—only smaller!" (figure 6.4).

James Klurfeld, the newspaper's editorial page editor, said he thought that the drawing "was in poor taste and so I didn't think it was appropriate for *Newsday* . . . that's my job as editor of the editorial pages. There are times when things in bad taste are appropriate, but this one struck me as kind of locker-room humor." Marlette countered that he found the drawing perfectly appropriate because it attacked Stern on his own terms. Mark

" HE SHOULD'VE HIRED A GOOD *P.R. FIRM !* "

Figure 6.3 Doug Marlette, not published, undated.

Figure 6.4 Doug Marlette, not published, undated.

Schultz, editor of the *Chapel Hill (N.C.) Herald*, published the cartoon, which had been distributed by Marlette's syndicate. "I thought twice about running it," Schultz said. "In the back of my mind I thought, 'This is just about the limits of what we might run,' but the purpose of the page is to generate discussion, to get people talking and to have them respond to what you have put up there."[4]

Marlette won his Pulitzer Prize for his work on televangelist Jim Bakker, who ended up in jail after being convicted for committing fraud. Bakker, it was later reported, used his ill-gotten gains to support his lavish lifestyle. While working for *Newsday*, Marlette drew Bakker in a prison cell writing a letter, which says: "Prison is *not* a blessing. There is no shag carpet and no gold toilet fixtures. Also, my cell-mate, Big Leroy, keeps giving me gifts and saying I'm his 'life-time partner'!" (figure 6.5). Marlette said his editor told him the drawing was racist because it used the name Leroy. Marlette countered that as a Southerner he had known just as many white Leroys as black Leroys. Nevertheless, the newspaper did not run the drawing.[5]

Marlette observed that he had had more cartoons rejected while working for *Newsday* than he had while working for any of the southern newspapers for which he has worked, contrary to the stereotype of tolerant Easterners and intolerant Southerners. Marlette wrote that the *Charlotte Observer*, the *Atlanta Constitution*, and now the *Tallahassee (Fla.) Democrat*

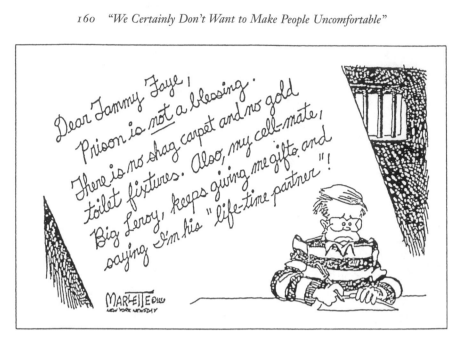

Figure 6.5 Doug Marlette, not published, undated.

were more willing to discuss unpopular ideas than was *Newsday*. Southern progressives, he said, took issues like civil liberties, free speech, and religious freedom more seriously because they had fought for them during the civil rights movement.

Eastern liberals enjoy ridiculing Southerners for their attitudes, but when their own opinions are called into question, Marlette said, they run for cover, hiding behind an apology if need be. "We Southerners were not raised in a culture suffused with lip service to liberalism and our ideas on race, civil rights, civil liberties were not spoon-fed to us but had to be earned, and for many of us those lessons were costly, our sense of commitment to freedom of expression is less an abstract notion than it seems to be here in the Northeast," Marlette wrote. "Free speech, for us, is not a liberal whim, a pretty ideal, a cocktail party pronouncement, something we write about in editorials but wuss out when the heat is on. Perhaps because in the time and place we came up in, during the crucible of the civil rights movement in the South, these ideas lived and breathed and were fought over and acted out in the flesh and blood of our lives. . . . And their absolute importance to the life and health of a community is not just in our minds now, but in our hearts and in our bones."[6]

Marlette's conclusion about Easterners' reluctance to publish hard-hitting cartoons was supported by Bob Englehart of the *Hartford (Conn.)*

Courant, who, before moving to Connecticut, worked for newspapers in the Midwest, such as the now-defunct *Dayton (Ohio) Journal Herald*. Englehart says that he has had more cartoons rejected since moving to the Northeast than he did in the Midwest. "The Midwest is more tolerant in terms of humor. I think it's because the Midwest doesn't have the intense history that New England does," he said. "It's extraordinarily boring living in the Midwest and the only entertainment is to make each other laugh. In New England people love their institutions a little too much, and there's no humor in institutions."[7]

Newspaper readers may take their politics seriously, but they take their religion solemnly, which explains why cartoons concerning religion make a lot of editors squeamish. Accordingly, many cartoonists proceed carefully when treading on ground that others find sacred, because they know that if they satirize a particular religion or its religious symbols, there will be hell to pay when people read their newspapers the next morning. Marlette, a Southern Baptist, has enraged Baptists, Catholics, Muslims, Jews, and probably even agnostics—and sensitive editors have declined to publish his drawings for fear of offending all these groups. Sometimes, Marlette said, editors will go to absurd lengths to limit any controversy. One newspaper even prohibited its cartoonist from using the Star of David, even when drawing Israeli tanks, which actually do have the Star of David on them.[8]

For Steve Benson of the *Arizona Republic*, being Mormon helps define him, and his criticism of the Mormon Church caused such a rift that it affected both his professional and his personal life. After the health of Benson's grandfather, Ezra Taft Benson, who was president and prophet of the Mormon Church, began to deteriorate to the point that he had become, according to the cartoonist, "semi-senile," the cartoonist told the Associated Press that the church had gone to great lengths to cover up the ninety-four-year-old man's illness and keep it from church members. Benson chided the church for turning his grandfather into what he called a "dimestore mannequin." Benson later resigned from the church over the issue. Brigham Young University, from which Benson had graduated, suppressed a magazine profile of the cartoonist, and the campus newspaper stopped publishing his work, which it had run regularly for fifteen years.[9]

For many cartoonists, religion is a natural part of their work because the symbols are so widely known, the issues are so personal, and it infuses the drawing with a sense of righteous morality. After Matthew Shepard, a gay man, was beaten, tied to a fence post, and left to bleed to death, Dennis Draughon of the *Scranton (Pa.) Times* drew a bound Shepard striking a Christ-like pose in a puddle of blood labeled "Hate Crimes" (figure 6.6).

Father, forgive them; for they know not what they do...

Luke 23:34

Figure 6.6 Dennis Draughon, not published, undated.

But Draughon's editor decided against running the cartoon because he was "uncomfortable comparing Shepard with Christ." When he heard the reason, one cartoonist responded by saying: "We certainly don't want to make people uncomfortable now, do we?"[10]

It is the job of the editorial cartoonist to be provocative, which often requires stretching the limits of taste, and it is the job of the editor to decide what goes into the newspaper. Editorial page editors and editorial cartoonists report that 70 percent of editors and almost 50 percent of editorial cartoonists believe that cartoons are rejected because they are in questionable taste. But defining taste is itself a questionable proposition. As the Supreme Court said in *Cohen v. California*, "one man's vulgarity is another man's lyric."[11] Similarly, a cartoonist's lyric can be an editor's vulgarity, and while the lyrical is permissible, the vulgar is not. Ted Rall submitted a cartoon titled "America: The Land of Many Penises," which satirized the media's preoccupation with sexual content in a number of stories, including one on John Wayne Bobbitt, whose wife cut off his penis after a domestic dispute, and Paula Jones, who once described Bill Clinton's penis during testimony regarding one of the Clinton administration's scandals. But Rall's syndicate refused to release the drawing.[12]

Ultimately the decision about what is lyrical and what is vulgar rests with the editor. But sometimes real life complicates that decision. For instance, having a character raise his middle finger is generally off limits in editorial cartoons. But what if a politician himself gives someone the finger, as Governor Nelson Rockefeller of New York once did? George Fisher, the longtime cartoonist of the *Arkansas Gazette*, remembered that his newspaper published a photograph of Rockefeller making the obscene gesture on page 1. But when Fisher drew Rockefeller giving someone the finger, the newspaper would not run the drawing.[13]

When Herblock drew angry motorists raising their middle fingers in a cartoon, the *Sacramento (Calif.) Bee* published the drawing—but only after deleting the offending fingers. According to the *Bee*'s cartoonist, Dennis Renault, the fingers were deleted by a lower-level editor without checking with the editorial page editor, which, he said, represented not just a breach of editorial protocol but also an example of the excesses of the "satirically challenged."[14] The *Los Angeles Times*, however, once published a Paul Conrad cartoon of Iran–contra conspirator Oliver North taking the oath during congressional hearings investigating the scandal. But instead of drawing North holding a Bible, Conrad tried to capture North's contempt for the judicial system by showing him with his middle finger in the air (figure 6.7).[15]

Figure 6.7　Paul Conrad, *Los Angeles Times*, 1987.

Since Conrad retired from the newspaper, it has rejected his syndicated cartoons, such as one entitled "Congressional Bipartisanship," which shows an elephant humping a displeased donkey.[16]

When Ronald Reagan's attorney general, Edwin Meese, called for mandatory drug testing in the workplace, Marlette drew Meese, with his back to the reader, urinating on the Bill of Rights. Reagan, standing nearby and holding a glass, says: "No, Meese—the urine sample goes in here!" (figure 6.8). The *Charlotte Observer* did not publish the cartoon, however, because, according to Marlette, it was in bad taste. "I thought it was entirely appropriate," Marlette said. "I wasn't the one who introduced urine samples into public discourse. Ronald Reagan did that."[17] In 1995, Justice Antonin Scalia wrote the Supreme Court's opinion approving random drug tests for student athletes. Englehart drew "Coach Scalia" ordering a boy to urinate his "constitutional rights" into a cup (figure 6.9). The newspaper did not publish it. "No 'piss' cartoons had been published in the [*Hartford*] *Courant* up to that time," Englehart said. "Since then, a couple have sneaked through, but urine remains a tough sell."[18]

In addition, Englehart said that any drawing containing sex or sexual organs also usually ends up on the drawing-room floor, although the Clinton scandals made these drawings more acceptable. During the first Bush administration, the president nominated Clarence Thomas as an associate justice of the Supreme Court, but the nomination ran into problems when Thomas was accused of sexual misconduct. Englehart drew Thomas posing in four positions: "Hear no evil," "See no evil," "Speak no evil," and, in the last panel, with his hands covering his groin. The newspaper did not publish it. "It was thought to be [in] bad taste," Englehart said, "but I thought it told his story in one simple graphic."[19]

During his twentieth anniversary of working for the *Courant*, the newspaper published a dozen of Englehart's cartoons that had not been published, by either the decision of the newspaper or that of the cartoonist. Englehart admitted that he sometimes did not need an editor to tell him that something should not be published. When a teenage ice-skating sensation was charged with DUI, Englehart drew her skating in the shape of a beer bottle. When he showed it to his wife, she said, "If you run that cartoon, I'll never speak to you again. She's just a kid who never had a childhood." Englehart decided not to submit it. "Any man who's married knows there's a hierarchy of bosses," he said. "This one never left the house." After singer Sonny Bono was killed in a skiing accident, Englehart drew Bono crashing into a tree on the slopes while singing, "I got you, Babe." Englehart knew better than to submit the cartoon for publication.[20] If he could not defend

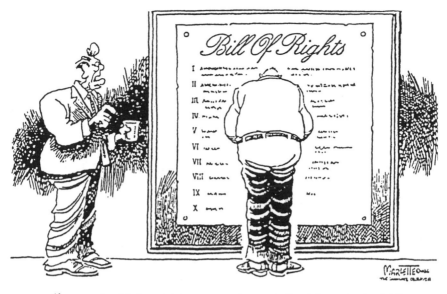

"NO, MEESE—THE URINE SAMPLE GOES IN HERE!"

Figure 6.8 Doug Marlette, not published, undated.

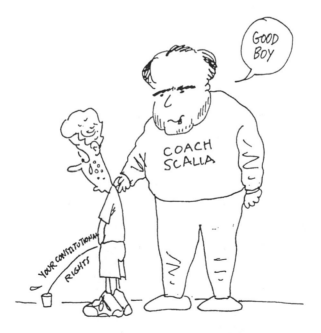

Figure 6.9 Bob Englehart, not published, undated.

why he drew it, he was not about to publish it, which is probably a good rule to follow.

Just as any man who is married knows, there is a hierarchy of bosses at home, as Englehart put it, and there also is a hierarchy of bosses at the newspaper. When the first President George Bush fainted during a state dinner in Japan in 1992, it meant that the much-maligned vice president, Dan Quayle, was briefly president. Englehart drew a cartoon of three Secret Service men standing next to the boyish Quayle. Behind them on a wall is an ax in a glass case with a sign that says "Break in case of emergency." One of the Secret Service agents is looking at the ax and wondering whether he should break the glass (figure 6.10). When the newspaper's publisher saw the cartoon, he called Englehart, yelling, "Are you advocating the assassination of the vice president of the United States?" Englehart answered, "Yes, sir." The publisher then replied firmly, "Not in my goddamn newspaper!"[21]

Whether or not a cartoon is approved for publication often depends on the sensibilities of the editor or publisher. But sensibilities change, just as editors do, as Englehart knows. "I've had my cartoons approved by a committee, a liberal, a Socialist, two conservative Reaganauts, a closet psychotic, a

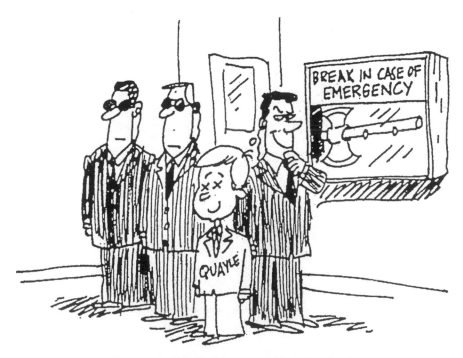

Figure 6.10 Bob Englehart, not published, undated.

Victorian patriarch, a nit-picker and the role model for TV's Lou Grant [television program]," Englehart said. "I depend on a sharp, gutsy editor. I try very hard to avoid self-censorship and am an extremist about freedom of expression and believe that virtually anything has a right to be published. I leave it to my editor to judge reader sensitivity, but occasionally we lock horns and do battle."[22]

In 1986, it was reported that Supreme Court justice William Rehnquist, then nominated to be chief justice, belonged to a country club that barred Jews and lived in a subdivision that did not allow blacks to buy houses there. Englehart drew Rehnquist raising his judicial garb to reveal himself as a caveman (figure 6.11). Englehart's editor rejected the cartoon as too "demeaning," whereupon Englehart replied, "Thank you. It's supposed to be." Englehart's syndicate distributed the cartoon, and it ran in several publications, including the usually tame *Newsweek*. When Englehart showed his editor the magazine, he replied: "I don't know if that reflects their bad judgment or mine."[23]

If cartoonists find their editors unwilling to publish a cartoon, they can take their chances with their syndicate, provided they have one. Mike Peters said he once drew a cartoon of Reagan's controversial secretary of the interior, James Watt, being hanged from a tree. When his editor declined

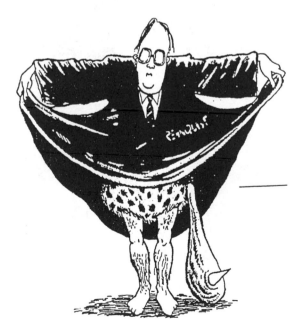

Figure 6.11 Bob Englehart, not published, undated.

to publish it, Peters still had it syndicated. "A couple of papers ran it and dropped me after," Peters said. "So it turned out that my editor was right, yet I still think that hanging was too good for Watt."[24] Cartoonists like Pat Oliphant, who is fortunate enough to make a good living through syndication, are in the enviable position of drawing what they please without being restrained by an editor. "There are no 'sacred cows' for yourself," Oliphant said, "and you're always going to offend somebody."[25]

Cartoonists who are not associated with a syndicate can send their forbidden work to other newspapers, in the hope that other editors will be more accepting. Joe Sharpnack of the *Iowa City Gazette* believed that Republicans had been disingenuous by putting so many blacks in front of television cameras during the 2000 National Republican Convention. So Sharpnack showed the Republican elephant talking on the phone: " . . . oh yeah, it was a GREAT Convention—hey, do me a favor & get those Negroes back to 'Minority Rental' before Thursday or they'll charge us for an extra day" (figure 6.12). In another cartoon, Sharpnack tried to juxtapose the news story of a black man in Texas who was tied to a truck by three white man and dragged to his death with the announcement by ultracon-

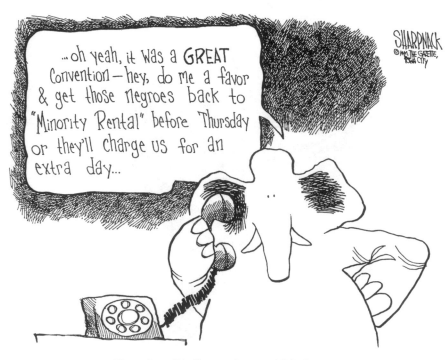

Figure 6.12 Joe Sharpnack, not published, 2000.

Figure 6.13 Joe Sharpnack, not published, 2000.

servative Pat Buchanan that he would be running for president. Sharpnack's cartoon showed the Buchanan campaign bus dragging a black man (figure 6.13). Sharpnack sent the drawing to a couple of dozen newspapers, but none of them published it. To some editors, the cartoon's message was too ambiguous. To the editors who understood it, the drawing was probably too mean-spirited. Sharpnack, however, had no trouble circulating a drawing on racial profiling (figure 6.14).

Even though religious cartoons are often deemed inappropriate because of their propensity to offend, other subjects would seem to be fair game, such as the brutality of totalitarian regimes, the ethics of the Nixon and Clinton administrations, and the honesty of cigarette company executives, who once testified that they did not believe smoking was hazardous. In 1998, the *Albany (N.Y.) Times-Union* rejected Rex Babin's cartoon of a man labeled "Big Tobacco," with a gaping hole in his throat, who is ripping up a sheet of paper marked "Settlement." "We're through talking," the man is saying (figure 6.15). Clyde Wells of the *Augusta (Ga.) Chronicle* submitted a drawing after the National Rifle Association announced that it was having financial problems. In the cartoon, a man, surrounded by guns, is holding out a cup to an approaching pedestrian, saying: "Buddy, can you spare a bullet?" The *Association of American Editorial Cartoonists Notebook* called the drawing "the cartoon that most surprised you it was deemed unpublishable."[26]

Ed Stein of the *Rocky Mountain (Colo.) News* found his editor unwilling to publish a rather innocuous cartoon on Dow Corning's settlement with women who had been given defective cosmetically enhanced breasts. The drawing showed a casket labeled "Dow Corning" with only the breasts visible.[27] Casket cartoons generally, and perhaps appropriately, have a high

Figure 6.14 Joe Sharpnack, *Iowa City Gazette*, 2000.

Figure 6.15 Rex Babin, unpublished, 1998.
Reprinted with special permission of Rex Babin and North America Syndicate.

death rate. When popcorn magnate Orville Redenbacher died, Englehart showed his casket flying open. "He keeps popping out of the casket," one of the mourners tells another. Englehart responded to the cartoon by saying, "I knew this wouldn't get in the paper but I sent it in anyway."[28]

The *Association of American Editorial Cartoonists Notebook* once published a drawing by Steve Benson following the announcement that well-heeled John F. Kennedy's large estate would be auctioning off some of the late president's belongings. Benson, who considered the auction in poor taste, submitted a cartoon of First Lady Jackie Kennedy climbing to the back of the presidential limousine in the moments after her husband's assassination to retrieve part of his brain matter as she thought: "This should fetch a good price at auction" (figure 6.16). His editor understandably refused to publish it.

When the government ordered the Hooters restaurant chain, known for its scantily clad waitresses and bartenders, to hire men, Marshall Ramsey of the *Jackson (Miss.) Clarion-Ledger* drew a man and a women sitting at a restaurant table and being served by a hairy waiter in a tank top with the word "Peckers" on it (figure 6.17). The man thus tells his companion: "Now I understand why the name 'Hooters' offends you." When asked about the drawing, Ramsey said his editors usually let him do almost anything, but they refused to publish this one. "At the last minute, the word *Pecker* was deemed offensive," he said, adding: "No more than Hooter."[29]

In 1994, while Clay Bennett was working for the *St. Petersburg (Fla.) Times*, he intended to comment on Paula Jones accusing Bill Clinton of sexual harassment when he was governor of Arkansas. The cartoon, drawn

Figure 6.16 Steve Benson, not published, undated.

Figure 6.17 Marshall Ramsey, not published, undated.
© Reprinted with permission of Copley News Service.

with Bennett's characteristic simplicity, shows a bewildered Clinton wear-
ing a T-shirt with the words "I'm with Stupid," but the finger is pointing
straight downward (figure 6.18). His editor refused to publish the cartoon
because he said it was "inappropriate for a family newspaper."[30] As it
turned out, however, given the sex scandals that nearly drove Clinton from
the White House, one could argue that this cartoon, as is often the case
with satire, was out in front of real life. Indeed, Bennett's cartoon perhaps
better encapsulates the Clinton presidency than does any other single ar-
ticle, editorial, photograph, or cartoon.

Since Bennett has been working for the *Christian Science Monitor*, he said
he often finds himself submitting work that falls outside the newspaper's
parochial field of acceptance. For instance, the newspaper, with its religious
editorial policy, will not publish work that includes a personal attack. When
the conservative William Bennett, the author of *The Book of Virtues* and a
lecturer on morality, revealed that he had a gambling problem that had cost
him hundreds of thousands of dollars, Clay Bennett wanted to attack him
for his hypocrisy. Bennett knew, however, that such a drawing might be a
difficult one to sell to his editor, who told him: "I don't know how you can
do that without getting personal." Bennett then replied: "But it is person-

Figure 6.18 Clay Bennett, not published, 1994.

al. He is an arbitrator of morality and I want to point out his hypocrisy." The cartoon never appeared.[31]

When one of Bennett's cartoons is rejected, which happens about once every two weeks, he posts it on his Web site after deleting the *Monitor*'s name. This means that at least his cartoon will have some visibility, although it is negligible when compared with the newspaper's circulation. "It is deflating to not have it appear in my own paper," Bennett confessed. "My disappointment about it reflects how strongly I feel about the cartoon."[32] In one cartoon, a pro–President George W. Bush bumper sticker with the words "Four more years" is replaced with one saying "Four more wars." In another, after it was reported that President Bush had lied in his State of the Union address to strengthen the administration's reasons for going to war with Iraq, Bennett drew the words in dispute failing a polygraph test (figure 6.19).

Bennett's cartoon of Clinton wearing an "I'm with Stupid" T-shirt resurfaced in 2003 at an exhibition at the Andy Warhol Museum in Pittsburgh, curated by Rob Rogers of the *Pittsburgh Post-Gazette*. The exhibition included several dozen cartoons that either had ended up on the drawing-room floor or had been published to great outrage. J. D. Crowe of the *Mobile (Ala.) Register* drew the hypervigilant U.S. attorney general John

Figure 6.19 Clay Bennett, not published, 2003.

Ashcroft to resemble the psychotic Jack Nicholson in the movie *The Shining*, breaking through a door and saying, "Here's Johnny!" Crowe's editors did not publish the cartoon because it was considered "a cheap shot, too unflattering and too unpatriotic."

Rob Rogers, too, had one of his editorial cartoons suppressed during the post–September 11 hysteria. He submitted a drawing that criticizes U.S. policy, equating the slaughter of American Indians with terrorism, but it was rejected despite the cartoonist's strong objections (figure 6.20). The next day, Rogers submitted a less objectionable drawing that, unknown to the reader, addresses his editor's squeamishness. In that cartoon, a man with an American flag says that any time we surrender our right to free speech, the terrorists win (see figure 1.18).

Because of the technology of the Internet, cartoons can be distributed farther, faster, more cheaply, and in better quality than ever before. In his biography of Thomas Nast, Albert Bigelow Paine mentioned that Nast took a leave of absence after his editor, George Curtis, would not publish a rather inoffensive caricature of the poet James Russell Lowell, even though the drawing had already been engraved and prepared for publication, at no small cost to the magazine. According to Paine, Curtis and Nast were squabbling

Figure 6.20 Rob Rogers, not published, 2003.

and Curtis believed that a man of letters like Lowell should be above approach from ridicule, however slight, and that Curtis was using the opportunity to flex his editorial muscle over his cartoonist.[33]

Editorial cartoonists now can have their work widely distributed even if their newspapers did not publish it or the drawings were not released by their syndicate. In early 2003, Mike Luckovich drew Georgia's conservative governor, Sonny Perdue, who supported flying the Confederate flag, standing next to a flag labeled "I'm with Stupid," showing the finger pointing directly at the governor (figure 6.21). The *Atlanta Journal-Constitution* editorial page editor, Cynthia Tucker, initially approved the drawing and then rejected it, but not before it had been put on the newspaper's Web site. Before it was pulled, however, a lot of people had already seen it. It then appeared on other Web sites and on television newscasts, and a poster-size version was exhibited in the state legislature.[34]

Tucker explained her decision to suppress the drawing by saying that she thought it was an "unfairly harsh and unduly disrespectful" attack against the new governor. Luckovich agreed. "The cartoon is harsh and disrespectful. Sometimes the truth hurts," he said. Luckovich, however, supported his editor's decision. "There have only been two or three times in ten years that Cynthia has had second thoughts about one of my cartoons,"

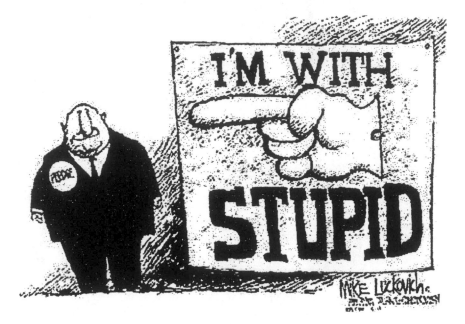

Figure 6.21 Mike Luckovich, not published, 2003.
Reprinted with permission of Creators Syndicate.

he said. "She's such a good editor that I can't be mad at her about this." Luckovich, who acknowledged he was glad the suppressed cartoon got publicity, said he was confident that Perdue would be the kind of governor who would demand such a cartoon at a later date. "I really like the cartoon," Luckovich said. "I'm happy it got a second life."[35]

In rare instances, such as Rall's "America: The Land of Many Penises" drawing, a syndicate decides against distributing a cartoon. In 1985, Universal Syndicate did not distribute a *Doonesbury* series spoofing the antiabortion film *The Silent Scream*, which shows the termination of a twelve-week-old pregnancy. In the parody, which shows the termination of a twelve-*minute*-old pregnancy, the newscaster says, "As the moment approaches, Timmy [the name given to the fetus] seems almost oblivious to the charged debate that attends his fate. . . . The final seconds. By studying his mouth through stop-action imaging, we can determine Timmy's final words, which are, almost certainly, 'Repeal Roe v. Wade'" (figure 6.22). Universal's editorial director, Lee Salem, explained that the decision not to circulate the strip was made because

"the whole question of abortion was so sensitive that it would cause too many problems for editors."[36] The series was later published in the *New Republic*.

During the strip's three decades, newspapers have refused to publish *Doonesbury* strips that either showed or implied nudity or sex, such as a 1976 strip that showed an unmarried couple in bed together or a 1985 strip that included a tangle of male and female students in a Florida motel room.[37] Newspaper editors also had reservations about a strip that had Vietnam War–era Secretary of State Henry Kissinger appearing on the television program *This Is Your Life* while figures from his past reminisced. Actress Marlo Thomas, who had once dated Kissinger, said: "I'm reminded of the many children who were maimed and killed during the Christmas bombings of Bach Mai Hospital." "But. . . . that's awful," the host replied. And Thomas then said, "You bet! Why do you think we stopped dating!"[38]

The *Doonesbury* series "Sleaze on Parade," satirizing Reagan administration officials who resigned or were fired after charges of improprieties, included a few inaccuracies, which made editors nervous. After the *Los Angeles Times* canceled the series, Conrad criticized his own newspaper for its timidity in a cartoon of his own, drawn in the style of *Doonesbury*.[39] The *Times* received six hundred complaints from readers for axing the *Doonesbury* series, and 150 readers canceled their subscriptions.[40] When the *San Francisco Chronicle* canceled a *Doonesbury* strip, it received two thousand irate phone calls. When the *Indianapolis Star* did not publish one of the strips in the first "Reagan's Brain" series, it received more than a thousand complaints.[41] When *Doonesbury* later returned to Reagan's brain, the *Tallahassee Democrat* did not run the series, prompting hundreds of readers to call or write to complain, calling the newspaper's executive editor "a fascist," "a twit," or worse.[42]

Figure 6.22 Garry Trudeau, not published, 1985.
Reprinted with permission of Universal Press Syndicate.

A *Cedar Rapids Gazette* columnist once admitted feeling embarrassed because his newspaper did not publish a *Doonesbury* series that showed the presidential candidate Pat Robertson, a religious fundamentalist, taking campaign orders from God. The columnist, however, disagreed with the angry readers who charged the newspaper with censorship. "It was simply a matter of a newspaper applying its own standards to its own product," he said. "That's something it not only has a right, but an obligation to do." The columnist was right; it is the editor's prerogative to publish—or not publish—what he or she wants. When a newspaper does not publish a cartoon, it does not necessarily mean that it is practicing censorship, and, conversely, it does not necessarily mean that it is not.[43]

An editor's prerogative does not, however, extend to editing the drawing as he might a column or a news article. While editors are free to publish or not to publish *Doonesbury*, their contract with Trudeau and Universal Syndicate prohibits their changing or altering the strip.[44] In Trudeau's strip on Frank Sinatra, the New York *Daily News* removed the reference to the singer's accomplice, who had been charged (though later cleared) with murder. The newspaper's editor explained that if a reporter had handed in the same information, "we would have made him add that [Aniello] Dellacroce was later acquitted."[45] Newspapers that agree to buy and distribute *Doonesbury* and other strips sign a contract stating they will not change them.[46]

During National Education Week in 1958, Walt Kelly's *Pogo* strip included a butterfly telling the Pogo possum: "This is National Education Week an' everybody ought to finish their education." Whereupon the possum replies: "Some places 'round here, education is perty well finished." While many southern newspapers refused to publish the strip, the *Richmond (Va.) Times-Dispatch* merely deleted the offending Pogoism. When the editor defended his right to edit the comic, Kelly disagreed. "Once my name and copyright are on the strips, I am responsible for what is said in them and how it is said," Kelly said. "I'd be willing to let 519 papers go to hell if they want to insist on a right—which they do not have—to edit my copy."[47]

It is difficult to ascertain how often editors refuse to publish cartoons. Somewhere, every day, it happens. Sometimes suppressing a cartoon is justifiable. Other times it is the result of honest differences of opinion between the editor and the cartoonist. Other times the decision reflects a weakness of spirit or backbone on the part of the editor. And sometimes it is the result of outright censorship. But when does editorial prerogative become censorship? One could argue that if a newspaper does not have a cartoonist on staff, that in itself is de facto censorship. If one uses the constitutional argument that prior restraint is the most insidious form of censorship, then such news-

papers practice censorship in every issue. When this happens, editorial decisions regarding which cartoons are published or not published are rendered moot, and therefore the voice of the editorial cartoon is silenced.

Censorship also refers to newspapers forbidding cartoonists to address certain issues or subject matter without at least seeing a rough draft. This happens when newspapers reject all cartoons regarding local concerns, reject those on divisive issues such as abortion, or reject those that violate the publishers' sacred cows. During the early years of the Reagan administration, *Newsday* reportedly told its cartoonist, M. G. Lord, not to criticize the administration's controversial CIA director, William Casey, and Senator Alphonse D'Amato of New York because both lived in prominent Long Island neighborhoods.[48]

Sometimes, in more diabolical instances, editorial cartoons are censored because of corporate interests. When the Detroit newspapers, Knight-Ridder's *Free Press* and Gannett's *News*, were trying to court a favorable joint-operating agreement decision in 1980s from U.S. Attorney General Edwin Meese, Bill Day of the *Free Press* drew several cartoons criticizing Meese. All were rejected. Day's editor told him that the newspaper did not want to jeopardize the joint-operating agreement. He told the cartoonist that whereas a columnist could include enough background or context to explain the criticism, a cartoonist could not. Day was not the only cartoonist in the newspaper's chain whose opinions were being censored. In Miami, where the newspapers also were trying to get a joint-operating agreement, the *Miami Herald*'s editor told its cartoonist, Jim Morin, not to draw cartoons about Meese for that newspaper or any other. Don Wright of the *Miami News* then satirized the *Herald* for backing off Meese.[49]

According to the *Philadelphia Daily News*'s editorial cartoonist, Signe Wilkinson, editors are far less restrictive when it comes to satirizing "cults in faraway places" than they are when satirizing local public figures.[50] Too many publishers and editors prefer drinking cocktails—neither shaken nor stirred—with the political and social elite in the community. One cartoonist said that no newspaper publisher or editor "playing golf with the governor on Saturday" wants to hear, "Why are you letting that commie jump on me?" Wiley Miller, frustrated with having to deal with office politics, left editorial cartooning to draw comic strips like *Non Sequitur*. According to him, "Publishers are afraid of offending their golfing buddies. They don't want to deal with the phone calls. Cartooning is a dying art, and the editors and publishers are standing over the corpse with a smoking gun."[51]

Other editors, perhaps understandably, would rather not spend their time listening to irate readers. As a result, there is no shortage of newspapers that

discourage—or even forbid—their cartoonists from drawing cartoons concerning local figures—that is, unless those being caricatured belong to different social circles. This removes the possibility of either the publisher or the editor having to weather the discomfort of being seated at the same dinner table with a person who appeared in the morning's newspaper as a drooling, addle-brained troglodyte. But something valuable is lost when newspapers put such limits on their cartoonists.

The *Chicago Tribune*'s editorial cartoonist, Dick Locher, told a story about a cartoon that he based on a remark made by the husband of Chicago's former Democratic mayor, Jane Byrne, who said that his wife had "a cute little ass." Locher subsequently drew a cartoon that showed a donkey standing in a corner of the mayor's office. Locher's editor rejected the cartoon for being in bad taste. Soon after, Byrne called Locher to say that she loved the cartoon. Puzzled because the drawing had not appeared in the newspaper, Locher asked the mayor how she found out about it. She told him that the editor had mailed it to her.[52]

Such pandering to politicians compromises a newspaper's integrity and ethics. So does pandering to pressure groups, corporations, and advertisers, but only if the public learns about it. Advertisers sometimes influence newspapers' selection of content by demanding that offending material be edited out or that the story be suppressed entirely. They do this by threatening to withdraw their advertising in hopes of its having a chilling effect on the newspaper.[53] Herbert Altschull's economic model places the influence on media content in the ideology of those who finance it.[54] With newspapers dependent on advertising for revenue, it is not surprising that their editors, whether on their own or fearful of having an ad pulled, will not run cartoons that criticize advertisers.

In the 1970s, Mobil Oil, recognizing that editorial cartoons could influence public opinion, began sending cartoons that criticize government regulations and other issues to use on editorial pages. The issue caused a debate among editors about whether they should tell readers that the cartoons were distributed by the oil company.[55] It may seem obvious that the Mobil Oil cartoons had to be identified as such—or, better yet, that they should not have been published. Newspapers should not reject editorial cartoons for the sole reason that they might offend politicians, advertisers, or readers. But of course, editors being editors, this will continue to happen as long as newspapers must answer to the influences of capitalism.

One, however, can hardly take issue with an editor who will not publish an editorial cartoon that is patently racist or sexist or that lacks redeeming social value. The same can be said for cartoons that are obscene, gratuitous,

obscure, poorly drawn, or poorly written. Many editorial cartoons should be rejected or sent back to the cartoonist because the drawing is not clear and thus may offend readers because they misunderstand it. Some cartoonists acknowledge that they sometimes receive phone calls asking them to explain what they meant. "When I have to explain a cartoon, I feel like I've fallen down on the job," Robert Ariail said.[56]

During the annual convention of the Association of American Editorial Cartoonists, cartoonists exhibit their work that their editors rejected during the previous year. This ritual has convinced cartoonists like Clay Bennett and Joel Pett that a lot of the drawings were rightly rejected. In addition, Bennett noted that many cartoons that were published could have used a bit more time on the drawing board. Some editorial cartoonists believe that any cartoon that upsets its readers is automatically a good cartoon. But this is not necessarily true. "If the outrage inspired by a cartoon is based on its misinterpretation, then the cartoonist did not do his or her job," Bennett said. "Is controversy a sign of a good cartoon? Not always. Sometimes it's just a sign of poor communication."[57] Pett added that the profession would benefit not from more sensitive editors but from more discerning editors. "I wish editors would throw out the silly ones, throw out the ones that are irrelevant, throw out the ones that are obvious, and throw out the cliché, and keep the ones that hit a home run that day," Pett said.[58]

But sometimes—as Bennett, Pett, and others well know—cartoons are indeed rejected for the wrong reasons. According to a survey of editorial page editors and editorial cartoonists, almost 30 percent of editors said they would not publish an editorial cartoon if it was "inaccurate." But accuracy means one thing to editors and something else to cartoonists. To the reporter, it means checking and double-checking a story's facts. But what if the cartoonists distort something that has happened, thereby making it inaccurate in a literal, though not in a figurative, sense? Satire must have a different definition of accuracy, or else cartoons will be needlessly rejected. To the cartoonist, the facts are subject to interpretation—and then to exaggeration. For satire to be effective, according to Mike Peters, there must be at least some truth to the picture. For instance, when the Reagan administration cut money for school lunches from the federal budget, Peters drew Reagan stealing candy from a baby. "He's never stolen candy from a baby. But in the context of the [school lunch funds], that cartoon is accurate because he's taking food away from kids."[59]

According to the aforementioned survey of editors and cartoonists, cartoons are unduly restricted by editors. For instance, 15.5 percent of cartoonists and 13.7 percent of editors said that cartoons were rejected because

they conflicted with the newspaper's editorial position on an issue; 12.7 percent of cartoonists and 17.6 percent of editors cited cartoons that were not published because of legal concerns; and 26.8 percent of cartoonists and 21.6 percent of editors said that cartoons were rejected for fear of offending readers, advertisers, or special-interest groups. If a newspaper wants its cartoonist to produce his or her best work, it should not reject cartoons solely because they might make readers uncomfortable.[60] To paraphrase Garry Trudeau, this is analogous to benching a nose guard because he might tackle the quarterback.

Editors can give cartoonists the freedom to do their best work by surrendering only a little—if any—of their control over the editorial page. First, editors can give cartoonists the same amount of freedom they give their columnists. Second, if editors feel a cartoon that contradicts an editorial will confuse readers, rather than rejecting it entirely, they can identify the drawing as the cartoonist's view. This happened in Buffalo, where Tom Toles's cartoons were labeled "Tom Toles's View." Or editors can publish cartoons that contradict the editorial viewpoint on the op-ed page. Syndicated cartoonist Pat Oliphant recognized the value of this: "Think about the freedoms that go with that move: You become a columnist. And you're free of the editorial page stigma."[61]

Arizona Republic cartoonist Steve Benson said that labeling his work "Benson's View" makes it clear to readers that the opinion of the drawing is not necessarily that of the newspaper's management. This means that he is under no obligation to reflect the editorial line and helps explain why he is one of the most provocative cartoonists working in the United States. If an editor is unsure about publishing a cartoon because of the expected reaction to it, Benson offers to include his office telephone number with the drawing so that calls will go directly to him and not to the editor. In addition, editorial cartoonists have learned that they can sometimes get a sensitive cartoon published if they can defend it by making sure they are knowledgeable about the issue, cite precedent if a similar cartoon has been approved in the past, or be flexible enough to allow a cartoon that runs contrary to a newspaper's editorial position to be printed a day afterward.[62] What if a cartoonist has doubts about whether his or her idea will be accepted? Cartoonist Bill Sanders suggests presenting an idea "more outrageous than you planned and then negotiate back to your original idea."[63]

More than 75 percent of the editors surveyed said that their cartoonists know what will be rejected. Almost 40 percent of cartoonists said that they censor themselves because they do not think a cartoon will be accepted,

which amounts to self-censorship. For every cartoon that is rejected, therefore, the cartoonist rejects another idea that he or she believes will not get past the editor—and therefore another idea lies stillborn in the creative process. Pett called self-censorship "one of the biggest problems in the business. . . . Like most people, we take the easy way out. That's a form of self-censorship when you don't work as hard as you should."[64]

Pett noted that in the past several years, he has had only one cartoon rejected. In that particular drawing, about holiday depression, Pett showed one of Santa Claus's elves hanging himself. When Pett looked at the newspaper the next day, his cartoon was not in it. "It never occurred to be that it was pulled," he said. When he got to the newspaper, his editor told him that she had killed the cartoon because she thought it might remind readers about loved ones who had killed themselves over the Christmas holidays. "Oh yeah," Pett responded. "They're going to forget that Daddy shot himself except for my cartoon."[65]

If an editor is interested in having a strong editorial cartoonist on staff—and he or she should be—it would benefit both the editor and the newspaper to give the cartoonist as much freedom as possible. "The cause of any conflict, naturally, is a difference of opinion—political, philosophical, or moral," one cartoonist said.[66] If an editor rejects enough drawings, the cartoonist will look for work elsewhere. But what if no other jobs are available? Cartoonists will become more willing to please their editors if they have little chance of finding another job. Under these circumstances, cartoonists learn to placate their editors by taking the path of least resistance, swallowing a lot of Maalox, or leaving the profession. This is what a number of cartoonists have done, and will continue to do, by either resigning or being fired. As job opportunities become more and more limited, fewer and fewer cartoonists will do less and less provocative work.

According to the survey, 73 percent of editorial page editors and 58 percent of cartoonists believe that the editor should make the final decision on whether a cartoon will be published. But 34 percent of cartoonists and 27 percent of editors said that the cartoonist and editor should decide together. Although this does not guarantee good results, it will create more mutual respect, which will give the cartoonist a shared sense of responsibility. Sometimes editors and cartoonists decide together not to publish a cartoon. When he was working for the *Chicago Tribune*, Jeff MacNelly and his editor decided against running a cartoon that showed President Jimmy Carter laying a wreath on President Harry Truman's grave—and the R.I.P. on the wreath was answered by a ghostly "S.O.B." In addition, when Wayne

Stayskal was working for the *Tribune*, he drew a group of gays arrested after a demonstration, and the desk sergeant then ordering them into separate cells because they "look a bit too happy."[67]

With few exceptions, no editorial cartoonist has all of his or her cartoons accepted, and they probably should not be. Many cartoonists pass their rough drafts around the newsroom to see whether they resonate. Regardless of the reception, the editor usually has veto power over whether the cartoon will be published. "It's part of the job," Bob Englehart said. He says the feedback he gets from his editor has made him a better cartoonist. But too much interference is bad for both the cartoonist and the newspaper, he said, adding: "A steady diet of censorship can kill the cartoonist's will to live."[68]

"That's Not a Definition of Libel; That's a Job Description"

On August 23, 1984, Milt Priggee, then with the *Dayton (Ohio) Journal Herald*, published a cartoon on a much-publicized feud between the chief justice of the Ohio Supreme Court, Frank Celebrezze, and the state bar association. In the drawing, Priggee portrayed the dispute as a 1930s-era feud between rival gangs, in which tommy gun–firing hoods are fleeing from a storefront labeled "Ohio Bar Association" in a car with "Celebrezze" on the license plate, leaving behind on the sidewalk two injured men and a skunk holding his stomach (figure 7.1).

Figure 7.1 Milt Priggee, *Dayton (Ohio) Journal Herald*, 1984.

In March 1985, Priggee learned that he and his newspaper were being sued over the cartoon for libel, invasion of privacy, and an intentional affliction of emotional distress. Priggee then learned that the plaintiff in the case was not Frank Celebrezze but his brother James, who had recently lost his reelection bid to the Ohio Supreme Court.[1] "The cartoon wasn't even about James Celebrezze," Priggee said. "It was Frank who instigated the feud, everyone knows that. When I heard that Jimmy Celebrezze was suing, I said, 'Wait a minute, I never did one on Jimmy.'"[2]

Even though the cartoon was not about him, James Celebrezze, smarting from an election loss, sued over an opinion based on news accounts. As a judge himself, Celebrezze knew—or at least should have known—that as a public figure, he had no real cause for action against either Priggee or the *Journal Herald*. A trial court agreed, ruling against Celebrezze, who then appealed. On July 5, 1988, the Ohio Court of Appeals upheld the lower court's decision, stating that the scene in the cartoon was "exaggeration, hyperbole . . . rhetorical, perhaps allegorical, but not capable of being interpreted as being factual or defamatory." It declared that the cartoon was an expression of opinion and that "there was no genuine issue as to Celebrezze's libel claim."[3]

Unlike a news story, which is supposed to be balanced and based on facts, an editorial cartoon makes no such claim. Its intent is not to report the facts of the news but to comment on them—and it often uses ridicule to make its point. Because of this inherent subjectiveness, cartoons are constitutionally protected expressions of opinion.[4] When a statement reasonably implies false and defamatory facts, the plaintiff in a libel suit must prove, in order to collect damages, that the statement was made with "actual malice," or knowledge of the falsity or reckless disregard for the truth.[5] This definition is problematic for editorial cartoonists. "That's not a definition of libel; that's a job description," one newspaper editor said. "That's what they're supposed to do. And if [they're not allowed to] do that we've got a problem in this country."[6]

Editorial cartoonists, however, are still susceptible to lawsuits from offended public figures who seek not justice but compensation for having been ridiculed. Therefore, even though Celebrezze ultimately failed to collect damages, he succeeded in forcing the *Journal Herald* to defend itself in court, which required attorneys, depositions, and other court-related costs. As a business with a bottom line, a newspaper might have second thoughts about publishing cartoons that offend a particularly sensitive public official. According to Priggee, even if the newspaper wins in court, it loses because it begins to censor itself. "As soon as they file, they've won. They know

they're not going to get money," Priggee said. "But now the editor is going to run all cartoons by the lawyers."[7] Priggee once called the libel suit "the ultimate hate letter."[8]

When the *Dayton Daily News* and *Journal Herald* merged, the *Journal Herald* folded, and Priggee then became the cartoonist of the *Spokane (Wash.) Spokesman-Review*. In 1995, after being reelected, Judge Donna Wilson charged that the newspaper had libeled her in a series of articles, editorials, columns, and editorial cartoons stating, among other things, that the judge had been reading a romance novel during a trial. Priggee, basing his cartoon on newspaper accounts, drew a number of courtroom spectators looking up at the judge and saying, "She seems to be reading a book!" In the next panel, an aggravated library employee cries out: "Hey! Where's our copy of Madonna's 'sex' book?!?" (figure 7.2).[9]

The trial court ruled for the newspaper, saying that as a public figure, Wilson had to prove that the newspaper acted with malice aforethought—in other words, that it knew that what it reported was false—in injuring her reputation. To win the lawsuit and collect damages, Wilson also had to prove that her reputation had been harmed. Given that she had won re-election, this would be a difficult task. In addition, if all the cartoon did was express an opinion on a real or an assumed fact, it was protected. The trial court therefore ruled in favor of the newspaper on all counts. Wilson then

Figure 7.2 Milt Priggee, *Spokane (Wash.) Spokesman-Review*, 1993.

appealed. A court of appeals upheld the trial court's verdict, ruling that the cartoon was based on a newspaper story quoting a number of witnesses that Wilson had been reading a paperback in court. "Because she [Wilson] has not produced sufficient evidence to support a finding of malice," the appellate court said, "her defamation claims based upon opinion also fail."[10]

In 1996, a videotape of a high-school wrestler in Colville, Washington, head-butting a referee received widespread play on television. In a cartoon about the incident, Priggee drew the wrestler striking the referee above the words "Head-Butt." In the next panel, headlined "Butt-Head," the wrestler is being praised by his coach, who is depicted as a small, anonymous figure in the corner of the drawing (figure 7.3). The real coach, who was not identified in the cartoon, sued Priggee and the newspaper, but he subsequently dropped the suit.[11]

The *Spokane Spokesman-Review* no longer has a full-time editorial cartoonist on its staff. Consequently, it publishes few, if any, local cartoons and so does not have to worry about publishing cartoons that will send wounded public figures scurrying to their attorneys, thereby forcing the newspaper to defend itself in court. This, of course, saves the newspaper money and headaches. But whenever a newspaper surrenders its right to comment, it loses something far more valuable. When Priggee worked in Dayton, he feared that the threat of a lawsuit could force a newspaper to censor itself. In Spokane, he learned how right he was.

Figure 7.3 Milt Priggee, *Spokane (Wash.) Spokesman-Review*, 1996.

If Priggee's cartoons had indeed been libelous, the newspaper's editor may have felt justified in muzzling the cartoonist, even though he would have been wrong to do so. But Priggee's cartoons were not libelous; they were not close to being libelous or even particularly objectionable. Was there any difference between the cartoons about Judge Celebrezze or Judge Wilson and the thousands of others Priggee has drawn? No, said Priggee, who now self-syndicates his cartoons. He was merely expressing his constitutionally protected opinion about a public matter. Nothing in the newspaper has more constitutional protection than editorial cartoons. And yet the mere threat of a lawsuit—even one that is clearly frivolous—can, and does, force newspapers to suppress editorial cartoonists and other forms of commentary, thereby reducing the drawing power of the First Amendment.

Although it has not ruled specifically on a cartoon in nearly a century, the Supreme Court has fashioned a formidable defense for cartoonists. The Court has consistently maintained that criticism of public affairs—or political speech—must be accorded the highest amount of protection under the First Amendment. In addition, the protection of fair comment, which stresses the value of protecting opinion on matters of public concern, has a long tradition. In addition, the Court has emphasized that opinion and rhetorical hyperbole are generally considered protected expression. In 1992 in *Milkovich v. Lorain Journal*, the Court ruled that even though opinions with provably false assertions are not protected, clearly satirical, hyperbolic, or rhetorical expression is protected.[12]

In 1988, the Supreme Court affirmed the freedom of cartoonists in *Hustler Magazine v. Falwell*, making the history of editorial cartooning central to its decision.[13] While *Hustler v. Falwell* did not directly concern a political cartoon—but, rather, the parody of a magazine—the decision had ramifications for cartoonists. In *Celebrezze v. Dayton Newspspers*, the Ohio appellate court, citing *Hustler*, said that Priggee's cartoon was not actionable because it "could not reasonably be construed as a statement of fact."[14]

In November 1982, *Hustler* published a parody of a Campari advertisement in which celebrities talk about the first time they drank Campari wine (figure 7.4). In the parody, religious leader Jerry Falwell recalls that his "first" sexual experience involved incest with his mother in an outhouse. Falwell sued *Hustler* publisher Larry Flynt and the magazine for invasion of privacy, libel, and the intentional infliction of emotional distress. The trial court granted a summary judgment for *Hustler* on the issue of invasion of privacy. But the jury found no libel because the parody "could not reasonably be understood as describing actual facts." The jury did find, however, that publication of the parody constituted intentional

Jerry Falwell talks about his first time.*

FALWELL: My first time was in an outhouse outside Lynchburg, Virginia.

INTERVIEWER: Wasn't it a little cramped?

FALWELL: Not after I kicked the goat out.

INTERVIEWER: I see. You must tell me all about it.

FALWELL: I never *really* expected to make it with Mom, but then after she showed all the other guys in town such a good time, I figured, "What the hell!"

INTERVIEWER: But your mom? Isn't that a bit odd?

FALWELL: I don't think so. Looks don't mean that much to me in a woman.

INTERVIEWER: Go on.

FALWELL: Well, we were drunk off our God-fearing asses on Campari, ginger ale and soda—that's called a Fire and Brimstone—at the time. And Mom looked better than a Baptist whore with a $100 donation.

INTERVIEWER: Campari in the crapper with Mom . . . how interesting. Well, how was it?

FALWELL: The Campari was great, but Mom passed out before I could come.

INTERVIEW-ER: Did you ever try it again?

FALWELL: Sure . . .

lots of times. But not in the outhouse. Between Mom and the shit, the flies were too much to bear.

INTERVIEWER: We meant the Campari.

FALWELL: Oh, yeah. I always get sloshed before I go out to the pulpit. You don't think I could lay down all that bullshit *sober*, do you?

© 1983—Imported
by Campari U.S.A.
New York, NY
48° proof Spirit
Aperitif (Liqueur)

Campari, like all liquor, was made to mix you up. It's a light, 48-proof, refreshing spirit, just mild enough to make you drink too much before you know you're schnockered. For your first time, mix it with orange juice. Or maybe some white wine. Then you won't remember anything the next morning. *Campari. The mixable that smarts.*

CAMPARI® You'll never forget your first time.

*AD PARODY—NOT TO BE TAKEN SERIOUSLY

Figure 7.4 Hustler, November 1983, inside cover.

and reckless misconduct that caused injury to the plaintiff and awarded Falwell \$200,000 in damages.[15]

The Court of Appeals for the Fourth Circuit upheld the verdict, stating that in order to collect damages for a claim of emotional distress, it is not necessary to prove falsity, as the Supreme Court had determined for libel. In his dissent, Judge Harvie Wilkinson questioned the wisdom of allowing public figures to recover damages for no other reason than hurt feelings. Wilkinson said that one simply cannot subject a parody of a political figure to a cause of action for emotional distress—because political satire and parody aim to distress. "Nothing could be more threatening to the long tradition of satiric commentary than a cause of action on the part of politicians for emotional distress," he said.[16] *Hustler* then appealed the decision to the Supreme Court. In an amicus curiae brief to the Court, the Association of American Editorial Cartoons said that political satire was uniquely vulnerable to the tort of emotional distress "because satire's instrument is the direct, often crude and tasteless, ad hominem attack."[17]

The Supreme Court overruled the appeals court. The Court said that the state's interest in protecting public figures from emotional distress was not sufficient to deny First Amendment protection when that speech could not reasonably have been interpreted as stating actual facts about the public figure involved. The Court ruled that Falwell could not collect damages because the ad parody could not be believed. Although Falwell's attorney argued that the parody was so outrageous that it could be distinguished from the broad standard of protection afforded to traditional cartoons, the Court disagreed.[18]

In the Court's opinion, Chief Justice William Rehnquist referred explicitly to the value of cartoons to the dialogue of ideas in this country and the importance of protecting them against unreasonable restrictions. "Despite their sometimes caustic nature," he said, "graphic depictions and satirical cartoons have played a prominent role in public and political debate." Rehnquist mentioned Thomas Nast's criticism of "Boss" Tweed, Walt McDougall's "The Royal Feast of Belshazzar Blaine and the Money Kings," Abraham Lincoln's tall, gangling posture, and Franklin Roosevelt's jutting jaw and cigarette holder. "From the viewpoint of history it is clear that our political discourse would have been considerably poorer without [editorial cartoons]," he said.[19]

In rejecting the claim of emotional distress in *Hustler*, the Court said that caricature cannot be actionable unless it contains a false statement of fact that was made with actual malice. "Were we to hold otherwise," the Court said, "there can be little doubt that political cartoonists and satirists would

be subjected to damage without any showing that their work falsely defamed its subject."[20] The *Hustler* decision thus further defined the protection given cartoonists that has been evolving for almost four centuries.

The earliest court judgment against a cartoonist was made in 1633 when an English court awarded Sir John Austin damages for a defamatory drawing of him in a pillory.[21] Then in 1693, an English court awarded damages on the basis that innuendo could be actionable in a libel suit if it depicted the plaintiff as "contemptible and ridiculous."[22] A British court also came to this conclusion in *Villers v. Mousley* when it ruled "that to publish anything of a man that renders him ridiculous is a libel."[23] English law said that caricature would be libelous if it represented someone in a "shameful" or "ignominious" posture. The law made a distinction in libel based on whether the plaintiff could be recognized in the cartoon. If he could be recognized, it was libel; if he could not, it was not libel.[24] In 1806, William Charles was believed to have fled Scotland to avoid prosecution for his cartoon "A Fallen Pillar of the Kirk," which portrays a clergyman bouncing a bare-breasted young woman on his knee and saying, "Oh, Lord, what good things dost thou provided for us men!"[25]

In 1808, the English chief justice, Lord Ellenborough, pronounced the doctrine of fair comment, which protects pure opinion and comment on public affairs.[26] The decision resulted from a libel suit by an author of travel books, John Carr, for a satire of one of his books that included a cartoon showing Carr as a man of ludicrous appearance. Ellenborough ruled that critics "in exposing the follies and errors of another may make use of ridicule, however poignant."[27] The justice added that social and political comment is necessary if truth is to be found. While the case involved criticism of the fine arts, the doctrine of fair comment became the legal foundation for protecting criticism of political and social issues.

Fair comment protects only opinion, however, not false statements of fact. That is, the comment has to be the honest opinion of the critic, be made without ill will, and be based on disclosed facts. Fair comment subjects the publisher to liability except where there exists a qualified or absolute privilege to publish, or proof by the publisher of the truth of all discreditable statements. In 1834, a Massachusetts court found that unless the language attributed to the plaintiff in a caricature was actually spoken by him, it should be considered defamatory if it caused him "public scandal and infamy."[28]

Fair comment permitted cartoons to flourish during the second half of the nineteenth century in magazines such as *Harper's Weekly* and satirical weeklies such as *Puck*, *Life*, and *Judge*.[29] When Bernard Gillam drew James

G. Blaine as the Tattooed Man, Blaine wanted to sue but was persuaded not to do so.[30] Other figures, like Judge Samuel Pennypacker, sought recourse from criticism with legislation, prompting Pennsylvania to pass an anticartoon law in 1903. But this attempt and others like it ultimately failed. Politicians and other public officials could indeed sue cartoonists for defamation, but they could not create laws that circumvented traditional constitutional protections. In 1904, a few weeks after a fire destroyed the Iroquois Theater in Chicago, *Life* published a drawing of a skeleton padlocking an exit door. Although the proprietors of the theater sued for libel, they lost because the magazine proved that the cartoon accurately portrayed the theater's condition at the time of the fire.[31]

When the Socialist magazine *The Masses* reported that the Associated Press wire service had suppressed information about a coal miners' strike in West Virginia, Art Young drew a cartoon showing the news as a reservoir poisoned at the source by the Associated Press (figure 7.5). The Associated Press sued *The Masses* for libel but then dropped the suit for fear of what would be disclosed during the trial's discovery process, whereupon Young drew another cartoon satirizing the wire service (figure 7.6). This issue helped establish *The Masses*'s reputation while demonstrating the lengths to which its editors were prepared to defend their constitutional rights.[32]

In 1907, the Supreme Court ruled directly on an editorial cartoon for the only time in U.S. history. In *Patterson v. Colorado*, the Court affirmed the contempt conviction of a newspaper editor for publishing editorials and cartoons in his newspaper that impugned the reputation of judges on the Colorado

Drawn by Art Young, April 1916

April Fool

Figure 7.5 Art Young, *The Masses*, April 1916.

Figure 7.6 Art Young, *The Masses*, 1916.

Supreme Court.[33] One cartoon was entitled "Lord High Executioner" and portrayed the chief justice beheading some public officials. The other cartoon, "The Great Judicial Slaughter-House and Mausoleum," implied that Colorado justices were controlled by political bosses. Justice Oliver Wendell Holmes wrote that the Colorado Supreme Court could punish the newspaper for interfering in a matter pending before it.[34] The following year, President Theodore Roosevelt urged that editors of the *Indianapolis News* be indicted for criminal libel for publishing editorial cartoons asserting that influential Americans were profiting from the building of the Panama Canal.[35] The charges were dismissed when a federal judge in Indiana refused to extradite the editors and cartoons to Washington, D.C.[36]

In 1911, a cartoon, "City Farm," which implied that a Massachusetts mayor was disdainful of conditions of the poor, was found to be "plainly defamatory." The cartoon showed emaciated inmates being brought a tray with a little bit of food and a teapot, labeled "Poor Food," "Rancid Butter,"

and "Shadow Tea." It was accompanied by a statement that the mayor had closed a charity board and replaced it with another that was insensitive to the needs of the poor. The drawing urged voters to vote against him in the next day's election, in the name of "humanity." The Massachusetts Supreme Judicial Court ruled that the cartoon held the mayor "up to ridicule and contempt" and harmed his reputation, concluding that the drawing was libelous because it suggested that the mayor was responsible for the city's treatment of the poor.[37]

Cartoonists were awarded exclusive rights to their drawings in 1916 when a U.S. court in New York ruled that Harry "Bud" Fisher, creator of the *Mutt and Jeff* strip, had the exclusive right to the use of the strip's name and characters. The suit had been filed by the *New York American*, which had sued Fisher after he left the newspaper and started his own syndicate. According to the court's decision, Fisher had the exclusive right to use the names in his strip because exclusive rights belonged not to the inventor or creator of a trademark but to the first to use it in a business.[38]

Without the court's protection, editorial cartoonists would not be able to profit from the reprinting of their work. In one instance, two of the profession's heavyweights became entangled in a lawsuit after Paul Conrad used Bill Mauldin's characters, Willie and Joe, in a strip mocking President Ronald Reagan's trip to a World War II concentration camp. Conrad acknowledged his debt to Mauldin in the strip, but Mauldin was not satisfied, saying that he had never used his World War II characters to make a political statement and was not going to let somebody else do it. "I agree there's a lot of thievery going on," Conrad said. "I've seen evidence of it. But my using Willie and Joe was for a distinctive purpose. They had to be World War II GIs, and they're the only two around."[39]

During World War I, the government used the Espionage Act to prohibit *The Masses* from being delivered by mail.[40] *The Masses* challenged the decision in court, and Judge Learned Hand agreed with the magazine. In a decision foreshadowing the expansion of civil liberties in this country, he said: "To [equate] agitation, legitimate as such, with direct incitement to violent resistance, is to disregard the intolerance of all methods of political agitation which in normal times is a safeguard of free government."[41] Judge Hand's decision, however, was overturned on appeal—and the magazine, its mailing privileges suspended, went out of business.[42]

Two cartoonists for *The Masses* were among those personally indicted under the Espionage Act. The offending cartoons included a drawing by Henry Glintenkamp of a skeleton measuring an army recruit (figure 7.7) and one by Art Young, entitled "Having Their Fling" (figure 7.8), showing

Figure 7.7 Henry Glintenkamp, *The Masses*, September 1917.

an editor, a capitalist, a politician, and a minister in a war dance led by the devil. When Young was asked whether he had intended to obstruct recruitment and enlistment in "Having Their Fling," he replied: "There isn't anything in there about recruiting and enlistment, is there? I don't believe in war, that's all!" The trial ended in a hung jury,[43] as did a second trial that year.[44] The government then dropped its case.

It was not until after World War I that the Supreme Court, in a series of decisions, first interpreted the meaning of the First Amendment. In *Schenck v. United States* in 1919, Justice Oliver Wendell Holmes created the "clear and present" danger standard for establishing limits on expression.[45] He later, however, found the "clear and present" danger standard restrictive, although it was retained by a majority of the Court. This standard was less tolerant than Judge Hand's "direct-incitement" test in *Masses Publishing Company v. Patten*. During the Red scare of the 1950s, the Supreme Court incorporated Hand's language in *Dennis v. United States*, which involved the arrest and conviction of several Communists for violating the Smith Act, which prohibited sedition.[46]

Figure 7.8 Art Young, *The Masses*, September 1917.

After World War I, cartoonists found little consistency in the courts from one state to another. In 1921, the *Los Angeles Record* published a cartoon depicting the city's police chief, C. E. Snively, holding a halo over his head and taking a bribe with the other. The California Supreme Court ruled that while the cartoon obviously accused the police chief of accepting bribes, it still was protected expression.[47] In 1923, an exhibition of drawings at the Waldorf-Astoria in New York included a satiric painting of Prohibition. Although a trial court convicted the secretary of the Society of Artists for permitting the painting to be shown, the conviction was overturned on

appeal. The court said that the artists might be guilty of sacrilege or blasphemy or bad taste but that there was no evidence of "willful intent."[48]

When a meeting between Boston mayor James Curley and *Boston Telegraph* publisher Frederick W. Enright resulted in a fist fight in 1926, Enright published a cartoon showing Curley in prison garb behind bars with the caption "Sober up, Jim." Even though Curley had once served a prison term for taking a civil-service examination for a friend, Enright was sentenced for criminal libel for his cartoon because it was demonstrated that Curley and Enright had had a fight before the cartoon was published and thus the cartoon intended ill will.[49] In a 1936 case, *Doherty v. Kansas City Star*, the Kansas Supreme Court ruled that a cartoon implying that the plaintiff charged exorbitant rates was defamatory.[50]

During and after World War II, the Supreme Court acknowledged that speech critical of government affairs—or political speech—must be protected because of its intrinsic value to self-government.[51] In *Baumgartner v. United States*, Justice Felix Frankfurter wrote that one of the prerogatives of American citizenship is "the right to criticize public men and measure."[52] In *Cantwell v. Connecticut*, the Court emphasized the importance of protecting political communication: "To persuade others to his own point of value, the pleader, as we know, at times resorts to exaggeration, to vilification of men who have been, or are, prominent in church or state, and even to false statement. But the people of this nation have ordained in the light of history, that, in spite of the probability of excesses and abuses, these liberties are, in the long view, essential to enlightened opinion and right conduct on the part of the citizens of a democracy."[53]

The Constitution does not protect the profane, but it does protect what is merely distasteful. In *Cohen v. California*, the Court also distinguished between speech and conduct, giving speech more protection than conduct. It said the protection of scurrilous speech is necessary in "the hopes that use of such freedom will ultimately produce a more capable citizenry" and "in the belief that no other approach would comfort with the premise of individual dignity and choice upon which our political system rests."[54] In *Hustler*, the Supreme Court took pains to emphasize that it was dealing with what it termed "political speech," or the highest degree of protection under the First Amendment.

Until 1964, there was no standard definition of libel law in America; what was or was not libel differed from state to state. Then in *New York Times v. Sullivan* that year, the Supreme Court held that a public official cannot recover damages in a libel action brought against a critic of his official conduct unless it can be proved, by clear and convincing evidence, "that the statement was made with 'actual malice'—that is, with knowledge that it was false

or with reckless disregard of whether it was false or not." The Court said it thought this standard would avoid self-censorship by the press. Justice William Brennan wrote that America's tradition of free press meant that there should be a commitment to robust speech and that this might include caustic and free attacks on public officials.[55] A public official was later defined to include all government employees having, or appearing to have, substantial responsibility over the conduct of governmental affairs.[56]

In *Gertz v. Welch*, the Court defined public figures as either people of widespread fame or people who have injected themselves into the debate of a public issue for the purposes of affecting its outcome. Private people, in contrast, have fewer opportunities to counter false statements and therefore require greater protection from the law. But later, in *Hepps v. Philadelphia Newspapers*, the Court held that a private figure involved in a matter of public concern must prove the falsity of a defamatory statement.[57] In *Gertz*, the Court ruled that opinion is protected expression. "Under the First Amendment there is no such thing as a false idea," he said. "However pernicious an opinion may seem, we depend for its correction not on the conscience of judges and juries but on the competition of other ideas."[58]

In *Old Dominion Branch No. 496, National Association of Letter Carriers v. Austin*, which was decided the same day as *Gertz*, the Court said that the use of the word *blackmail* is protected expression in context because "even the most careless reader must have perceived that the word was no more than rhetorical hyperbole."[59] In *Greenbelt Publishing Association v. Bresler*, the Court had recognized that "rhetorical hyperbole," or what is exaggerated beyond belief, is protected expression and must be considered within its context.[60]

The "rhetorical hyperbole" defense has regularly been applied to editorial cartoons. In 1970 in *Yorty v. Chandler*, a California appellate court first applied the "rhetorical hyperbole" protection to a political cartoon.[61] After Los Angeles mayor Sam Yorty had publicly expressed an interest in being appointed to the position of secretary of defense in President-elect Richard Nixon's cabinet, the *Los Angeles Times* cartoonist, Paul Conrad, drew Yorty in his office talking on the telephone, saying, "I've got to go now. . . . I've been appointed Secretary of Defense and the Secret Service men are here!" while four orderlies prepare to slip a straitjacket on him (figure 7.9). Yorty argued that the cartoon implied that he was insane. But the court countered that even the most careless reader would perceive the cartoon as "no more than rhetorical hyperbole."[62]

In *Yorty*, the court said that editorial cartoons that falsely depict public officials committing crimes are not exempt from libel law but that "a cartoon which depicts a fanciful, allegorical, anthromorphical, or zoomorphical sense

"I've got to go now. . . . I've been appointed Secretary of
Defense and the Secret Service men are here!"

Figure 7.9 Paul Conrad, *Los Angeles Times*, 1968.

will not be considered libelous because it depicts a public person as a flower, a block of wood, a fallen angel, or an animal." The court did, however, indicate that a cartoon could be libelous if it could reasonably be interpreted as an accusation of criminal activity.[63] This ruling is problematic, as satire is rhetoric, not literal truth. But other courts have since applied the "rhetorical hyperbole" in ruling that cartoons are protected expression. Conrad later was sued again when Union Oil executive Fred Hartley took offense at a drawing (figure 7.10). Conrad and the *Los Angeles Times* easily won the case.

In *Keller v. Miami Herald Publishing Co.*, a U.S. court in Florida ruled that a cartoon about a nursing home was "pure opinion." The plaintiff had sued the *Miami Herald* over a cartoon exaggerating the condition of a nursing home that had been closed by the state and its proprietors investigated for criminal misconduct. The cartoon identified the nursing home by a condemnation notice. It also included three men depicted as gangsters, each carrying a sack with a dollar sign on it and one of them saying, "Don't worry, boss, we can always reopen it as a haunted house for the kiddies."[64] The complainant alleged defamation because the cartoon falsely depicted the condition of the nursing home and portrayed him as a criminal. In granting a summary judgment for the defendant, the court ruled that the facts surrounding the case had been well known. "Cartoonists employ hyperbole,

FEDERAL GOVERNMENT DIVERTS 500,000 BARRELS OF UNION CRUDE
OIL FROM SOUTHERN CALIFORNIA TO GUAM. — NEWS ITEM

Figure 7.10 Paul Conrad, *Los Angeles Times*, 1973.

exaggeration, and caricature to communicate their message to the reader," the court said. "One cannot reasonably interpret a cartoon as literally depicting an actual event or situation."[65]

William Loeb, the late publisher of the *Manchester (N.H.) Union Leader*, sued the *Boston Globe* over a Paul Szep cartoon entitled "The Thoughts of Chairman Loeb," which pictured the publisher with eyes askew and a cuckoo springing from his forehead. While the cartoon was obviously literally incorrect, the court decided that the drawing was "an opinion and not a diagnosis."[66] The Massachusetts Supreme Judicial Court used the same rationale in *King v. Globe Newspaper Co.* for a Szep cartoon implying that billboard officials had contributed to the governor's reelection campaign in exchange for canceling the removal of the billboards. The cartoon shows the governor and his secretary of transportation holding bags of money and depicted on a billboard that says: "Ackerley billboards can put money in your pockets too!" (figure 7.11). The court ruled that the cartoon could not reasonably be interpreted as saying the governor was criminal or unethical.[67]

Figure 7.11 Paul Szep, *Boston Globe*, 1981.

Figure 7.12 Bob Englehart, *Dayton (Ohio) Journal Herald*, 1978.

Other political cartoons have been similarly protected. An Ohio county administrator, "Babe" Ferguson, sued the Dayton newspapers over a series of articles, editorials, and cartoons portraying her as a liar, skunk, rat, and witch, but the court found them to be protected expression (figure 7.12). Bob Englehart, then the cartoonist of the *Dayton Journal Herald*, said he could not figure out the grounds for the suit because the subject of the cartoon was a public figure. "The editorials and the news stories were factual, and we were exercising our opinion based on that," he said.[68] The Ohio Court of Appeals agreed: "There is no doubt that Mrs. Ferguson was personally embarrassed and felt personally defamed by cartoons depicting her as a skunk, a witch, a rat, and a liar, . . . [but] as vicious as these personal attacks upon Mrs. Ferguson are, they are not libelous."[69]

Despite their occasional viciousness and obvious falseness, the courts have declared cartoons to be protected expression. In *Palm Beach Newspapers, Inc., v. Early*, a Florida appellate court reversed a jury verdict that a cartoon was libelous. Despite maintaining that the cartoon was mean-spirited, the court also deemed it "rhetorical hyperbole" and thus protected.[70] An appellate court in *Corcoran v. New Orleans Firefighters' Association Local 632* also reversed a jury verdict that a cartoon was libelous. It, too, ruled that the cartoon was "rhetorical hyperbole."[71] This also was the conclusion of the Colorado Court of Appeals in *Russell v. McMullen*, wherein it ruled that a

cartoon was "clearly a symbolic expression of the opinion espoused in the accompanying article and editorial."[72]

In granting summary judgment for a newspaper that published a cartoon critical of a ski resort, a Vermont court said that the drawing imposed a harsh judgment on known or assumed facts and was therefore protected (figure 7.13). Citing the *Restatement of Torts* and the *New York Times* standard, the court ruled that the ski resort was a "limited public figure" and that the cartoon was pure opinion and thus protected.[73] The *Restatement of Torts* says that if all a cartoon does "is to express a harsh judgment upon known or assumed facts, there is no more than an expression of opinion of the pure type."[74]

The Oklahoma Supreme Court also decided that a cartoon was not libelous in *Miskovsky v. Tulsa Tribune Co.* The *Tulsa Tribune* had published a cartoon implying that a candidate for the U.S. Senate had persuaded another man to ask—during a press conference—his opponent if he was a homosexual. The court ruled that the newspaper did not know that the cartoon was false.[75] Even though the courts have said that cartoons implying defamatory facts are not protected, they have been reluctant to punish cartoons that do just that.[76] In *La Rocca v. New York News*, two policemen alleged that

" UH-OH – LOOKS LIKE THE SNOW-MAKING MACHINES ARE CLOGGED AGAIN."

Figure 7.13 Tim Newcomb, *Barre-Montpelier (Vt.) Times Argus*, 1985.

an article, an editorial, and a cartoon defamed them. The police officers had gone to a school looking for a teacher wanted for assault and escorted him from the school. In a cartoon the next day, the officers, who were drawn wearing dunce caps, were shown handcuffing the teacher in the classroom. Although the arrest was not made in the classroom, the court declared that the mistake was minor and not related to the gist of the alleged libel.[77]

In *Buller v. Pulitzer Publishing Co.*, however, a cartoon based on a news article portrayed a psychic as lacking integrity.[78] The Missouri Court of Appeals determined that the article and cartoon had injured the reputation of the psychic, a private figure, and so were libelous per se. The court pointed out that if the psychic's business were a matter of public concern, there would be no libel.[79] There is an important distinction between *Buller* and other suits against cartoonists. For one thing, *Buller* involved a private figure, not a public official or public figure, who, furthermore, was not involved in a matter of public concern.[80]

After *New York Times v. Sullivan* expanded the First Amendment's legal protection, libel suits against editorial cartoonists were rare and flicked away like scrapings on a drawing board. But that changed in the late 1970s. In 1979, the Supreme Court's chief justice, Warren Burger, questioned the wisdom of courts dismissing libel suits without going to trial, thereby creating a more litigious climate.[81] Public figures began striking back at the press in the courtroom, whether or not they had a legitimate suit, hoping to win damages because they could take advantage of the antimedia feelings of either the judge or the jury. Between 1981 and 1987, at least nineteen suits against editorial cartoonists advanced in state and federal courts.[82]

Jerry Robinson, a former president of the Association of American Editorial Cartoonists, said that just because you have the law behind you does not automatically mean you will win a jury verdict. "When [a lawsuit] goes to court, anything can happen, no matter how frivolous the suit is," he said. "Then, also there is the time and expense involved. Quite often they are brought for that effect alone."[83] Regardless of the verdict, Paul Conrad observed, a lawsuit can have a chilling effect on free expression, especially for a smaller newspaper or one that belongs to a chain that puts profits above journalism.[84]

Freelance cartoonist Tim Newcombe drew a cartoon for the *Barre-Montpelier (Vt.) Times Argus* that poked fun at the Killington, Vermont, ski resort for wanting to change the state laws so that it could make snow using sewer waste. Newcomb said he marked the ski resort in the cartoon "Killington" because not all resorts in the area wanted to do it. Killington's official response to the cartoon was, "You have people believing they need

snowshoes and toilet plungers to ski here," which Newcomb called "ridiculous." Attorney Robert Hemley, who represented Newcomb and the *Times Argus,* said that the Killington ski resort brought the suit "maliciously not because they thought there was any merit to the lawsuit but rather to chill the expression of opinion contrary to what their position was."[85]

Killington lost the suit but clearly intimidated Newcomb, who drew no more cartoons of the resort while the case was active. Later, when Newcomb agreed to exhibit the cartoon at a nearby art gallery, Killington went to court the next day and filed a lawsuit against him for displaying the drawing in public. Newcomb said that the American Civil Liberties Union agreed to defend him. "I had no idea what a bunch of nuts they were," Newcomb said of Killington. "I can't believe they've made such a fuss over it."[86]

Since *Hustler,* there has been a sharp decline in the number of lawsuits against cartoonists. This does not mean that cartoonists are freer to draw their conclusions without being sued—or even that their newspaper will support them. Instead, there may be fewer lawsuits brought against cartoonists because fewer daily newspapers have fewer editorial cartoonists, who are drawing fewer local cartoons. In addition, rather than defending themselves in court, newspapers are settling lawsuits, suppressing cartoons, or simply not publishing local cartoons. Lawsuits over cartoons have become "a dollar and cents thing, and that's what the publisher looks at," concluded Paul Szep, who has been sued a number of times. "Eventually the publisher is going to say, 'We can't do that guy because he'll probably sue, and we don't want to get into that.'"[87]

In 1991, the *Fort Worth Star-Telegram* settled a libel suit with an aviation attorney who claimed he was portrayed in both an editorial and an editorial cartoon for soliciting clients at the site of a 1988 airline crash. The cartoon portrayed the attorney as an unnamed vulture on a tree; however, the accompanying editorial identified the attorney and others who perpetuated "the vulture image of self-serving" attorneys. The attorney, who settled with the newspaper, said he had not solicited business at the crash site and thus the editorial and cartoon were based on information that was false. The newspaper settled before going to trial.[88]

In 2000, a weekly newspaper in North Carolina, the *Topsail Voice,* agreed to pay a settlement after publishing an editorial cartoon that criticized two local businessmen. The newspaper's editor said the paper agreed to pay the settlement not because he thought the cartoon was libelous but because he thought it was in poor taste. The editor added that he thought it was time for both sides to reconcile, even though he did not believe the lawsuit "would have stood up in court."[89]

When a newspaper settles a lawsuit over a cartoon or anything else that it does not believe is libelous, it sends a bad signal. Rather, it is in the best interests of newspapers with deeper pockets to support small dailies and weeklies when they are sued for libel. But this is expecting a lot from newspapers that put the corporate bottom line over the First Amendment. In 2003, the *Columbia (Mo.) Daily Tribune* apologized in print as part of a settlement with a local school board candidate, Henry Lane, who claimed he was libeled by a drawing by the editorial cartoonist John Darkow. Lane, who had called for a return of spanking to strengthen discipline in schools, insisted that he had lost his reelection bid after Darkow's cartoon appeared showing the candidate wearing women's underwear, long black gloves, and high heels, and holding a whip that came from a box labeled "Election success record." The settlement included removing the cartoon from the newspaper's electronic archives. Although the *Daily Tribune* said that it did not believe the cartoon was defamatory, it settled the case to bring the issue to an end.[90]

In recent years, too many newspapers have surrendered their right of expression, despite having the power of the First Amendment on their side. In 1998, for instance, the Delaware Supreme Court confirmed that an editorial cartoon published in the *Wilmington News Journal* was protected expression, saying that the law looks "disfavorably on libel suits" based on editorial cartoons. The courts, it wrote, are "fearful of the threat to free speech that could arise" if cartoons were not protected. "Cartoons are seldom vehicles by which facts are reported," it said. "Quite the contrary, they are deliberate departures from reality designed forcefully, and sometimes viciously, to express opinion."[91]

In 2001, a Cuyahoga County, Ohio, juvenile court judge, Robert A. Ferrari, sued the *Cleveland Plain Dealer* over a series of news articles, editorials, and editorial cartoons that portrayed him as "a reckless, arrogant, publicity-hungry bully." In one cartoon, Jeff Darcy, basing his work on Ferrari's being suspended by the Ohio Supreme Court, drew the judge sitting behind bars with a child in an adjacent cell saying: "Yeah . . . I know, we're all innocent here, pal! Got any bubble gum?" In dismissing the suit against Darcy, the court wrote that the cartoon did not imply an assertion of fact: "No reasonable person could conclude from viewing the cartoon that [the] appellant had actually been jailed in Juvenile Detention and was falsely proclaiming his innocence to a child in an adjoining cell. The scene depicted was exaggeration and hyperbole."[92]

The First Amendment is not, however, bulletproof, as the Ohio Supreme Court showed in its ruling in August 2000 regarding a cartoon in an election campaign brochure. The brochure, which was published during

a 1995 township council election near Canton, consisted of a quiz in which one candidate, Dan McKimm, illustrated the reasons why he would make a better candidate than his opponent, Randy Gonzalez, the incumbent. Appearing next to one of the question was a cartoon indicating that the incumbent had taken a bribe. In *McKimm v. Ohio Elections Commission*, the Ohio Supreme Court said that the inference was false, that it had no basis in fact, and that the candidate who published the brochure knew it was false, and therefore it was libelous.[93] In 2001 the U.S. Supreme Court refused to review the Ohio decision, letting the ruling stand.[94]

This case fell outside the parameters of protected expression because it was not based on widely known real or assumed facts, as most cartoons are. But it is doubtful that any editorial cartoon about public officials, public figures, or matters of public concern is lacking constitutional protection. This standard allows cartoonists to contribute to the dialogue of ideas free of nuisance lawsuits, which may be brought merely to intimate the cartoonists and their newspaper from publishing more drawings. Such a practice infringes on the value of dialogue regarding matters of social concern, which would detract from the exchange of ideas necessary to a democracy.

According to Priggee and other cartoonists, if there is no substantive legal issue at stake, instead of going into full retreat, newspapers need to countersue when a public figure takes them to court. Indeed, Priggee blames the newspapers for allowing themselves to be intimated. If they countersue, charging that the suit against them is frivolous, it would mean higher attorney's fees in the short term, but it would send a strong statement that could deter future lawsuits. But this is not likely as long as money trumps the First Amendment in newsrooms. Courts could return to the pre–Warren Burger days and make more summary judgments when the facts of the case clearly do not merit a trial. In addition, the number of frivolous lawsuits would fall if the losing party had to pay the winner's attorneys' fees and court costs.

The *Spokane Spokesman-Review* no longer has a full-time staff cartoonist and therefore does not run editorial cartoons on local issues, making it, like so many other newspapers, a conscientious objector in the war over free speech. Priggee continues to self-syndicate his drawings, giving him less economic security but more freedom to express himself. On his Web site, where he posts his cartoons, he has written: "The cure for bad speech is more speech, but if it is your intent to shut me, Milt Priggee, up by suing me for any of the onions expressed in my 'toons, please understand that I am not a First Amendment pacifist."[95] The name and telephone number of his attorney follow.

8

"Comfort the Afflicted and Afflict the Comfortable"

During his State of the Union address on January 28, 2003, President George W. Bush emphasized the need to invade Iraq in order to oust its leader. "The British government," Bush announced, "has learned that Saddam Hussein recently sought significant quantities of uranium from Africa." Bush's words, delivered with an unmistakable sense of urgency, made clear the dire consequences to the United States and the rest of the world if Iraq's brutal regime possessed nuclear weapons and other weapons of mass destruction. With those sixteen words and over the objections of the United Nations, the Bush administration issued a moral imperative for attacking Iraq. The United States then invaded Iraq, defeated its army, and quickly toppled its government, sending Saddam Hussein into hiding.

In July, however, the administration acknowledged that the sixteen words that the president had used to justify the invasion of Iraq were not credible. Months before the State of the Union address, the Central Intelligence Agency told the administration that the British report that Iraq had tried to purchase five hundred tons of uranium oxide from the African country of Niger was based on forged documents. Bush, nevertheless, did not remove the information from his speech. The Niger reference notwithstanding, Bush sold the war to the American people based in large part on the fact that Iraq had a large number of weapons of mass destruction. The administration also floated an unsubstantiated rumor that Iraq had cooperated with Osama bin Laden and his terrorist network in the attacks on the World Trade Center and the Pentagon on September 11, 2001. The United Nations disputed both the presence of weapons of mass destruction and the connection to September 11, and most of the international community opposed the U.S.-led invasion of Iraq. Cartoonist Joe Sharpnack captured America's indifference to the world's opinion in one of his drawings (figure 8.1).

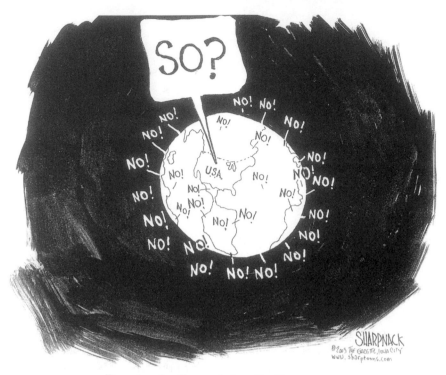

Figure 8.1 Joe Sharpnack. *Iowa City Gazette*, 2003.

After the invasion of Iraq, no weapons of mass destruction were found. The war left Iraq in ruins and thousands and thousands of its people dead. After Bush declared victory on May 1, U.S. soldiers, who remained to restore order to the country, found themselves under deadly fire from hostile Iraqis who resented the occupation. By August, the number of soldiers killed after Bush had declared victory had exceeded the number killed during the war itself. In response, Jeff Danziger drew two soldiers running for cover, one telling the other: "I'm tellin' you . . . This whole situation could give slapdash, dimwitted, politically-inspired interventions a bad name" (figure 8.2). Ted Rall drew the number of dead American soldiers stacked as high as the World Trade Center (figure 8.3).

When Americans learned that Bush had lied in his State of the Union address, a number of editorial cartoonists questioned the administration's credibility. Mike Keefe of the *Denver Post* drew Bush dictating his State of the Union address. "Write that Saddam has links to al Qaeda," Bush instructs, and his speechwriter nods. "Write that he's buying material for nuclear weapons," Bush says, and again the speechwriter agrees. Then Bush

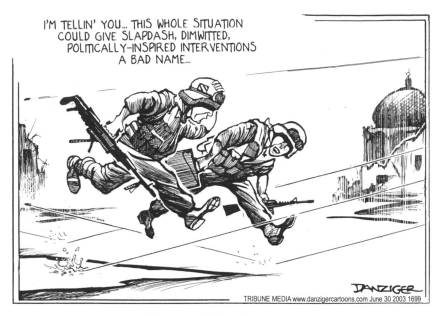

Figure 8.2 Jeff Danziger, 2003.
Reprinted with permission of Tribune Media Services.

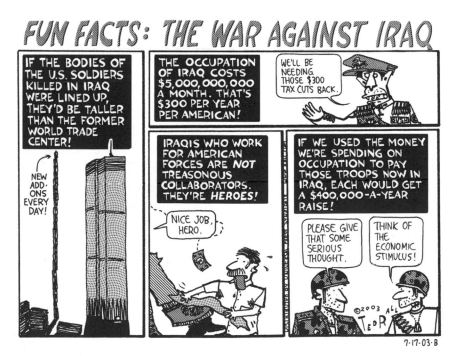

Figure 8.3 Ted Rall, 2003.

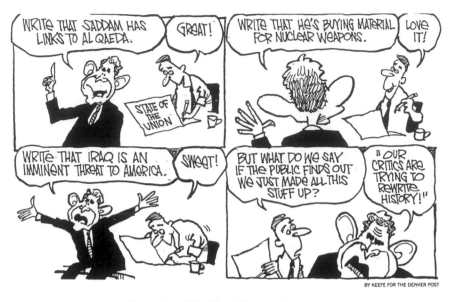

Figure 8.4 Mike Keefe, *Denver Post*, 2003.

adds, "Write that Iraq is an imminent threat to America." Then the speech-writer asks, "But what do we say if the public finds out we just made all this stuff up?" Bush replies, "Our critics are trying to rewrite history!" (figure 8.4). Ann Telnaes drew Vice President Dick Cheney, the "Niger Report" tossed in a nearby trash can, saying: "Telling the truth may be a sign of personal virtue, but it is not a sufficient basis for a sound, comprehensive political agenda" (figure 8.5). With his characteristic bluntness, Rall drew a cartoon entitled "Bush Lied. They Died." In it, Bush's mouth is filled with gravestones, dead bodies, and other symbols of death, which are accompanied by tepid explanations from the administration such as "Let's just say he stretched the truth" and "Maybe the C.I.A. memos didn't get to him on time" (figure 8.6).

Mike Ramirez of the *Los Angeles Times* drew a cartoon showing a man labeled "politics" aiming a gun at President Bush against a backdrop labeled "Iraq" (figure 8.7). The drawing was based on the searing 1968 photograph of a South Vietnamese general executing a Viet Cong officer at point-blank range. "President Bush is the target, metaphorically speaking, of a political assassination because of sixteen words that he uttered in the State of the Union," Ramirez said. "The image, from the Vietnam era, is a very disturbing image. The political attack on the president, based strictly on sheer political motivation, also is very disturbing."[1]

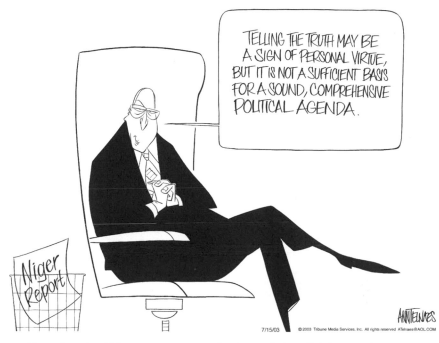

Figure 8.5 Ann Telnaes, 2003. Reprinted with permission of Tribune Media Services.

Figure 8.6 Ted Rall, 2003.
Reprinted with permission of Universal Press Syndicate. All rights reserved.

Figure 8.7 Michael Ramirez, *Los Angeles Times*, 2003.
Reprinted with permission of Copley News Service.

Ramirez's message was meant to defend Bush against those who used a relatively few words in the State of the Union address to issue what he believed were politically motivated attacks against the popular president. But to a lot of readers, Ramirez seemed to be calling for the assassination of Bush. That Ramirez's purpose was to defend the president means that because the drawing was so widely misinterpreted, it was not particularly good. But it did not constitute a clear and present danger to the president's life, nor did it mean that Ramirez should even be questioned by police, given the standards of both common sense and the First Amendment.

Nonetheless, shortly after Ramirez's cartoon appeared, a Secret Service agent went to the *Los Angeles Times* to question the cartoonist because the cartoon was "construed as a threat against the president," the newspaper reported in a story. *Times* executives prohibited the agent from questioning Ramirez. Los Angeles–area congressman Christopher Cox, a Republican who heads the House committee that oversees the Secret Service, characterized the incident as an attempt at intimidation, calling it "extremely bad judgment." *USA Today*, hardly the voice of fellow travelers, pointed out that Ramirez was fortunate to have the support of a congressman and a large pro-Bush newspaper.[2] If, however, Ramirez had been working for an alternative weekly or even for a mainstream paper less friendly to the president,

USA Today was implying, he might indeed have been interrogated or even jailed, given the administration's record on civil liberties. Ramirez later drew a cartoon satirizing the Secret Service for overreacting to the original cartoon (figure 8.8).

The pro-administration cartoonist nearly became collateral damage in the Bush administration's efforts to protect us from ourselves. Since the terrorist acts on American soil of September 11, 2001, the administration—and Attorney General John Ashcroft in particular—have suspended Americans' civil liberties, asserting that it is necessary to do so to protect their constitutional rights, which, as critics said, made as much sense as engaging in intercourse to preserve chastity. Joel Pett juxtaposed the State of the Union falsehood with the state of civil rights by drawing Bush at a press conference insisting that the sixteen words in question should never have been written. In the next panel, the following words appeared: "Freedom of speech, freedom of the press, freedom of worship, freedom of assembly shall not be . . . " Bush then says: "Wrong graphic, Ashcroft" (figure 8.9).

A day after the Ramirez cartoon appeared, the Justice Department released a chilling report on abuses by law-enforcement agencies administering the antiterrorism U.S. Patriot Act. It said that almost eight hundred people, most of them Arab Americans, had been confined without justification

Figure 8.8 Michael Ramirez, *Los Angeles Times*, 2003.
Reprinted with permission of Copley News Service.

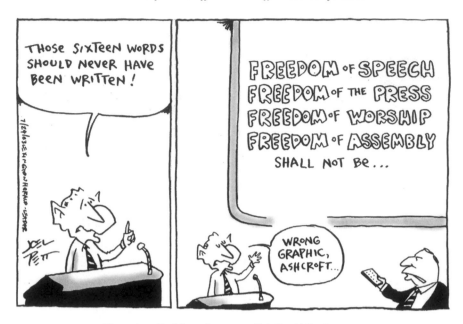

Figure 8.9 Joel Pett, *Lexington (Ky.) Herald-Leader*, 2003.
Reprinted with permission of Universal Press Syndicate. All rights reserved.

and that some were mistreated while in custody. During World War I, the Espionage Act resulted in the deportation of hundreds of law-abiding eastern Europeans. Likewise, the Patriot Act has meant the deportation of hundreds of law-abiding Arab Americans. The Justice Department report detailed dozens of particularly egregious examples of allegations of death threats, raids based on false information, evidence planted in suspects' homes, and a loaded gun held to the head of one detainee. "Such [civil rights] protections are sorely needed as long as law enforcement agencies can't resist the temptation to abuse power," *USA Today* said in a editorial. "If freedom of expression becomes a target for government intimidation, and other basic liberties are trashed on the altar of the war on terror, the forces of oppression will have won."[3]

The same week, Americans learned that the disgraced former national security adviser John Poindexter had resurfaced, with dubious intentions. While working for the Pentagon, Poindexter created a futures market in which people could bet on predicted acts of terrorism, assassinations, and coups. That such an idea could be considered, let alone supported by the administration and funded by taxpayers' dollars, raised serious questions about the priorities of the U.S. government. After September 11, Poindexter,

whose credibility had long been discredited, was put in charge of the Pentagon's Information Awareness Office, which was created to identify possible terrorists by secretly compiling electronic dossiers on millions of Americans. As President Ronald Reagan's national security adviser, Poindexter had been convicted as one of the conspirators in the ignominious Iran–contra scandal, although the conviction was later overturned.

In response to the Poindexter story and the disclosure that Vice President Dick Cheney's former company, Haliburton, was financially profiting from the war in Iraq, Ann Telnaes drew a man placing a bet and announcing: "I want to place a bet on future Middle East business deals connected with past and present members of the Bush administrations" (figure 8.10). As the abuses of the Patriot Act became better known, Steve Breen of the *San Diego Union-Tribune* drew the Justice Department sweeping up immigrants without regard for due process (figure 8.11). Don Wright of the *Palm Beach (Fla.) Post* illustrated the excesses of the Patriot Act by drawing FBI agents interrogating a man for having rented the movie *Lawrence of Arabia* (figure 8.12). Steve Sack of the *Minneapolis Star-Tribune* drew an

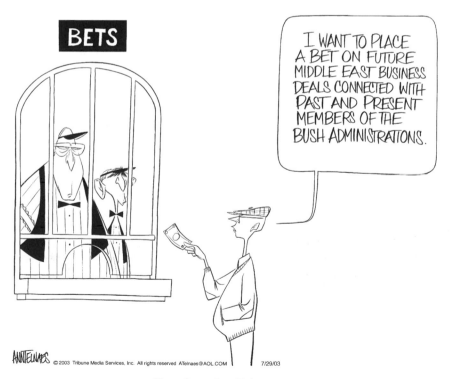

Figure 8.10 Ann Telnaes, 2003.
Reprinted with permission of Tribune Media Services.

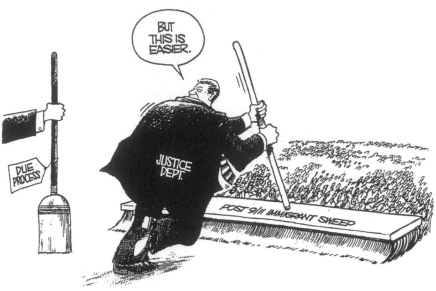

Figure 8.11 Steve Breen, *San Diego Union-Tribune*, 2003.

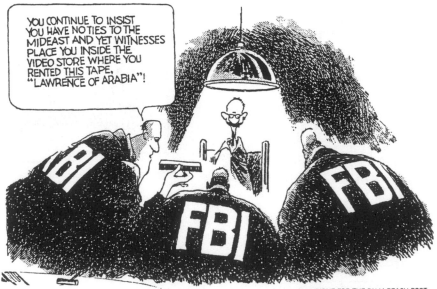

Figure 8.12 Don Wright, *Palm Beach (Fla.) Post*, 2003.
Reprinted with permission of Tribune Media Services.

American bald eagle labeled "USA" sitting in a nest of wiretaps, thinking: "More secure? Maybe. But definitely less comfortable."

With drawings like these, editorial cartoonists have revealed the shortcomings, flaws, and outright deceptions of the Bush administration. As these cartoons also have demonstrated, the administration often has acted in its own self-interest and not for the good of either the country or the world. The administration has justified its suspension of civil liberties as necessary to protect the security of the republic. With the crassest kind of cynicism, the administration and its supporters argued that they could violate the Constitution and later pretend they never did and that nothing would be lost in the process. Every time the government ignores the Constitution, regardless of its intentions, the document is weakened and, therefore, so is the spirit that gives meaning to our democracy. To argue otherwise is to undervalue the Constitution's power.

After the terrorist attacks of September 11, 2001, amid the sadness and fear on America's darkest day, the Bush administration held out a U.S. flag for Americans to take cover under, and they felt more secure. Then the administration took advantage of a vulnerable America to advance its political agenda. It disguised nationalism as patriotism and treated social criticism as sedition. According to President Bush, you either were with us or you were with the terrorists. Those who dared criticize the government were condemned for their lack of patriotism. Social critics turned inward and silent. To paraphrase Walt Kelly's *Pogo*, we had met the enemy and they were us.

Some editorial cartoonists understand better than most Americans that patriotism and nationalism are not the same. Nationalism means slavishly following one's country, right or wrong. In a democracy, however, the people's most fundamental right, one that separates them from those who live in a totalitarian state, is the right to criticize the government when they believe it is wrong. In colonial days, Americans found the spirit of patriotism in Benjamin Franklin's "Join, or Die," Thomas Paine's *Common Sense*, the Declaration of Independence, and the Constitution. The Bill of Rights guarantees certain freedoms that are not dependent on the whims of the current government. If the Constitution does not protect criticism—however unpopular it may be—it cannot protect anything. In today's America, this message is found in editorial cartoons, and the fact that the number of editorial cartoonists is falling should concern both cartoonists and the rest of us.

In June 2003, the Association of American Editorial Cartoonists met in Pittsburgh for its annual convention, at which the members commiserated about the state of the art, ordered up a lot of beer, and then cried in it, in

that order. It had been another bad year for the profession, which had seen the number of editorial cartoonists working full time for daily newspapers drop to a thirty-year low. These annual conventions have become more and more like reunions of World War II veterans: fewer and fewer of the veterans return, and those who do mourn the passing of greats like Herblock and Bill Mauldin, hrrumph at the state of affairs, gripe that things will never be as good as they once were, and wonder which of them will be the next one to go.

It was symbolic, although probably unintentional, that the convention was held in Pittsburgh, where the *Post-Gazette* is one of the few newspapers left with two staff cartoonists, Rob Rogers and Tim Menees. Rogers, the conference's organizer, observed that the shrinking number of cartoonists reflects the economics and priorities of the newspaper industry. "With media conglomerates and takeovers, it's even more likely that the first thing to go when the budget cuts come down is a fringe job like staff cartoonists," he said. "What we're saying is that the cartoonist slot is not a fringe job. We're integral to the identity of a newspaper."[4]

On April 24, two months before the convention, Kirk Anderson of the *St. Paul Pioneer Press* learned that he was being laid off for budgetary reasons. Knight-Ridder, which owns the *Pioneer Press*, made a number of staff cuts because the newspaper had failed to meet its projected 20 percent profit margin, even though the country was in the midst of its worst economy in a generation.[5] Anderson drew a cartoonist, presumably himself, sitting on a curb outside the newspaper, surrounded by his art supplies and thinking, "Okay, *now* it's a recession" (figure 8.13). The *Pioneer Press*, in a display of oversensitivity, did not publish it.

Anderson sent out an e-mail to staffers that criticized the corporate priorities of Knight-Ridder and its CEO and president, Tony Ridder. In the e-mail, Anderson also pointed a finger at his own publisher, suggesting that instead of laying off a cartoonist, whose cartoons the paper's readers saw every day, he first would have cut the service that waters the publisher's plants. Anderson remarked that he would have gladly watered the publisher's plants himself if that meant keeping his job at the newspaper. "I hope job cuts don't make anyone feel resigned to their fate and lucky merely to have a job," Anderson wrote in his e-mail. "They should make us all fight harder for what we've got, and fight harder to build on it. Strong journalism doesn't come from frightened workers. Strong journalism comes from empowered employees who believe in themselves, in their mission, and who know that their company supports and cares about them and their mission too."[6]

Figure 8.13 Kirk Anderson, *St. Paul Pioneer Press*, 2003.

David Astor of *Editor & Publisher Online* reported Anderson's termination, which included the cartoonist's criticism of Tony Ridder. Within hours after the article appeared on the Internet, an incensed Ridder called up *Editor & Publisher*—and Anderson's quotation about him was deleted. Astor, a highly respected reporter who has covered the newspaper industry for the magazine for twenty years, said that he was surprised that his editors had removed Anderson's remark about Ridder. "I would certainly have been willing to update the . . . story with Tony Ridder's response to Kirk's quote," he said.[7] Anderson was aware that the criticism of his former employer would not earn him many letters of recommendation. "I think I've just burned a bridge," Anderson said. "But the fire makes me feel warm all over."[8] A couple of years earlier, Anderson had drawn a cartoon concerning the state of the newspaper industry, showing a barking dog chained to a doghouse marked "Watch Dog Press" (figure 8.14).

After a story on Anderson's dismissal was aired on Minnesota Public Radio, readers learned more about what had happened to Anderson and began sending letters and e-mails to the newspaper in support of the cartoonist. On May 1, the newspaper published a short item on Anderson's dismissal and also included his final cartoon. Then the *Pioneer Press* began publishing syndicated cartoons on its editorial page, which, while filling Anderson's space on the page, did not replace the talented cartoonist's

NEWSPaPeR cHaiN

Figure 8.14 Kirk Anderson, undated.

distinctive perspective on local issues. "At a time when newspapers are looking for local [angles], for visuals, for quick reads, for graphics, for young readers, cartoons do all these things," Anderson said. "It doesn't make any sense to be cutting them. . . . It makes sense to be hiring more."[9]

In a comment to *Editor & Publisher Online*, Bruce Plante, of the *Chattanooga (Tenn.) Times Free Press* and president of the Association of American Editorial Cartoonists, expressed the association's displeasure at the bottom-line mentality of newspaper publishers. "We at the AAEC are aware of the financial realities of the newspaper industry, but our industry leaders must realize that by laying off an editorial cartoonist of Kirk Anderson's stature, they are contradicting their own stated goals," Plante said. "Readership surveys have told us readers want more local content, more local commentary, and more visual elements. Editorial cartoonists provide all three. If our industry leaders are truly concerned about readership, laying off cartoonists like Kirk Anderson is the last thing they should do."[10] According to Plante, now only eighty-four full-time editorial cartoonists are working for the nation's more than fifteen hundred daily newspapers. Perhaps another hundred or so were contributing drawings on a part-time or freelance basis.[11]

In a speech to the Association of American Editorial Cartoonists in 2002, Leonard Downie Jr., executive editor of the *Washington Post*, expressed his concern about what he called the "alarming" decline in the number of newspapers with editorial cartoonists. "The determinedly independent, cantankerous and crusading nature of editorial cartoonists gives important individuality and color to newspapers—too many of which are indistinguishable, bland, and complacent these days," he said. "In fact, the alarming steady decline in the number of editorial cartoonists working for American papers is an important sign of the crisis in resources, confidence and dedication to public service that threatens the future of American newspaper journalism." Downie urged cartoonists to make themselves heard "if you are going to prevent editorial cartooning from becoming an endangered species in daily newspapers. And that is part of the larger struggle for the soul of the American newspaper industry."[12]

The depressing state of editorial cartooning is linked to the state of American newspapers, which are acting more like Wal-Marts than guardians of the public trust. In their 2002 book *The News About the News*, Downie and a colleague at the *Post*, Robert G. Kaiser, portrayed Tony Ridder as a poster boy for what is wrong with the newspaper industry. When Ridder became CEO, according to Downie and Kaiser, he began firing off harsh memos to his editors warning them of what would happen if they did not make their profit objective for the week. Although even in their dreams, few American companies approach a 20 percent profit, Ridder pressured his newspapers to shrink their staffs, regardless of the impact it would have on news coverage. In 2000 when the economy began to deteriorate, Ridder said he did not expect any further cuts to his staffs and then went ahead and cut staffs. Ridder told stockholders that he expected profits closer to 25 percent by 2003 or 2004, although as the economy has continued to struggle, he has lowered that projection.[13]

In 2001, Knight-Ridder corporate executives ordered the *San Jose (Calif.) Mercury News* publisher, Jay T. Harris, to raise his profit margin to almost 30 percent. Harris protested, telling the executives that he would have to cut his staff so severely that the newspaper would not "fulfill its responsibilities to the community." He further explained that while the corporation would benefit by cutting staff, it then would lose because the newspaper would cease to be a vital part of the community. Harris was therefore replaced, and the new publisher cut 10 percent of the newsroom staff and 25 percent of the newsroom's operating budget, suspended the newspaper's Sunday magazine, and shrank its book section.[14]

According to Downie and Kaiser, Knight-Ridder's bottom line, while extremely profitable for a few, was bad not only for journalism but also for democracy, which depends on an informed citizenry, which of course depends on newspapers and their reporters, photographers, editors, editorial writers, and editorial cartoonists. "What Knight-Ridder did in San Jose . . . is precisely the opposite of what newspaper companies will have to do to preserve their place in a crowded media environment," Downie and Kaiser wrote. "Newspapers must get better, not worse, to retain the loyalty of readers, and thus the dollars of advertisers. If they fail to get better, newspapers will continue to shrink—in size, in quality, in importance. This would be tragic, because no other news medium can fill the role that good newspapers play in informing the country."[15] The *Mercury News*'s purge included its editorial cartoonist, Mark Fiore. Dennis Ryerson, the newspaper's vice president and editorial page editor, said he hoped to hire a cartoonist because "when a staff cartoonist focuses on a local issue, it really draws attention to it."[16]

Such a decision ultimately rests with Ridder and his bean-counting inner circle. In 2002, Knight-Ridder did approve the hiring of Doug Marlette for the *Tallahassee (Fla.) Democrat* in Florida's capital city. Marlette's drawings, according to editorial page editor Mary Ann Lindley, "have really electrified our pages." Governor Jeb Bush, for instance, has gotten so angry over Marlette's portrayal of him that he suggested that the state Republican Party hire its own editorial cartoonist. Given how Bush's father reacted to Garry Trudeau's criticism of him, one wonders whether somebody can be genetically predisposed to having thin skin. "Jeb Bush," Lindley said, "is just rattled by Doug Marlette's cartoons."[17] In one drawing, Marlette questioned why Florida continued to execute criminals when national study after national study reported the existence of innocent men and women on death row. Marlette showed an electric chair with the caption "Proposed Official State Motto." Above the chair is the word "Oops."[18]

When Jeff MacNelly died in 2000, the *Chicago Tribune*'s editorial page editor, Bruce Dold, said that the newspaper would hire another editorial cartoonist as soon as it found the right one. The editorial cartoon, he said, "is the best-read thing on the [editorial] page. People like that it's quick, it's funny, and, often, insightful. It's often the only laugh on a page of very serious public policy."[19] But after three years, the newspaper is still without a staff cartoonist. As more and more editorial cartoonists have lost their jobs, editors have professed the intrinsic value of having a cartoonist on their staffs. Their words, however, appear more and more disingenuous. Other

editors, however, understand, as any journalist should, that if words are used carelessly, they are of little value.

When Herblock died in late 2001, the *Washington Post*'s editorial page editor, Fred Hiatt, also said it was important for the newspaper to have its own staff cartoonist. "A good cartoonist develops a relationship with readers and embodies the spirit of a newspaper," Hiatt said. "And it's important for newspapers to give homes to cartoonists. If we all relied just on syndicated cartoons, there eventually wouldn't be a reservoir of talent to draw from." Donald E. Graham, chairman of the Post Company, told Hiatt to hire the best cartoonist, regardless of political ideology, and to give that person the autonomy to do his or her best work.[20]

Four months after Herblock's death, Hiatt hired Pulitzer Prize–winning Tom Toles from the *Buffalo (N.Y.) News*. "Luckily, the person I thought was the best cartoonist is pretty in sync with where our editorials are, although not always and not on everything," Hiatt said, adding that editorial cartoonists must have independence. Therefore, Toles would be free, as Herblock was, to offer a point of view contrary to that of the newspaper. Toles's drawings do not look like anyone else's. Like Pat Oliphant, he includes a small, secondary character in the corner of his drawings who makes a secondary comment. Toles's work does not, however, have the savagery of Oliphant's, and yet, unlike too many others in the profession, it puts thoughtful insight ahead of forgettable gags. In addition, Toles often uses multiple panels, which can strengthen the message if the reader follows them to the end. "Reading four panels for me is almost like going to the dentist," Mike Peters said. "Toles, other than Jules Feiffer, is the only one who makes it worthwhile getting there. He always has a punch."[21] In one drawing, for example, Toles combined the weapons of mass destruction issue with the Bush administration's cozy relationship with rich people (figure 8.15).

When Toles moved to Washington, D.C., he left behind a vacancy in Buffalo. When the *Buffalo News* announced that it would not hire a successor for Toles, the Association of American Editorial Cartoonists sent a letter to the newspaper in June 2002 asking it to reconsider its decision.[22] Like the *News*, many newspapers in recent years have not hired cartoonists after theirs retired, quit, or were fired or laid off, leaving perhaps a historic high of qualified cartoonists—like Anderson and Fiore—looking for work. "Editorial cartoonists spend a lot of time wringing our hands and gnashing our teeth over the dwindling visibility of the profession," Anderson said, "but nobody seems to know what to do about it."[23]

Figure 8.15 Tom Toles, *Washington Post*, 2003.

Publishers need to be convinced that hiring a cartoonist is good for their newspapers' bottom lines, both journalistically and economically. But this becomes problematic as long as newspapers put profit margins over journalistic responsibilities, which is frustrating for editorial cartoonists and many editorial page editors, who understand what publishers do not: that local cartoons bring a dimension to the editorial page that otherwise would be missing. During a discussion of the state of editorial cartooning during the 2002 convention of the Association of American Editorial Cartoonists, Richard Aregood, the editorial page editor of the *Newark (N.J.) Star-Ledger*, said he did not expect publishers to add editorial cartoonists or other staff positions. "I wouldn't hold my breath for [publishers] to hire somebody," Aregood reportedly said. "Publishers don't give a rat's ass about us."[24]

As the number of cartoonists fell to disheartening numbers and social criticism quieted after September 11, 2001, those who followed the profession—like Aregood and Stephen Hess, a senior fellow at the Brookings In-

stitution and the author of two books on editorial cartooning—concluded that the profession had indeed had better days. "Cartoonists lost their edge after 9/11," Hess said. "There has been a recovery since then—you're starting to question the war, and that's a healthy sign." Aregood dismissed much of cartooning as gags and "giggles." He urged cartoonists to strike harder at the issues. In response, Steve Benson of the *Arizona Republic* blamed editors. "Editors want us to be 'fair,' not opinionated," he said, adding that when cartoonists draw hard-hitting work, it often is killed for fear of offending readers or advertisers.[25]

USA Today editorial page editor Carol Stevens answered Benson by saying that newspapers were trying to appeal to a more diverse audience: "The readers aren't just white males . . . our readers demand diversity . . . and fairness."[26] Her words reflected misconceptions about editorial cartoons by editorial page editors, one that dilutes the spirit of editorial cartoons and the personality of editorial pages. Editorial cartoons are not supposed to be fair, and readers do not necessarily demand fairness from their editorial pages. On one point, however, Stevens was right. Editorial pages should be diverse. She added that she and other editors were having trouble finding cartoons by syndicated women and minority cartoonists. Ann Telnaes, a Pulitzer Prize winner who works solely through syndication, interrupted Stevens with a pointed question: "Why don't you hire us?"[27]

The editorial page should be the most democratic section of the newspaper, on which all voices of the community are heard. One finds no dearth of female letter writers or mug shots of women or black columnists on the editorial or op-ed pages. But who draws the editorial cartoons? For the most part, editorial cartoons are drawn by white men, and the decision whether to hire cartoonists and then which drawings to publish are also made, for the most part, by white men. If, however, editorial cartooning thrives only on the pens of men and, in particular, white men, the art form will fail to fulfill its potential. The lack of women and minority editorial cartoonists is unnoticed mainly because—unlike columns and, to a lesser extent, letters—it is difficult to identify a cartoonist's gender or race because he or she signs with a last name only and that signature often is difficult to decipher.[28]

Women represent roughly 50 percent of the U.S. population but less than 4 percent of editorial cartoonists. Signe Wilkinson is the only woman working full time for a daily newspaper. A few others—like Cindy Procious, Linda Boileau, Elena Steier, and Genny Guracar—work on a part-time or freelance basis. Telnaes, Wilkinson, and Etta Hulme are nationally syndicated. Mike Ramirez is the only Latino working full time for a

daily newspaper; Lalo Alvarez is self-syndicated. Corky Trinidad of the *Honolulu Star-Bulletin* is the only Asian working for a daily newspaper. There are no black staff cartoonists, although Aaron McGruder's *Boondocks* strip is distributed by the Universal Press Syndicate. Darrin Bell is self-syndicated, and Eric Harrison freelances his work.

One reason that there are so few women and minority cartoonists working for daily newspapers is because there is no tradition of women and minority editorial cartoonists working for daily newspapers. Over the last several decades, even as women and minorities have established themselves throughout the newsroom, editorial cartooning has remained a white men's game. But why? Guracar, who signs her work "Bulbul," explained that there are so few women working in editorial cartooning because of the declining number of newspapers, the narrow views of editors and publishers, and a culture that does not encourage female opinions and assertiveness.[29] Telnaes observed: "Editorial cartoons have to be strong and forceful. And frankly I think that little girls are taught more to be a little bit more demure . . . so maybe that's the reason that women are not drawn to it."[30]

M. G. Lord, who worked as an editorial cartoonist for *Newsday* and whose cartoons were syndicated by the Copley News Service, described herself as "the rotten kid who did drawings of the teacher behind her back."[31] This, she said, prepared her for editorial cartooning. In addition, she had role models in cartooning and found encouragement from male cartoonists. Lord went to Yale University, where she became friends with Garry Trudeau and Bill Mauldin, who taught a seminar for aspiring cartoonists. Bill said,' "'Look, sweetheart, you're funny. There are no women doing this, so I'll get you a job,' and that's how it started," Lord said.[32]

With Mauldin's help, Lord got a job as an editorial artist for the *Chicago Tribune*, and after a year at the *Tribune*, *Newsday* hired her as its first female cartoonist. Lord gave two reasons why there are very few female cartoonists working for U.S. dailies. "Part of it is conditioning," Lord said. "You sort of have to get angry every day and petulant and peevish. Women are not taught to get angry every day. And also, frankly it's a sexist field." Lord said she once had a sexist editor who made her job unpleasant: "He introduced me very abruptly [to the fact] that everybody was not going to be like Bill Mauldin and think it was charming for a woman to be doing this." Lord left the profession to become a columnist and an author.[33]

From how men and women are raised to how they are treated in school, in their friendships, and in the workplace, they learn what is acceptable and what is not. When a boy interrupts a teacher with a sarcastic comment or put-down, making his classmates laugh, he will likely repeat the act, and his

insolence will be excused with the words "boys will be boys." But if a girl uses sarcasm in the classroom, she may be rebuked by being told her actions are "not ladylike," thus discouraging her from repeating the behavior.

Women editorial cartoonists agree that there is something to this. "We encourage our sons to be aggressive and outspoken," Cindy Procious pointed out, "but encourage our daughters to be demure, dampening their passion so they're not labeled an aggressive bitch. From an early age girls are channeled into the more gentle art forms—fine arts and literature."[34] Telnaes agreed: "It's more socially acceptable for men to be associated with this medium. A confident, aggressive man is a go-getter; a confident, aggressive woman is a bitch."[35]

Wilkinson said that aggressive humor is more appealing to men than women. "It's the moms and babysitters who are usually telling future cartoonists that 'if you don't have anything good to say, don't say anything at all.'"[36] Elena Steier said that the lack of women in cartooning and all humor fields is because "women, both by upbringing and by nature, tend to be responsible human beings," she said, adding: "We women tend to be very conscious of having to conform." She said that because editorial cartooning is individualistic and aggressive and challenges the status quo, "the reigning Alpha females would doubtless find this in bad taste and discourage cartooning as a recommended diversion."[37]

The dearth of women cartoonists also is, as Lord pointed out, a reflection of gender stereotypes. Kate Sally Palmer, formerly of the *Greenville (S.C.) News*, said that male editors have been slow to hire female cartoonists because they find abrasive women threatening.[38] If editors believe that cartooning is men's work—and there certainly is anecdotal evidence that a number do—this exacerbates the difficulty of women's trying to enter what has traditionally been a male-dominated profession. Even if a female cartoonist is fortunate enough to find a job, she may find, as Palmer did, that her freedom is restricted by a male hierarchy that determines what is or is not acceptable subject matter for a cartoon.

As a liberal working for a conservative newspaper in a conservative part of a conservative state, Palmer said she would have had differences of opinion with her editor regardless of whether she was a woman or a man. If her politics had agreed with her editor's, she said she probably would have been accepted as a "token woman." But because her politics were unacceptable and she was the sole dissenting voice, she was ridiculed and told she was not a good sport. "If I had been a man," she concluded, "they would have left me some self-respect."[39] Frustrated, Palmer left the profession to illustrate children's books.

Conflicts between male editorial cartoonists and their male editors are inevitable—and sometimes because of the conflict, the cartoonist quits or is fired. And if the editor is male and the cartoonist is female, it creates one more potential source of disharmony, especially if the editor has his own ideas of what man's work and what woman's work is, if the editor does not believe that so-called women's issues are as important as political or other social issues, or if the editor believes that female cartoonists are women first and cartoonists second.

Women in cartooning believe that editors too often see them as "female cartoonists" and not simply as cartoonists. It is more acceptable for women to become editorial writers because they first established themselves as reporters. Lord said that women confront certain problems when breaking into editorial cartooning. "No one knew what the phrase 'a woman's point of view' meant when it was applied to an editorial cartoonist," she said.[40] This introduces a double standard. No one assumes that a male cartoonist will restrict himself to "a man's point of view." Female cartoonists argue that their gender helps shape what issues they draw and how they draw them. They say they are cartoonists who happen to be women and are not just "women cartoonists." In addition, many editors believe that female cartoonists—because of their gender—cannot be as hard-hitting as men. When she drew strong cartoons, Palmer said that colleagues and readers praised her work by saying that she "drew like a man."[41]

Wilkinson argues that it is men—and not women—who often tend to have a less serious approach. Wilkinson and other cartoonists believe that one of the reasons the profession is suffering is that editors are encouraging harmless gag cartoons rather than issue-oriented ones. Gag cartoons often sacrifice substance for sophomoric humor, which is "not as funny to women as men," Wilkinson said. She thinks that cartooning should go beyond gag lines commenting on the morning's news: "Cartoons can fight for ideas, defend the downtrodden, and, most important, use humor to subvert the status quo."[42]

Women cartoonists say they are drawn more naturally to some subjects than others, including so-called women's issues such as sexual discrimination and equal pay but also concerns about the family and even military defense. It is not coincidental that female cartoonists tend to oppose the war in Iraq. In one of her cartoons, Ann Telnaes drew a group of men in the midst of a discussion on world affairs being interrupted by women holding newspapers referring to bleak international events. "This just isn't working," one of the women is saying. "Why don't you let us take over for a while?" (figure 8.16). According to Wilkinson, women draw "home and

hearth" issues by default because most male cartoonists overlook them.[43] During a series of well-publicized child abductions, Procious, the mother of three children, drew a worried man looking under his daughter's bed. "C'mon, Dad . . . I'm not afraid of monsters under my bed anymore," the daughter tells him (figure 8.17).

Given these days of political correctness, when criticisms of women are often accompanied by charges of sexism, to avoid such an allegation, cartoonists simply avoid drawing women or tone down their satire when women are involved. In 1984 when Geraldine Ferraro became the first woman in a major political party to run for vice president, editorial cartoonists, according to one study, treated her as Joan of Arc and not as one of the other boys running for president or vice president.[44] But as more and more women have entered politics, familiarity with female politicians has bred an accompanying sense of contempt. For instance, editorial cartoonists have hardly given U.S. senator and former first lady Hillary Clinton the Geraldine Ferraro treatment. As women ascend to higher positions of power and influence, they will have to open themselves up to what Hess once called "the ungentlemanly art."

Figure 8.16 Ann Telnaes, 2003.
Reprinted with permission of Tribune Media Services.

"C'MON, DAD...I'M NOT AFRAID OF MONSTERS UNDER MY BED ANYMORE."

Figure 8.17 Cindy Procious, *Huntsville (Ala.) Times,* 2001.

As newspaper readership stagnates and publishers reduce their staffs, women interested in becoming editorial cartoonists may find that their greatest obstacle is not biological, organizational, or sociological but economic. As a result of the deteriorating newspaper industry, cartoonists are losing jobs and few are finding new ones, regardless of their race, gender, or politics. "Editorial cartooning is a dying art, and the pool of editorial cartooning is shrinking. I think it's equally difficult for men as it is for women," Steier said.[45] Wilkinson agreed. "This isn't a growing business," she said. "Women of humor go directly to LA and start writing for Fox."[46]

The same, of course, may be said for talented blacks, who for generations were prohibited from working for mainstream newspapers. Oliver Harrington, for example, was restricted to black newspapers and was virtually unknown to white America. As he began to make a name for himself when his work appeared in the mainstream, he was driven from the country by McCarthy-era oppression. When the newspapers integrated along with the rest of American society, black journalists moved to mainstream dailies, and black newspapers lost their particular identity and influence. Black cartoonists, limited by both discrimination and the general lack of openings in editorial cartooning, found themselves frustrated and so drifted into other fields. *Boondocks* creator Aaron McGruder nowadays is producing arguably the hippest social commentary appearing in daily newspapers.

McGruder, like Trudeau, Oliphant, Rall, Telnaes, and others, works solely through syndication. What these cartoonists lack in security—job, financial, and otherwise—they gain in autonomy, not having to answer to either oversensitive editors or editors who have little understanding of editorial cartooning. For this reason, these syndicated cartoonists produce some of the most compelling editorial cartoons appearing today in newspapers. During the Iraqi war, *Rolling Stone* said that some editorial cartoonists, including Rall, McGruder, and Tom Tomorrow, who were working mainly for alternative newspapers and magazines, were "bringing the noise of dissent to America." According to Tomorrow, whose real name is Dan Perkins, the job of an editorial cartoonist is "to grab people by the lapels, shake them and say, 'Don't you understand what's happening?'"[47]

Many newspapers hire cartoonists on a freelance basis so they can say they have a cartoonist but do not have to give him or her a salary or a dental plan. Some of these editors no doubt believe that occasionally allowing their staff artists to draw cartoons is the same as having their own cartoonists. But this argument is fundamentally flawed—unless you believe there is no difference between substitute teachers and full-time teachers. With a full-time position comes not just more money but a greater sense of prestige and security. Such independence does not guarantee provocative social criticism, but it vastly improves the possibilities. Editorial cartoons are most effective when they pick a fight with city hall or the local school board, shining the bright light of public scrutiny on these public servants and forcing them to act according to the democratic principles they are supposed to represent.

In 2002, Rall, who answers only to himself, his syndicate, and his readers, edited a book entitled *Attitude: The New Subversive Political Cartoonists*, which profiles the work of cartoonists not working for metropolitan dailies: "too alternative for the mainstream and too mainstream for the underground," he said.[48] According to Rall, these cartoonists—which include Tomorrow, Lalo Alvarez, Scott Bateman, Joe Sharpnack, and himself—work apart from the commercial pressures of mainstream journalism and, because of this, produce hard-hitting commentary that does not chuckle at the news but scowls at it, questioning issues that otherwise would be neglected by the mainstream press. "Cartooning won't change the world, but that's no reason not to try," Rall said. "In the proudest traditions of great art and political activism, they're not drawing these cartoons for the money."[49]

Year after year, Joe Sharpnack self-syndicated his work from his tiny Iowa City apartment, for little money and no job security but also nobody telling him what he could draw and how. His work appeared regularly

throughout the state, often in the *Des Moines Register*, criticizing the policies of then Republican governor Terry Bransted. Sharpnack, like Paul Conrad, another Iowan, suspected that his work had made him enemies. "I don't think I can prove it, but the timing was just too close to be coincidental," Sharpnack said. Shortly after one series on Bransted, Sharpnack received a notice that his taxes were being audited by the state of Iowa for the past seven years, even though his income was at the poverty level. "They dug back seven years, which I believe is as far as the law allows," he remembered. "I think they only went back three for Al Capone."[50]

Like other cartoonists hoping to become syndicated or find a staff job with a newspaper, Sharpnack sent out his cartoons week after week, month after month, hoping to add to his list of newspapers or, better yet, become one of the relatively few cartoonists working for a daily newspaper. When the *Cedar Rapids (Iowa) Gazette* began publishing an edition in nearby Iowa City, it hired Sharpnack to draw three cartoons a week that appeared in the newspapers in Iowa City and Cedar Rapids. Living in progressive Iowa City and working for a liberal newspaper, Sharpnack's work captured an appreciative audience and earned him at least the makings of a national reputation. He won an honorable mention in the 2002 John Fischetti Award for the best editorial cartoonist of the year.

But in July 2003, Sharpnack's editors told him that it would be suspending its Iowa City edition for economic reasons, and as a result, it could afford to pay him only one-third of what he was currently making. His annual salary from the *Gazette* thus dropped from $15,000 to $5,000. "A steady check from the *Gazette* gave me breathing room," he said. "I had time to work on other projects without having the daily pressure of constantly beating the bushes for more newspapers and magazines to buy one-shot pieces. It's back to hand-to-mouth at the moment. Which sucks, as you can imagine."[51]

The climate for editorial cartooning has forced many promising cartoonists to either seek alternative employment or find a niche outside the mainstream newspapers. For years, Genny Guracar tried to find a job as a cartoonist for a daily newspaper or with a syndicate. She was told that her cartoons were too "strident." She said she tried to tone them down. But this did not lead to a job and left her unhappy with her work. "Ultimately, I felt like I was having to rein in my best energy and impulses," she said, "so I decided to find an audience for cartoons that honestly reflected my ideas." Since then, she has published her drawings in the labor and alternative press.[52]

Other editorial cartoonists, similarly frustrated with the restrictions of working in mainstream journalism, have gone into business for themselves.

For twenty years, Gary Huck and Mike Konopacki have self-syndicated their cartoons to labor publications, focusing on issues like health and safety in the workplace, sexual harassment, and right-to-work laws. Huck and Konopacki say that they give their readers something they will not find in the mainstream press.[53] In 2002, three conservative cartoonists—Colin Hayes, Bob Lang, and Paul Nowak—created Rightoons.com on the Internet to appeal to readers on the political right. *Editor & Publisher Online* found that there were thirty-five conservative and thirty liberal columnists at America's eight biggest syndicates, but that liberal editorial cartoonists outnumbered conservatives by two to one.[54]

Whereas once television offered promise for editorial cartoonists, now do computers, which, because of Web sites, make cartoons more accessible, although not necessarily profitable for those who produced them. Some cartoonists, notably Mark Fiore, a San Francisco–based artist, have reinvented the art form of editorial cartooning by producing animated work on the Web. This gives the editorial cartoonist the ability to almost literally grab the reader by the collar and shake him out of his complacency. However, such technology will continue to be limited until it becomes profitable. If things continue as they have, Washington State–based editorial cartoonist Milt Priggee said that editorial cartoonists may be forced to do as they did in colonial days: sell their work on the streets.[55] Kevin Kallaugher, a former president of the Association of American Editorial Cartoonists, predicted that editorial cartooning would rise and fall with daily newspapers: "The future of cartooning is inextricably bound to the future of newspapers" (figure 8.18).[56]

The glory days of the late 1960s and 1970s may be gone forever for cartoonists. Ten years ago, when editorial cartoonists were asked whether it was easy for cartoonists to find jobs at newspapers, none said it was. Only 14 percent reported that there were more opportunities than there had been a decade earlier. When asked to comment on the state of the art, 11 percent called it "good," 34 percent had mixed feelings, and 55 percent called it "bad." One cartoonist offered this summary: "Large buyouts and political correctness, plus the loss of the art of drawing, makes me concerned." Others blamed so-called gag cartoons on cartoonists and on the overly cautious attitudes of editors. One cartoonist described the state of cartooning more bluntly: "It's in the toilet."[57]

If editorial cartoonists took the same survey now, the results, while distressing then, would be positively bleak today. The decline in cartooning cannot be blamed entirely on the state of newspapers or the tepidness of editors, or in the stars for that matter—but with the cartoonists themselves,

Figure 8.18 Kevin Kallaugher, *Baltimore Sun*, 1996.

who, too often, illustrate headlines or look for easy gags at the expense of social criticism. On any given day, too many cartoons approach the same subject in the same way, saying the same thing that is immediately forgettable. Doug Marlette was once asked what makes a good cartoon: "Can you remember it?" Marlette answered. "Did it tattoo your soul? Did it get under your skin?"[58] According to one editorial cartoonist, Jim Morin of the *Miami Herald*, the profession has compromised itself by not taking itself seriously. He said that the greats in the field—from Thomas Nast to Jeff MacNelly—used passion and memorable ideas in their work but that neither draftsmanship nor caricature was enough for an editorial cartoon. "Poor use of the medium . . . [has] given us a preponderance of visual editorial comment resembling comic strips or greeting cards," he said, "instead of the potentially explosive catalyst for thought and feeling that cartooning could be."[59] Paul Conrad once told a gathering of cartoonists that they had shrunk from their responsibilities because they were ill informed on either the issues of the day or the classics of antiquity.[60]

Morin and Conrad have earned the right to criticize their profession. Those cartoonists who go with their first idea and then rush off their draw-

ings as though a cab were waiting, those who have nothing to say beyond stereotypes and caricature, or those who believe that editorial cartoons are no different from joke-of-the-day calendars reduce the prestige of the profession and give ammunition to their critics. For instance, Ralph Lowenstein, dean emeritus of the University of Florida's College of Journalism and Communications, expressed his low opinion of editorial cartooning by saying that the "profession is one that succeeds best by reducing the most serious issues of the day to a one-line, very funny joke. When they do not succeed, they reduce the most serious issue of the day to a one-line statement that is not very funny."[61]

Such simplistic criticism does little to contribute to the understanding of an underappreciated and undervalued medium. But other media scholars have recognized what Lowenstein and many editors and publishers do not. Stephen Hess insists that the editorial cartoon is worth saving because it "is the embodiment of the American form of government. Democracy is fed by encouraging a free forum for discussion." In addition, he said, "there's something basically healthy about a society that has hard-hitting, clever, smart fresh cartoonists."[62] John Soloski, dean of the University of Georgia's Grady College of Journalism and Mass Communication, acknowledged that the decline in the profession is bad for journalism. "Fewer newspapers will have cartoonists and they'll be syndicated," he said. "To me, it's a disservice. This is an important form of American journalism."[63]

While it is true that much of the profession has little to say—politically, philosophically, or rhetorically—the same could be said for the preponderance of America's columnists and editorial writers. For instance, when was the last time you read an op-ed column that torched your soul? Many editorial cartoonists, though, have much to say—and are saying it loudly and clearly and with great zeal, in newspapers throughout America. While greats like Herblock, Mauldin, and MacNelly are dead and Conrad and Oliphant are in the twilight of their careers, at least a couple of dozen editorial cartoonists, and maybe more, still regularly express themselves in the best tradition of journalism. They have the talent, courage, and self-respect to make a difference in a country that depends on social criticism. Perhaps another twenty-five or thirty could rise to this level if publishers and editors simply did what editors and publishers are supposed to do, given the First Amendment and the country's tradition of a free press. Yet too many editors and publishers have the priorities of accountants and the souls of government bureaucrats.

Newspapers that give their cartoonists the freedom to express their own views, as free as possible from editorial restraint, reinforce the provocative

message that an uninhibited exchange of opinions not only strengthens but maintains a democracy; in fact, it is necessary for a democracy. No one serves the role of government critic as well as editorial cartoonists do. As artists, satirists, and commentators, editorial cartoonists make a unique and invaluable contribution to society. But editorial cartoons are becoming endangered species, and like any national treasure, they are worth protecting.[64]

While editors consider reporters, photographers, columnists, and editorial writers indispensable—at least for now—relatively few newspapers have their own full-time editorial cartoonists on staff or believe it is necessary. Doug Marlette thinks that this devalues not just cartooning but journalism in general, and this, he said, is reflected in the declining readership and declining influence of American newspapers.[65] Editorial cartoonists will continue to be an endangered species until publishers and editors believe that they are worth saving. How do you convince publishers and editors of this? Joel Pett said that publishers and editors can hire cartoonists without sacrificing the newspaper's bottom line. "If they take seriously the journalistic side of their obligation," he said, "if they sign on to the quaint but true notion that journalism ought to comfort the afflicted and afflict the comfortable, there's no better way to afflict the comfortable than with editorial cartoons."[66]

1. "You Should Have Been in the World Trade Center"

1. Chip Bok, "Editorial Cartoonists Return to Satirical Ways," *News Media and the Law* (winter 2002): 15.

2. Steve Breen, on *Morning Edition*, National Public Radio, December 21, 2001.

3. Drew Sheneman, "Suppressing the Gag Reflex," *Newark (N.J.) Star-Ledger*, September 30, 2001; Association of American Editorial Cartoonists Web site (http://info.detnews.com/aaec), April 2002.

4. Quoted in David Horsey, "How Osama Bin Laden Made Us Feel Relevant," Association of American Editorial Cartoonists Web site (http://info.detnews.com/aaec), December 2001.

5. Bok, "Editorial Cartoonists Return to Satirical Ways," 14.

6. Jesse Walker, "Doonesburied: The Decline of Garry Trudeau—And of Baby Boom Liberalism," *Reason*, July 2002, 50.

7. "An Annotated Conversation with the Author," in *The People's Doonesbury: Notes from Underfoot, 1978–1980* (New York: Holt, Rinehart and Winston, 1981).

8. Quoted in Alicia Tugend, "Reports of the Death of Irony May Have Been Greatly Exaggerated," Association of American Editorial Cartoonists Web site (http://info.detnews.com/aaec), June 2002, published in *American Journalism Review*, May 2002, 52.

9. Interview with Mike Luckovich, Project for Excellence in Journalism and Committee of Concerned Journalists Web site (www.journalism.org), November 2001.

10. Walker, "Doonesburied," 51.

11. Telephone interview with Joel Pett, February 25, 2003.

12. Joel Pett, "Reflections on Editorial Cartooning in Post-9/11 World," Association of American Editorial Cartoonists Web site (http://info.detnews.com/aaec), April 2002, and American Press Institute Web site (www.americanpressinstitute.org), September 28, 2001.

13. Ibid.

14. Quoted in Tugend, "Reports of the Death of Irony."

15. Ibid.

16. Umut Ozkimli, *Theories of Nationalism* (New York: St. Martin's Press, 2000).

17. Guntram Herb, "National Identity and Territory," in *Nested Identities*, by Guntram Herb and David Kaplan (New York: Rowman & Littlefield, 1999), 16; see also Peter Sahlins, *Boundaries* (Berkeley: University of California Press, 1991), and Miroslav Hroch, "From National Movements to Fully-Formed Nation: The National-Building Process in Europe," in *Mapping the* Nation, ed. Gopal Balakrishnan (New York: Verso and New Left Review, 1996), 78–97.

18. Philip Knighly, *The First Casualty* (New York: Harcourt Brace Jovanovich, 1975).

19. Zechariah Chaffee Jr., "Freedom of Speech and Press," in *The Heritage of Freedom*, ed. Wilfred S. Dowden (New York: Harcourt, Brace and Howe, 1946), 149.

20. Quoted in "Fate of Eastman in the Jury's Hand," *New York Times*, April 26, 1918, 20.

21. Richard Aldington, "Purfleet," in *The Colonel's Daughter, a Novel* (London: Chatto and Windus, 1931), pt. 1, chap. 6.

22. Carl Schurz, "The Policy of Imperialism," *Speeches, Correspondence and Political Papers of Carl Schurz*, ed. Frederic Bancroft (New York: Putnam, 1913), 6:119–20.

23. Quoted in Andrew Buncombe, "U.S. Cartoonists Under Pressure to Follow the Patriotic Line," *Independent* (London), June 23, 2002, 16.

24. Quoted in Tugend, "Reports of the Death of Irony."

25. Telephone interview with Joe Sharpnack, March 19, 2003.

26. "Benson's View Vexes Vets: Two Papers Run, Then Run from Anti-War Cartoon," Association of American Editorial Cartoonists Web site (http://info.detnews.com/aaec), April 2002.

27. Bok, "Editorial Cartoonists Return to Satirical Ways," 15.

28. Buncombe, "U.S. Cartoonists Under Pressure to Follow the Patriotic Line."

29. Quoted on Associated Press Web site (www.ap.org), February 14, 2002.

30. Ibid.

31. Quoted in Buncombe, "U.S. Cartoonists Under Pressure to Follow the Patriotic Line."

32. Quoted on Associated Press Web site (www.ap.org), March 7, 2002.

33. Alan Keyes, on MSNBC Web site (www.msnbc.com/news), March 12, 2002.

34. Universal Syndicate, on Association of American Editorial Cartoonists Web site (http://info.detnews.com/aaec), April 2002.

35. Telephone interview with Ted Rall, June 25, 2003.

36. Quoted on Associated Press Web site (www.ap.org), March 6, 2002.

37. *The O'Reilly Factor* (transcript), Fox News Channel, March 7, 2002.

38. Quoted in Tugend, "Reports of the Death of Irony."

39. Telephone interview with Ted Rall, June 25, 2003.

40. Quoted in David Astor, "'The Boondocks' Comic Strip Causes Post-September 11th Controversy," *Editor & Publisher*, December 10, 2001, 12.

41. Ibid.

42. "Censoring 'Boondocks' Comic Strip," *Dollars and Sense*, January 2002, 4.

43. Astor, "'The Boondocks' Comic Strip," 12.

44. Telephone interview with Joel Pett, February 25, 2003.

45. Allan Wolper, "The New College Try," *Editor & Publisher*, October 8, 2001, 22.

46. Quoted in David Astor, "A Post 9/11 Review of Editorial Cartooning," *Editor & Publisher*, February 4, 2002, 31.

47. Chris Lamb, "Drawing the Line on September 11 Cartoons," *The State* (Columbia, S.C.), September 4, 2002.

48. Telephone interview with Ted Rall, June 25, 2003.

49. Ranan Lurie, *Nixon-Rated Cartoons* (New York: New York Times, 1973), 15.

50. Telephone interview with Ted Rall, June 25, 2003.

51. Quoted on Associated Press Web site (www.ap.org), October 25, 2001.

52. David Astor, "Rising to the Occasion?" *Editor & Publisher*, February 4, 2002.

53. Quoted in John Kuenster, "The Responsible Editorial Cartoonist," *Voice of St. Jude*, March 1961, 10.

54. Herb Block, "The Cartoon," in *The Editorial Page*, ed. Laura Longley Babb (Boston: Houghton Mifflin, 1977), 152.

55. Kuenster, "Responsible Editorial Cartoonist," 10.

56. Quoted in Roger Fischer, *Them Damned Pictures!* (North Haven, Conn.: Archon Books, 1996), xi.

57. Quoted in "One of the Few," *Time*, June 13, 1968, 55.

58. Quoted on Associated Press Web site (www.ap.org), February 26, 2002.

59. Leonard Downie and Robert Kaiser, *The News About the News* (New York: Knopf, 2002).

60. Chip Bok, *Bok! The 9.11 Crisis in Political Cartoons* (Akron, Ohio: University of Akron Press, 2002), 7.

61. Horsey, "How Osama Bin Laden Made Us Feel Relevant."

62. Quoted in Bok, "Editorial Cartoonists Return to Satirical Ways," 16.

63. Telephone interview with Ted Rall, June 25, 2003.

64. "Anti-War Cartoonists Find Feedback Split," Association of American Editorial Cartoonists Web site (http://info.detnews.com/aaec), May 2003.

65. Ibid.

66. Telephone interview with Clay Bennett, June 3, 2003.

67. Ibid.

2. *"President Bush Has Been Reading* Doonesbury *and Taking It Much Too Seriously"*

1. Mark Singer, "Boola-Boola Bush vs. Trudeau, Chapter 1," *New Yorker*, January 8, 2001, 28.

2. Garry B. Trudeau, *Doonesbury Deluxe* (New York: Holt, 1988), back cover.

3. Garry B. Trudeau, *Flashbacks: Twenty-five Years of Doonesbury* (Kansas City, Mo.: Andrews and McMeel, 1995), 228–30.

4. Quoted on Trudeau, *Doonesbury Deluxe*, back cover.

5. Quoted in Singer, "Boola-Boola Bush," 29.

6. Trudeau, *Flashbacks*, 234.

7. Quoted in Singer, "Boola-Boola Bush," 29.

8. Quoted in Trudeau, *Flashbacks*, 311.

9. "An Annotated Conversation with the Author," in *The People's Doonesbury: Notes from Underfoot, 1978–1980* (New York: Holt, Rinehart and Winston, 1981).

10. Michelle Woodson, "Enter Mike Doonesbury," *Time*, October 28, 1994, 104.

11. Trudeau, *Flashbacks*, 187.

12. "An Annotated Conversation with the Author."

13. Ibid.

14. Trudeau, *Flashbacks*, 277.

15. "Doonesbury: Drawing and Quarterbacking for Fun and Profit," *Time*, February 9, 1976, 58.

16. Edward Rosenheim Jr., *Swift and the Satirist's Art* (Chicago: University of Chicago Press, 1962), 12.

17. Jean H. Hagstrum, "Verbal and Visual Caricature in the Age of Dryden, Swift, and Pope," in *England in the Restoration and Early Eighteenth Century*, ed. H. T. Swedenberg Jr. (Berkeley: University of California Press, 1972), 188–89.

18. Matthew Hodgart, *Satire* (New York: McGraw-Hill, 1969), 12.

19. Quoted in Trudeau, *Flashbacks*, 305.

20. Quoted in Carla Hall, "Arizona in Uproar over 'Doonesbury,'" *Daily Iowan*, September 3, 1987, 1.

21. Quoted in David Astor, "'Doonesbury,' Series Brohaha," *Editor & Publisher*, September 12, 1987, 56.

22. Quoted in Andrew Radolf, "Don't Shrink the Comics," *Editor & Publisher*, April 30, 1988, 49.

23. Garry B. Trudeau, "The Views of a Cartoonist," *Nieman Reports* 3 (autumn 1988): 8.

24. Thomas Rosentiel, "Doonesbury Strips Dropped, Edited as Controversy Grows," *Los Angeles Times*, April 17, 1986, A3.

25. Ibid., A26.

26. "Doonesbury: Drawing and Quarterbacking," 60.

27. Alex S. Jones, "Sinatra Seeks Lists of Papers Printing 'Doonesbury' Comic," *New York Times*, June 21, 1985, A30.

28. Quoted in ibid.

29. Quoted in Trudeau, *Flashbacks*, 185.

30. Quoted in Stephen Hess and Milton Kaplan, *The Ungentlemanly Art: A History of American Political Cartoons* (New York: Macmillan, 1968), 41.

31. W. Clark Hendley, "The Horatian Satire of Trudeau's 'Doonesbury,'" *Journal of Popular Culture* 16 (1983): 115.

32. Trudeau, *Flashbacks*, 240.

33. Ibid., 258.

34. Quoted in "Doonesbury: Drawing and Quarterbacking," 59.

35. Quoted in Sam Zagoria, "When Funnies Aren't Funny," *Washington Post*, October 16, 1985, A22.

36. Jesse Walker, "Doonesburied: The Decline of Garry Trudeau—And of Baby Boom Liberalism," *Reason*, July 2002, 51.

37. M. Thomas Inge, "Introduction: The Comics as Culture," *Journal of Popular Culture* 12 (spring 1976): 631.

38. John Colapinto, "The Art of War," *Rolling Stone*, April 17, 2003, 50.

39. Quoted in David Astor, "Tinsley v. Trudeau in Funny Page Flap," *Editor & Publisher*, February 7, 1998, 40–41.

40. Quoted in Trudeau, *Flashbacks*, 288.

41. Rosenheim, *Swift and the Satirist's Art*, 12.

42. Hodgart, *Satire*, 118.

43. Quoted in "The Finer Art of Politics," *Newsweek*, October 13, 1980, 85.

44. Hodgart, *Satire*, 10.

45. Ibid., 33.

46. Robert Elliott, *The Power of Satire: Magic, Ritual, Art* (Princeton, N.J.: Princeton University Press, 1960), 180.

47. Ibid., 261.

48. Ibid., 257, 261.

49. James Sutherland, *Defoe* (Philadelphia: Lippincott, 1938), 92.

50. Steven Heller, "Man Bites Man," *The Progressive*, February 1982, 47.

51. Ibid.

52. Lawrence Streicher, "David Low and the Mass Press," *Journalism Quarterly* (summer 1966): 211.

53. "The Caged Cartoonist in the Andropov Era," *Newsweek*, May 7, 1983, 48; "Paco Freed from Prison Cell," *Association of American Editorial Cartoonists Notebook* (fall 1984): 4; "Palestinian Satirist Is Shot by Lone Assailant in London," *New York Times*, July 24, 1987, A4; "AAEC Protests Recent Treatment of Two Panamanian Cartoonists," Association of American Editorial Cartoonists Web site (http://info.detnews.com/aaec), September 2002.

54. Joseph George Szabo, "Worldwide Madness," *WittyWorld International Cartoon Magazine* 17 (winter–spring 1994): 9.

55. Garry B. Trudeau, "Drawing Dangerously," *New York Times*, July 10, 1994, E19.

56. Quoted in J. Chal Vinson, *Thomas Nast, Political Cartoonist* (Athens: University of Georgia Press, 1967), 11.

57. Quoted in John Geipel, *The Cartoon: A Short History of Graphic Comedy and Satire* (London: David and Charles, 1972), 19.

58. Quoted in Michael Colton, "No Laughing Matter," *Brill's Content*, February 2000, 126.

59. Quoted in John Culhane, "Political Cartoonists Take Aim," *New York Times Magazine*, 1975, 14, courtesy of Ohio State University Cartoon Research Library, Columbus.

60. Quoted in Kat Yancey, "The Outspoken Oliphant," CNN Web site (www.cnn.com), February 15, 1998.

61. Clay Bennett, at "It's a Draw: Political Cartoonists Reflect on the 2000 Presidential Election," College of Charleston, Charleston, S.C., April 5–7, 2001.

62. Telephone interview with Doug Marlette, July 1, 2003.

63. Christopher Morley, introduction to *A History of American Graphic Humor*, by William Murrell (New York: Macmillan, 1933), 1:x.

64. Quoted in "Finer Art of Politics," 74.

65. Quoted in Stephen Hess and Milton Kaplan, *The Ungentlemanly Art: A History of American Political Cartoons* (New York: Macmillan, 1968), 86.

66. Quoted in Frank Luther Mott, *American Journalism, a History: 1690–1960* (New York: Macmillan, 1962), 529.

67. "A Conversation with Mike Peters," *U.S. News & World Report*, June 22, 1981, 65.

68. David Astor, "Clay Bennett," *Editor & Publisher*, November 26, 2001, 10; telephone interview with Clay Bennett, June 3, 2003.

69. Thomas Collins, "Whose Idea Is It?" *Newsday*, December 10, 1985, pt. 2, p. 3.

70. Quoted in Lori Robertson, "Is There an Echo in Here?" *American Journalism Review*, January 1999, 10.

71. Telephone interview with Joel Pett, February 25, 2003.

72. Telephone interview with Clay Bennett, June 3, 2003.

73. Quoted in John Kuenster, "The Responsible Editorial Cartoonist," *Voice of St. Jude*, March 1961, 11.

74. Telephone interview with Clay Bennett, June 3, 2003.

75. Robertson, "Is There an Echo in Here?" 10.

76. Ted Rall, ed., *Attitude: The New Subversive Political Cartoonist* (New York: Nantier, Beall, Minoustchine, 2002), 8.

77. Chris Lamb and Joe Burns, "What's Wrong with the Picture? The Anti-Incumbent Bias of Cartoons During the '92 Campaign" (paper presented at the Association for Education in Journalism and Mass Communication Southeast Colloquium, March 14–16, 1996).

78. Quoted in Yancey, "Outspoken Oliphant."

79. LeRoy M. Carl, "Editorial Cartoons Fail to Reach Many Readers," *Journalism Quarterly* 45 (autumn 1968): 534.

80. Werner Hofmann, *Caricatures from Leonardo to Picasso* (New York: Crown, 1957), 21.

81. Roger Fischer, *Them Damned Pictures!* (North Haven, Conn.: Archon Books, 1996), 11.

82. Quoted in Draper Hill, "Joseph Keppler on Caricature," *Association of American Editorial Cartoonists Notebook* (summer 1984): 30.

83. Fischer, *Them Damned Pictures*, 70–71.

84. Chris Lamb, "Censorship Is No Laughing Matter," *Quill*, June 2002, 60.

85. "Journalism Education in-Brief," Society of Professional Journalists Web site (http://www.spj.org/quill).

86. Jeffrey Leib, "Campus Paper's Editor Resigns over April 1 Edition," *Denver Post*, April 10, 2002, 2D.

87. "Journalism Education in-Brief."

88. "Black Purdue Students Want Cartoonist Dropped from Campus Paper," Association of American Editorial Cartoonists Web site (http://info.detnews.com/aaec), April 2002.

89. "Stop Stifling Free Speech," *Daily Free Press* (Boston University), November 18, 2002.

90. Quoted in David Astor, "Laughs and Gripes About Stereotypes," *Editor & Publisher*, June 22, 1996, 46.

91. Telephone interview with Ted Rall, June 25, 2003.

92. Quoted in Debra Gersh Hernandez, "Political Cartoonists Confront Political Correctness," *Editor & Publisher*, August 6, 1994, 34.

93. Astor, "Laughs and Gripes About Stereotypes," 46–47.

94. David Astor, "Cartoon on Welfare Stirs a Big Response," *Editor & Publisher*, September 30, 1995, 32.

95. M. L. Stein, "Cartoon's Message Backfires in Calif.," *Editor & Publisher*, February 19, 1994, 9.

96. Patrick T. Reardon, "Drawing Blood: A Newspaper's Editorial Cartoons Are Meant to Sting, Even Offend; It's a Grand, Old Tradition," *Chicago Tribune*, June 18, 2003, 1C.

97. Ibid.

98. Associated Press Web site (www.ap.org), June 2, 2003.

99. Ibid.

100. Reardon, "Drawing Blood," 1C.

3. "No Honest Man Need Fear Cartoons"

1. Clay Bennett and Doug Marlette, at "It's a Draw: Political Cartoonists Reflect on the 2000 Presidential Election," College of Charleston, Charleston, S.C., April 5–7, 2001.

2. Art Spiegelman, "Emergency Session of the United Cartoon Workers of America," *New Yorker*, January 24, 2001, 78.

3. Charles Press, *The Political Cartoon* (London: Macmillan, 1981), 113.

4. Matthew Hodgart, *Satire* (New York: McGraw-Hill, 1969), 77.

5. Christopher Jon Lamb, "Drawing the Limits of Political Cartoons in the U.S.: The Courtroom and the Newsroom" (Ph.D. diss., Bowling Green State University, 1995), 49–50.

6. *The Image of America in Caricature and Cartoon* (Fort Worth, Tex.: Amon Carter Museum, 1975), 2.

7. Stephen Hess and Sandy Northrop, *Drawn and Quartered: The History of American Political Cartoons* (Montgomery, Ala.: Elliott and Clark, 1996), 38–40.

8. Ralph Shikes, *The Indignant Eye* (Boston: Beacon Press, 1969), 308.

9. Stephen Hess and Milton Kaplan, *The Ungentlemanly Art: A History of American Political Cartoons* (New York: Macmillan, 1968), 86.

10. Roger Fischer, *Them Damned Pictures!* (North Haven, Conn.: Archon Books, 1996), 178.

11. Shikes, *Indignant Eye*, 304.

12. Albert Bigelow Paine, *T. H. Nast: His Period and His Pictures* (New York: Macmillan, 1904), 82.

13. J. Chal Vinson, *Thomas Nast, Political Cartoonist* (Athens: University of Georgia Press), 26.

14. Paine, *T. H. Nast*, 98.

15. Shikes, *Indignant Eye*, 311.

16. Ibid., 316.

17. Morton Keller, *The Art and Politics of Thomas Nast* (Oxford: Oxford University Press, 1968), 159.

18. Ibid., 73.

19. Quoted in ibid., 76.

20. Quoted in Paine, *T. H. Nast*, 179.

21. B. O. Flower, "How Four Men Rescued the City from Entrenched Corruption," *The Arena*, March 1905, 277.

22. Quoted in Paine, *T. H. Nast*, 182.

23. Keller, *Art and Politics of Thomas Nast*, preface.

24. Fischer, *Them Damned Pictures*, 3.

25. Ibid.

26. Quoted in Paine, *T. H. Nast*, 581.

27. Fischer, *Them Damned Pictures*, 32–33.

28. Ibid., 36–37.

29. Quoted in David Astor, "Nast as Prologue," *Editor & Publisher*, November 16, 2002, 29.

30. Richard Samuel West, *Satire on Stone: The Political Cartoons of Joseph Keppler* (Urbana: University of Illinois Press, 1988), 397–98.

31. Hess and Northrop, *Drawn and Quartered*, 63.

32. Hess and Kaplan, *Ungentlemanly Art*, 119–21.

33. Richard E. Marschall, "The Century in Political Cartoons," *Columbia Journalism Review*, May–June 1999, 55, 57.

34. Hess and Kaplan, *Ungentlemanly Art*, 124.

35. Richard Cox, "The Art of Art Young," *American Artist*, May 1981, 60.

36. Dale Spenser, *Editorial Cartooning* (Ames: Iowa State University Press, 1949), 56.

37. Quoted in Hess and Kaplan, *Ungentlemanly Art*, 127.

38. B. O. Flower, "Homer Davenport: A Cartoonist Dominated by Moral Ideas," *The Arena*, July 1905, 665–76.

39. "At Age 100, the Yellow Kid Is Still a Draw," *Toledo Blade*, April 23, 1995, 19A.

40. Marschall, "Century in Political Cartoons," 55.

41. Henry Ladd Smith, "The Rise and Fall of the Political Cartoon," *Saturday Review*, May 29, 1954, 9.

42. Hess and Kaplan, *Ungentlemanly Art*, 177–178.

43. *Statutes of California*, 1899, chap. 29.

44. Frank Luther Mott, *American Journalism, a History: 1690–1960* (New York: Macmillan, 1962), 588.

45. *Laws of Pennsylvania*, 1903 sess., 353.

46. *New York Sun*, May 15, 1903, 8.

47. Chris Lamb, "Suppression in the Muckraking Era: The Pennsylvania Anti-Cartoon Law of 1903" (paper presented at the annual convention of the Association for Education in Journalism and Mass Communication, August 1987).

48. Ibid.

49. Richard Samuel West, "The Pen and the Parrot," *Target: The Political Cartoon Quarterly* (autumn 1986): 13.

50. *Philadelphia North American*, September 17, 1902, 1.

51. *Philadelphia North American*, September 26, 1902, 1.

52. *Philadelphia North American*, January 27, 1903, 1.

53. Walt McDougall, editorial, *Philadelphia North American*, January 30, 1903, 1.

54. *Philadelphia North American*, April 16, 1903, 16.

55. *Philadelphia North American*, May 20, 1903, 1.

56. Lamb, "Suppression in the Muckraking Era."

57. Editorial, *New York Times*, reprinted in *Philadelphia North American*, May 18, 1903, 6.

58. "Press Gag History Is Recommended to Historian Who Has Missed the Point," *New York Evening Post*, reprinted in *Philadelphia North American*, May 18, 1903, 16.

59. Quoted in Lamb, "Suppression in the Muckraking Era."

60. Hess and Kaplan, *Ungentlemanly Art*, 131.

61. Ibid., 132.

62. Barton Bernstein and Allen Matusow, eds., *Twentieth Century America: Recent Interpretations* (New York: Harcourt Brace Jovanovich, 1972), 1.

63. Steven Piott, "The Right of the Cartoonist: Samuel Pennypacker and the Freedom of the Press," *Pennsylvania History* 55 (April 1988): 88.

64. Albert Fried, *Socialism in America* (Garden City, N.Y.: Doubleday, 1970), 12.

65. Lauren Kessler, *The Dissident Press* (Beverly Hills, Calif.: Sage, 1984), 129.

66. Joseph R. Conlin, *The American Radical Press, 1880–1960*, vol. 1 (Westport, Conn.: Greenwood Press, 1974).

67. Ibid., 538.

68. Rebecca Zurier, *Art for The Masses, 1911–1917: A Radical Magazine and Its Graphics* (New Haven, Conn.: Yale University Press, 1985), 106.

69. Ibid., 18.

70. Chris Lamb, "Free Speech at All Costs: A Short History of *The Masses*" (paper presented at the annual convention of the Association for Education in Journalism and Mass Communications, Atlanta, 1994).

71. George Hecht, ed., *The War in 100 Cartoons* (New York: Dutton, 1919), 27.

72. Richard Samuel West, "Crusading for World Peace: Ding Darling, Woodrow Wilson, and the League of Nations," *Inks: Cartoon and Comic Art Studies* 2 (May 1994): 18.

73. *Cartoons*, June 1916; see also Chris Lamb, "Drawn and Quartered: The Government and Cartoonists During World War I" (paper presented in the History Division at the annual convention of the Association for Education in Journalism and Mass Communication, Washington, D.C., August 1995).

74. *Cartoons*, July 1916; see also Lamb, "Drawn and Quartered."

75. Ibid.

76. Marschall, "Century in Political Cartoons," 55.

77. *Cartoons*, June 1917; see also Lamb, "Drawn and Quartered."

78. *Cartoons*, July 1917; see also Lamb, "Drawn and Quartered."

79. *Cartoons*, June 1916; see also Lamb, "Drawn and Quartered."

80. David Kennedy, *Over Here* (Oxford: Oxford University Press, 1980), 12, 24.

81. J. N. Darling, *Aces and Kings* (Des Moines: Des Moines Register, 1918).

82. Richard Fitzgerald, *Art and Politics* (Westport, Conn.: Greenwood Press, 1973), 82; Zurier, *Art for The Masses*, 40.

83. Fitzgerald, *Art and Politics*, 68.

84. Hess and Kaplan, *Ungentlemanly Art*, 137.

85. *Cartoons*, February 1917, 420–21.

86. *New York Tribune*, May 12, 1918.

87. *Cartoons*, November 1917, 718.

88. *Cartoons*, April 1917.

89. Stanley Cohen, ed., *Reform, War and Reaction: 1912–1932* (Columbia: University of South Carolina Press, 1974), 92.

90. George Creel, *Complete Report of the Chairman of the Committee on Public Information* (New York: Da Capo Press, 1972), 2.

91. Ibid., 1–8.

92. Espionage Act, 30 Stat. 217 (1917). Title XII of the Espionage Act forbade mailing any matter violating the act or advocating treason, insurrection, or forcible resistance to any law of the United States.

93. Joseph R. Conlin, *The American Radical Press, 1880–1960* (Westport, Conn.: Greenwood Press, 1974), 2:574.

94. John Stephens, *Shaping the First Amendment* (Beverly Hills, Calif.: Sage, 1982), 47.

95. Espionage Act, 30 Stat. 217 (1917).

96. Kessler, *Dissident Press*, 100.

97. George Juergens, *News from the White House* (Chicago: University of Chicago Press, 1981), 203.

98. Robert Rosenstone, *Romantic Revolutionary* (New York: Knopf, 1975), 333.

99. Fitzgerald, *Art and Politics*, 215.

100. *Cartoons*, February 1918, 288.

101. Hecht, ed., *War in 100 Cartoons*, 72.

102. Ibid., 5.

4. "McCarthyism"

1. Alice Sheppard, *Cartooning for Suffrage* (Albuquerque: University of New Mexico Press, 1994), 25.

2. Lucy Shelton Caswell, "Edwina Dumm, Cartoonist," *Journalism History* 15 (spring 1988): 6.

3. Elisabeth Israels Perry, "Image, Rhetoric, and the Historical Memory of Women," introduction to Sheppard, *Cartooning for Suffrage*, 3.

4. Caswell, "Edwina Dumm," 5.

5. Sheppard, *Cartooning for Suffrage*, 213.

6. Ibid., 154.

7. Ibid., 148.

8. H. I. Brock, "New York Between the Wars, *New York Times Magazine*, October 1, 1944, 23.

9. Richard Samuel West, "The Politicizing of Ding," *Target: The Political Cartoon Quarterly* 4 (summer 1982): 16.

10. Stephen Hess and Milton Kaplan, *The Ungentlemanly Art: A History of American Political Cartoons* (New York: Macmillan, 1968), 145–46.

11. Caswell, "Edwina Dumm," 6.

12. Lucy Shelton Caswell, "Seven Cartoonists," in *The 1989 Festival of Cartoon Art* (Columbus: Ohio State University Libraries, 1989), 73.

13. Sheppard, *Cartooning for Suffrage*, 9.

14. Ibid., 25.

15. Ibid.

16. Ibid., 156.

17. Quoted in Stephen Hess and Sandy Northrop, *Drawn and Quartered: The History of American Political Cartoons* (Montgomery, Ala.: Elliott and Clark, 1996), 90–91.

18. Caswell, "Seven Cartoonists," 73–75.

19. Ibid., 77–79.

20. Quoted in ibid., 71.

21. Everette E. Dennis and Melvin Dennis, "100 Years of Political Cartooning," *Journalism History* 1 (spring 1974): 10.

22. Charles Press, *The Political Cartoon* (London: Macmillan, 1981), 47.

23. Ibid., 277.

24. Richard Samuel West, "Crusading for World Peace: Ding Darling, Woodrow Wilson and the League of Nations," *Inks: Cartoon and Comic Art Studies* 1 (May 1994): 25–26.

25. Richard Samuel West, "The Politicizing of Ding," *Target: The Political Cartoon Quarterly* 4 (summer 1982): 15.

26. David L. Lendt, *Ding: The Life of Jay Norwood Darling* (Mount Pleasant, S.C.: Maecenas, 2001).

27. Gustavus Widney, "John McCutcheon, Cartoonist," *World Today*, October 1908, 1021.

28. Quoted in "Orr-Cartoonist," *Literary Digest*, May 30, 1925, 36.

29. Henry Ladd Smith, "The Rise and Fall of the Political Cartoon," *Saturday Review*, May 29, 1954, 28.

30. Hess and Northrop, *Drawn and Quartered*, 34.

31. Quoted in Draper Hill, "Art Young Kept Giving 'Em Hall," *Association of American Editorial Cartoonists Notebook* (fall 1985): 13.

32. Syd Hoff, *Editorial and Political Cartooning* (New York: Stravon Educational Press, 1976), 118–19.

33. Ibid., 128.

34. Hess and Northrop, *Drawn and Quartered*, 99.

35. "Cartoonist: Peace Prize Puzzles the Militant Kelly," *Newsweek*, April 6, 1935, 36.

36. Quoted in Everette E. Dennis, "The Regeneration of Political Cartooning," *Journalism Quarterly* 45 (winter 1974): 664.

37. Hess and Kaplan, *Ungentlemanly Art*, 155.

38. Ibid., 156.

39. Hoff, *Editorial and Political Cartooning*, 129.

40. Oliver Harrington, *Why I Left America* (Oxford: University of Mississippi Press, 1993), xxi, xxii.

41. *New York Times*, June 27, 1945.

42. Hess and Northrop, *Drawn and Quartered*, 103.

43. Richard Samuel West, "Mauldin: From Willie and Joe to Ronnie," *Target: The Political Cartoon Quarterly* 10 (Winter 1984): 8–9.

44. Hess and Northrop, *Drawn and Quartered*, 108.

45. Telephone interview with Herbert Block, 1991; see also Chris Lamb, "Herblock Talks About Life as a Cartoonist," *Editor & Publisher*, June 29, 1991, 32.

46. Ibid.

47. "Out Goes Pogo," *Time*, December 1, 1958, 68.

48. Robert Ellis Smith et al., *The Big Brother Book of Lists* (Los Angeles: Sloan, 1984), 167.

49. "Pogo Problem," *Commonweal*, June 8, 1962, 337.

50. Quoted in Hess and Northrop, *Drawn and Quartered*, 107.

51. Kat Yancey, "The Outspoken Oliphant," CNN Web site (www.cnn.com), February 15, 1998.

52. Hess and Northrop, *Drawn and Quartered*, 113.

53. Smith, "Rise and Fall of the Political Cartoon," 28.

54. Audrey Handleman, "Political Cartoonists as They Saw Themselves During the 1950s," *Journalism Quarterly* 61 (spring 1984): 141.

55. Dennis, "Regeneration of Political Cartooning," 668.

56. Jack Bender, "The Outlook for Editorial Cartooning," *Journalism Quarterly* 40 (spring 1963): 176–77.

57. Quoted in ibid., 176.

58. Scott Long, "Are Editors Dulling Edge of the Cartoon?" *AAEC News*, March 1962, 4.

59. J. Stevenson, "Profiles: Endless Possibilities," *New Yorker*, December 31, 1979, 42.

60. Quoted in Yancey, "Outspoken Oliphant."

61. "Quintessential Cartooning: The Political Art of Pat Oliphant," *Target: The Political Cartoon Quarterly* 4 (summer 1982): 8.

62. Quoted in Yancey, "Outspoken Oliphant."

63. Ibid.

64. Rick Friedman, "Cartoonist Suffers 'Fringe' Harassment," *Editor & Publisher*, December 19, 1964, 47, 52.

65. "One of the Few," *Time*, June 13, 1968, 55.

66. Telephone interview with Paul Conrad, 1988; see also Chris Lamb, "Pulitzer Prize–Winning Cartoonist Still Draws His Own Conclusions," *Daily Iowan*, November 2, 1988, 1.

67. Telephone interview with Herbert Block, 1991; see also Lamb, "Herblock Talks About Life," 32.

68. John D. Weaver, "Drawing Blood," *Holiday*, August 1965, 72.

69. Quoted in Theodore H. White, *The Making of the President* (New York: Atheneum Press, 1961), 266.

70. Telephone interview with Herbert Block, 1991; see also Lamb, "Herblock Talks About Life," 32.

71. Quoted in Hoff, *Editorial and Political Cartooning*, 281.

72. "The Finer Art of Politics," *Newsweek*, October 13, 1980, 83.

73. Ibid., 74.

74. Ibid., 75.

75. Eileen White, "Paul Conrad's Work Uses Dramatic Images and Packs a Wallop," *Wall Street Journal*, September 22, 1986, 17.

76. Telephone interview with Bruce Tinsley, 1995; see also Chris Lamb, "Early Success for a Conservative Comic," *Editor & Publisher*, March 25, 1995, 52–53.

77. Telephone interview with Mike Shelton, 1990; see also Chris Lamb, "Color Political Cartoons Being Syndicated," *Editor & Publisher*, January 19, 1991, 34–35.

78. Personal communication with Ann Telnaes, April 8, 2002; see also Paige Burns and Chris Lamb, "'Boys Will Be Boys'—And So Will Editorial Cartoonists: Why Are There So Few Women in the Profession?" (typescript, 2002).

79. Personal communication with Ann Telnaes, April 8, 2002.

80. Doug Marlette, at "It's a Draw: Political Cartoonists Reflect on the 2000 Presidential Election," College of Charleston, Charleston, S.C., April 5–7, 2001.

81. Quoted in Yancey, "Outspoken Oliphant."

82. Ibid.

83. Stephanie Simon, "A Gray Future for Political Cartooning," *Los Angeles Times*, October 28, 1999, 28A.

84. Joel Pett, "What's So Funny?" *Media Studies Journal* 8 (spring 1994): 94.

85. Quoted in David Astor, "St. Petersburg Times Criticized for Firing Its Editorial Cartoonist," *Editor & Publisher*, October 15, 1994, 37.

86. Clay Bennett, at "It's a Draw: Political Cartoonists Reflect on the 2000 Presidential Election," College of Charleston, Charleston, S.C., April 5–7, 2001.

87. Marlette, at "It's a Draw: Political Cartoonists Reflect on the 2000 Presidential Election."

88. Chris Lamb, "Save the Cartoonist," *The Masthead* (fall 2001): 26.

89. Chris Lamb, "A Political Cartoon Primer," *Charleston City Paper*, April 4, 2001, 13.

90. Pett, "What's So Funny?"

5. *"Second-Class Citizens of the Editorial Page"*

1. Doug Marlette, *The Bridge* (New York: HarperCollins, 2001), 9–14, 18–29.

2. Doug Marlette, "A Cartoon, an Apology and an Answer," *Nieman Reports* (summer 1994): 74.

3. Quoted in David Astor, "Poking Fun at the Pope," *Editor & Publisher*, July 2, 1994, 12.

4. Daniel Riffe, Donald Sneed, and Roger Van Ommeren, "How Editorial Page Editors and Cartoonists See Issues," *Journalism Quarterly* 62 (winter 1985): 898.

5. Telephone interview with Doug Marlette, June 26, 2003.

6. V. Cullum Rogers, "Newsday Hires Handelsman," Association of American Editorial Cartoonists Web site (http://info.detnews.com/aaec), April 2001.

7. J. P. Trostle, "San Diego Cans Kelley—Breen Will Replace 20-Year Union-Tribune Vet," Association of American Editorial Cartoonists Web site (http://info.detnews.com/aaec), July 2001.

8. Ibid.

9. Quoted in "Tallahassee Democrat Picks Up Marlette," Association of American Editorial Cartoonists Web site (http://info.detnews.com/aaec), September 2002.

10. Art Moore, "'What Would Mohammed Drive?'" (www.WorldNetDaily.com), December 28, 2002.

11. Quoted in ibid.

12. Ibid.

13. J. Chal Vinson, *Thomas Nast, Political Cartoonist* (Athens: University of Georgia Press, 1967), 39–40.

14. Doug Marlette, at "It's a Draw: Political Cartoonists Reflect on the 2000 Presidential Election," College of Charleston, Charleston, S.C., April 5–7, 2001.

15. Chris Lamb, "Rise of an Unusual Editorial Page Cartoonist," *Editor & Publisher*, January 26, 1985, 44.

16. Quoted during panel discussion at "It's a Draw: Political Cartoonists Reflect on the 2000 Presidential Election," College of Charleston, Charleston, S.C., April 5–7, 2001.

17. Marlette, "Cartoon, an Apology and an Answer," 72.

18. Ibid.

19. Marlette, at "It's a Draw: Political Cartoonists Reflect on the 2000 Presidential Election."

20. "Mike Luckovich Wins the Pulitzer," *Association of American Editorial Cartoonists Notebook* (spring 1995).

21. Riffe, Sneed, and Van Ommeren, "How Editorial Page Editors and Cartoonists See Issues," 898.

22. Telephone interview with Clay Bennett, June 3, 2003.

23. Christopher Lamb and Nancy Brendlinger, "Perceptions of Cartoonists and Editors About Cartoons," *Newspaper Research Journal* 17 (summer–fall 1996): 109.

24. Telephone interview with Paul Conrad, 1988; see also Chris Lamb, "Pulitzer Prize–Winning Cartoonist Still Draws His Own Conclusions," *Daily Iowan*, November 2, 1988, 1.

25. Eileen White, "Paul Conrad's Work Uses Dramatic Images and Packs a Wallop," *Wall Street Journal*, September 22, 1986, 18.

26. Syd Hoff, *Editorial and Political Cartooning* (New York: Stravon Educational Press, 1976), 127.

27. James Squires, "Quick-Draw Artists: Cartoon Kings and Mere Pretenders," *Wall Street Journal*, April 16, 1984, 32.

28. "Cartoon Slots Still Vacant in Chicago and Elsewhere," Association of American Editorial Cartoonists Web site (http://info.detnews.com/aaec), June 2002, from *Editor & Publisher Online*, April 22, 2002.

29. Telephone interview with Clay Bennett, June 3, 2003.

30. Joel Pett, at "It's a Draw: Political Cartoonists Reflect on the 2000 Presidential Election," College of Charleston, Charleston, S.C., April 5–7, 2001.

31. Telephone interview with Joel Pett, June 30, 2003.

32. Ibid.

33. Lary Bloom, "Too Hot for Hartford," *Hartford Courant*, April 29, 2001, reprinted in *Association of American Editorial Cartoonists Notebook*, May 2001, 20–21.

34. Robert Ariail, during panel discussion at "It's a Draw: Political Cartoonists Reflect on the 2000 Presidential Election," College of Charleston, Charleston, S.C., April 5–7, 2001.

35. David Astor, "He Argues the Case for Local Cartooning," *Editor & Publisher*, June 25, 1988, 42.

36. Quoted in Michael Colton, "No Laughing Matter," *Brill's Content*, February 2000, 93–94.

37. Stephen Green, "Cartooning in the Land of Conrad," *Sacramento Bee*, reprinted in *Association of American Editorial Cartoonists Notebook* (fall 1984): 10.

38. J. P. Trostle, "David Horsey: 20 Questions," Association of American Editorial Cartoonists Web site (http://info.detnews.com/aaec), May 2003.

39. David Astor, "Another Major Newspaper Fires a Political Cartoonist," *Editor & Publisher*, October 29, 1994, 33.

40. "Seattle Times Hires Devericks," Association of American Editorial Cartoonists Web site (http://info.detnews.com/aaec), May 2003.

41. David Astor, "St. Petersburg Times Criticized for Firing Its Editorial Cartoonist," *Editor & Publisher*, October 15, 1994, 37.

42. Telephone interview with Bruce Tinsley, 1995; see also Chris Lamb, "Early Success for a Conservative Comic," *Editor & Publisher*, March 25, 1995, 52–53.

43. Telephone interview with Clay Bennett, June 3, 2003.

44. Chris Lamb, "Save the Cartoonist," *The Masthead* (Fall 2001): 26.

45. Marlette, during panel discussion at "It's a Draw: Political Cartoonists Reflect on the 2000 Presidential Election."

46. Ibid.

47. Quoted in Patrick T. Reardon, "Drawing Blood: A Newspaper's Editorial Cartoons Are Meant to Sting, Even Offend; It's a Grand, Old Tradition," *Chicago Tribune*, July 18, 2003, 1C.

48. Telephone interview with Doug Marlette, June 25, 2003.

49. Todd Gitlin, *The Whole World Is Watching* (Berkeley: University of California Press, 1980), 12.

50. Warren Breed, "Social Control in the Newsroom," *Social Forces* 33 (May 1955): 326.

51. Gaye Tuchman, *Making News: A Study in the Construction of Reality* (New York: Longman, 1978), 27.

52. Lamb and Brendlinger, "Perceptions of Cartoonists and Editors About Cartoons," 106.

53. Daniel Riffe, Donald Sneed, and Roger Van Ommeren, "Behind the Editorial Page Cartoon," *Journalism Quarterly* 62 (summer 1985): 378.

54. Lamb and Brendlinger, "Perceptions of Cartoonists and Editors About Cartoons," 108–9.

55. Telephone interview with Bruce Beattie, 1992; see also Chris Lamb, "Does Editorial Cartoons and Comics," *Editor & Publisher*, July 4, 1992, 30.

56. Lamb and Brendlinger, "Perceptions of Cartoonists and Editors About Cartoons," 106.

57. Mike Peters, *Win One for the Geezer* (New York: Bantam Books, 1982), 3–4.

58. Personal interview with Mike Peters, 1983, quoted in Chris Lamb, "The Editorial Cartoonist in the United States: An Analysis of Mike Peters of the *Dayton Daily News*" (master's thesis, University of Tennessee, 1984), 100.

59. Charles Press, *The Political Cartoon* (London: Macmillan, 1981), 185.

60. David Lendt, *Ding: The Life of Jay Norwood Darling* (Mount Pleasant, S.C.: Maecenas, 2001), 25, 26, 30.

61. Al Hirschfeld, *The World of Hirschfeld* (New York: Abrams, 1967), 1.

62. Quoted in Christopher Jon Lamb, "Drawing the Limits of Political Cartoons in the U.S.: The Courtroom and the Newsroom" (Ph.D. diss., Bowling Green State University, 1995)," 150.

63. Quoted in Jack Bender, "The Outlook for Editorial Cartooning," *Journalism Quarterly* 40 (spring 1963): 178.

64. Quoted in Rick Friedman, "Sanders to K.C. Star Editorial Cartoonist," *Editor & Publisher*, June 22, 1963, 46.

65. Rick Friedman, "Angry Young Man at the Drawing Board," *Editor & Publisher*, June 29, 1963, 38.

66. Quoted in Rick Friedman, "European Influence in U.S. Cartooning," *Editor & Publisher*, July 13, 1963, 40.

67. "Shoemaker Answers the New Wave," *Editor & Publisher*, August 17, 1963, 48–49.

68. Ladd Hamilton, "Cartoonists Can Ruin an Editor's Day," *The Masthead* (fall 1979): 3.

69. Don Robinson, "Let the Cartoon Speak for Itself," *The Masthead* (fall 1979): 7.

70. Jim Borgman, "Go @%?!&* Yourself,'" *Bulletin of the American Society of Newspaper Editors*, September 1983, 10.

71. Quoted in "How Much Freedom," *Editor & Publisher*, November 1, 1986, 48.

72. Quoted in Lamb, "Rise of an Unusual Editorial Page Cartoonist," 44.

73. Quoted in Riffe, Sneed, and Van Ommeren, "How Editorial Page Editors and Cartoonists See Issues," 898.

74. Personal interview with Mike Peters, 1983; see also Lamb, "Editorial Cartoonist in the United States," 101.

75. Quoted in Scott Long, "Ralph McGill Urges More Cooperation Between Editors and Editorial Cartoonists," *AAEC News*, June 1960, 3.

76. Quoted in John Fischetti, "The Editor, on the Other Hand . . . ," *Bulletin of the American Society of Newspaper Editors*, October 1975, 9.

77. Ibid.

78. Ken McArdle, "Cartoonists I Have Known?" *Bulletin of the American Society of Newspaper Editors*, October 1975, 9.

79. Jimmy Margulies, "American Drawing Board," *Target: The Political Cartoon Quarterly* 9 (autumn 1983): 28.

80. Telephone interview with Doug Marlette, June 26, 2003.

81. Ibid.

82. Telephone interview with Clay Bennett, June 3, 2003.

83. Jerry Fearing, "Jerry Fearing," *Cartoonists Profiles*, June 1987, 21, 23.

84. Ed Williams, "Working with Your Editorial Cartoonist," *The Masthead* (spring 2000): 32.

85. Ibid., 32–33.

86. David Astor, "National Furor over Editorial Cartoon," *Editor & Publisher*, July 5, 1997, 33–34.

87. Ibid., 34.

6. *"We Certainly Don't Want to Make People Uncomfortable Now, Do We?"*

1. Doug Marlette, *In Your Face: A Cartoonist at Work* (Boston: Houghton Mifflin, 1991), 157–158.

2. Ibid., 160.

3. Ibid., 161–62.

4. Quoted in "A Matter of Taste," *Association of American Editorial Cartoonists Notebook* (spring 1993): 15.

5. Marlette, *In Your Face*, 156.

6. Doug Marlette, "A Cartoon, an Apology, and an Answer," *Nieman Reports* (Summer 1994): 73.

7. Quoted in Lary Bloom, "Too Hot for Hartford," *Hartford Courant*, April 29, 2001, reprinted in *Association of American Editorial Cartoonists Notebook*, May 2001, 20–21.

8. Marlette, *In Your Face*, 162.

9. Walt Jayroe, "Drawing the Line on Religion," *Editor & Publisher*, April 23, 1994, 20–22.

10. Quoted in "A Golden Spike Retrospective," *Association of American Editorial Cartoonists Notebook* (spring 2000): 23.

11. *Cohen v. California*, 403 U.S. 15 (1971).

12. "Killed by the Editor," *Association of American Editorial Cartoonists Notebook* (summer 1994).

13. George Fisher, *The Best of George Fisher* (Fayetteville: University of Arkansas Press, 1993), 258

14. "Bee Gives Herblock De-Finger," *Association of American Editorial Cartoonists Notebook* (gall 1996): 6.

15. "Conrad Strikes Again," *Quill*, June 1988.

16. Michael Colton, "No Laughing Matter," *Brill's Content*, February 2000, 126.

17. Marlette, *In Your Face*, 163.

18. Quoted in Bloom, "Too Hot for Hartford," 19, 23.

19. Ibid.

20. Ibid., 20.

21. Ibid.

22. Bob Englehart, "Bob Englehart," *Cartoonist Profiles*, December 1983, 32, 36.

23. Quoted in Bloom, "Too Hot for Hartford," 22.

24. Personal interview with Mike Peters, 1983, quoted in Chris Lamb, "The Editorial Cartoonist in the United States: An Analysis of Mike Peters of the *Dayton Daily News*" (master's thesis, University of Tennessee, 1984), 101.

25. Quoted in Richard Samuel West, "Quintessential Cartooning: The Art of Pat Oliphant," *Target: The Political Cartoon Quarterly* 5 (autumn 1982): 3.

26. "Golden Spike Retrospective," 22.

27. Ibid., 23.

28. Quoted in Bloom, "Too Hot for Hartford," 23.

29. Quoted in "Killed by the Editor," 23.

30. Quoted in "Drawing Conclusions," *Pittsburgh City Paper*; on Association of American Editorial Cartoonists Web site (http://info.detnews.com/aaec), August 2003.

31. Telephone interview with Clay Bennett, June 3, 2003.

32. Ibid.

33. Albert Bigelow Paine, *T. H. Nast: His Period and His Pictures* (New York: Macmillan, 1904), 362–64.

34. "Luckovich Work Gets Wide Exposure After Getting Pulled," Association of American Editorial Cartoonists Web site (http://info.detnews.com/aaec), May 2003.

35. Quoted in ibid.

36. "Shelving a 'Doonesbury' Series," *Time*, June 3, 1985, 27.

37. Alex S. Jones, "Sinatra Seeks List of Papers Printing 'Doonesbury' Comic," *New York Times*, June 21, 1985, A30.

38. Quoted in "Doonesbury: Drawing and Quarterbacking for Fun and Profit," *Time*, February 9, 1976, 60.

39. Eileen White, "Paul Conrad's Work Uses Dramatic Images and Packs a Wallop," *Wall Street Journal*, September 22, 1986, B1.

40. Thomas Rosenstiel, "Doonesbury Strips Dropped, Edited as Controversy Grows," *Los Angeles Times*, April 17, 1986, A3.

41. "Doonesburying Reagan," *Newsweek*, November 10, 1980, 121.

42. "Doonesbury Series on Reagan's Brain Is Pulled," *Editor & Publisher*, April 11, 1987, 40.

43. Mike Deupree, "Has Anyone Here Seen 'Doonesbury'?" *Cedar Rapids (Iowa) Gazette*, September 24, 1986, A2.

44. Rosenstiel, "Doonesbury Strips Dropped," A26.

45. Quoted in "Doonesbury Contra Sinatra," *Newsweek*, June 24, 1985, 82.

46. Rosenstiel, "Doonesbury Strips Dropped," A26.

47. Quoted in "Out Goes Pogo," *Time*, December 1, 1958, 40.

48. William Henry, "The Sit-Down Comics," *Washington Journalism Review*, October 1981, 28.

49. Bryan Gruley, *Paper Losses* (New York: Grove Press, 1993), 290.

50. "How Much Freedom?" *Editor & Publisher*, November 1, 1986, 48.

51. Quoted in Michael Colton, "No Laughing Matter," *Brill's Content*, January 2000, 126.

52. "How Much Freedom?" 48.

53. Herbert Gans, *Deciding What's News: A Study of CBS Evening News, NBC Nightly News, Newsweek and Time* (New York:: Pantheon Books, 1979), 253.

54. Herbert Altschull, *Agents of Power* (New York: Longman, 1984), 254–55.

55. Carla Marie Rupp, "Message Cartoons Sent to Editors by Mobil Oil," *Editor & Publisher*, July 9, 1977, 12.

56. Robert Ariail, at "It's a Draw: Political Cartoonists Reflect on the 2000 Presidential Election," College of Charleston, Charleston, S.C., April 5–7, 2001.

57. Telephone interview with Clay Bennett, June 3, 2003.

58. Joel Pett, at "It's a Draw: Political Cartoonists Reflect on the 2000 Presidential Election," College of Charleston, Charleston, S.C., April 5–7, 2001.

59. Personal interview with Mike Peters, 1983; see also Lamb, "Editorial Cartoonist in the United States," 107–9.

60. Christopher Jon Lamb, "Drawing the Limits of Political Cartoons in the U.S.: The Courtroom and the Newsroom" (Ph.D. diss., Bowling Green State University, 1995), 169.

61. Quoted in Richard Samuel West, "Quintessential Cartooning: The Art of Pat Oliphant," *Target: The Political Cartoon Quarterly* 5 (autumn 1982): 3.

62. David Astor, "Your Cartoon Nixed? Here Are Some Tips!" *Editor & Publisher*, July 12, 1997, 30.

63. Quoted in David Astor, "He Argues the Case for Local Cartooning," *Editor & Publisher*, June 25, 1988, 42.

64. Telephone interview with Joel Pett, February 25, 2003.

65. Telephone interview with Joel Pett, June 30, 2003.

66. Quoted in Daniel Riffe, Donald Sneed, and Roger Van Ommeren, "How Editorial Page Editors and Cartoonists See Issues," *Journalism Quarterly* 62 (winter 1985): 898.

67. "The Finer Art of Politics," *Newsweek*, October 13, 1980, 84.

68. Telephone interview with Bob Englehart, 1990, quoted in Chris Lamb, "Different Route to National Exposure: Bob Englehart Discusses His Switch from Syndication to the LAT–WP News Service," *Editor & Publisher*, April 25, 1992, 29.

7. *"That's Not a Definition of Libel; That's a Job Description"*

1. *Celebrezze v. Dayton Newspapers, Inc.*, 15 Media Law Reporter, 1588.

2. Telephone interview with Milt Priggee, 1985; see also Chris Lamb, "With Malicious Intent," *Target: The Political Cartoon Quarterly* 17 (August 1985): 17.

3. *Celebrezze v. Dayton Newspapers, Inc.*, 41 Ohio App. 3d 343; 535 N.E. 2d 755 (1988).

4. *Hustler Magazine v. Falwell*, 485 U.S. 51 (1988).

5. *Milkovich v. Lorain Journal*, 497 U.S. 19 (1990).

6. Quoted in Lamb, "With Malicious Intent," 15.

7. Telephone interview with Milt Priggee, February 20, 2003.

8. Telephone interview with Milt Priggee, February 20, 1985; see also Lamb, "With Malicious Intent," 15.

9. *Wilson v. Cowles Publishing Co.*, 2000 Wash. App. LEXIS 2035.

10. Ibid.

11. Telephone interview with Milt Priggee, February 20, 2003.

12. *Milkovich v. Lorain Journal*, 497 U.S. 19 (1990).

13. Robert Spellman, "Pricking the Mighty: The Law and Editorial Cartooning," *Communications and the Law* 100 (December 1988): 44.

14. *Celebrezze v. Dayton Newspapers, Inc.*, 15 Media Law Reporter, 1591.

15. *Hustler Magazine v. Falwell*, 485 U.S. 47 (1988).

16. Ibid., 47–48.

17. Ibid., 51–52.

18. Ibid., 51.

19. Ibid.

20. Ibid.

21. *Austin v. Culpepper*, 89 English Reporter 960 (1633).

22. *Cropp v. Tilney*, 3 Salk 226 (1693).

23. "Caricature and the Law of Libel," *Law Notes* 41 (May 1937): 12–13.

24. "Fat Man on Thin Act," *The Studio*, April 1968, 225.

25. Spellman, "Pricking the Mighty," 45–46.

26. Ibid., 51.

27. *Carr v. Hood*, 170 English Reporter 984 (1808).

28. *Ellis v. Kimball*, 33 Mass. (16 Pick.) 132 (1834).

29. Spellman, "Pricking the Mighty," 46.

30. Stephen Hess and Milton Kaplan, *The Ungentlemanly Art: A History of American Political Cartoons* (New York: Macmillan, 1968), 107.

31. Ibid., 47.

32. William O'Neill, *Echoes of Revolt: The Masses, 1911–1917* (Chicago: Quadrangle Books, 1966), 33.

33. *Patterson v. Colorado*, 205 U.S. 454 (1907).

34. Ibid., 463.

35. Spellman, "Pricking the Mighty," 48.

36. *United States v. Smith*, 173 F. 227 (D. Ind. 1909).

37. *Brown v. Harrington*, 208 Mass. 600, 95 N.E. (1911).

38. *Star Company v. The Wheeler Syndicate, Inc.*, 160 N.Y. Supp. 689 (1916).

39. Thomas Collins, "Whose Idea Is It?" *Newsday*, December 10, 1985, pt. 2, p. 3.

40. Title XII of the Espionage Act forbade mailing any matter violating the act or advocating treason, insurrection, or forcible resistance to any law of the United States (30 Stat. 217 [1917]).

41. *Masses Publishing Company v. Patten*, 244 F. 535 (S.D.N.Y. 1917).

42. Ibid., 246.

43. "Fate of Eastman in the Jury's Hand," *New York Times*, April 26, 1918, 20.

44. "Judge Dismisses the Masses Jury," *New York Times*, October 6, 1918, 5.

45. *Schenck v. United States*, 249 U.S. 47 (1919).

46. *Dennis v. United States*, 341 U.S. 494 (1951).

47. *Snively v. Record*, 185 Cal. 565 (1921).

48. Edward DeGrazia, *Censorship Landmarks* (New York: Bowker, 1969), 43.

49. Robert Phelps, *Libel: Rights, Risks, Responsibilities* (New York: Macmillan, 1966), 108.

50. *Doherty v. Kansas City Star*, 144 Kan. 206, 59 2d 30 (1936).

51. Christopher Jon Lamb, "Drawing the Limits of Political Cartoons in the U.S.: The Courtroom and the Newsroom" (Ph.D. diss., Bowling Green State University, 1995), 86.

52. *Baumgartner v. United States*, 322 U.S. 665, 673–74 (1944).

53. *Cantwell v. Connecticut*, 310 U.S. 296, 310 (1940).

54. *Cohen v. California*, 403 U.S. 15 (1971).

55. *New York Times v. Sullivan*, 376 U.S. 270 (1964).

56. *Rosenblatt v. Baer*, 383 U.S. 75 (1966).

57. *Hepps v. Philadelphia Newspapers, Inc.*, 475 U.S. 767 (1986).

58. *Gertz v. Welch*, 418 U.S. 323 (1974).

59. *Old Dominion Branch No. 496, National Association of Letter Carriers v. Austin*, 418 U.S. 264 (1974).

60. *Greenbelt Publishing Association v. Bresler*, 398 U.S. 6 (1970).

61. *Yorty v. Chandler*, 13 Cal. App. 3d 467 (1970).

62. Ibid., 467–77.

63. Ibid., 472.

64. *Keller v. Miami Herald Publishing Co.*, 778 F. 2d 711 (11th Cir. 1985).

65. Ibid., 716.

66. *Loeb v. Globe Newspaper Co.*, 489 F. Supp. 481 (D. Mass. 1980).

67. *King v. Globe Newspaper Co.*, 512 N.E. 2d 241 (D. Mass. 1987).

68. Telephone interview with Bob Englehart, 1985; see also Lamb, "With Malicious Intent," 18.

69. *Ferguson v. Dayton Newspapers*, 7 Media Law Reporter 2506 (Ohio App. 1981).

70. *Palm Beach Newspapers, Inc., v. Early*, 334 So. 2d 50 (Fla. Dist. Ct. App. 1976).

71. *Corcoran v. New Orleans Firefighters' Association Local 632*, 468 So. 2d 648 (La. App. 1985).

72. *Russell v. McMillen*, 685 P. 2d 259 (Colo. App. 1984).

73. *Killington Ltd. v. Times Argus*, 14 Media Law Reporter, 1316.

74. *Restatement of Torts*, 556.

75. *Miskovsky v. Tulsa Tribune Co.*, 678 P. 2d 242 (Okla. 1983).

76. Lamb, "Drawing the Limits," 115.

77. *La Rocca v. New York News*, 156 N.J. Super. 59, 383 A. 2d 451 (1978).

78. *Buller v. Pulitzer Publishing Co.*, 684 S.W. 2d 473 (1984).

79. Ibid., 483.

80. Lamb, "Drawing the Limits," 116.

81. Lamb, "With Malicious Intent," 21.

82. George Garneau, "Libel Panel," *Editor & Publisher*, February 13, 1988, 28.

83. Quoted in Lamb, "With Malicious Intent," 16.

84. Ibid., 15.

85. Telephone interview with Tim Newcomb, 1985; see also Lamb, "With Malicious Intent," 16.

86. Ibid.

87. Telephone interview with Paul Szep, 1985; see also Lamb, "With Malicious Intent," 15.

88. Andrew Blum, "Libel Suit Settled," *National Law Journal*, June 24, 1991, 6.

89. Victoria Rouch, "Claims Cartoon Was Offensive; Newspaper Settles Lawsuit with Brothers," *Wilmington (Del.) Star-News*, December 1, 2000, 3B.

90. Associated Press Web site (www.ap.org), March 21, 2003.

91. *Ramunno v. Cawley, MBNA America Bank, N.A., Gannett Co., T/A The News Journal Co.*, 705 A. 2d 1029; 1998 Del. LEXIS 41; 26 Media Law Review, 1651. The decision cited *Keller v. Miami Herald Publishing Co.*, 778 F. 2d 711 (11th Cir. 1985).

92. *Ferrari v. Plain Dealer Publishing Co.*, 142 Ohio App. 3d 629; 756 N.E. 2d 712; 2001 Ohio App. LEXIS 1965.

93. *McKimm v. Ohio Elections Commission*, 89 Ohio St. 3d 139; 2000 Ohio 118; 729 N.E. 2d 364; 2000 Ohio LEXIS 1435.

94. Phillip Taylor, "Supreme Court Okays Ruling that Cartoon Was Libelous," *Freedom Forum*, on Association of American Editorial Cartoonists Web site (http://info.detnews.com/aaec), June 2001.

95. Milt Priggee Web site (www.miltpriggee.com).

8. *"Comfort the Afflicted and Afflict the Comfortable"*

1. Quoted in "Cartoon in *Times* Prompts Inquiry by Secret Service," *Los Angeles Times*, July 22, 2003, B3.

2. "Code-Red Cartoonists" [editorial], *USA Today*, July 24, 2003, 12A.

3. Ibid.

4. Quoted in "Editorial Cartoonists Draw Discouraging Portrait," *Pittsburgh Post-Gazette*, June 17, 2003, on Association of American Editorial Cartoonists Web site (http://info.detnews.com/aaec), August 2003.

5. David Astor and J. P. Trostle, "Kirk Anderson Laid off by Knight-Ridder–Owned Pioneer Press," Association of American Editorial Cartoonists Web site (http://info.detnews.com/aaec), August 2003.

6. Quoted in " . . . But Kirk Goes Out with a Bang," Association of American Editorial Cartoonists Web site (http://info.detnews.com/aaec), August 2003.

7. Astor and Trostle, "Kirk Anderson Laid Off."

8. Quoted in " . . . But Kirk Goes Out with a Bang."

9. Quoted in "Editorial Cartoonists Draw Discouraging Portrait."

10. Quoted in Astor and Trostle, "Kirk Anderson Laid Off."

11. Susan Pierce, "Plante Encourages Cartoonists' Growth," *Chattanooga (Tenn.) Times/Free Press*, September 28, 2002, 1F.

12. Leonard Downie Jr., speech presented to Association of American Editorial Cartoonists, on Association of American Editorial Cartoonists Web site (http://info.detnews.com/aaec), September 2002.

13. Leonard Downie Jr. and Robert G. Kaiser, *The News About the News* (New York: Knopf, 2002), 79–80, 82–83, 100, 109.

14. Ibid., 109–110.

15. Ibid., 110.

16. Quoted in David Astor, "Cartoon Slots Still Vacant in Chicago and Elsewhere," *Editor & Publisher Online*, April 22, 2002, on Association of American Editorial Cartoonists Web site (http://info.detnews.com/aaec), June 2002.

17. Patrick T. Reardon, "Drawing Blood: A Newspaper's Editorial Cartoons Are Meant to Sting, Even Offend; It's a Grand, Old Tradition," *Chicago Tribune*, July 18, 3003, 1C.

18. Ibid.

19. Quoted in ibid.

20. David Astor, "Cartoonist Hirings on Drawing Board," *Editor & Publisher*, April 22, 2002, 29.

21. Quoted in Howard Kurtz, "Tom Toles Joins the *Washington Post*'s Editorial Page," *Washington Post*, 10 April 2002, on Association of American Editorial Cartoonists Web site (http://info.detnews.com/aaec), April 2002.

22. "The AAEC's Letter to the Buffalo News," Association of American Editorial Cartoonists Web site (http://info.detnews.com/aaec), June 2002.

23. "Editorial Cartoonists Draw Discouraging Portrait."

24. Quoted in J. P. Trostle, "Do We Still Matter?" Association of American Editorial Cartoonists Web site (http://info.detnews.com/aaec), September 2002.

25. Ibid.

26. Ibid.

27. Ibid.

28. Paige Burns and Chris Lamb, "'Boys Will Be Boys'—And So Will Editorial Cartoonists: Why Are There So Few Women in the Profession?" (typescript, 2001).

29. Personal communication with Genny Guracar, October 30, 2002.

30. Quoted in Natalie Cortes, "Ann Telnaes Brings 'Something New to the Table,'" Freedom Forum Web site (Freedom Forum.org), January 11, 2002, on Association of American Editorial Cartoonists Web site (http://info.detnews.com/aaec), September 2002.

31. Telephone interview with M. G. Lord, 1991; see also Chris Lamb, "An Editorial Cartoonist and a Columnist," *Editor & Publisher*, April 6, 1991, 44.

32. Ibid.

33. Telephone interview with M. G. Lord, 1991; see also Lamb, "Editorial Cartoonist," 44–45.

34. Personal communication between Cindy Procious and Paige Burns, April 16, 2002; see also Burns and Lamb, "Boys Will Be Boys."

35. Personal communication between Ann Telnaes and Paige Burns, April 8, 2002; see also Burns and Lamb, "Boys Will Be Boys."

36. Personal communication between Signe Wilkinson and Paige Burns, April 4, 2002; see also Burns and Lamb, "Boys Will Be Boys."

37. Personal communication between Elena Steier and Paige Burns, April 11, 2002; see also Burns and Lamb, "Boys Will Be Boys."

38. Lucy Shelton Caswell, "Seven Cartoonists," in *The 1989 Festival of Cartoon Art* (Columbus: Ohio State University Libraries, 1989), 83.

39. Quoted in ibid.

40. Ibid., 86.

41. Ibid., 83

42. Signe Wilkinson, "Signe Wilkinson on Khaki and Caa-Caa," *American Editor*, December 1988, reprinted in *Association of American Editorial Cartoonists Newsletter* (winter 1999).

43. Caswell, "Seven Cartoonists," 85.

44. John Sena, "A Picture Is Worth a Thousand Votes: Geraldine Ferraro and the Editorial Cartoonists," *Journal of American Culture* 8 (spring 1985): 2.

45. Personal communication between Elena Steier and Paige Burns, April 11, 2002; see also Burns and Lamb, "Boys Will Be Boys."

46. Personal communication between Signe Wilkinson and Paige Burns, April 4, 2002; see also Burns and Lamb, "Boys Will Be Boys."

47. John Colapinto, "The Art of War," *Rolling Stone*, April 17, 2003, 48.

48. Ted Rall, ed., *Attitude: The New Subversive Political Cartoonists* (New York: Nantier, Beall, Minoustchine, 2002), 7.

49. Ibid.

50. Telephone interview with Joe Sharpnack, August 28, 2003.

51. Ibid.

52. Personal communication with Genny Guracar, October 30, 2002.

53. Telephone interview with Gary Huck and Mike Konopacki, 1987; see also Chris Lamb, "Their Work Is About Work-Related Issues," *Editor & Publisher*, December 27, 1986, 26.

54. "Three Conservative 'Toonists Band Together," Association of American Editorial Cartoonists Web site (http://info.detnews.com/aaec), February 2003.

55. Telephone interview with Milt Priggee, February 20, 2003.

56. Telephone interview with Kevin Kallaugher, 1996; see also Chris Lamb, "Slings, Arrows and Cartoons," *Baltimore Sun*, October 13, 1996, 6N.

57. Christopher Jon Lamb, "Drawing the Limits of Political Cartoons in the U.S.: The Courtroom and the Newsroom" (Ph.D. diss., Bowling Green State University, 1995), 172.

58. Telephone interview with Doug Marlette, June 25, 2003.

59. Jim Morin, "The State of the Art of Editorial Cartoons," *American Editor: The Bulletin of the American Society of Newspaper Editors*, January 1999.

60. Michael Colton, "No Laughing Matter," *Brill's Content*, February 2000, 93.

61. Quoted in David Astor, "Rising to the Occasion," *Editor & Publisher*, February 4, 2002, 31.

62. Quoted in Reardon, "Drawing Blood," 1C.

63. Quoted in Natalie Pompilio, "Not So Funny," *American Journalism Review*, October 2002, 44–52.

64. Lamb, "Slings, Arrows and Cartoons," 6N.

65. Pompilio, "Not So Funny," 44–52.

66. Telephone interview with Joel Pett, June 30, 2003.

reserved; **2.5.** Garry Trudeau. © 1985. Reprinted with permission of Universal Press Syndicate. All rights reserved; **2.6.** Benjamin Franklin, metal cut, *Pennsylvania Gazette*, May 9, 1754; **2.7.** Elkanah Tisdale, metal cut, *Boston Gazette*, March 26, 1812; **2.8.** Thomas Nast, "The Brain," metal cut, *Harper's Weekly*, October 21, 1871; **2.9.** Thomas Nast, "Under the Thumb," metal cut, *Harper's Weekly*, June 10, 1871; **2.10.** Mike Peters. © NAS. 1976. Reprinted with special permission of North America Syndicate; **2.11.** Clay Bennett. © 2001. Reprinted with permission of *The Christian Science Monitor*; **2.12.** Paul Conrad. © 1972. With permission, Paul Conrad, *Los Angeles Times*; **2.13.** Doug Marlette. © 1984. Reprinted with permission of Doug Marlette; **2.14.** Thomas Nast, "The American River Ganges," wood engraving, *Harper's Weekly*, September 30, 1871; **2.15.** Dick Locher. © 2003. Reprinted with permission of Tribune Media Services.

3.1. Robert Ariail. © 2000. Reprinted with permission of Robert Ariail; **3.2.** Robert Ariail. © 2000. Reprinted with permission of Robert Ariail; **3.3.** Robert Ariail. © 2000. Reprinted with permission of Robert Ariail; **3.4.** John Deering. © 2000. Reprinted with permission of Creators Syndicate; **3.5.** Doug Marlette. © 2001. Reprinted with permission of Doug Marlette; **3.6.** Frank Bellew, wood engraving, *Harper's Weekly*, November 26, 1864. Reprinted from Charles Press, *The Political Cartoon* (Rutherford, N.J.: Farleigh Dickinson University Press, 1980), 244; **3.7.** Thomas Nast, "Who Stole the People's Money?" wood engraving, *Harper's Weekly*, August 19, 1871; **3.8.** Thomas Nast, "The Tammany Tiger Loose," *Harper's Weekly*, November 11, 1871; **3.9.** Bernard Gillam, lithogragh, *Puck*, June 4, 1884. Reprinted from Stephen Hess and Milton Kaplan, *The Ungentlemanly Art* (New York: Macmillan, 1968), 20; **3.10.** Walt McDougall, "The Royal Feast of Belshazzar Blaine and the Money Kings," *New York World*, October 30, 1884, 1; **3.11.** Homer Davenport, "Mr. Hanna's Stand on the Labor Question," *New York Journal*, June 16, 1900. Reprinted from Syd Hoff, *Editorial and Political Cartooning* (New York: Stravon Educational Press, 1976), 95; **3.12.** Frank Spangler, Alabama Cartoon, *Montgomery (Ala.) Advertiser*, February 3, 1915; **3.13.** Homer Davenport, "Anti-Cartoon Bill," *New York Journal*, April 25, 1897. Reprinted in Stephen Hess and Milton Kaplan, *The Ungentlemanly Art* (New York: Macmillan, 1968), 49; **3.14.** Charles Nelan, "Worse than Worthless!" *Philadelphia North American*, September 26, 1902; **3.15.** Walt McDougall, "Fatal Weaknesses," *Philadelphia North American*, January 30, 1903; **3.16.** Charles Nelan, "Pennypacker: I will stop this 'most conspicuous of ills,'" *Philadelphia North American*, May 2, 1903; **3.17.** Robert Minor, "Your Honor, this woman gave birth to a naked child!" *The Masses*, September 1915; **3.18.** Robert Minor, "Army Medical Examiner," *The Masses*, July 1916; **3.19.** J. N. "Ding" Darling. "How We Forced Germany into the War." 1916. Reprinted with permission of the J. N. "Ding" Darling Foundation; **3.20.** Luther D. Bradley, "The Final Answer?" *Chicago Daily News*. Reprinted in *Cartoons* magazine, February 1918; **3.21.** Boardman Robinson, "Europe, 1916," *The Masses*, October 1916; **3.22.** Art Young, "Congress and Big Business," *The Masses*, August 1917; **3.23.** Henry Glintenkamp, "Conscription," *The Masses*, August 1917; **3.24.** Boardman Robinson, "Making the World Safe for Capitalism, *The Masses*, August 1917.

4.1. Lou Rogers, "Tearing Off the Bonds," *Judge*, 19 October 1912. Reprinted from Alice Sheppard, *Cartooning for Suffrage* (University of New Mexico Press, 1994), 171; **4.2.** J. N. "Ding" Darling. 1919. © Reprinted with permission of the J. N. "Ding" Darling Foundation; **4.3.** John McCutcheon, "A Wise Economist Asks a Question," *Chicago Tribune*, August 19, 1931; **4.4.** J. N. "Ding" Darling. © Reprinted with permission of the J. N. "Ding" Darling Foundation; **4.5.** D. R. Fitzpatrick, "One Person Out of Every Ten," *St. Louis Post-Dispatch*, January 16, 1938; **4.6.** Edmund Duffy, "Maryland, My Maryland!" *Baltimore Sun*, December 6, 1931; **4.7.** Rollin Kirby, "Now Then, All Together, 'My Country 'Tis of Thee,'" *New York World*, January 17, 1920; **4.8.** Vaughn Shoemaker, "Take Me to Czechoslovakia, Driver," *Chicago Daily News*, September 8, 1938; **4.9.** Bill Mauldin, "Joe, yestiddy ya saved my life an' I swore I'd pay ya back. Here's my last pair of dry socks." © 1944 by Bill Mauldin. Reproduced with permission for this publication in this medium only. Copying or reproduction without written permission of the estate of William H. Mauldin is prohibited; **4.10.** Bill Mauldin, "Let that one go. He says he don't wanna be mah equal." © 1947 by Bill Mauldin. Reproduced with permission for this publication in this medium only. Copying or reproduction without written permission of the estate of William H. Mauldin is prohibited; **4.11.** Bill Mauldin, "Lincoln Memorial sobbing." © 1963 by Bill Mauldin. Reproduced with permission for this publication in this medium only. Copying or reproduction without written permission of the estate of William H. Mauldin is prohibited; **4.12.** Oliver Harrington, undated. © Reprinted with permission of Walter O. Evans Collection of African-American Art; **4.13.** Oliver Harrington, undated. © Reprinted with permission of Walter O. Evans Collection of African-American Art; **4.14.** Herbert Block, "Fire!" *Herblock: A Cartoonist's Life* (Times Books, 1998). Reprinted with permission of The Herb Block Foundation; **4.15.** Herbert Block, "You Mean I'm Supposed to Stand on That?" *Herblock: A Cartoonist's Life* (Times Books, 1998). Reprinted with permission of The Herb Block Foundation; **4.16.** Herbert Block, "Here He Comes Now," *Herblock: A Cartoonist's Life* (Times Books, 1998). Reprinted with permission of The Herb Block Foundation; **4.17.** Walt Kelly, © 1953. Reprinted with permission of Okefenokee, Glee, and Perloo, Corp.; **4.18.** Pat Oliphant. © 1966. Reprinted with permission of Universal Press Syndicate. All rights reserved; **4.19.** Herbert Block, no caption. Published in *Herblock: A Cartoonist's Life* (Times Books, 1998). Reprinted with permission of The Herb Block Foundation; **4.20.** Paul Conrad. © 1974. Used with permission, Paul Conrad, *Los Angeles Times*; **4.21.** Mike Peters. © 1974. NAS. Reprinted with special permission of North America Syndicate; **4.22.** Ann Telnaes. © Reprinted with permission of Ann Telnaes; **4.23.** Joel Pett. © 1997. *Lexington (Ky.) Herald-Leader*. Reprinted with permission of Universal Press Syndicate. All rights reserved; **4.24.** Robert Ariail. © 1998. Reprinted with permission of Robert Ariail.

5.1. Doug Marlette. © 1994. Reprinted with permission of Doug Marlette; **5.2.** Steve Kelley. © 2001. Reprinted with permission of Creators Syndicate; **5.3.** Doug Marlette. © 2002. Reprinted with permission of Doug Marlette; **5.4.** Doug Marlette. © Reprinted with permission of Doug Marlette. Published in Doug Marlette, *In Your*

INDEX

Because of the overwhelming number of individual newspapers that are mentioned in this text, the names of newspapers have not been included in this index. Numbers in italics refer to pages on which cartoons appear.